FROM LIOTARD TO LE CORBUSIER
200 Years of Swiss Painting, 1730-1930

FROM LIOTARD TO LE CORBUSIER
200 Years of Swiss Painting, 1730-1930

with Essays by Hans Ulrich Jost, Brandon Brame Fortune,
and William Hauptman

High Museum of Art
Atlanta, Georgia

Edited by
the Swiss Institute for Art Research
on behalf of the
Coordinating Commission for the Presence of Switzerland Abroad

Published on the occasion of the exhibition
From Liotard to Le Corbusier
200 Years of Swiss Painting, 1730–1930,
held at the High Museum of Art, Atlanta, Georgia,
from February 9 to April 10, 1988

The works in the exhibition have been selected by

Hans A. Lüthy
Director
Swiss Institute for Art Research

Donald A. Rosenthal
Chief Curator and Curator of European Art
High Museum of Art

Gudmund Vigtel
Director
High Museum of Art

Edited by the Swiss Institute for Art Research
Marcel Baumgartner, chief editor

Translations: Tapan Bhattacharya, Denise L. Bratton,
Karin Rosenberg

Design by Ewald Graber, Bern

Photolithographs by Schwitter AG, Allschwil-Basel

Filmset in Times, printed and bound by Benziger AG,
Einsiedeln

Printed in Switzerland

The Coordinating Commission for the Presence of Switzerland Abroad
wishes to thank the following corporations for their generous contribu-
tion to the project:

Swiss Bank Corporation
swissair

Library of Congress Catalog Card Number 8-80084

ISBN 0-939802-46-5

Contents

Catalogue

Foreword

Switzerland has come a long way since the days when it exported soldiers for sheer lack of other "commodities." There has been much change and growth, especially since the mid-eighteenth century when the natural beauty of our country became an object of admiration for foreign travelers. To illustrate the past 200 years, we decided not to export well-established clichés but rather paintings of our landscape and of our people.

It is the first time, indeed, that such an important group of paintings has been assembled for exhibition in an American museum. Thanks to the cooperation of a number of Swiss museums and art collectors, the Coordinating Commission for the Presence of Switzerland Abroad was able to undertake this ambitious project. It will serve as a focal point for the multi-faceted "Swiss Weeks" being celebrated in Atlanta, Georgia, this spring. We hope that the exhibition will open the hearts and eyes of American viewers, allowing them to glimpse a Switzerland that is quite a "many-splendored thing."

This exhibition will not travel beyond the High Museum of Art in Atlanta. Knowing its own audience best, the Museum selected the paintings with the expert advice of the Swiss Institute for Art Research in Zürich. If the selection of artists stops before the middle of the twentieth century, it is certainly not a sign that artistic talent is lacking in Switzerland today. Quite the contrary: in choosing to exhibit our old masters now, we want to open doors for contemporary artists.

The catalogue for the exhibition has been compiled by the Swiss Institute for Art Research. It contains various scholarly contributions on aspects of Swiss art and history which deal not only with the paintings but also, for example, with the historical situations of Swiss artists in (self-imposed) exile, and with the social context in which these paintings were produced. Such topics are crucial to an understanding of Swiss art. Many young artists had to seek training and aesthetic fulfillment beyond the borders of Switzerland. Where once it was Paris, Munich, Rome, or London, today it is New York which attracts a surprising number of Swiss artists. Regarding art and politics, your great author Ralph Waldo Emerson once said poignantly: "Beauty will not come at the call of legislature." I quite agree with him, but I daresay that farsighted legislature can provide the possibility for beauty.

This exhibition has come about through the cooperative efforts of members of our Commission, all of whom are involved with foreign countries, and of experts in the field of art. We have also had generous support from Swiss economic circles in the Atlanta area, especially the Swiss Bank Corporation, Atlanta Agency. I am most grateful to them all for their participation. Special thanks go to Mr. Gudmund Vigtel, Director of the High Museum of Art, and his chief curator, Dr. Donald Rosenthal, together with his competent staff; to Dr. Hans A. Lüthy, Dr. Marcel Baumgartner, Ms. Denise Bratton, Ms. Elisabeth Schreiber, and Mr. Paul Müller of the Swiss Institute for Art Research, Zürich; to the Swiss Consul General Paul Studer and his staff in Atlanta; and to the members of our Commission, in particular, Swissair, Pro Helvetia, the Swiss National Tourist Office, the Swiss Office for Trade Promotion with Mr. Kurt Büchler, and the Federal Department of Foreign Affairs with Ms. Hanna Widrig and Mr. Claude Borel.

Massimo Pini, National Councilor
President of the Coordinating Commission
for the Presence of Switzerland Abroad

Preface

Compared with the United States of America, Switzerland covers a very small area of the globe. There are many similarities between the two nations, however, the most important one being the composition of the population. Modern Switzerland was founded as a federation of independent units, called cantons, with very different traditions, languages, and topographical conditions. For instance, the 200 miles between the cantons of Appenzell and Geneva correspond psychologically to the much greater distance between Chicago and New Orleans, with the rural population of Appenzell speaking a Swiss-German dialect and the wealthy citizens of Geneva a Parisian-colored French. Even today, the contrasts between the various Swiss regions are similar to those in the United States.

When, in connection with "Swiss Weeks" in Atlanta, the project of an exhibition covering 200 years of Swiss painting was discussed by the Swiss Consul General and the High Museum of Art, Swiss experts could only question such a hazardous plan. The compilation of the works seemed at first an impossible task, secondly a risky adventure. In fact, the responsible staff of the Museum and the connoisseurs in the Swiss Institute for Art Research in Zürich managed to find a workable formula: the Americans proposed their ideal list of works and the Swiss — following the general concept — revised and augmented the original selection. In many cases, first choices had to be replaced with other paintings: nevertheless the exhibition bears the stamp of a specific view by American art historians of the Swiss scene.

The diversity of cultures in Switzerland corresponds to some extent to the conditions under which America was founded; art of the nineteenth century mirrors in each country the turmoil of influences and styles of the other. Swiss painters never had a geographical focal point like Paris, London, or Rome. Travels abroad and openness to foreign art characterize Swiss as well as American artists. It would be tempting to organize in the future a comparative exhibition, showing contemporary Swiss and American art together. For the moment, however, Swiss painting seems to be as little known in the United States as earlier American painting is in Switzerland, and the present exhibition may serve as a first foray into an unfamiliar field in the arts.

Hans A. Lüthy
Gudmund Vigtel

Nation, Politics, and Art

Hans Ulrich Jost

A statement about the relationship between art and the cultural policy of the Swiss state must begin with the proposition that in Switzerland, bourgeois society and state consciously fashioned not only a national art tradition, but also an aesthetic sense of space, and a specifically Swiss way of seeing. These phenomena came to be considered national cultural assets, but only insofar as they served the social and political needs of the bourgeoisie. One could venture the hypothesis that art produced somewhere between the Alps and the Jura Mountains — but to an even greater extent in the influential spheres of Vienna, Berlin, London, Paris, and Rome[1] — is embraced by the Swiss state only when it functions as a vehicle for political discourse or is useful for internal commerce. Such official recognition of art is reflected in (I) the cultural policy of the state, in (II) the social life of the cities, and in (III) the wholesale appropriation of the land and the mountains of Switzerland.

I.

Modern constitutions rely primarily on the rationality of language to uphold the ideals of a nation. Nevertheless, political leaders have always depended upon symbolic and mythic imagery to make themselves even better understood.[2] In Switzerland this tendency could be observed by the second half of the eighteenth century, for example in the story of Wilhelm Tell. The story suffered unmasking and exposure as a fable in the course of the critique of the Enlightenment. At the same time, the image of Tell, for example *Tell's Leap* by Füssli of c. 1780–90, was commonly understood as a visual manifesto of the revolution.[3] (Fig. 1)

This example points to the curious dialectic between art and politics in nineteenth century culture: symbolic and mythic imagery is superimposed on the rational political discourse of a bourgeois society seeking to legitimize itself. These images, which have an irrational relationship to both the traditions of history and those of the history of art, function to provide what could be called *intuitive* access to the modern state.

The contemporary political system of Switzerland developed in two stages. The period between 1750 and 1848 saw the spread of industrialization as well as the realization of the political objectives of liberal bourgeois society. Between 1848 when the Federal Government and the Constitution were formulated, and 1874 when the Constitution was first revised, the Swiss state as we know it today was born.[4] French domination had shaped the Helvetic Republic of 1798 to 1803, giving dramatic expression to the end of the Ancien Régime and propagating, for the first time in Swiss history, the idea of a modern nation state. In the larger view of political history, this Republic represents an insignificant episode; but for the development of a programmatic approach to the politics of art and of culture, it was a decisive moment.[5] With the Confederation of 1848, liberal forces finally succeeded in creating a national — though still strongly federalistic — state. The twenty-two cantons (states) retained considerable autonomy, especially in the realm of cultural activities. The revision of the Constitution in 1874 reinforced confederational authority, and opened the way for the mod-

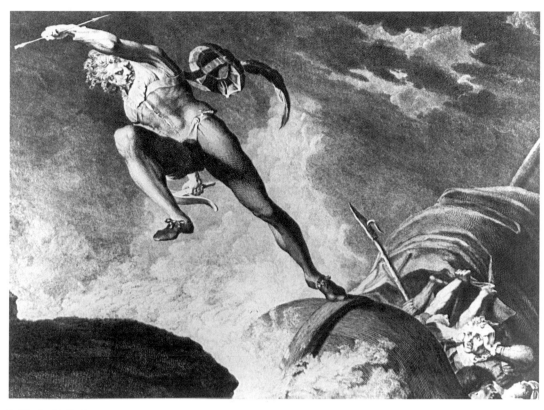

1 Charles Guttenberg
Tell's Leap, c. 1780–1790
Copperplate etching after Johann Heinrich Füssli
Kunsthaus Zürich

ern, though increasingly conservative, constitutional state of the twentieth century.

It was during the period between 1848 and 1874 that a national politics of art took shape. The most important principles of Swiss cultural politics had already been defined at the beginning of the century by the Minister of Art and Science, Philipp Albert Stapfer.[6] Under Stapfer, art and science were considered essential vehicles for expressing the patriotic spirit and the ideals of the civil constitution. This sentiment was so pervasive that even reactionary cantonal governments like the one at Bern during the restoration of the 1820s considered an active policy on art to be a responsibility of the state. In response, cultural politics were highly visible during the formative years of the national state as is evident in the numbers of exhibitions of art and industry, and the tendency toward the wholesale purchase of art with public funds for public collections. On the whole, however, such efforts were quite modest and notably lacked coherent objectives.

The Federal Constitution of 1848, which did not contain a specific article on culture, failed to improve the situation. The insensitivity of government officials toward the need for a coherent policy on art is reflected in the following statement of 1832: "Splendor exists only in nature, which offers us the wonder of the art of architecture, and the magic of painting. More limited is the

[1] See the recent publication on this subject by Oskar Bätschmann and Marcel Baumgartner, "Historiographie der Kunst in der Schweiz," in *Unsere Kunstdenkmäler* (Bern) vol. 38, no. 3 (1987):347–366 and extensive bibliography.

[2] On this theme, see the publication of Jean Starobinski, *1789: Les emblèmes de la raison* (Paris, 1979).

[3] See *Quel Tell? Dossier iconographique de Lilly Stunzi*, with texts by Alfred Berchtold, Manfred Hoppe, Ricco Labhardt, Jean Rodolphe de Salis, Leo Schelbert (Lausanne, 1973).

[4] See Beatrix Mesmer, ed., *Geschichte der Schweiz - und der Schweizer*, vol. 3 (Basel, 1983), especially chapters 7 and 8.

[5] See Pierre Chessex, "Documents pour servir à l'histoire des arts sous la République Helvétique," in *Etudes de lettres* (Lausanne) series IV, vol. 3, no. 2 (1980):93–121.

[6] See William Hauptman, "The Swiss Artist and the European Context: Some Notes on Cross-Cultural Politics," in this volume, 35–36.

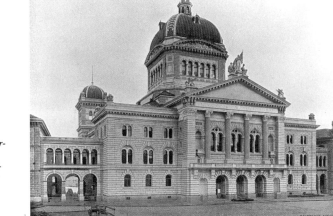

[7] See *Bericht über den Entwurf einer Bundesurkunde, erstattet an die Eidgenössischen Stände von der Commission der Tagsatzung. Berathen und beschlossen in Luzern, den 15. Christmonatt 1832* [15 December 1832] (Zürich, 1833), 13.

[8] In *Der Bund* (Bern) no. 300 (31 October 1865).

[9] See Johannes Stückelberger, "Das Bundeshaus als Ort schweizerischer Selbstdarstellung," in *Unsere Kunstdenkmäler* (Bern) vol. 35, no. 1 (1984):58 – 65; see also Hans Martin Gubler, "Architektur als staatspolitische Manifestation: Das erste schweizerische Bundesrathaus in Bern 1851 – 1866," in *Architektur und Sprache: Gedenkschrift für Richard Zürcher* (Munich, 1982), 96 – 126; and Johannes Stückelberger, "Die künstlerische Ausstattung des Bundeshauses in Bern," in *Zeitschrift für Schweizerische Archäologie und Kunstgeschichte* (Zürich) vol. 42 (1985):185 – 234.

[10] Hans Ulrich Jost, "Un juge honnête vaut mieux qu'un Raphaël: Le discours esthétique de l'Etat national," in *Etudes de lettres* (Lausanne) no. 1 (1984):49 – 73.

[11] In Gottfried Wälchli, *Frank Buchser* (Zürich, 1941), 105.

[12] See the collected works of Burckhardt, *Jacob Burckhardt-Gesamtausgabe* (Berlin/ Leipzig, 1929 – 1934).

[13] See Hans Christoph von Tavel, *Ein Jahrhundert Schweizer Kunst* (Geneva, 1969), especially the chapter "Pflege und Anwendung der Kunst in der Schweiz," 11 – 60.

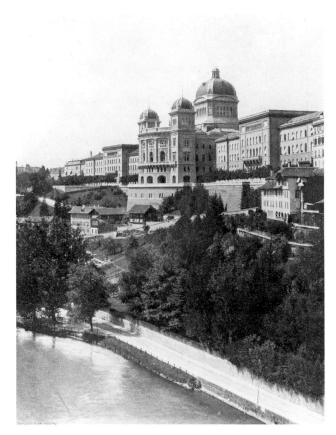

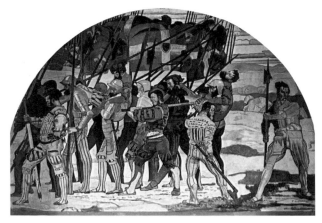

2a,b View of the Bundeshaus at Bern, 1902

3 Ferdinand Hodler
Retreat from Marignano, 1899 – 1900
Fresco and tempera, 131 × 193 inches (332.5 × 490 cm)
Hall of Weapons, Swiss National Museum, Zürich

capacity of man."[7] In a debate of 1865 over the commissioning of art to embellish the chambers of Parliament, it was affirmed that "the best decoration for the House of Parliament will always be wise laws and a government working in the spirit of the Federal Constitution."[8] Nevertheless, a tendency toward bridging the gap between the state and the people with larger, more artfully designed buildings was already making itself felt. In 1902, the new Parliament building, the *Bundeshaus,* was finally inaugurated at Bern.[9] (Figs. 2a, 2b) Its domed architectural design and elaborately decorated interior clearly revealed the tendencies of the newly emerging political aesthetic.

Material and political success, however, by far outdistanced cultural achievements, revealing an unpleasant contradiction between the assuredness of the "founding fathers" and the actual quality of art being produced in Switzerland. In spite of the fact that economic success, the triumph of liberal principles, and the monopoly over power had been declared achievements of civilization — all of which were subsumed under the term "Kulturstaat"[10] — the presence of great art was lacking. In comparison with art being produced in the great cities abroad, there was no important art tradition developing in Switzerland. Rudolf Koller wrote to his friend, the painter Frank Buchser in 1864 that " . . . the state of our art is miserable; the greater public is indifferent; civic associations are narrow-minded and only serve mediocrity; there is no place for the proper exhibition of works of art. Nothing has been done, to speak of, in the upper echelons of government. To put it simply, art does not yet have a home in our country."[11]

Between the demand for a political aesthetic and the need for a national salon for the exhibition of art, a federal policy on art gradually took shape. Buchser was an indefatigable herald for Swiss art, delivering speeches in the foyers of Parliament and in public places frequented by the Councilors. He was no stranger to this milieu: in connection with a journey to the United States in 1866, the painter had been entrusted with a confidential mission for the government. His activities were supported by Federal Councilor, Karl Schenk, a former schoolmaster, and by Salomon Vögelin, a member of Parliament, clergyman, and professor of art history, who had utterly fallen under the spell of the "history of culture" which at the time was gaining popularity.[12] Each of these figures represented a different motive of the developing cultural policy of the Swiss state. Through promotion of the arts, the pragmatist Schenk wanted to improve the competitive potential of Swiss industrial production, but he also believed that art could help overcome the social issue — the widening gap between the bourgeoisie and blue-collar workers. Vögelin, on the other hand, believed that a growing national awareness and promotion of the arts in the context of the materialistic Swiss democracy might allow the buried soul of the people to re-emerge. What had been good for the church, should, according to Vögelin, be equally beneficial to the secularized state. Frank Buchser finally demanded the institution of a national salon, which he considered to be a prerequisite for the development of an effective market for art.[13]

The Federal Parliament allowed itself to be convinced by these arguments. In 1887, a formal resolution was passed creating the Federal Art Commission, which would control a yearly budget of 100'000 Swiss Francs.

This development may suggest that the federal government had at last sanctioned a cultural policy, thereby establishing the foundation on which a national art tradition might develop. On the contrary, the ideological contradictions of a liberal society growing more and more conservative, the deepening social tensions created by industrialization, and the increasing alienation of the various linguistic regions of Switzerland further complicated the search for a national aesthetic identity. Around 1900, Hodler's *Retreat from Marignano* brought the tensions into open conflict for the first time. (Fig. 3) The *Marignano* had been commissioned to decorate the Hall of Weapons — the holy hall — of the newly-founded Swiss National Museum in Zürich. Hodler's retreating warriors, covered with blood, deeply offended the prevailing sense of classical aesthetics and patriotic Swiss idealism. A public outcry forced the Federal Council to declare an opinion on the disdained frescoes, and to defend the persecuted Art Commission which was responsible for the project.[14] In the end, the *Retreat from Marignano* came to be recognized as a symbol of the victory of officially sanctioned art in Switzerland. With a glance back to Hodler's *Wilhelm Tell* of 1896/1897 — Tell's cross-bow would eventually be taken over by Swiss industry as a symbolic seal of quality — and forward to his 1915 portrait of Swiss Army general Ulrich Wille, the patriotic legitimation of art was complete, and the mythical circle of a national art in Switzerland could be closed.

In the first half of the twentieth century, a makeshift patriotic aesthetic based on Hodler's style clearly marked much of the officially recognized art of Switzerland. This style was later allied with a kind of totalitarian cultural politics presented by the Federal Council in a 49-page statement issued in 1938.[15] In this atmosphere, modern tendencies in Swiss art (abstract, non-figurative, or surrealist) were met with resistance. It is typical that Paul Klee — who today is claimed to represent Swiss painting for the period between the two world wars — had in fact been denied Swiss citizenship.[16]

II.

In the development of bourgeois Swiss society, official cultural policy did not measurably alter the circumstances of art and artists. Involvement with art in the social context was limited to sporadic and supportive efforts, and to a kind of ritual sanctioning of objects, in order to maintain a "reasonable aesthetic" and a visual idiom which would be commonly understood. On the other hand, the patronage of art in nineteenth-century society embraced a much broader field of activity. The focal point was the city, where under the auspices of public interest, private circles strove for the promotion of art and science. On the surface merely engaged with apolitical cultural activities and concerned about the aesthetic pleasures of art, these endeavors nevertheless disguised a political, or at least a social purpose.[17]

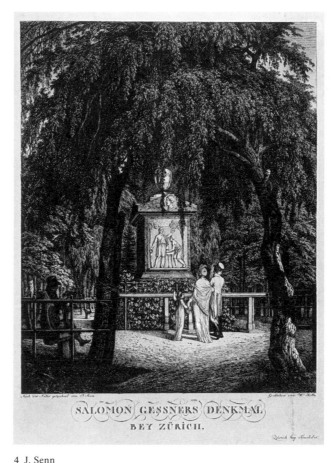

4 J. Senn
Salomon Gessner Monument, Zürich, 1806–1808
Copperplate etching by W. Kolbe, printed by Trachsler
Graphische Sammlung der Zentralbibliothek, Zürich

With the inauguration of the first bourgeois monument in Zürich, a portrait of poet and politician Salomon Gessner erected in 1797, such intentions are at once clearly evident. (Fig. 4) In a pamphlet promoting the monument, an erudite and academically educated citizen explains to a simple working man the sense and purpose of the work. He points out not only Gessner's significance as an ancestor worthy of honor, but also that such a work testifies explicitly to the "patriotic mind" of those who built it.[18]

Artistic activity in Switzerland at this time was intimately related to the bourgeois self-image and social structure which paved the way toward achieving political power. Decades before the founding of the federal state, associations of artists were among the first national organizations to help shape the idea — and image — of modern Switzerland. These associations also played a principal role in creating urban communities. They participated in the founding of museums, organized exhibitions, directed art schools, and they did not disdain to lend a hand in designing decorations for shooting matches and song fests — those festive political demonstrations of the victorious bourgeoisie. (Fig.

[14] See Lucius Grisebach, "Historienbilder," in *Ferdinand Hodler* exh. cat. (Berlin/Paris/Zürich, 1983), 257–283, and for more literature, see n. 10, 260.

[15] In *Bundesblatt der Schweizerischen Eidgenossenschaft*, vol. II (Bern, 1938), 985–1034.

[16] For the details of Klee's plight, see O.K. Werckmeister, "From Revolution to Exile," in *Paul Klee*, exh. cat. (New York, 1987), 39–63, especially "1939: The Failed Application for Citizenship," 58–59. The politics of art between the wars is certainly a story in its own right, and limitations of space prohibit the telling of it here, but for reference and bibliography, see *Dreissiger Jahre Schweiz: Ein Jahrzehnt im Widerspruch*, exh. cat. (Zürich, 1981/1982); see also Paul-André Jaccard, "Suisse romande: centre ou périphérie? Retour en Suisse, retour à l'ordre," in *Zeitschrift für Schweizerische Archäologie und Kunstgeschichte* (Zürich) vol. 41 (1984):118–124; Jürgen Glaesemer, "Das wechselnde Verhältnis zu Paul Klee," in *Neue Zürcher Zeitung*, no. 15 (19/20 January 1980); and Bernard Crettaz, Hans Ulrich Jost, Rémy Pithon, *Peuples inanimes, avez-vous donc une âme? Images et identités suisses au XXe siècle (Études et mémoires de la section d'histoire de l'Université de Lausanne*, published under the direction of H.U. Jost), vol. 6 (1987).

[17] See Hans Ulrich Jost, "Künstlergesellschaften und Kunstvereine in der Zeit der Restauration: Ein Beispiel der soziopolitischen Funktion des Vereinswesens im Aufbau der bürgerlichen Öffentlichkeit," in *Gesellschaft und Gesellschaften, Festschrift zum 65. Geburtstag von Professor Dr. Ulrich Im Hof* (Bern, 1982), 341–368.

[18] See Irma Noseda, "Das Gessner-Denkmal, ein Krokus im bürgerlichen Frühling," in *Tages Anzeiger Magazin* (Zürich), no. 7 (15 February 1975):30–33.

[19] See Lisbeth Marfurt-Elmiger, *Der Schweizerische Kunstverein, 1806–1981: Ein Beitrag zur schweizerischen Kulturgeschichte* (Bettingen, 1981); see also Willi Fries, *Geschichte der GSMBA,* in *100 Jahre Gesellschaft Schweizerischer Maler, Bildhauer und Architekten, 1865–1965* (Bern, 1965).

[20] *Neue Zürcher Zeitung* (23 March 1891).

[21] See Leïla El-Wakil, "Architecture et urbanisme à Genève sous la Restauration," in *Genava* (Geneva) vol. XXV (1977):153–198; Eugène-Louis Dumont, "Sous la Restauration, une création architecturale: La Corraterie," in *Revue du Vieux Genève* (Geneva) vol. 6 (1976):56–60; Armand Brulhart and Erika Deuber-Pauli, *Arts et monuments: Ville et canton de Genève* (Geneva, 1985), 72–77 and 136–139; *Inventaire Suisse d'Architecture, 1850–1920 (INSA),* vol. 4 (Bern: Société d'Histoire de l'Art en Suisse, 1982), especially "Genève: Développement urbain," 276–303.

[22] See William Hauptman, "The Swiss Artist and the European Context: Some Notes on Cross-Cultural Politics," in this volume, 42.

[23] Around 1800, Charles Pictet-de-Rochemont was widely recognized for his visionary agricultural experiments, his contributions to the *Bibliothèque britannique,* and his *Tableau de la situation des Etats-Unis d'Amérique,* a work of two volumes published in 1795/96. The Republic of Geneva sent him as delagate to the Congress of Vienna, where he was instrumental in defining territorial boundaries for the canton which are still valid today. After the fall of Napoleon, Pictet-de-Rochemont served as ambassador for the Swiss Confederation in peace negotiations in Paris, and he authored there the document of 20 November 1815 which declared the everlasting neutrality of Switzerland.

[24] Karl Viktor von Bonstetten, *Briefe/Jugenderinnerungen,* W. Klinke, ed. (Bern, 1945), 132.

[25] Active in both the local government of Zürich and the Swiss Parliament, Alfred Escher (1819–1882) was founder and principal promoter of the ambitious project for the Gotthard railroad line (1863–1882). He is counted among the most influential figures in Swiss politics and commerce. Because of his role in the railroad project, he was known by the people as "Eisenbahnkönig" (Railroad King). See Hans Ernst Mittig and Volker Plagemann, editors, *Denkmäler im 19. Jahrhundert, Deutung und Kritik,* (Studien zur Kunst des 19. Jahrhunderts) (Munich) vol. 20 (1972); Maurice Agulhon, "La statuomanie et l'histoire," in *Ethnologie française* (Paris) vol. 8 (1978):145–172; Marianne Matta, "Richard Kissling (1848–1919), der schweizerische Nationalbildhauer im 19. Jahrhundert," in *Zeitschrift für Schweizerische Archäologie und Kunstgeschichte* (Zürich) vol. 38 (1981):151–161; Toni Stooss, "Das Alfred-Escher-Denkmal, ein Monument der Gründerjahre," in *archithese* (Niederteufen) vol. 3 (1972):34–42.

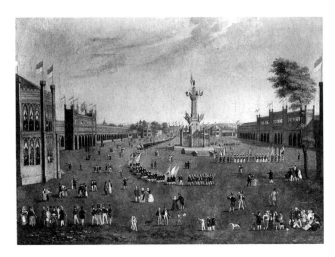

5 Unknown painter
National Shooting Festival at Basel, 1844
Private collection

6 Richard Kissling
Alfred Escher Monument, 1889
Bahnhofplatz, Hauptbahnhof, Zürich
Photograph by Brunner & Hauser.
Graphische Sammlung der Zentralbibliothek, Zürich.

7 Johann Georg Volmar
Nikolaus von der Flüe Taking Leave of his Family, 1810
Oil on canvas, 92½ × 141¾ inches (235 × 360 cm)
Kunstsammlung des Kantons Nidwalden, Rathaus, Stans

5) Political leaders were keenly aware of the importance of these artists' organizations, and promoted their activities with financial contributions. The Swiss Society of Art, for example, was one of the first private organizations to be given the benefit of annual federal subsidy. In 1887, this Society, along with the Swiss Society of Painters and Sculptors, founded in 1865, functioned as recognized interlocutors for matters concerning official art patronage.[19] Thus, artists and art lovers, like innumerable other special interest groups, established themselves within the capitalist political system as neo-corporate entities. Operating under the leadership of the Federal Art Commission, associations openly fought over the considerable federal funds allocated to the arts. By the 1890s this was already causing bitter polemics which ultimately jeopardized public support for government art patronage. Regarding the purchase of paintings by the federal government, for example, the *Neue Zürcher Zeitung* complained: "We shudder at the thought that the quality of Swiss art production can be measured by these works which will now, of course, be preserved and hung in the museums."[20]

In Swiss cities, the interdependence of art and social politics extended to the aesthetic restructuring of public spaces, and this went hand in hand with commercial land speculation. Between promenades, casinos, theatres, and museums, a new space was created whose aesthetic qualities had an attraction which was soon reflected in escalating real estate prices. In Geneva, this strategy characterized the building projects for the *Corraterie* and the *Place Neuve* of 1824–1834, including the addition of a theater, and the Musée Rath inaugurated in 1826; these structures expressed a new domain which was marked by a certain aura, and in which the bourgeoisie could manifest its new social dynamic.[21] And, though most Swiss cities had to wait for museums to be built,[22] art collections which were just being installed throughout the country served the same purpose: providing a platform for the new public image of the bourgeoisie.

Finally, as a culminating gesture in the aesthetic conquest of the city, statues and monuments were added. They of course played a strategic political role. During the fundraising campaign in Geneva for a monument honoring Charles Pictet-de-Rochemont (1755–1824),[23] Karl Viktor von Bonstetten complained: "Here, art becomes a factional issue [. . .] How deeply all political evils are rooted."[24] The 1889 monument to Alfred Escher, railroad magnate, financier, and powerful leader of the liberals, by Richard Kissling, also demonstrates the symbolic importance of such public works.[25] (Fig. 6) The image of Escher was impossible to overlook, installed at the terminus of that "nerve center" of modern Zürich, the Bahnhofstrasse. This broad avenue which connects the financial center of Zürich with the railroad station was just beginning to develop as a commercial center at unprecedented property values.

Toward the end of the nineteenth century, the Swiss addiction to monuments developed into a full-scale plague. In 1897, liberal politician and cultural critic Carl Hilty said that "Our time has, next to other special passions, also the passion for monuments. As soon as an

important person has died, a committee of citizens inevitably suggests collections for a monument . . . "[26]

The business of exhibiting qualified art prospered as well, but in a manner which reflected the same refined bourgeois self-image we have encountered in the social and urban spheres. It is not surprising that art exhibitions were frequently organized to coincide with sessions of Parliament. The "Swiss Exhibition of Industry, Agriculture and Art" held in Bern in 1857 took place, for example, at the same time as the sessions of Parliament. On such occasions, paintings with political content had high visibility, and exhibition organizers deliberately took such opportunities to confront state envoys. In 1818, during a moment of deep internal political crisis, Johann Georg Volmar's *Nikolaus von der Flüe Taking Leave of his Family,* painted eight years earlier, was moved to the center of an exhibition in Bern especially for the envoys of the Diet (Tagsatzung). (Fig. 7) Nikolaus von der Flüe, the mythic and historic symbol of old confederate mediation and reconciliation, was to lead the way out of the crisis.[27]

This bourgeois self-promotion fueled by official cultural policy came to fruition in the Swiss national fairs of 1883, 1896 and 1914.[28] Here, the aesthetic identity of Switzerland was expressed in the design of exhibition pavilions. In these constructions one easily recognizes the attempt, doomed from the start, to unite the form of the Swiss chalet, that incarnation of rural patriotism, with the Greek temple, the standard expression of aesthetic grandeur.

The art event of the 1914 national fair did not, however, take place in the pavilions themselves, but rather in streets and squares all over the country. The trigger was the official poster for the exhibition, a work by Emil Cardinaux, whose daring colors (a green horse) provoked a storm of indignation.[29] This controversy brought the breach between the Swiss Confederation of the nineteenth century and Switzerland of the twentieth century into sharp focus.

Switzerland found aesthetic identity in another impressive form: the *Village Suisse* (Geneva, 1896) and the *Dörfli* (Bern, 1914). These were nostalgic reconstructions of ideal Swiss villages, in reduced scale, and came to be regarded as sacred images. In both cases, seamless environments were conceived and fabricated based on towns which had long ago been sacrificed to tourism and industrialization. In Geneva, for example, the *Village Suisse* included an artificial mountain and waterfall, and the scene was animated with costumed staffage imported from all parts of the country, and with cows.[30] (Figs. 8a, 8b, 8c) In these constructions, the idyll painted by Albert Anker was finally achieved, and the Swiss people were able to find the cultural and aesthetic greatness they so desperately sought.

Fine art increasingly came to be regarded as the exclusive property of art dealers and specialists educated in the new art history departments of Swiss universities. Public opinion on art varied, as is reflected in the multitude of small groups and circles which formed at this time. Almost simultaneously, popular theme exhibitions,[31] special exhibition halls called *Kunsthallen,*[32] and a plethora of art galleries came into being. Whereas the

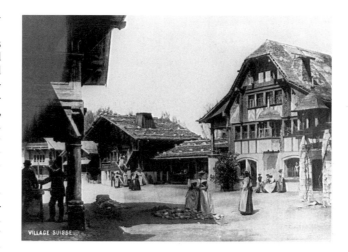

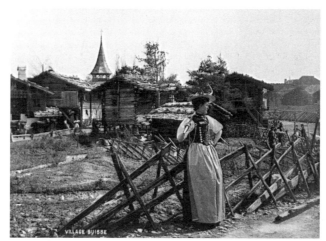

8a,b,c The *Village Suisse*
Swiss national fair, Geneva, 1896

[26] Carl Hilty, *Politisches Jahrbuch der Schweizerischen Eidgenossenschaft,* vol. XI (Bern, 1897), 733.
[27] See Hans Ulrich Jost, "Les Expositions, miroirs de la culture politique suisse au XIXe siècle," in *Zeitschrift für Schweizerische Archäologie und Kunstgeschichte* (Zürich) vol. 43, no. 4 (1986):348 – 352.
[28] See Hermann Büchler, *Drei Schweizerische Landesausstellungen: Zürich 1883; Genf 1896; Bern 1914* (Zürich, 1970).
[29] See Peter Martig, "Die Schweizerische Landesausstellung in Bern 1914," in *Berner Zeitschrift für Geschichte und Heimatkunde* (Bern) vol. 46 (1987):163 – 179.
[30] See Bernard Crettaz and Juliette Michaelis-Germanier, "Une Suisse miniature ou les grandeurs de la petitesse," in *Bulletin annuel du Musée d'ethnographie de la Ville de Genève,* vol. 25/26 (1982/1983):63 – 185.
[31] For example, *Französische Impressionisten,* an exhibition of October and November 1908, Künstlerhaus, Zürich. See Lukas Gloor, *Von Böcklin zu Cézanne: Die Rezeption des französischen Impressionismus in der deutschen Schweiz* (Europäische Hochschulschriften, vol. 58, series XXVIII Kunstgeschichte, Bern/Frankfurt am Main/New York, 1986), 109 118.
[32] For example, those inaugurated at Basel in 1870, and at Bern in 1918.

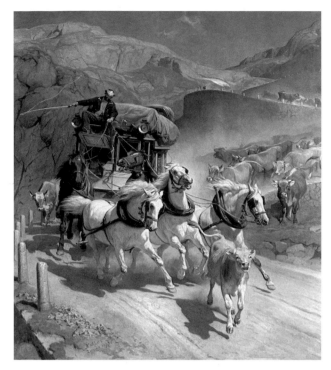

9 Rudolf Koller
The Gotthard Post, 1873
Oil on canvas, 45⅞ × 39⅛ inches (116.5 × 99.5 cm)
Kunsthaus Zürich

[33] Hans Gustav Keller, *Minister Stapfer und die Künstlergesellschaft in Bern* (Thun, 1945), 9 – 12, and especially 11.

[34] Jonas Fränkel and Carl Helbling, eds., *Gottfried Keller: Sämtliche Werke* (Bern, 1926 – 1949), vol. 6, 284; see also Peter Utz, "Die ausgehöhlte Gasse: Stationen der Wirkungsgeschichte von Schillers *Wilhelm Tell,*" in *Forum Academicum, Hochschulschriften Literaturwissenschaft* (Königstein, Taunus) vol. 60 (1984):122.

[35] See Ernst Gagliardi, *Alfred Escher: Vier Jahrzehnte neuerer Schweizergeschichte* (Frauenfeld, 1919), 155.

[36] Ernest Bovet, "Nationalité," in *Wissen und Leben* (Zürich) vol. IV (1909):431 – 445, and especially 441.

[37] See Hans Christoph von Tavel, et. al., *Schweiz im Bild - Bild der Schweiz? Landschaften von 1800 bis heute,* exh. cat. (Zürich, 1974).

[38] David Hess, "Kunstgespräch in der Alpenhütte," in *Alpenrosen, ein Schweizer-Taschenbuch auf das Jahr 1822* (Bern, 1822), 111 – 166.

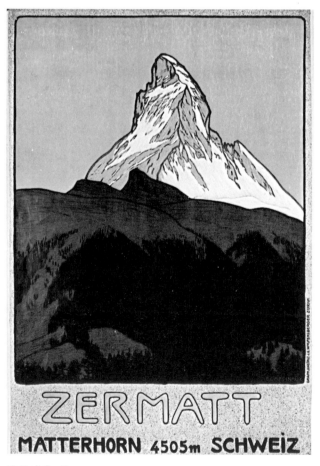

10 Emil Cardinaux
Zermatt/Matterhorn, 1908
Poster
Plakatsammlung, Museum für Gestaltung, Zürich

cultural management of the city, and of the production of art, had once been seen as a means of bringing society and state closer together, by the end of the nineteenth century, art had already been co-opted into the systems of market competition and division of labor which characterize modern capitalistic production.

III.

A bourgeois nation without land is like a phantom ship in the fog. In Switzerland of the nineteenth century, it was not sufficient to merely control the land through the sovereignty of the state: the ultimate goal was to transform territory into fatherland, and land into private property. In this context, mediation between nation and citizen was accomplished through the use of landscape painting and land register, cartography, and educational tour. Views of the landscape came to embrace a new perspective, tinged with political meaning, which was heightened by the introduction of highways and bridges, by steamboat and railroad. Swiss landscape painting was, accordingly, tuned to the needs of commercial tourism as well as the patriotic discourse. Nature had been hailed as Switzerland's greatest cultural asset, and even as the very aesthetic expression of the Swiss state. Stapfer had demanded more landscape painting because it offered the Swiss people a gallery which surpassed any other national treasure.[33] And Gottfried Keller's *Grüner Heinrich* frankly admits that "With the thoughtlessness of youth and childish age, I believed that the natural beauty of Switzerland was a reflection of historical and political merit and of the patriotism of the Swiss people: an equivalent to freedom itself."[34]

This discourse took on a religious tone as soon as the mountains came up for discussion. A hymn in praise of the Swiss Alps had arisen with Albrecht von Haller's poem of 1729 "Die Alpen". This sentiment was recast during World War II into the concept of *réduit national,* adding a spiritual edge to the military goal of national defense. In fact, the Alps came very near to being written into the Constitution. Alfred Escher's speech at the opening session of Parliament in 1850 introduced the term *Hochaltar der Freiheit* ("high altar of freedom") giving new meaning to the Alps in the context of national politics.[35] And, at the beginning of the twentieth century, when the mountain valleys of Switzerland were depopulating and at the same time being overrun by tourism, intellectuals like Ernest Bovet (1870 – 1941) declared the mountains to be the only unchanging feature of Switzerland.[36] Yet, as industrialization drew the Swiss population out of the mountains, the image of a *Volk der Hirten* — a people of herdsmen — was being powerfully instilled in the collective consciousness.[37]

The appropriation of land, and especially mountains, played an important role in the development of a Swiss art tradition. In nearly every text on painting from the nineteenth century, painters are urged to look to the landscape and to nature for inspiration. It is no coincidence that one of the first popular articles on art theory published in Switzerland was dedicated to landscape painting: "Kunstgespräch in der Alpenhütte"[38] describes a fictive conversation which takes place in an alpine hut among four travelers thrown together by a sud-

den thunderstorm. A young painter, art history professor, English tourist, and art dealer represent contemporary perspectives on Swiss art.

There was no lack of large-scale landscape painting, and especially alpine landscape painting. Eighteenth-century illustrations of travels in the Alps, for example those of Johann Ludwig Aberli (1723–1786), are followed by the landscapes of Alexandre Calame (1810–1864) and Rudolf Koller (1828–1905) — whose *Gotthard Post* of 1873 was one of the most widely disseminated art reproductions of its time (Fig. 9) — and eventually by the mountains of Ferdinand Hodler. In 1921, Swiss art critic Hermann Ganz commented on the relationship between Hodler's interpretation of the landscape and the national identity: "The mountains of Hodler add an overpowering force and magnitude to the Swiss landscape, enabling Switzerland to stand out as an independent entity against the countries which surround it."[39]

This heroic image of the Alps corresponded precisely to the marketing requirements of tourism in Switzerland. Emil Cardinaux's *Zermatt/Matterhorn* of 1908, a commercial poster inspired by Hodler's portraits of the mountains, is one of the most striking examples of this marriage of tourism, patriotism, and popular art.[40] (Fig. 10) A deluxe edition, without the advertising text, found its way into countless middle class living rooms, and served as a favorite decoration for Swiss military hospices during the war. The image was also reproduced on the cover of cultural magazines such as *Wissen und Leben*. Thus, the aesthetic value of the mountain landscape, framed by a particularly Swiss patriotic spirit, found its ultimate commercial purpose.

An important feature of this appropriation of landscape for social, cultural, patriotic, and commercial purposes was technological progress and the resulting changes in perceptions of nature and the land. The views available to a traveler from the deck of a lake-bound steamboat, as well as those possible from one of the new suspension bridges serve to demonstrate this point. A tour on the *Guillaume Tell,* the first steamboat on Lake Geneva, moved Karl Viktor von Bonstetten to record his impressions of the dazzling procession of framed views "floating by like phantoms" as he stood on the ship's deck.[41] A French tourist recorded similar impressions some years later, apparently from the same perspective, of the *panorama charmant* revealed to the spectator traveling by boat.[42]

With these descriptions we encounter the term which describes the new way of seeing: *panorama.*[43] Throughout the nineteenth century, panoramas and panorama-like imagery were immensely popular.[44] The most familiar of all, known far beyond the borders of Switzerland, was the Bourbaki Panorama of 1881, originally installed in Geneva, but moved to Lucerne in 1889. (Figs. 11a, 11b) The panorama depicts the entrance into Switzerland and the disarming of the French Eastern Army of General Bourbaki at Les Verrières, February 1871. This decisive incident brought an end to the Franco-German War. The Bourbaki Panorama was instrumental in fostering the myth of Switzerland as a place of refuge, and was thus able to add a new dimension to Swiss foreign

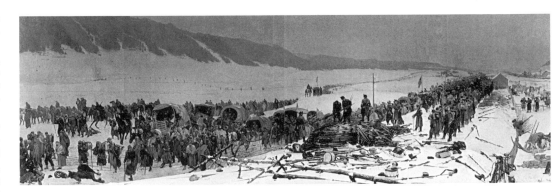

11a Edouard Castres
Detail of the *Bourbaki Panorama,* 1881
Panorama Building, Lucerne

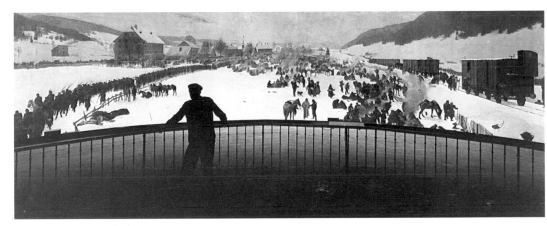

11b Spectator in the Bourbaki Panorama Building, Lucerne

[39] Hermann Ganz, "Zur Entstehung der nationalen Schule in der schweizerischen Kunst," in *Die Schweiz* (Zürich) vol. 25 (1921):35–43.

[40] See Bruno Margadant, *Das Schweizer Plakat 1900–1983* (Basel/Boston/Stuttgart, 1983), 14–19.

[41] Karl Viktor von Bonstetten, *Briefe* (see n. 24), 121.

[42] J. Couperie Aîné, *Voyage en Suisse et en Savoie* (Nogent-sur-Seine, 1825), 75.

[43] See Stephan Oettermann, *Das Panorama: Die Geschichte eines Massenmediums* (Frankfurt am Main, 1980), with bibliography; see also the proceedings of the colloquium *Das Panorama* (Lucerne, 25–27 April 1985) organized by the Swiss Association of Art Historians in *Zeitschrift für Schweizerische Archäologie und Kunstgeschichte* (Zürich), vol. 42, no. 4 (1985):241–344.

[44] The first panorama of the Alps was produced by a Geneva military officer from the special unit of architects and engineers called *Genietruppen.* The social and political critic Jacques Barthélemy Micheli du Crest (1690–1766) produced a topographically exact panorama during his imprisonment at the Fortress of Aarburg for conspiracy against the aristocratic Bernese government.

[45] In response to the Bourbaki panorama, the young and as yet unknown painter Ferdinand Hodler made his first experiments with parallelism. See Jura Brüschweiler, "La participation de Ferdinand Hodler au *Panorama* d'Edouard Castres et l'avènement du parallélisme hodlérien," in *Zeitschrift für Schweizerische Archäologie und Kunstgeschichte* (Zürich), vol. 42, no. 4 (1985): 292–296; on the "parallelism" of Hodler, see Oskar Bätschmann, "Ferdinand Hodlers Kombinatorik," in *Schweizerisches Institut für Kunstwissenschaft, Jahrbuch 1984–1986: Beiträge zu Kunst und Kunstgeschichte um 1900* (Zürich, 1986), 55–79, and especially 68–72 and bibliography; see also Oskar Bätschmann, "The Landscape Oeuvre of Ferdinand Hodler," in *Ferdinand Hodler: Landscapes,* exh. cat. (Zürich, 1987), 35.

[46] See Charles Rosen and Henri Zerner, *Romanticism and Realism: The Mythology of Nineteenth Century Art* (London/Boston, 1984), chapter II, "Caspar David Friedrich and the Language of Landscape," 49–70.

[47] See Tom F. Peters, "Guillaume-Henri Dufour, 1787–1875: Ingenieur und Hängebrückenbauer," in *Schweizer Pioniere der Wirtschaft und Technik: Fünf Schweizer Brückenbauer* (Zürich) vol. 41 (1985):59–86; Dufour was also an officer of the *Genietruppen*, and in 1847, as General, he led the Army of liberal Switzerland in a civil war against the conservative Catholic opposition.

[48] In 1291, the "Oath of the Rütli" was taken by representatives of the three original Swiss cantons: Uri, Schwyz, and Unterwalden. This solemn declaration, which took place in a meadow overlooking the Lake of Uri, has come to symbolize the foundation of the Swiss Confederation.

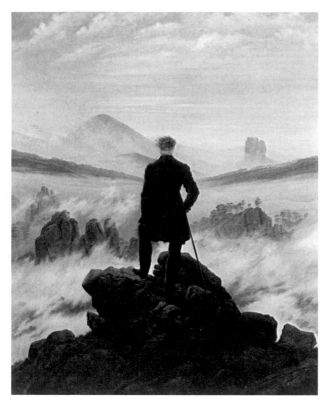

12 Caspar David Friedrich
The Wanderer above the Mists, c. 1818
Oil on canvas, 38¾ × 29½ inches (98.4 × 74.8 cm)
Kunsthalle Hamburg

13 Detail of Plate XVII of Dufour's Map of Switzerland

14 Unknown artist
Switzerland, 1890
Poster
Plakatsammlung, Museum für Gestaltung, Zürich

policy. Since the foundation of the German Reich, the Swiss nation had been surrounded by large and aggressive political powers, and had sought international legitimation.[45]

The special perspective of such panoramas characterizes another nineteenth century view: the one experienced from a bridge, and especially a suspension bridge. Switzerland, with its rugged terrain and numerous rivers cutting through the mountain ranges, was an ideal setting for the construction of bridges. Spanning a mountain valley, the bridge offers the viewer a new vantage point which seems to hover high above the landscape, not unlike the prospects of Caspar David Friedrich (1774–1840).[46] (Fig. 12) One of the first of such constructions was designed by Guillaume Henri Dufour in 1823.[47] Dufour had directed the redevelopment of the *Place Neuve* and the *Corraterie* in Geneva, and the utopianism embodied in this new approach to urban spaces found another expression in the technological conquest of the Swiss landscape. Like the first modern map of Switzerland, also by Dufour (Fig. 13), and the railroad

line through the Gotthard massif of 1882, the nineteenth-century enthusiasm for bridge building reveals the familiar self-conscious political objectives of bourgeois society. This conquest of the land unquestionably left emblematic traces on the art of the end of the nineteenth century, finding a special medium in tourism posters which also took up the symbols of progress. (Fig. 14)

Panoramic landscape painting and cartography gave concrete form to the new vision of land and nation in Switzerland, but they also provided points of view which were common in political and economic experience of bourgeois society at that time. The majestic views of the Swiss Alps from lakeside promenades; the sweeping hemicycle of the hall of Parliament, decorated with an enormous panoramic painting by Charles Giron of The Lake of Uri (Lake Lucerne) and the Rütli (Fig. 15);[48] and depictions of land and history in numerous patriotic parades through urban spaces: all refer to a specific way of seeing, characterized by a special perspective, which strives to embrace the totality of experi-

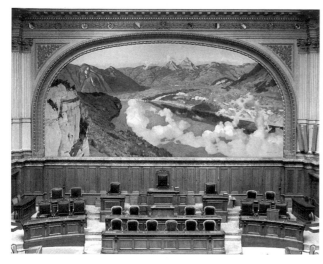

15 Charles Giron
The Cradle of the Confederation, 1901–1902
Oil on canvas, 5 × 11.5 meters
Chamber of the Federal Parliament, Bundeshaus, Bern

17 Ferdinand Hodler
Wilhelm Tell, 1896–1897
Oil on canvas, 100¾ × 77¼ inches (256 × 196 cm)
Kunstmuseum Solothurn

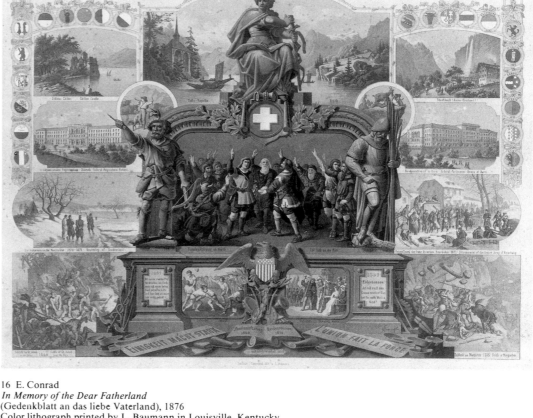

16 E. Conrad
In Memory of the Dear Fatherland
(Gedenkblatt an das liebe Vaterland), 1876
Color lithograph printed by L. Baumann in Louisville, Kentucky

Central Image: Top: Helvetia seated between Tell's Chapel on the left and the Rütli on the right; below her, the Swiss Flag; *Center.* Oath of the Rütli flanked by the figure of Wilhelm Tell on the left and the Swiss hero Winkelried on the right; *Bottom:* Below Tell is displayed a text drawn from Schiller's dramatic work; in the center are two panels depicting a wrestling match and a shooting match, Swiss national sports; on the right, below Winkelried, is a text relating to the legend about his sacrifice. In the area between the central and lower panels, the American eagle and national flag are prominently displayed, and in front rests the symbolic representation of the Swiss Constitution.
Peripheral imagery: Clockwise from upper right, surrounded by the flags of the Swiss cantons, panels include images of: a waterfall in the Bernese Oberland; the Federal Parliament building in Bern (Bundeshaus); the 1871 disarming of General Bourbaki's troops; the 1315 Battle of Morgarten; the 1444 Battle of St. Jakob near the Birs River; the "Neutrality of Switzerland" 1870–1871; the Federal Polytechnic School in Zürich; and, the Chillon Castle on Lake Geneva. Above Tell and Winkelried, rondels portray alpine herders with goats.

ence, but which also has a tendency toward the quantitative techniques of listing, lining up, wide circumspection, overview as large as possible. In short, a visual language effective on the concrete as well as the symbolic level which makes possible the total consideration of space.

The symbolic imagery accompanying political discourse (Fig. 16), the social and political patronage of art, and the conquest of the national space all take inspiration from the same source: the historical figure. Like the statues populating the social space of the bourgeoisie, an historic image infiltrates the collective consciousness of bourgeois society.[49] The historic representation has little

to do with a rational critical discourse: it is merely a portrait petrified in myth. Hodler's *Tell* is just one of the historic figures who have been strategically positioned at the forefront of politics and art. (Fig. 17) Such a figure, made rigid as a mountain in the posture of defense, dominates a space whose significance is impregnated with symbols, but which at the same time is impossible to define. An example of the facile application of patriotic discourse to such an image is found in the foreword to an exhibition catalogue published in 1941: "Here, Tell; here, the (Swiss) Confederation."[50] In this way, the quality of a "Swiss" art blends seamlessly and beyond all critical reflection with the mythologized genuineness of the political system of bourgeois society.

[49] See Franz Zelger, *Heldenstreit und Heldentod: Schweizerische Historienmalerei im 19. Jahrhundert* (Zürich, 1973).
[50] Conrad von Mandach, *450 Jahre Bernische Kunst,* exh. cat. (Bern, 1941), Foreword, 10.

Painting in America and Switzerland 1770 – 1870

Preliminaries for a Comparative Study

Brandon Brame Fortune

During the later eighteenth century, there was a certain respect in the American colonies for the ideal republican government believed to have existed at one time in Switzerland. American statesmen of the pre-Revolutionary period even praised the surviving structures of patrician Swiss republics. Thought to be in "safe possession of [their] freedom," these governments were regarded as the last bastions (with England) of ancient "saxon" or "gothic" liberties. The Swiss themselves were seen as a "rustic people locked in mountain sanctuaries," whose virtue had been preserved.[1] This admiration for the Swiss republic, and the Swiss love of freedom may have colored the impressions American artists formed of their Swiss counterparts from the middle of the eighteenth century onward. In a letter to the Swiss painter Jean-Etienne Liotard (1702 – 1789) of 1762, colonial portraitist John Singleton Copley (1738 – 1815) asked for "one sett of Crayons of the very best kind," but also wrote of his hope that "America, which has been the seat of war and desolation, [. . .] will one Day become the school of fine Arts and Monsieur Liotard['s] Drawing with Justice be set as patterns for our immitation."[2] (Figs. 1, 2)

The Swiss, on the other hand, admired the new American government and its leading figures. A painting for the Bundeshaus at Bern, honoring American democracy and celebrating the end of the Civil War, was planned by a liberal Swiss group around 1865.[3] Though never executed, this work was intended as a tribute to the newest democracy from members of the oldest one. Swiss citizens migrated in large number to America before and after the Revolution, seeking relief from political or religious persecution and from economic distress. Among them were artists who traveled to America as settlers, or in order to study the landscape and peoples which were so fascinating, yet so little known, to Europeans. Swiss artists produced paintings and drawings of the uncharted landscape, images of the native American Indian and the black peoples, and portraits of colonial leaders and heroes of the American Revolution. America offered these artists exotic and unspoiled peoples and vistas which were not available in Europe.

With the rise of republican governments during this time, the notion of national art expressing nationalistic ideals and goals took hold.[4] Visual artists increasingly

[1] See Franco Venturi, *Utopia and Reform in the Enlightenment* (Cambridge, 1971), 22 – 23, 44 – 46, 28 – 87, and *passim;* see also Bernard Bailyn, *The Ideological Origins of the American Revolution* (Cambridge, 1967), 65 – 67, 138, 282 – 283, and 287.
[2] Jules David Prown, *John Singleton Copley* (Cambridge, Mass., 1966), vol. I, 37.
[3] On this subject, see chapter III of this essay.
[4] See Hans Ulrich Jost, "Nation, Politics, and Art," in this volume, *passim.*

1 Jean-Etienne Liotard
Woman from Molduu
Chalk and pencil on paper, 8½ × 6 inches (21.5 × 15 cm)
Kupferstichkabinett, Staatliche Museen Berlin

2 John Singleton Copley
Mrs. Seymour Fort, 1785 – 1790
Oil on canvas, 50 × 40 inches (127 × 101.5 cm)
Wadsworth Atheneum, Hartford, Connecticut

5 See Hans Lüthy, "The Sense of a Common Heritage from the Late Eighteenth to the Early Twentieth Century," in Florens Deuchler, Marcel Roethlisberger, and Hans Lüthy, *Swiss Painting from the Middle Ages to the Dawn of the Twentieth Century* (New York, 1976), 129 – 130, and bibliography.

6 See Lillian B. Miller, *Patrons and Patriotism: The Encouragement of the Fine Arts in the United States 1790 – 1860* (Chicago, 1966); see also Maybelle Mann, *The American Art-Union* (New York, 1977); and Mary Bartlett Cowdrey, *American Academy of Fine Arts and American Art-Union 1816 – 1852* (New York, 1953). Current scholarship in this area examines strategies for determining a national art in nineteenth-century America and Europe by reflecting on past attempts to create or define native traditions and "national" arts. Many of the papers presented at the conference "Nationalism in the Visual Arts" (16/17 October 1987, Department of the History of Art, The Johns Hopkins University/Center for Advanced Study in the Visual Arts, National Gallery of Art) dealt with these issues. Another source on this subject is Linda Jones Docherty, "A Search for Identity: American Art Criticism and the Concept of the Native School, 1876 – 1893." Ph.D. diss., University of North Carolina at Chapel Hill, 1985.

7 See William Hauptman, "The Swiss Artist and the European Context: Some Notes on Cross-Cultural Politics," in this volume, 35 – 46, passim.

8 On study in London, see Dorinda Evans, *Benjamin West and His American Students* (Washington, D.C., 1980).

9 For an account of artistic training in Paris, the standard source is Albert Boime, *The Academy and French Painting in the Nineteenth Century* (New Haven, 1986; originally published in London, 1971), especially 22 – 78; see also M. Landgren, *American Pupils of Thomas Couture* (College Park, Md., 1970).

10 On Gleyre's teaching, see Albert Boime, "The Instruction of Charles Gleyre and the Evolution of Painting in the Nineteenth Century," in *Charles Gleyre ou les illusions perdues,* exh. cat. Winterthur/Marseille/Munich/Kiel/Aarau/Lausanne 1974/75 (Zürich, 1974), 102 – 125; see also William Hauptman, "Delaroche's and Gleyre's Teaching Ateliers and Their Group Self-Portraits," in *Studies in the History of Art,* vol. XVIII (November 1985):79 – 119.

focused on local landscape and scenery, peoples, and history. The search for national characteristics in visual expression, and for government support for the fine arts would be a predominant concern throughout the nineteenth century. This was particularly evident wherever more than one or two ethnic or linguistic traditions were present, as was the case in both Switzerland[5] and the United States. Thus, obvious similarities between the two countries — their geographic isolation, diverse populations, republican origins, and extraordinary landscapes — offer a perspective from which to study the situation of artists in America and Switzerland during the period between the late eighteenth and late nineteenth centuries.

Although specifically American, or Swiss, themes and technical approaches to the visual arts were publicly praised and sought after, they were rarely defined with any degree of exactitude.[6] Despite the increase in political stability and international recognition, the desire for geographically bound or nationally determined art was rarely fulfilled in the new nations. It proved impossible to direct the development of a national art in the United States or in Switzerland when artistic practice and training remained an international phenomenon developing around shifting centers at London, Rome, and Paris through the mid-nineteenth century, with Paris emerging as the center where artistic standards were really determined. Any discussion of artists' training (I), practice and patronage (II) as well as subjects chosen for their paintings — portraiture (III), landscape (IV), and genre painting (V) — must begin with this tension in mind: that nationalistic tendencies, as well as growing middle-class taste for pictures, were at times in conflict with standards set in European cultural centers. In this regard, Swiss and American artists found themselves in similar circumstances.

I. Training

American artists, like their Swiss counterparts,[7] often traveled abroad to obtain training in Rome, London, Paris, and Düsseldorf. Some of them established themselves as teachers and eventually directed their own ateliers.

Study in Italy was most common, especially for artists pursuing landscape painting, classical themes, or the Italian old masters. The first American-born artist to study in Rome was Benjamin West (1738 – 1820), and after him, John Singleton Copley (1737 – 1815), and Washington Allston (1779 – 1843), among others. There, the Americans came into contact not only with Italian and classical art, but also with European artists studying and working there. These included Swiss-born Angelika Kauffmann (1741 – 1807), whom West met in Florence, Johann Heinrich Füssli (1741 – 1825), and also Louis Ducros (1748 – 1810), whose landscapes would have great impact on American painting of the nineteenth century. Before the Civil War, Americans were most likely to pursue serious studies of art in London. Benjamin West directed a studio there, and three generations of New World artists were trained under him.[8] American artists who sought training in history painting were especially drawn to the Ecole des Beaux-Arts in Paris, where they absorbed the carefully defined, highly discursive imagery of French neoclassicism as practiced by Jacques-Louis David (1748 – 1825), François-André Vincent (1746 – 1816), and their contemporaries. After the Civil War, artists preferred to study in one of the many Paris ateliers directed by French painters outside the Ecole, such as Jean Léon Gérôme (1824 – 1904), Thomas Couture (1815 – 1879), and the Swiss painter, Charles Gleyre (1806 – 1874).[9] Gleyre was a master of the polished brushwork and elaborate classical, biblical or oriental compositions typical of the French academic painting so admired by other Europeans, and also by many Americans. His Paris atelier was frequented by both American and European artists.[10] By the 1830s, when academies of art were well-established in the United States, some American artists made the conscious choice not to study in Europe, for example Winslow Homer, who did not travel abroad until after he was 30 years old.

II. Patronage

European training based on the standards of the French Academy gave emphasis to historical subjects, including biblical themes and ancient and modern literary themes. However, there was very little patronage in the United States for such subjects, especially in less urban areas. This was also true in Switzerland.[11] Although history paintings were often highly praised in the critical press, and sometimes even attracted a paying public, they were seldom sold. Patriotic or nationalistic subjects were popular for official commissions, but not for the private market. John Trumbull (1756–1843), for example, found no buyers for paintings and engravings depicting decisive events of the American Revolution (Fig. 3). But in 1817, four paintings based on this earlier series were commissioned for the Capitol rotunda in Washington, D.C. Similar commissions were given to John Vanderlyn (1776–1852), Robert W. Weir (1803–1889), and William H. Powell (1824–1879) after 1836.[12] Nevertheless, government commissions represented a minor force in American art patronage at this time. In predominantly protestant United States, church patronage was also limited.

In fact, American and Swiss artists trained in European cultural centers frequently returned home to find that they were compelled by their markets to revise their choice of subject or certain technical aspects of their work in order to suit the tastes or needs of the buying public.[13] Those who intended to pursue history painting despite the lack of patronage, or to cultivate clients of great wealth and social position returned to London, Paris, or Rome, and remained there in order to pursue their chosen subjects. The most talented of these artists achieved international reputation. For example, John Singleton Copley left America on the eve of the American Revolution, and settled in London where he achieved success as a portraitist and history painter. Angelica Kauffmann, known for her portraits of the aristocracy of London, and for decorative still life painting, also devoted herself to history paintings (cat.nos. 5, 6).[14] Charles Willson Peale (1741–1827) knew Kauffmann in London, and described her as a female "genius" whose lively imagination rendered her capable of "perfection in painting."[15] Benjamin West (Fig. 4) chose to remain in England, becoming Historical Painter to King George III in 1772, and President of the Royal Academy at the death of Sir Joshua Reynolds in 1792.[16] Johann Heinrich Füssli emigrated from Switzerland to London in 1779. There, he was appointed professor of painting at the Royal Academy in 1799.

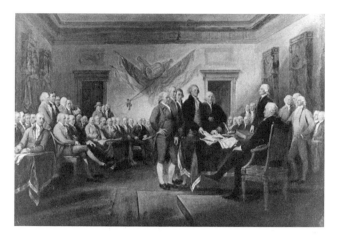

3 John Trumbull
The Declaration of Independence, 1786
Oil on canvas, 21⅛ × 31⅛ inches (53.5 × 79 cm)
Yale University Art Gallery, New Haven, Connecticut

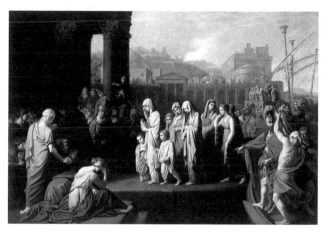

4 Benjamin West
Agrippina Landing at Brundisium with the Ashes of Germanicus, 1768
Oil on canvas, 64½ × 94½ inches (164 × 240 cm)
Yale University Art Gallery, New Haven, Connecticut

[11] On this subject, see William Hauptman, "The Swiss Artist" (see n. 7), especially 40.

[12] An early example of such a commission in Switzerland was that given to Johann Heinrich Füssli for the *Oath of the Rütli* (1779–1781) for the Rathaus of Zürich. This painting celebrated the medieval origins of the Swiss Confederation with the oath taken by representatives of the three original cantons in a meadow above Lake Lucerne. See Lilian B. Miller, *Patrons and Patriotism* (see n. 6), 40–57; for Trumbull's contributions, see also Helen A. Cooper, et. al., *John Trumbull: The Hand the Spirit of the Painter* (New Haven, 1982), 39–41; on Füssli, see Gert Schiff, *Henry Fuseli 1741–1825* (London, 1975) 57, nos. 16 and 17; and, see Marcel Roethlisberger, "From the Baroque Era to the Age of Enlightenment," in *Swiss Painting* (see n. 5), 122–123.

[13] See Hans Lüthy, "The Sense of a Common Heritage" (see n. 5), 130.

[14] On Kauffmann, see Arthur S. Marks, "Angelica Kauffmann and Some Americans on the Grand Tour," in *American Art Journal,* vol. XII (Spring 1980):4–24; and, by the same author, *Angelica Kauffmann und ihre Zeitgenossen* (Bregenz, Austria, 1968).

[15] Charles Willson Peale, "Autobiography," cited in Charles Coleman Sellers, *The Artist of the Revolution: The Early Life of Charles Willson Peale* (Hebron, Ct., 1939), 80.

[16] Helmut von Erffa and Allen Staley, *The Paintings of Benjamin West* (New Haven, 1986).

17 On Theüs, see Margaret Simons Middleton, *Jeremiah Theüs: Colonial Artist of Charles Town* (Columbia, S.C., 1953); on Du Simitière, see Paul G. Sifton, "Pierre Eugène Du Simitière (1737 – 1784): Collector in Revolutionary America." Ph.D. diss., University of Pennsylvania, 1960.

18 The painting was intended to glorify American democracy, but it also embodied the sentiments of a liberal Swiss faction which wished to see the constitution of Switzerland revised along the lines of the American model. See Johannes Stückelberger, "Die künstlerische Ausstattung des Bundeshauses in Bern," in *Zeitschrift für Schweizerische Archäologie und Kunstgeschichte* (Zürich), vol. 42, no.3 (1985):188 – 189.

5 Frank Buchser
Study for the projected group portrait with General Grant before President Lincoln and his Cabinet, 1866
Ink wash on paper
Kupferstichkabinett, Öffentliche Kunstsammlung, Kunstmuseum Basel

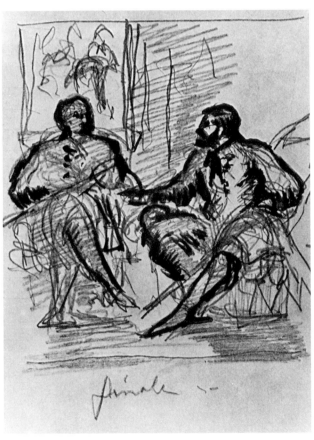

6 Frank Buchser
General Grant and General Lee in Conference
Charcoal and ink on paper

III. Portraiture

In the new republican United States, where Calvinist sumptuary laws inhibited the range of artistic expression until the mid-eighteenth century, portraits were the mainstay of local artists. Portraits of all sorts were sought by patrons: images of wives and children, horses and other animals, and even estates, all were meant to mark particular milestones or glorify public figures. Each of the major cities in America had its important portraitists: Gilbert Stuart (1755 – 1828) in Boston, Charles Willson Peale and his brother James Peale (1749 – 1831) in Philadelphia, and William Dunlap (1766 – 1838) and John Wesley Jarvis (1780 – 1840) in New York.

Since before the middle of the eighteenth century, European portraitists had been influential in the United States, and two of the more important ones were Swiss: Jeremiah Theüs (1719 – 1774) arrived in South Carolina in 1735, and was Charleston's principal portrait painter for over thirty years; Pierre Eugène Du Simitière (1737 – 1784) settled in Philadelphia in 1770, where he quickly became established as a portrait artist, collector, natural historian, and American patriot. Du Simitière's efforts to collect materials documenting the American Revolution for a proposed national history are well known. His crayon profile portraits of over a dozen of the leaders of the American Revolution were engraved and published in Paris, London, and Madrid in 1781 and 1783, providing Europe with its first corporate view of these worthy republicans.[17] The promising young Swiss artist Peter Rindisbacher (1806 – 1834) spent the last five years of his life working as a portrait painter in St. Louis. And Frank Buchser (1828 – 1890), who had originally been chosen to execute a large group portrait of American Civil War leaders for the Bundeshaus in Bern, traveled to America in order to make studies for the painting (Figs. 5, 6). The project did not succeed, perhaps because Buchser was not able to arrange a sitting with General Grant. Nevertheless, he painted portraits of many prominent figures, including Generals Lee and Sherman (Figs. 7, 8).[18]

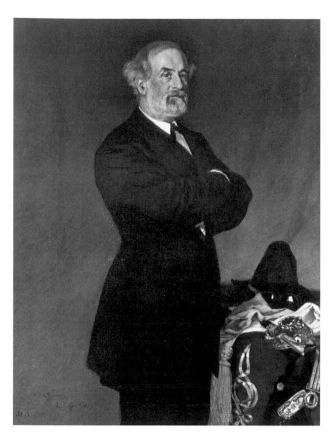

7 Frank Buchser
General Robert E. Lee, 1869
Oil on canvas, 54 × 40³⁄₈ inches (137 × 102.5 cm)
Kunstmuseum Bern

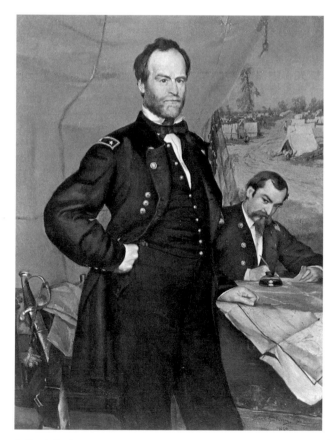

8 Frank Buchser
General T. Sherman, 1869
Oil on canvas, 54 × 40³⁄₈ inches (137 × 102.5 cm)
Kunstmuseum Bern

IV. Landscape

At the end of the eighteenth century, however, the dominance of portrait painting gave way to a new interest in images of the landscape. American artists began to draw on indigenous scenery, contributing to a renewal of artistic conventions for landscape painting. A growing fascination with nature and landscape led to increased interest in painted views during the eighteenth and nineteenth centuries. Poetic descriptions and visual imagery affected the way in which educated persons viewed the natural landscape, and travelers observing scenes from nature often described them as though they were pictures (Fig. 9). Writers and artists in Switzerland and America transformed the landscape of their homelands into a source of *national* pride. A parallel interest in topographical representations of the landscape was inspired by developments in the natural sciences and the desire to explore and chart the new continent.

Aesthetic appreciation of the landscape was already common among those who lived in the more picturesque or dramatic areas of Europe or America. One member of a Swiss family who journeyed to New Switzerland, Illinois, described a day on the Mississippi River: "For Swiss eyes today's journey offered much charming scenery. The west bank is bordered by fifty to one hundred foot high cliffs whose rock formations are not unlike old stone walls, fortifications, and knights' castles, with niches, windows and doors."[19] Another Swiss traveler to the United States betrayed his memories of the landscape of his homeland in one passage from an account of his journey: "I wander at your side into the quiet, remote Alpine valley and climb with you the dizzying heights. I feast with you on the boundless view before us and race down the glaciers, shouting jubilantly [...] We feast our eyes upon the golden sunset. That I am by your side I often imagine on my solitary walks though the American oak forests which extend for hours. I share with you my amazement when suddenly a mighty river lies at my feet, bringing light and air and life into the wilderness [...] When at last reality awakens me from this sweet, blessed illusion, I call out with streaming eyes, Oh, if only you were here!"[20]

This attitude toward the natural landscape was quite new. Earlier in the eighteenth century, for example, a British army surveyor had described the Highlands of Scotland as "monstrous excrescences [...] rude and offensive to the sight [...] their huge naked rocks producing the disagreeable appearance of a scabbed head ... "[21] And as late as in 1770, Oliver Goldsmith portrayed the following uninviting vision of the "distant clime" of Georgia:

"Those matted woods where birds forget to sing,
But silent bats in drowsy clusters cling;
Those poisonous fields with rank luxuriance crown'd,
Where the dark scorpion gathers death around;
Where at each step the stranger fears to wake
The rattling terrors of the vengeful snake;
Where crouching tigers wait their hapless prey,
And savage men more murderous still than they;
While oft in whirls the mad tornado flies,
Mingling the ravag'd landscape with the skies."[22]

[19] Joseph Suppiger, "River Journey from New York to St. Louis on the Mississippi," in Joseph Suppiger, Salomon Koepfli, and Kaspar Koepfli, *Journey to New Switzerland . . .*, John C. Abbott, ed., and Raymond J. Spahn, trans. (Carbondale & Edwardsville, Ill., 1987), 127.

[20] Robert H. Billigmeier and Fred Altschuler Picard, eds., *The Old Land and the New: The Journals of Two Swiss Families in America in the 1820s* (Minneapolis, 1965), 35.

[21] Captain Birt's letters were written during the 1720s and published in 1754. See Peter Bicknell, *Beauty, Horror, and Immensity: Picturesque Landscape in Britain, 1750– 1850* (Cambridge, 1981), ix.

[22] Oliver Goldsmith, "The Deserted Village", 1770, quoted in: Hugh Honour, *The European Vision of America,* exh. cat. (Cleveland Museum of Fine Arts) (Cleveland, 1975), 179.

[23] See Nicolò Rasmo, Marcel Roethlisberger, Eberhard Ruhmer, Bruno Weber (ed.), Alexander Wied, *Die Alpen in der Malerei* (Rosenheim, 1981), with chapters on Italy, France, Switzerland, Austria, Germany, and Yugoslavia.

9 Asher B. Durand
Kindred Spirits, 1849
Oil on canvas
The New York Public Library, New York

Sentiments like these were not uncommon at a time when natural features, particularly dramatic ones, were perceived primarily as dangerous obstacles. By the 1750s, however, travelers to Italy found mountain and wilderness journeys less dangerous than in earlier years, and thus, freed from fear for their lives, they were more open to aesthetic experiences. Tourists began to cast admiring glances at the Swiss Alps, whose sublime and dizzying heights inspired a wonderful terror in onlookers schooled in the aesthetics of Burke's sublime and in notions of the picturesque that would be codified in published accounts in the 1780s.

European painters were drawn to the Alps.[23] Philippe Jacques de Loutherbourg (1740–1820), the son of a Swiss-born painter in Paris, first exhibited a *Vue des Alpes* at the Paris Salon of 1771, where the reaction was positive. He was encouraged by other painters to pursue this theme, especially by Swiss artists. The alpine views of Caspar Wolf (1735–1783; cat. nos. 16, 17) were also admired by landscape painters internationally. His paintings and watercolors, published in volumes such as

10 *The painter Caspar Wolf standing at his easel in front of the Staubbach Falls in the Valley of Lauterbrunnen (Bernese Oberland) with the publisher Abraham Wagner and natural scientist Jakob Samuel Wyttenbach*, drawing by Balthasar Anton Dunker after a sketch of Caspar Wolf; engraving by Johann Joseph Störklin, Bern; reproduced as frontispiece in *Merkwürdige Prospekte aus den Schweizer-Gebürgen und derselben Beschreibung*, first edition (Bern, 1777)

11 *Herrenbaechli in Winter*, etching after a painting by Caspar Wolf, by Johann Joseph Störklin, published in *Alpes Helveticae* (Bern, 1777)

28

the *Vues remarquables des montagnes de la Suisse* (first edition 1777; Fig. 10), depict with great particularity the mass and verticality of the peaks, as well as the finest details of the terrain (Fig. 11).[24] Images of spectacular natural phenomena, such as Johann Heinrich Wüest's (1741–1821) view of the *Rhone Glacier* (cat. no. 18) or Louis Ducros' *Storm at Night, Cefalù* (cat. no. 15), were also immensely popular during these years.

The varied and dramatic scenery of America, much written about and illustrated by Europeans who knew it only from fabled accounts, also appealed to the late eighteenth and early nineteenth century tastes. If not filled with the same storied associations as the European countryside, this wild and untamed landscape was equally worthy of notice. As American painter Thomas Cole (1801–1848) remarked in his *Essay on American ScenSery* of 1836: "There are those who through ignorance or prejudice strive to maintain that American scenery possesses little that is interesting or truly beautiful — that it is rude without picturesqueness, and monotonous without sublimity — that being destitute of those vestiges of antiquity whose associations so strongly affect the mind it may not be compared with European scenery. But from whom do these opinions come? From those who have read of European scenery, of Grecian mountains, and Italian skies, and never troubled themselves to look at their own [...] I would have it remembered that nature has shed over this land beauty and magnificence, and although the character of its scenery may differ from the old world's yet inferiority must not therefore be inferred; for though American scenery is destitute of many of those circumstances that give value to the European, it still has features, and glorious ones, unknown to Europe."[25] Cole's *Whirlwind* (Fig. 12) provides convincing evidence for his *Essay*.

America rivaled and perhaps surpassed Switzerland in the sheer number of dramatic views and spectacular natural phenomena. (Fig. 13) It was the American painter Charles Willson Peale who first suggested that the natural landscape could be conceived of as the subject of a painting without historical, biblical, or mythological connotations. Only one professional European land-

24 See Barbara Maria Stafford, *Voyage into Substance: Art, Science, Nature, and the Illustrated Travel Account, 1760–1840* (Cambridge, Mass., 1984), 88–91.
25 Thomas Cole, "Essay on American Scenery," in *The American Monthly Magazine*, vol. I (January 1836):1–12; the essay was also published in John W. McCoubrey, ed., *American Art 1700–1960, Sources and Documents* (Englewood Cliffs, N.J., 1965), 101.

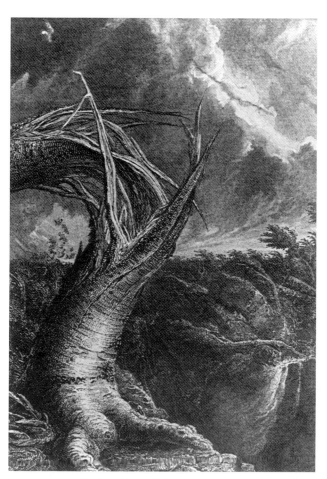

12 Edward Gallaudet
Engraving after Thomas Cole's *The Whirlwind*
in *The Token and Atlantic Souvenir* (Boston, 1836)
American Antiquarian Society

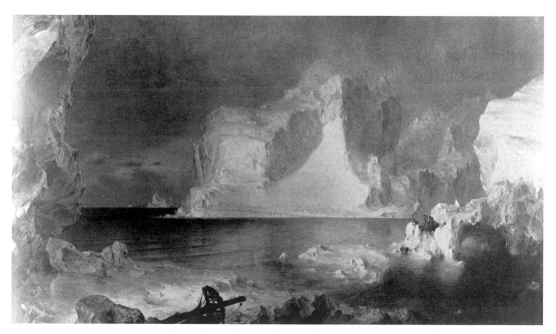

13 Frederic Edwin Church
The Icebergs, 1861
Oil on canvas
Dallas Museum of Art

26 See Hugh Honour, *The European Vision of America* (see n. 22), 179, 190 and text of no. 165; for examples of Wäber's engravings, see J.C. Beaglehole, ed., *The Journals of Captain James Cook on his Voyages of Discovery: The Voyage of the Resolution and Discovery 1776 – 1780* (Cambridge, 1967).

14 Father Louis Hennepin
Niagara Falls
Engraving after Hennepin's study, in *Voyage curieux . . .*
(The Hague, 1704)

15 John Trumbull
Niagara Falls from Below the Great Cascade on the British Side, 1808
Oil on canvas, 24⁷/₁₆ × 36³/₈ inches (62 × 92.5 cm)
Wadsworth Atheneum, Hartford, Connecticut

scape painter had gone to America before 1800: Johann Wäber, son of a Swiss sculptor, was born in London and trained in Paris, Bern and at the Royal Academy in London. As draughtsman on the final voyage of Captain Cook, he left London in July of 1776 and arrived in America in March of 1778. There he produced ink wash drawings of the landscape which were later engraved for the printed volumes of Captain Cook's *Voyage to the Pacific Ocean.*[26]

A variety of options was open to the landscape painter in America during the course of the eighteenth and nineteenth centuries. There were those who recorded images of the vast wilderness, serving as topographical draughtsmen for exploratory or scientific expeditions. This included the artist-reporters George Catlin (1796 – 1872), Alfred Jacob Miller (1810 – 1874), John James Audubon (1785 – 1851), John Mix Stanley (1814 – 1872), and Swiss artists Peter Rindisbacher, Frank Buchser (cat. no. 37), and Karl Bodmer (1809 – 1893). Some painters took the naturalist's approach to the pastoral scenes of American woods and glades, as did the romantic realists Asher B. Durand (1796 – 1886), or Worthington Whittredge (1820 – 1910). Others painted allegorical landscape views, as did Washington Allston (1779 – 1843) and Thomas Cole (1801 – 1848). *Plein-air* painting, panoramic views, romantic views of the wild natural terrain, dramatic treatments of unusual natural phenomena, and illustrations of the landscape which revealed the encroaching presence of explorers, settlers, tourists, and even technology, like the intercontinental railroad: all of these trends have direct parallels in Swiss landscape painting of the period.

Niagara Falls was perhaps the most awesome, memorable, and troublesome of subjects for artists. Often interpreted visually and in literature as an incomparably sublime phenomenon, it was first treated by artists who subjected it to classical artistic conventions, concentrating on controlled, picturesque effects. The first European to record a visual as well as a written account of the falls was Louis Hennepin, the Franciscan priest who accompanied René Robert Cavelier's expedition on behalf of France in 1679. (Fig. 14) Later, John Vanderlyn and John Trumbull made their way through the forests of New York to paint views of Niagara Falls. The two surviving paintings by Trumbull focus on the less dramatic, less threatening aspects, and display his use of the traditional painterly conventions he learned in West's London studio. (Fig. 15) The paintings were intended only as studies for a panorama which was unfortunately never executed.[27] Frederic Church's grandly successful *Niagara* of 1857, by contrast, revealed the power and magnificence of the falls and the scope of panoramic landscape painting. (Fig. 16) Frank Buchser left a sketch of Niagara Falls (Fig. 17),[28] and in 1834, Karl Bodmer and the party of Maximilian encountered the natural spectacle toward the end of their expedition. Bodmer's watercolor painting of the falls was later published in a series of aquatints (Fig. 18).[29]

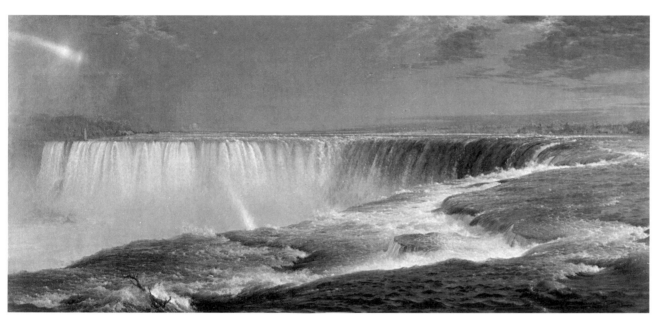

27 See Jeremy Elwell Adamson, "Nature's Grandest Scene in Art," in *Niagara: Two Centuries of Changing Attitudes, 1697–1901* (Washington, D.C., 1985), 11–12, and 30; and, in the same publication, see Elizabeth McKinsey, "An American Icon," 88; see also the review of this publication by Bryan Wolf, "The Fall of Niagara," in *Winterthur Portfolio* vol. 22 (Spring 1987):81–86.

28 The main source for Buchser's travel to America are his diaries: Frank Buchser, *Mein Leben und Streben in Amerika. Begegnungen und Bekenntnisse eines Schweizer Malers*, Gottfried Wälchli ed. (Zürich and Leipzig, 1942). See also *Frank Buchser in Amerika 1866–1871*, exh. cat. (Biberist, 1975); H. Lüdeke, *Frank Buchsers amerikanische Sendung, 1866–1871* (Basel, 1941); and Walter Hugelshofer, *Swiss Drawings, Masterpieces of five Centuries*, exh. cat. (Washington, D.C., 1967), 55–56, no. 93.

29 See William H. Goetzmann, David C. Hunt, Marsha V. Gallagher, and William J. Orr, *Karl Bodmer's America* (Joslyn, 1984), 344, with color ill.

16 Frederic Church
Niagara, 1857
Oil on canvas
Corcoran Gallery of Art, Washington, D. C.

17 Frank Buchser
Niagara Falls, 6. Oktober 1866, 1866
Pencil on paper, 11¾ × 19 inches (29.8 × 48.3 cm)
Kupferstichkabinett, Öffentliche Kunstsammlung, Kunstmuseum Basel

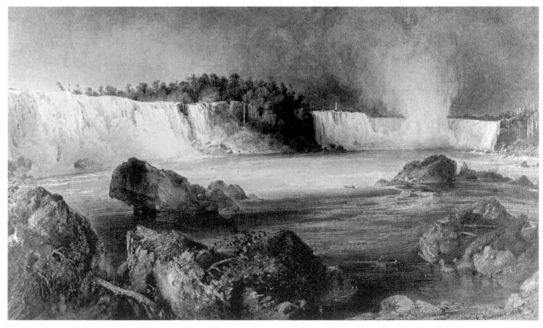

18 Karl Bodmer
Niagara Falls, c. 1834
Watercolor on paper, 12¼ × 20 inches (31 × 50.8 cm)
The Inter-North Art Foundation

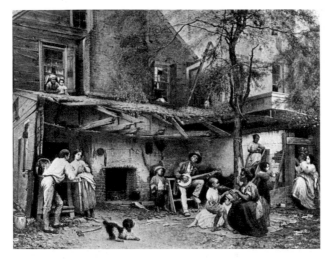

19 Eastman Johnson
The Old Kentucky Home
Oil on canvas

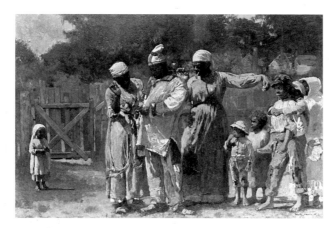

20 Winslow Homer
The Carnival, 1877
Oil on canvas, 20 × 30 inches (50.8 × 76.2 cm)
The Metropolitan Museum of Art, New York

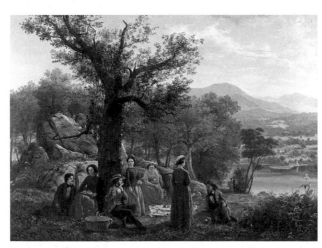

21 Jerome B. Thompson
The "Pick-Nick" near Mount Mansfield, c. 1850
Oil on canvas, 41½ × 56 inches (105.5 × 142.2 cm)
The Fine Arts Museum, San Francisco

[30] Elizabeth Johns, "*The Farmer in the Works of William Sidney Mount*," in *The Journal of Interdisciplinary History*, vol. XVII (Summer 1986):257 – 81.

[31] Joshua Taylor, "The American Cousin," in *America as Art* (Washington, D.C., 1976), 37 – 94; and see the review of the latter publication by Dawn Glanz, in *Winterthur Portfolio*, vol. (1980):171 – 174.

[32] Hans Lüthy, "The Sense of a Common Heritage" (see n. 5), 129.

[33] Kaspar Koepfli, "Advantages and Disadvantages of the Area We Chose to Settle," in Joseph Suppiger, Salomon Koepfli, and Kaspar Koepfli, *Journey to New Switzerland* (see n. 19), 196.

[34] Kaspar Koepfli, "Spiegel von Amerika," in Raymond Jurgen Spahn and Betty Alderton Spahn, eds., and Jennie Latzer Kaeser and Manfred Hartwin Driesner, trans., *New Switzerland in Illinois, as Described by Two Early Swiss Settlers, Kaspar Koepfli and Johann Jacob Eggen* (Edwardsville, Ill., 1977), 55.

V. Genre Painting

Genre painting during this period was equally expressive of the national ideals, yet American and Swiss works of this type are not unique in the larger context of nineteenth century European art. Influenced by seventeenth-century Dutch prototypes and often filtered through the work of the early nineteenth century British masters, genre pictures expressed the social, economic, and often, political values of society. Although the meanings of certain pictures are lost to us today, or are only subject to partial and awkward reconstruction, they were meant to be legible to large, non-aristocratic audiences, and often made reference to community activities, timely political themes, or social desires or fears. Critics often judged such pictures by varying standards of artistic or historical "truth".[30] For example, the images of black peoples in Virginia produced by Frank Buchser tell one story, while those of native American painters often tell another (Fig. 19). American genre painters, including Samuel F. B. Morse (1791 – 1872), William Sidney Mount (1807 – 1868), John Lewis Krimmell (1787 – 1821), George Caleb Bingham (1811 – 1879), and by mid-century, Eastman Johnson (1824 – 1906), often made use of subtle caricature, as well as literary and pictorial styles drawn from contemporary drama, almanacs, and popular prints.[31] By the 1820s and 1830s, genre had become a serious form of painting in America. As was the case in Switzerland, it was certainly more popular and lucrative than history paintings had ever been, though the critical press continued to focus on the latter.[32]

Community life was frequently the subject of genre pictures, like *The Carnival* of Winslow Homer. (Fig. 20) Leisure activities were another popular topic, such as Jerome B. Thompson's *Pick-Nick near Mount Mansfield* of c. 1850. (Fig. 21) Wolfgang-Adam Töpffer's *Rural Picnic* (cat. no. 19) demonstrates the parallel Swiss interest in such subjects.

Although attitudes toward peasants and farmers in Europe differed dramatically from the American concept of the free-hold farmer, both were quite often the subject of paintings during the first half of the nineteenth century. European, especially Swiss, travelers to the United States revealed their own preoccupations when commenting on farm life in America. One mid-century Swiss settler, Kaspar Koepfli, wrote that there " . . . seem to be no class distinctions, laborers and farmers, for example, being the equal of, say, clergymen and merchants. For example, the man who supervised the construction of our house is an excellent Methodist preacher who also builds houses and plasters them, makes boots and shoes, makes and lays bricks, and owns land and cattle."[33] Another report authored by Koepfli in 1849 was more direct: "The American farmer is regarded as the most necessary member of society and is its most important foundation; not only is he addressed as 'Mister' in society (as is our farmer), but he is also respected and treated accordingly, and not as low and ignorant rabble who is hardly worth a glance, as is the case in many places in civilized Europe. He is an educated man, and appears in manner and dress as a man of good sense and judgment."[34]

William Sidney Mount's pictures of farmers resting (Fig. 22), haggling over livestock, keeping up with political events, etc., and Eastman Johnson's portraits of rural activities like cranberry picking and corn husking (Fig. 23), are masterpieces of American genre subjects. Perhaps Swiss paintings of country life and people, conceived with a certain monumentality, for example those of Ferdinand Hodler (Fig. 24), demonstrate that they shared the American notion of the dignity of the independent farmer in a democratic state.

Farmers and black slaves on early American plantations held great interest for artists depicting the image of the new country, but it was the native American Indian which truly fascinated artists who were accustomed only to civilized society in Europe and the growing cities in America. Americans George Catlin (1796–1872), Seth Eastman (1808–1875), and Carl Wimar (1828–1862), among many others, ventured to the edges of the frontier in order to make illustrations of the Indian peoples. Swiss artists also took up the subject of the Indians and their "exotic" ways of life. Johann Wäber, Peter Rindisbacher, Frank Buchser (cat. no. 36), Karl Bodmer, Lukas Vischer (1780–1840) and Rudolf Friedrich Kurz (1818–1871) produced studies which constitute a unique portrait of early America as it looked during this period.

In both countries, the specifically national characteristics of genre pictures, portraiture, and landscape painting reached a culmination during the third quarter of the century, and boundaries between traditional types of painting began to blur. Despite continued interest in academic training during the later nineteenth century, European artists began to abandon traditional narrative forms in search of more subjective and expressive subjects and means. Similar changes were taking place in the United States, although artists producing increasingly abstract works persisted in using the carefully controlled brushwork of French academic painting. As artists became increasingly concerned with individual expression, they obscured their links with other artists or art traditions, and even with nationalistic objectives and subject matter. Thus, the art traditions which had evolved in Switzerland and the United States roughly between 1770 and 1870 became part of a larger international phenomenon by the end of the nineteenth and the beginning of the twentieth centuries.

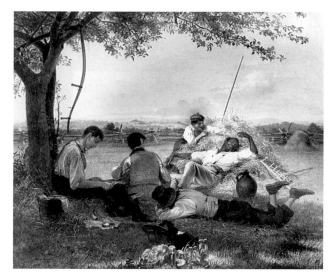

22 William Sidney Mount
Farmer's Nooning, 1836
Oil on canvas, 20¼ × 24½ inches (51.4 × 62.2 cm)
The Museums at Stony Brook, New York

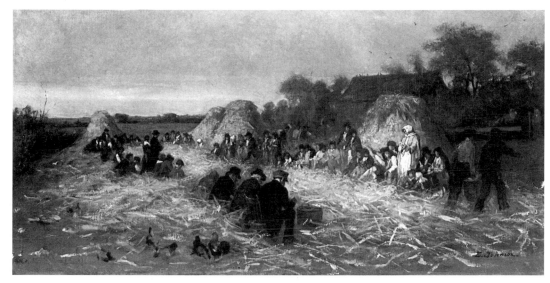

23 Eastman Johnson
Corn Husking, 1876
Oil on canvas, 25⅝ × 54½ inches (65 × 138.5 cm)
The Metropolitan Museum of Art, New York

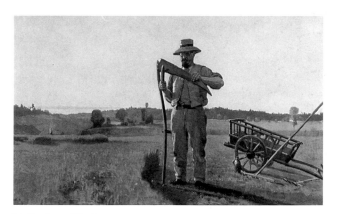

24 Ferdinand Hodler
The Reaper, c. 1878
Oil on canvas, 28 × 44 ⅞ inches (71 × 114 cm)
Private collection

The Swiss Artist and the European Context: Some Notes on Cross-Cultural Politics

William Hauptman

In the famous Prater scene of Carol Reed's 1949 film, *The Third Man,* the devoted protagonist Holly Martins encounters his school friend, the cynical and supposedly dead Harry Lime, who is sought by the police for running a racket of diluted penicillin in post-war Vienna. In the climax of the meeting atop the Great Wheel, Lime uses his charm and persuasion to entice Martins into the scheme, noting that

"... After all, it's not that awful — you know what the fellow said ... In Italy for thirty years under the Borgias they had warfare, terror, murder, bloodshed — they produced Michelangelo, Leonardo da Vinci and the Renaissance. In Switzerland, they had brotherly love, five hundred years of democracy and peace, and what did they produce? The cuckoo clock."[1]

Lime's speech points up one of the chief problems of Swiss art and the cultural politics surrounding it. The popular image of Switzerland, developed partly by the Swiss themselves, renders almost no role at all for artistic achievement. For generations of art historians, Swiss art has represented a minor force, that has been relegated to footnotes or to brief mention in anthologies. With the exception of Johann Heinrich Füssli (1741–1825), Léopold Robert (1794–1835), and Ferdinand Hodler (1853–1918) in the eighteenth and nineteenth centuries, and Paul Klee (1879–1940) and Giacometti — Alberto (1901–1966), not Giovanni, his father (1868–1933), or Augusto, his cousin (1877–1947) — in the twentieth century, few Swiss artists earned international acclaim or even found their way into art historical surveys of the period.

Clearly this situation is gradually changing, as is reflected in contemporary revisions of previous art historical concepts, categories, and hero-worship. Artists as different as Cuno Amiet (1868–1961), Arnold Böcklin (1829–1901), Alexandre Calame (1810–1864), Louis Ducros (1748–1810), Charles Gleyre (1806–1874), Jean-Etienne Liotard (1702–1789), Giovanni Segantini (1858–1899), and Félix Vallotton (1865–1925), among those represented in the present exhibition, have recently been studied anew and in a context which places their genuine artistic merit in a more positive light.[2] Yet the introduction to virtually every exhibition catalogue on Swiss art, especially those produced for non-Swiss audiences, begins with an *apologia* making reference to the fact that Füssli made his career in England, Giacometti in France, Klee in Germany, and so forth. This fact, that most Swiss artists studied and practiced their art outside Switzerland, is essentially accurate. As early as the eighteenth century, conditions were such that neither high quality education for artists nor a viable art market were available in Switzerland to promote an ongoing national artistic tradition. In response to this situation, Ducros thrived in Italy, Benjamin Bolomey (1739–1819) became a court painter in Holland, the Sablet brothers (François, 1745–1819, and Jacques, 1749–1809) prospered in France, and Pierre-François Bourgeois (1756–1811) worked in the Polish court before settling in the London of George III, where he became Sir Peter Francis and participated in the founding of the Dulwich Gallery.[3] In this respect, it might be well to consider a remark Hodler made at the end of the ni-

neteenth century to his friend Johann Friedrich Büzberger: "The German Swiss will not understand me until they see that I have been understood elsewhere; also, only then will I impress the French Swiss."[4] Hodler's complaint, angry and ironic, emphasizes the persistent circumstance of obligatory expatriotism which characterized so much of Swiss art production during this period. Hodler's remark must also be seen in the context of Swiss geography which acts both as political protector and as artistic insulator.[5]

Not only were the Swiss obliged to work and exhibit elsewhere, but circumstances dictated that they also had to train, beyond the elementary level, in France, Germany, and in some cases, Italy. From the list of artists represented in this exhibition, few can be found who studied exclusively in Switzerland: Jacques-Laurent Agasse (1767–1849) and Léopold Robert studied with Jacques-Louis David, Jean-Pierre Saint-Ours (1752–1809) with Joseph-Marie Vien, François Diday (1802–1877) with Antoine Jean Gros, Gleyre with Louis Hersent, Karl Girardet (1813–1871) with Léon Cogniet, Böcklin with Johann Wilhelm Schirmer, Klee with Franz von Stuck, and so forth. Of the artists who did receive most of their training within the borders of the country, one can point to Calame, who studied with Diday in Geneva, or Hodler, who studied with Barthélemy Menn (1815–1893). However, both Calame and Hodler found much of their markets outside of Switzerland. Only Menn remained in the country to undertake the task of establishing better conditions for the training of Swiss artists.

Thus, inherent to the situation of the Swiss artist was a negation of native artistic talent, from the training process through professional practice. This was expressed forcefully at least twice during the period in question, both times by preeminent figures in politics and art. Although factors determining the situation remain little-known beyond art historical circles in Switzerland, they now bear deeper study in light of a broadening awareness of Swiss art over the last two decades and its role in European artistic currents. The first instance was marked by an effort to create a more favorable climate in which Swiss artists could work and exhibit, as well as to establish a greater role for art in the general cultural fabric of Swiss society. The second instance, more than half a century later, involved the publication of a report which attempted to explain the failure of Swiss art to achieve international recognition and prestige. The first effort stemmed from the fervor of national restoration; the second came under the auspices of an international exhibition in the context of which Swiss art could be seen in comparison to the artistic efforts of other countries.

On January 11, 1799, during the brief political interlude of the Helvetic Republic (1798–1803), the newly appointed Minister of Art and Science, Philipp August Stapfer, published a remarkable appeal to Swiss artists in which he requested vital information on the current state of artistic production.[6] Stapfer's appeal is a bold and unprecedented document, rooted in his own Kantian ideals about the role of art in the overall progress of mankind toward a higher level of civilization. He as-

1 Graham Greene and Carol Reed, *The Third Man* (London, 1984), 100. The celebrated line does not actually appear in the working script prepared by Greene and director Carol Reed, who participated in the scriptwriting scenario; it was actually written by Orson Wells, who played the role of Lime, *after* filming had begun; see C. Higham, *Orson Wells: The Rise and Fall of an American Genius* (London, 1987), 312. – As a matter of fact, this age-old misconception incorrectly attributes the invention to Switzerland: the cuckoo clock was invented in the Black Forest of Germany.

2 See George Mauner, *Cuno Amiet* (Zürich, 1984); Rolf Andree, *Arnold Böcklin: Die Gemälde* (Basel, 1977); Valentina Anker, *Calame: Vie et Oeuvre* (Fribourg, 1987); Pierre Chessex, *Images of the Grand Tour: Louis Ducros 1748–1810* (Geneva, 1985); William Hauptman and Nancy Scott Newhouse, *Charles Gleyre 1806–1874* (New York, 1980); Renée Loche and Marcel Roethlisberger, *L'Opera Completa di Liotard* (Milan, 1978); Annie-Paule Quinsac, *Segantini* (Milan, 1982); and M. Vallotton, *Félix Vallotton: Catalogue raisonné de l'oeuvre gravé et lithographié* (Geneva, 1972). For a general historical survey of Swiss art, see Joseph Gantner and Adolf Reinle, *Kunstgeschichte der Schweiz* (Frauenfeld/Leipzig, 1936–1962), especially vol. 4 by Adolf Reinle (1962) devoted to the art of the nineteenth century; see also Florens Deuchler, Marcel Roethlisberger, and Hans A. Lüthy, *Swiss Painting from the Middle Ages to the Dawn of the Twentieth Century* (New York, 1976).

3 On Bolomey, see D. Agassiz, *Benjamin Bolomey* (Lausanne, 1928); on the Sablet brothers, see Anne van de Sandt, *Les Frères Sablet*, exh. cat. (Nantes/Lausanne/Rome, 1985); on Bourgeois, see D. Agassiz, *Sir François Bourgeois* (Lausanne, 1937).

4 Letter from Paris, dated 15 April 1891: "Die Deutschschweizer wollen mich nicht verstehen bis sie sehen, dass ich anderswo verstanden bin, den französischen Schweizern imponiere ich Ihnen nur dann." Carl Albert Loosli, *Ferdinand Hodler: Leben, Werk und Nachlass,* vol. IV (Bern 1924), 334.

5 The issue of Swiss art in relation to geography is treated by Dario Gamboni in *La géographie artistique,* vol. I, in the series *Ars Helvetica* (forthcoming publication). My thanks to M. Gamboni for sharing parts of the manuscript with me.

6 The appeal was first published in the *Schweizer Republikaner* vol. II, no. LXXI (11 January 1799):569; a French translation was published in the *Bulletin Officiel du Directoire Helvétique* (20 January 1799). On Stapfer, see Hans Gustav Keller, *Minister Stapfer und die Künstlergesellschaft in Bern* (Thun, 1945). For a discussion of Stapfer's appeal, see Pierre Chessex, "Documents pour servir à l'histoire des arts sous la République Helvétique," in *Etudes de Lettres* (Lausanne) series IV, vol. 3, no. 2 (April/June 1980):93–121.

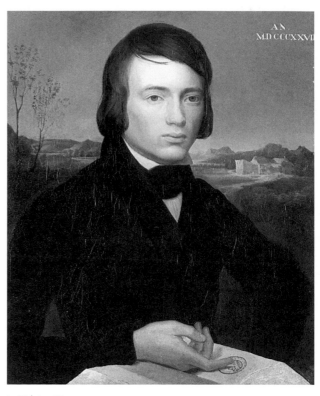

1 Charles Gleyre
Self Portrait at the Age of 21, 1827
Oil on canvas, 23⅝ × 19¼ inches (60 × 49 cm)
Musée cantonal des beaux-arts, Lausanne

7 Wäber (also known as John Webber) accompanied Cook as illustrator and journalist on his third voyage to the South Seas in 1776–1779.

8 The idea did not originate with Stapfer, but had already been expressed by Jean-Jacques Burlamaqui (1694–1748) who was instrumental in founding the first school of drawing in Geneva; regarding Burlamaqui's ideas on the social role of art and artists, see Jean Senebier, *Histoire littéraire de Genève*, vol. III (Geneva, 1786), 89.

9 D.D. Egbert, *Social Radicalism and the Arts* (New York, 1970), 11ff.

10 For example, the only merchant noted in H. Mallet, *Description de Genève, ancienne et moderne* (Geneva, 1807), 254, describes a collection of maps and scientific instruments despite the fact that the dealer was noted as a "marchand d'estampes et de tableaux." See also T.C. Bruun-Neergaard, *De l'état actuel des arts à Genève* (Paris, 1802).

11 The first competition in Geneva (excluding the competition of Napoleon in 1802) was held in 1824 through the efforts of the collector Jean-Jacques de Sellon (1782–1839); the subject of the competition was *The Deliverance of Bonivard in the Château de Chillon*, the subject of Byron's poem. Only two painters actually participated, Georges Chaix (who was French, but naturalized Swiss) and Jean-Léonard Lugardon. See David Dunant, *Notice sur le prix de peinture d'Histoire nationale, qu'un généreux concitoyen a offert cette année pour l'encouragement de l'art, et sur le sujet mis au concours par la Classe des Beaux-Arts* (Geneva, 1824); see also Danielle Buyssens, "Art et Patrie: polémique autour d'un concours de peinture d'histoire nationale à Genève," in *Genava* (Geneva) vol. XXXIII (1985):121–132.

12 Essential for the history of collecting in Geneva is Mauro Natale, *Le goût et les collections d'art italien à Genève* (Geneva, 1980); see also Florens Deuchler, "Des collectionneurs, des collections et des musées," in Florens Deuchler, et. al., *Richesses des musées Suisses* (Lausanne, 1979), 8–37.

13 For examples from archival sources, see Pierre Chessex, "Documents pour servir," (see n. 6) 98ff.

14 See Florens Deuchler, *Richesses* (see n. 12), 23; see also Lisbeth Marfurt-Elmiger, *Der Schweizerische Kunstverein, 1806–1981* (Bern, 1981), 38–39.

15 Charles Clément, *Gleyre, étude biographique et critique* (Geneva/Neuchâtel/Paris, 1878). It was widely felt in the French region of Switzerland that Gleyre was the *peintre national*, as the contemporary historian Louis Vulliemin noted in a letter of September 12, 1858 (Lausanne, private collection).

16 William Hauptman, "Allusions and Illusions in Gleyre's *Le Soir*," in *The Art Bulletin*, vol. LX, no. 2 (June 1978):321–330.

serted that for a long time, important Swiss painters willingly worked in London, Paris, Rome, and even in the South Seas. He referred to Füssli and Philippe Jacques de Loutherbourg (1740–1812) who were active in London; Ducros and Alexander Trippel (1744–1793) who worked in Rome; and Johann Wäber (1750–1793) who accompanied Captain Cook.[7] He pointed out that Swiss artists had worked elsewhere to such extent that they were welcomed by all European nations except Switzerland herself. In its essence, the appeal attempted to examine the very conditions under which the best Swiss artists had been forced to emigrate in order to practice their art. At its heart was the patriotic hope that conditions could be changed in order to foster a national art which would be rooted in the inherent iconography of Swiss culture, and in service to the general national Enlightenment.[8] Implicit in the very nature of Stapfer's plea was the importance of art in the general system of education, an idea not far removed from the contemporaneous ideals of Diderot and David in France, where art and society were entwined in a unified schema.[9] In a questionnaire which accompanied the appeal, Stapfer asked painters, sculptors, architects and musicians to respond to three essential questions in order to better comprehend why present political and social systems actually impeded artistic production on native soil. The points he addressed were:

1. Which artists, at the time little known or unknown in Switzerland, deserved to be recognized because of their merit, and why had they gone unrecognized if their talents warranted recognition?

2. How could the arts in general be better supported by the Republic, and in what manner could art be exhibited in Switzerland?

3. What obstacles had hindered the progress of Swiss art in general? (By this, Stapfer meant an indigenous art expressive of the national identity.)

To further emphasize the importance of this document, it must be understood that the conditions Stapfer wished to improve were still primitive, at best, and hardly comparable to the highly evolved situation in France or England; a more valid comparison could be made between the cultural climate of the nascent Swiss cantons and the new American states. There were no professional academies of art which were wholly equipped to train artists, in the purest sense of the term; nor were there exhibition spaces of note, with the exception of private salons. The first public museum in Switzerland devoted exclusively to the fine arts would open in Geneva more than 25 years after Stapfer's appeal. Thus, examples from the history of art, the foundation of contemporary training for artists elsewhere in Europe, were not readily available to the prospective student of art in Switzerland; in fact, collections were extremely uneven in quality, often with only fragmented representation of major schools, and generally inaccessible to students. Art merchants were occupied with the lively trade in prints, book illustrations, or the minor arts;[10] salon competitions did not exist before 1824, when the first true competition occurred in Geneva;[11] and, as a result, there was no economic encouragement for painting or sculpture, except through a select, elite clientele who commissioned works for private audiences.[12] Even news of artistic events beyond the borders of Switzerland was barely reported by the press. The Swiss artist at the end of the eighteenth century was still isolated in a provincial world where his very geographical identity denied him a viable artistic context.

The immediate response to Stapfer's appeal was, however, meager. Only 52 questionnaires were returned, 35 of them from the more populous German Swiss region, and only 22 from painters themselves. Some responses generally advocated greater public interest and financial support for art, but gave no practical advice on how to achieve these goals; others presented elaborate plans for the institution of public exhibitions in cantonal and federal buildings.[13] The changes Stapfer hoped to effect were not forthcoming, in part due to the brief life of the stable Republic and the subsequent political turmoil of the Napoleonic period. Stapfer's ideas never evolved beyond the stage of admirable patriotic intention. The only tangible results of his cultural policy were early efforts to catalogue and preserve national monuments and the organization of a national exhibition of contemporary Swiss art in Zürich.[14]

The condition of Swiss art became an issue again in 1867, on the occasion of the Exposition Universelle in Paris. The organization of the Swiss Fine Arts Pavilion was entrusted to Charles Gleyre (Fig. 1), who at that time was arguably the most celebrated Swiss painter of his epoch.[15] He was not trained in Switzerland, but, having been taken to Lyon as a child, he began his studies there and later moved to Paris to continue his training with Hersent at the Ecole des Beaux-Arts. He neither studied nor worked for any length of time in his own country, but Gleyre was, nevertheless, recognized as the greatest Swiss exponent of historical and classical subjects, having won public and critical acclaim in 1843.[16] Gleyre never became a French citizen despite having lived in France for more than three decades, and always

preserved close ties to his native Swiss village of Chevilly, near Lausanne. He even refused French commissions in favor of Swiss ones, usually to his own financial detriment. By 1867, he had already produced two major works on Swiss themes, both of which would later be identified as national icons, and had also fulfilled an important commission for the city of Basel.[17] In addition, since 1843 Gleyre had directed one of the most important private teaching ateliers in Paris through which a generation of Swiss art students passed.[18] Gleyre was, therefore, in many ways ideally suited to select the works which would represent his homeland, but also to evaluate them honestly in an international forum.

Gleyre provided a final report to the federal government in Bern, in which he explained his method of selection and volunteered a polite but pointed explanation of why the Swiss could not compete with artists from other nations.[19] The points he enumerated are worth studying since they pinpoint clearly the weaknesses of Swiss art at a time when the political and social situation should have provided the necessary stimuli for high quality art production. In a sense, Gleyre's report constitutes a reiteration of Stapfer's appeal, but this time the situation is seen through the tutored eye of a practicing painter and teacher.[20]

Gleyre correctly noted that the real strength of Swiss art lay in landscape and genre painting. Of the former, it may be observed that following Caspar Wolf's depictions of alpine sites, much of Swiss imagery was concentrated on the exploration and glorification of national beauty.[21] Like the discovery of the Hudson River Valley in America, or the opening of the western frontier,[22] painters in Switzerland were naturally drawn to the grandeur of the yet unspoiled topography which permitted the expression of romantic ideals or touristic views. And the Swiss artist had an almost unlimited access to a pictorial iconography which could not have but appealed to national tastes for clear, identifiable images. Diday and Calame in the southwest, and Rudolf Koller (1828–1905; Fig. 2) and Robert Zünd (1827–1909; Fig. 3) in the northeast exploited this potential ideally, but most often for clients abroad who reveled in the picturesque and the dynamic. With this emphasis on Swiss natural wonders, it is no surprise that a viable school of *plein-air* painting developed rapidly throughout the diverse regions of the country. It is equally unsurprising that in 1847 — when Monet was seven years old and Renoir six — Girardet could advise painters to work out-of-doors, because in doing so one learned, among other things, that shadows were not always black as had been habitually taught in academic ateliers.[23] Many painters specialized in capturing the natural phenomena around them; Bocion, for example, spent virtually his entire career painting the changing patterns of Lake Geneva and the surrounding mountains.[24] In this sense, Swiss painters of landscape seemed to follow the ideals of the painter Pierre-Louis Bouvier (1766–1836), who told young artists in 1827 that if a painter wished to please, he should paint the portrait of his country.[25] Thus, in Switzerland during the 19th century, the national portrait was decidedly topographical.

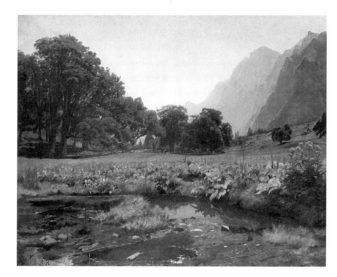

2 Rudolf Koller
Richisau, 1858
Oil on canvas, 32¼ × 39¾ inches (82 × 101 cm)
Oskar Reinhart Foundation, Winterthur

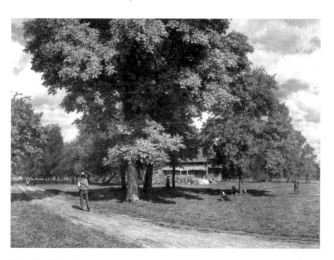

3 Robert Zünd
Farmhouse at Lucerne with Trees, 1863
Oil on canvas, 30½ × 40¾ inches (77.5 × 103.5 cm)
Kunstmuseum, Lucerne

[17] On Gleyre's two commissions depicting Swiss themes, see William Hauptman, "Charles Gleyre: Tradition and Innovation," in William Hauptman and Nancy Scott Newhouse, *Charles Gleyre* (see n. 2), 29ff. On the Basel commission, see William Hauptman, "Gleyre's *Penthée* and the Creative Imagination," in *Zeitschrift für Schweizerische Archäologie und Kunstgeschichte* (Zürich) vol. XLIII, no. 2 (1986):215–228.

[18] On Gleyre's teaching, see Albert Boime, "The Instruction of Charles Gleyre and the Evolution of Painting in the Nineteenth Century," in *Charles Gleyre ou les illusions perdues*, exh. cat. Winterthur/Marseille/Munich/Kiel/Aarau/Lausanne 1974/75 (Zürich, 1974), 102–125; see also William Hauptman, "Delaroche's and Gleyre's Teaching Ateliers and Their Group Self-Portraits," in *Studies in the History of Art*, vol. XVIII (November 1985):79–119.

[19] Gleyre's report was published in the *Feuille Fédérale Suisse* vol. XX, no. 10 (7 March 1868):295–299. For a study of the context of the report, see William Hauptman, "Charles Gleyre and the Swiss Fine Arts Section of the Exposition Universelle of 1867," in *Zeitschrift für Schweizerische Archäologie und Kunstgeschichte* (Zürich) vol. XLIII, no. 4 (1986):368–370.

[20] It might be added that two years later, in 1869, a similar report was read to the Société Suisse des Beaux-Arts which included no mention of the fact that Gleyre had previously issued a report. See M. Monnier, *Rapport sur les moyens d'élever le niveau de l'art en Suisse* (Geneva, 1869).

[21] The literature on the importance of landscape in Swiss art is vast, but see in particular Hans Christoph von Tavel, et. al., *Schweiz im Bild - Bild der Schweiz: Landschaften von 1800 bis heute*, exh. cat. (Zürich, 1974); and *Die Alpen in der Schweizer Malerei*, exh. cat. (Tokyo/Chur, 1977); both contain useful bibliography.

[22] On the American landscape tradition, see P. Birmingham, *American Art in the Barbizon Mood* (Washington, D.C., 1975); Barbara Novak, *Nature and Culture: American Landscape and Painting 1825–1875* (New York/Toronto, 1981); and, Theodore E. Stebbins, et. al., *A New World: Masterpieces of American Painting 1760–1983* (Boston, 1983).

[23] Pierre von Allmen, *Maximilien de Meuron et les peintres de la Suisse romantique* (Neuchâtel, 1984), 7.

[24] See Béatrice Aubert-Lecoultre, *François Bocion* (Lutry, [1977]).

[25] "En un mot, si le peintre veut plaire, qu'il fasse le portrait du pays." Pierre-Louis Bouvier, *Manuel des jeunes artistes et amateurs de peinture* (Geneva, 1827). On Bouvier's work, see Elisabeth della Santa, *Pierre-Louis Bouvier, peintre et miniaturiste Genevois* (Meyrin, 1978).

[26] On the Geneva school and its formation, see Daniel Baud-Bovy, *Peintres genevois 1702 – 1849,* 2 vols. (Geneva, 1903 – 1904); and, Louis Gielly, *L'école genevoise de peinture* (Geneva, 1935). Of particular importance in regard to the drawings of the Geneva school is Anne de Herdt's introduction in *Dessins genevois de Liotard à Hodler,* exh. cat. (Geneva, 1984), 15 – 58.

[27] On the importance of Dutch art in the collections of the Suisse Romande, see Marcel Roethlisberger, "Holländische Malerei in der Westschweiz, Sammlungs- und Wirkungsgeschichte," in *Im Lichte Hollands: Holländische Malerei des 17. Jahrhunderts aus den Sammlungen des Fürsten von Liechtenstein und aus Schweizer Besitz,* exh. cat. Basel (Zürich, 1987), 41 – 48.

[28] On Bingham, see E. M. Bloch, *George Caleb Bingham: The Evolution of an Artist* (Berkeley/New York, 1967); on Mount, see A. Frankenstein, *William Sidney Mount* (New York, 1975); see also the essay by Brandon Brame Fortune in this publication, "Painting in America and Switzerland 1770 – 1870, Preliminaries for a Comparative Study".

[29] The principal monograph on Buchser remains Gottfried Wälchli, *Frank Buchser* (Zürich/Leipzig, 1941).

[30] Juste Olivier (1806 – 1876) was one of the many Swiss poets of the nineteenth century who was particularly interested in translating local legends and language into serious poetry. He won the admiration of Sainte-Beuve and Victor Hugo. On Olivier's contributions to literary style as well as his influence on Swiss literature, see E. Rambert, "Juste Olivier, notice biographique et littéraire," in *Oeuvres choisies de Juste Olivier* (Lausanne, 1879), iv-ccxxiv.

[31] On the question of religious art in Switzerland, see the essays in *"Ich male für fromme Gemüter," Zur religiösen Schweizer Malerei im 19. Jahrhundert,* exh. cat. (Lucerne, 1985).

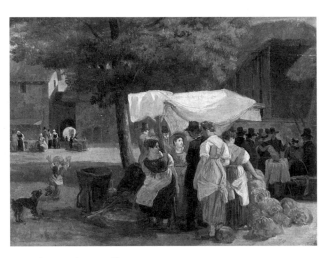

4 Wolfgang-Adam Töpffer
Market Scene
Oil on wood, 10⅜ × 14 inches (26.5 × 35.5 cm)
Oskar Reinhart Foundation, Winterthur

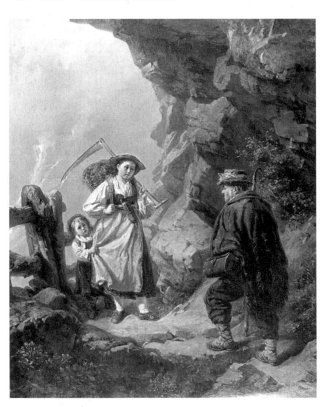

5 Raphael Ritz
The Botanist in the Mountains, 1872
Oil on canvas, 27 × 21⅞ inches (68.5 × 55.5 cm)
Private collection

Precisely the same attitude, implicit or not, applied equally to genre painting. The rise of genre painting in Switzerland is often associated with the so-called school of Geneva, and especially around the figures of Wolfgang Adam Töpffer (1766 – 1847; Fig. 4) and Agasse.[26] These artists and their immediate circle took as their subjects the simple events of daily life, unburdened by explicit philosophical or social messages. Like Dutch painting of the 17th century, which influenced the work of these artists through the collecting habits of Geneva society,[27] daily events were stripped to their essence and then re-composed in a direct and enchanting pictorial language which was accessible to all levels of society. Again, the comparison with American art is apt, as can bee seen in the homespun compositions of George Caleb Bingham (1811 – 1879) or William Sidney Mount (1807 – 1868),[28] which found their parallels not only in the Geneva school, but also in the works of Raphael Ritz (1829 – 1894; Fig. 5), Emil Rittmeyer (1820 – 1904; Fig. 6), and especially Frank Buchser (1828 – 1890; Fig. 7), who had visited America between 1866 and 1871 and may have seen similar paintings.[29] Moreover, the small genre picture found an enthusiastic and marketable audience in the same way that Juste Olivier's rustic, Vaudois poems discribed local legends and customs,[30] or Mark Twain's narratives embraced events with an unaffected language. Gleyre used the terms "charming" and "sentimental" to describe this aspect of Swiss art, terms which for him clearly had no pejorative implications.

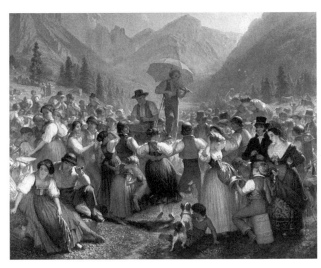

6 Emil Rittmeyer
Fête of Alpine Husbandmen at Alp Sol, 1865
Oil on canvas, 44⅝ × 55⅞ inches (113.5 × 142 cm)
Kunstmuseum, St. Gallen

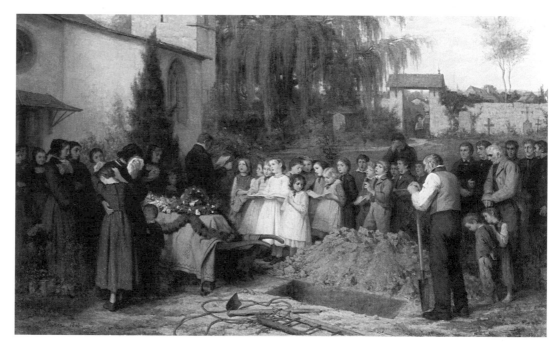

8 Albert Anker
A Child's Funeral, 1863
Oil on canvas, 43¾ × 67⅜ inches (111 × 171 cm)
Aargauer Kunsthaus Aarau

Gleyre's single most important criticism of Swiss art of this period was the feebleness of history painting. Under the broad label of history painting, he included the representation of actual historical events, as well as the tradition stemming from the Renaissance which included classical, mythological, literary and biblical themes. The paucity of religious art in Switzerland may be attributed clearly to the continued influence of the Reformation on the predominant artistic centers of Geneva, Zürich, and Basel.[31] The need or desire for church decoration or illustrations for biblical texts did not dominate Swiss art production, and therefore throughout the nineteenth century, religious art was neither a part of the program for training young artists, nor an active concern for commissions. When religious images do appear, they are often in the context of genre scenes, where they refer to the inherent piety of the peasants. This is the case in works of Albert Anker (1831–1910; Fig. 8), Segantini, and even the younger Hodler (Fig. 9). In the Catholic regions of Switzerland religious iconography was in greater demand, but even here altarpieces and other decorations were often imported from Italy and Germany. The best known practitioners of Swiss religious art, such as Melchoir Paul von Deschwanden (1826–1861) or Antonio Ciseri (1821–1891; Fig.10), based their efforts in general on Nazarene or Renaissance models, yet very few of these works rise above the banal or the derivative.

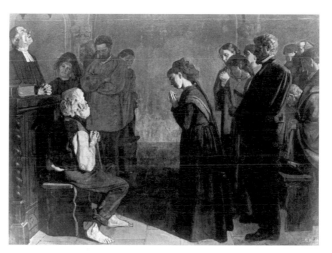

9 Ferdinand Hodler
Prayer in the Canton of Bern, 1880/81
Oil on canvas, 81½ × 109 inches (207 × 277 cm)
Kunstmuseum Bern, Gottfried Keller Foundation

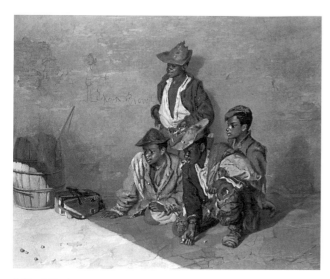

7 Frank Buchser
Four Black Boys playing Dice, February 1867
Oil on canvas, 25 × 30¼ inches (63.5 × 77 cm)
Private collection

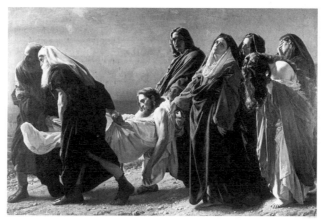

10 Antonio Ciseri
Burial of Christ, 1864–1870
Oil on canvas, 74¾ × 107½ inches (190 × 273 cm)
Church of Madonna del Sasso, Orselina

39

32 See, however, Franz Zelger, *Heldenstreit und Heldentod: Schweizerische Historienmalerei im 19. Jahrhundert* (Zürich, 1973), 31–77 and 199–200.

33 William Hauptman and Nancy Scott Newhouse, *Charles Gleyre* (see n. 2), 29–43; and William Hauptman, "Le Major Davel de Charles Gleyre, ou la naissance d'un chef-d'oeuvre vaudois" (Lecture delivered at the Palais de Rumine, Musée Cantonal des Beaux-Arts, Lausanne, March 1982.)

34 See Franz Zelger, *Heldenstreit* (see n. 32), 99–100.

35 Adrien Bovy, *La Peinture suisse de 1600 à 1900* (Basel, 1948).

36 "Le romantisme était dans les esprits et dans les coeurs, mais qu'en a-t-il passé dans la peinture? En quoi est-elle renouvelée? Et quand elle ne ressemble pas à celle qu'on avait faite auparavant, ne faut-il pas le regretter? Où est Delacroix? Nous n'avons pas même un Devéria ou un Delaroche." Adrien Bovy, *La Peinture suisse* (see n. 35), 97.

37 The funds for the painting came from public sources without private supplement. In the case of the *Davel* of 1850, however, the work was paid for through the estate of Marc-Louis Arlaud's will, with no public subsidy. The commission Gleyre received from Basel was paid for with funds from the painter Samuel Birmann (1793–1847), thus the source was private and not cantonal. For the latter commission, see William Hauptman, "Gleyre's *Penthée*" (see n. 17), 215–228.

38 The idea originated with Jean Jacques Burlamaqui in 1732, but it was not adopted until 1748; the school opened in 1751 under Soubeyran's direction. See Mauro Natale, *Le Goût* (see n. 12), 29–30; see also Anne de Herdt, *Dessins genevois* (see n. 26), 35ff. On significant initiatives in the development of art schools at Geneva, see Arnold Neuweiler, *La Peinture à Genève de 1700 à 1900* (Geneva, 1945), 203–208; see also J.J. Rigaud, *Renseignements sur les beaux-arts à Genève* (Geneva, 1876), 89–97; and, G.E. Haberjahn, "Resumé de l'histoire des Ecoles d'Art à Genève..." in *200ème anniversaire de la fondation de l'Ecole des Beaux-Arts, 1748–1948* (Geneva, 1948), 7–38. For a discussion of the Geneva school in relation to the European context, see Nikolaus Pevsner, *Academies of Art: Past and Present* (Cambridge, 1940), 157ff.

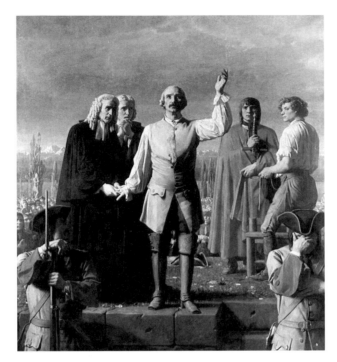

11 Charles Gleyre
Major Davel, c. 1850
Oil on canvas, 118⅛ × 106¼ inches (300 × 270 cm)
Destroyed (Musée cantonal des beaux-arts, Lausanne)

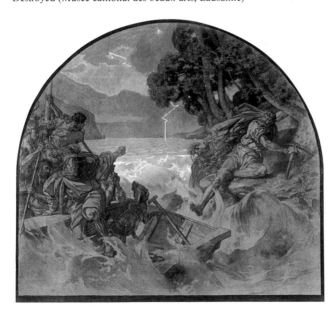

12 Ernst Stückelberg
Tell's Leap (cartoon)
Charcoal and white crayon on paper, 76⅜ × 85 inches (194 × 216 cm)
Collection of the Canton of Uri

With regard to pure history painting in which the subject is itself rooted in historical episode, it is true that one could point to artists such as Jean-Pierre Saint-Ours or Ludwig Vogel (1788–1879), both of whom may be properly classified as painters of Swiss historical subjects, and especially of popular scenes from the lives of Wilhelm Tell and Calvin. But Gleyre was correct in pointing out that proportionately these artists represented the exception rather than the rule.[32] When Gleyre himself painted the *Death of Major Davel* (Fig. 11) in 1845–1850, a work commissioned by the canton of Vaud but paid for with private funds, it represented one of the first examples of a major work representing an event from Swiss history, commissioned by and for a Swiss museum, and painted primarily for a Swiss audience.[33] There would be other works produced of a similar nature by artists such as August Weckesser (1821–1899), Konrad Grob (1824–1904), and Ernst Stückelberg (1831–1903), who painted an important cycle on the life of Wilhelm Tell (Fig. 12);[34] but the tradition of history painting in Switzerland was relatively minor and could never be compared with that of France, Germany, or England. This point was brought up again in 1948 by the art historian Adrien Bovy in a survey of Swiss art,[35] when he addressed the pressing question of why the romantic spirit in Switzerland was never translated into a glorification of its own rich national history: "Where is the Swiss Delacroix?" he asked, adding that there were not even local equivalents of Eugène Devéria or Paul Delaroche.[36] We know now that this is not quite accurate; artists with equivalent talent surely existed, but few avenues were open to them for the development of an artistic base of history painting in Switzerland. The romantic spirit was submerged beneath the Swiss landscape tradition where the anecdotal image was more commercially viable than the glorification of the past.

The root of the problem was already apparent to Gleyre in 1867. He put blame on the fact that the Swiss had no substantial art schools, nor adequate or accessible cultural resources such as public museums or monuments which could provide the necessary stimuli or market for a school of history painting or sculpture. Moreover, he noted that economic encouragement in the form of commissions usually came from private sources or from societies, both of which generally favored smaller works appropriate for salons, and often of a narrative or decorative nature. In Gleyre's case, an exceptional one because of his celebrity, only one commission for a historical work derived wholly from Swiss cantonal funds, *Les Romains Passant sous le Joug* (Fig. 13) of 1850–1858, a canvas intended as a pendant to the *Davel* which depicted the humiliation of the Roman legions by the weaker Helvetic forces.[37] The lack of art schools was clearly of paramount importance for Gleyre, who as the master of a prestigious private atelier in Paris was particularly sensitive to the necessity of a solid foundation in art training. As noted earlier, Swiss artists were compelled to pursue studies on an advanced level outside the country due to the lack of adequate facilities within Switzerland. In Geneva, for example, the first art school was founded in 1748 under Jean-Pierre Soubeyran,[38] but he noted himself that the intention of

the school was not to educate painters, sculptors and architects to further their own careers, but rather to give instruction in drawing in order to "improve the work and manufacture most usual in commerce and everyday life."[39] The program rested essentially on the practice of drawing from plaster casts. Models were not permitted until at least 1786, and the study of anatomy was not introduced until 1815. This was followed by perspective instruction a year later, but painting did not figure in the program, nor did aesthetics or art history until the latter half of the century. Students acquired formal knowledge of the history of art through plaster-cast examples of Greek and Roman sculpture which had been carefully selected for their beauty or modesty.

In Lausanne, a more typical example than Geneva, the situation was even less encouraging. No school of drawing in the official sense existed until 1822, when Louis Ducros established one in a limited context.[40] The attitude prevailed that education in art was important for the overall culture of man and society, but there was no specific training program for artists on a professional basis; the emphasis was rather on the application of art to craft and industry. After Ducros' death, Marc-Louis Arlaud (1773–1845), the former student of David who was said to have been the model for the figure of Tatius in the master's *Sabine Women* of 1799,[41] and who paid for the commission of Gleyre's *Davel*, donated a substantial sum to the city for the establishment of a museum which opened in 1841. The new space was divided between exhibition halls and drawing ateliers, and the program was based loosely upon the example set in Geneva. The art historical examples provided by Geneva collections, however, were lacking in Lausanne. It is interesting to note that upon Arlaud's death in 1845, the post of the director of the museum and the drawing school was offered to Gleyre, who politely declined it. The letter from the canton outlining the qualifications for the position specified 12 hours of teaching a week and stipulated an annual salary of 1,200 Swiss francs. This sum represented less than Gleyre had earned from the sale of one painting two years earlier.[42]

The situation was essentially the same in the German part of Switzerland, although the cultural heritage was hardly like that of the southwest. An art school existed in Basel by 1762, largely inspired by the example at Strasbourg, where the goal of the training process was consistent with that of Geneva.[43] In Bern, an academy of drawing was founded in 1779, but it closed during the Revolution, and could remain open only one year afterward due to lack of funding and space. Later, a smaller scale academy replaced it, profiting by the plaster casts sent from the Musée Napoléon in 1806. In Bern, too, the focus was exclusively on training in drawing, often for commercial application.[44] In Zürich, private drawing schools existed during the eighteenth century, such as that of Johann Martin Usteri (1763–1827); and, after the establishment of the local art society in 1787, instruction in drawing at public schools became more and more a part of the general curriculum.[45] The significance of drawing as a basis for art education was even more apparent in Zürich because of its close ties to

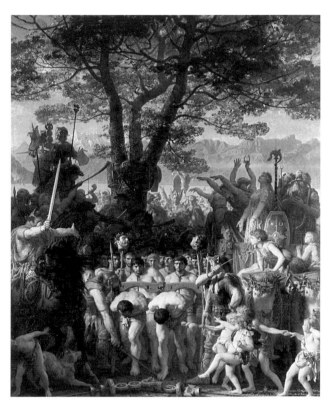

13 Charles Gleyre
Les Romains passant sous le Joug, c. 1858
Oil on canvas, 94½ × 75⅝ inches (240 × 192 cm)
Musée cantonal des beaux-arts, Lausanne

Germany, where Winckelmann's belief in the superiority of line over color was predominant.

If the prospective Swiss artist found it virtually impossible to find adequate training at home, he also found it difficult to exhibit his work. Again, we refer back to Stapfer's curious question of 1799, regarding the manner of exhibiting work by local artists. The question was not naive, but rather practical, since the idea of regular, continuous exhibitions had not yet been incorporated into the Swiss cultural physiognomy. The first exhibition of Swiss art in Switzerland may be properly dated to September 1789, in the halls of the Geneva Société des Arts.[46] There were 46 works in view, including paintings by Ducros and Liotard. Originally intended to last one week, it was extended to two weeks by popular demand. More than half of the works were portrait miniatures, and 15 were of landscape subjects; none were historical, biblical, or literary in nature. Another exhibition followed in 1792, with 54 works, including 24 examples from private collections in Geneva.[47] During the French occupation of the city (1798–1813), there were sporadic attempts at mounting exhibitions through the Société des Arts, but these often involved the work of a single artist, usually a member of the society.[48] When the Société des Amis des Beaux-Arts was established in 1822, exhibitions were more regular, but still wholly determined by the wishes and tastes of the members. The first permanent site for exhibitions sponsored by the

[39] [Johann Caspar Füssli], *Joh. Caspar Fuesslins Geschichte der besten Künstler in der Schweitz, nebst ihren Bildnissen* vol. IV (Zürich, 1774), xvi. Füssli was the father of the painter Johann Heinrich Füssli and the Swiss counterpart of Giorgio Vasari; on his contribution, see Oskar Bätschmann and Marcel Baumgartner, "Historiographie der Kunst in der Schweiz," in *Unsere Kunstdenkmäler* (Zürich) vol. XXXVIII, no. 3 (1987):350–352. On Soubeyran's remarks regarding the utilitarian purpose of the training process, see Anne de Herdt, *Dessins genevois* (see n.26), 35. It should also be added that this was a common idea which was applied in the various branches of public education, for example, primary education for children and training of officiers in military schools; on the former, see Heinrich Pestalozzi, "Über Volksbildung und Industrie," (1806) in *Sämtliche Werke*, vol. XVIII (Berlin, 1943), 148–149; on the latter, see Guillaume Henry Dufour, *Instructions sur le dessin des reconnaissances militaires à l'usage des officiers de l'école fédérale* (Geneva, 1828), passim. Pestalozzi (1746–1827) was the celebrated educator; Dufour (1787–1875) was the general who commanded the army of the Confederation.

[40] The principal source on the origins and development of the school at Lausanne is J. Hügli, "Histoire et préhistoire d'une école d'art," in *Cette Ecole d'Art: De l'école cantonale de dessin à l'école des beaux-arts et d'art appliqué de Lausanne* (Lausanne, 1983), 7ff.

[41] Juste Olivier, "Chronique," in *Revue Suisse* vol. VIII (May 1845):321.

[42] The letter is preserved in a rough draft which was later transcribed and sent to Gleyre. Département des Manuscrits, Bibliothèque cantonale et universitaire, Lausanne: Fonds Druey, IS 3442. In 1843, Gleyre's painting *Le Soir* was bought by the French government for 3,000 French francs.

[43] See Florens Deuchler, *Richesses* (see n. 12), 21.

[44] For a history of the situation at Bern, see Artur Weese and Karl L. Born, *Die Bernische Kunstgesellschaft, 1813–1913* (Bern, 1913).

[45] U. Ernst, *Die Kunstschule in Zürich, die erste Zürcherische Industrieschule, 1733–1833* (Zürich, [1900]); Florens Deuchler, *Richesses* (see n. 12), 21, and Nikolaus Pevsner, *Academies of Art* (see n. 38), 143ff.

[46] Pierre Chessex, "Documents sur la première exposition d'art suisse: Genève 1789," in *Zeitschrift für Schweizerische Archäologie und Kunstgeschichte* (Zürich) vol. XLIII, no. 4 (1986):362–366. This issue is devoted to the subject of exhibitions of Swiss art in and beyond Switzerland. It represents the proceedings of a colloquium on this subject organized by Paul-André Jaccard (Neuchâtel, 1986).

[47] Pierre Chessex, "Documents sur la première exposition" (see n. 46), 365, including a reproduction of the catalogue.

[48] See Danielle Buyssens' addition to the article of Pierre Chessex, "Documents sur la première exposition" (see n. 46), 367, which lists no exhibitions in Geneva between 1798 and 1814.

49 See E. Favre, *Cent ans de peinture genevoise* (Geneva, 1957), 8.

50 See n. 14.

51 These exhibitions were documented by Sandor Kuthy, "Kunst fasst Fuss. Kunstausstellungen in Bern zwischen 1804 und 1878," in *Berner Kunstmitteilungen* (Bern) no. 246–248 (May-June 1986):1–16.

52 On the tradition of the Exposition Nationale Suisse des Beaux-Arts and its relationship to the Exposition Nationale Suisse, see Paul-André Jaccard, "Turnus, Expositions nationales suisses des beaux-arts, SPSAS, SSFPSD, Expositions Nationales Suisses: listes des expositions et des catalogues" in *Zeitschrift für Schweizerische Archäologie und Kunstgeschichte* (Zürich) vol. XLIII, no. 4 (1986): 436–459. On the exhibition in Bern, see Sandor Kuthy's introduction to *Kunstszene Schweiz 1890 im Kunstmuseum Bern 1980* (Bern, 1980), 6–19, including a reproduction of the catalogue; see also, Sandor Kuthy, "1890" in *Zeitschrift für Schweizerische Archäologie und Kunstgeschichte* (Zürich) vol. XLIII, no. 4 (1986): 377–386. On the exhibition at Geneva, see P. Pictet, *Exposition nationale suisse: Rapport administratif* (Geneva, 1898). On the Swiss national fairs, see Hans Ulrich Jost, "Nation, Politics, and Art," in this volume, 17, n. 28.

53 See Paul-André Jaccard, "Turnus" (see n. 52), 437–446, including a complete list of the exhibitions.

54 Florens Deuchler, *Richesses* (see n. 12), 24.

55 Paul-André Jaccard, "Turnus" (see n. 52), 440. In 1859, it was installed in the Bundeshaus at Bern; in 1852, it was shown in the Stadtcasino, Zürich; in 1856, it was shown in the Stiftsbibliothek, St. Gallen.

56 The foundation of the museum is due to the endowment of Jeanne and Henriette Rath in 1824. On the history of the museum, see Maurice Pianzola, André Corboz, Armand Brulhart and Claude Lapaire, *Le Musée Rath a 150 ans* (Geneva, 1976); see especially the essay by Armand Brulhart, "De la Genèse du Musée Rath et de son utilisation primitive," 37–51.

57 On the history of the private collections of Tronchin, Duval, and de Sellon, see Mauro Natale, *Le Goût* (see n. 12), passim.

58 E. Bonjour, *Le Musée Arlaud, 1841–1904* (Lausanne, 1905), 20ff.

59 For the essential background, see Maurice Jeanneret, *Un siècle d'art à Neuchâtel* (Neuchâtel, 1924). On the construction of the museum, see Nicole Soguel, "Historique de la construction du Musée de peinture de Neuchâtel," in *Léo Châtelain, architecte, 1839–1913*, exh. cat. (Neuchâtel, 1985), 69–100.

60 Sandor Kuthy, *Das Kunstmuseum Bern, Geschichte seiner Entstehung* (Bern, 1971). The collection originated in 1820 when the city bought 13 paintings from the collector Sigmund Wagner. The plan for constructing a public museum was not introduced until December 1871. See also Sandor Kuthy, "Das Berner Kunst-Museum im Bundesrathaus: Zur Geschichte des Kunstmuseums von August 1864 bis Frühjahr 1879," in *Berner Kunstmitteilungen* (Bern) no. 180 (February/March 1978):1–9.

society was not established until much later: the Athénée, founded by the private funds of the philanthropist Jean-Gabriel Eynard which opened on October 1, 1863.[49]

In Zürich, the first exhibition of Swiss art was held in 1799 as a direct result of Stapfer's inquiry, and in collaboration with the patriotic society.[50] Similar exhibitions were held through local societies in Bern as well, but many contained examples of applied and industrial arts along with fine arts.[51] These exhibitions were generally small, and were never intended to represent national tendencies. Regular exhibitions of Swiss art did not begin until 1890, with the first Exposition Nationale Suisse des Beaux-Arts at Bern under the auspices of the Federal Art Commission founded two years earlier on the initiative of Frank Buchser. The exhibition took place in Bern every other year until it was integrated into the national fair in 1896 in Geneva. Only after this was the exhibition hosted by other cities in Switzerland, and in 1900 it even appeared in Paris in the context of the World Fair. In Zürich it was hosted only in 1910.[52]

But a major development toward exhibiting contemporary Swiss art on a regular basis occurred in 1840 with the establishment of the so-called *Turnus,* a traveling exhibition of Swiss art. The exhibition, open to foreign as well as Swiss artists, occurred annually until 1850, and after that, bi-annually.[53] The *Turnus* originally toured only three cities: Basel, Bern, and Zürich, with Winterthur and Lucerne added to the program in 1842. The traveling exhibition was not introduced into the French speaking region of Switzerland until 1856, when the *Turnus* toured Geneva and Lausanne. In the Italian speaking region, the first city to participate was Lugano, but only in 1891. These exhibitions were organized through local art societies who often juried them as well. In some instances, the works exhibited at the beginning of the tour differed from those exhibited at the end, because local societies were known to make favored additions, works might be sold during the course of the tour, and in some cases, artists would remove works from the exhibition while it was in progress. Because there was not always a single jury making selections for the exhibition, the aesthetic merit of the works chosen was not always consistently high or homogeneous. In the very year that Gleyre issued his report, the city of Aarau in Argovie, for example, declined to show the exhibition because the local society of art deemed the proposed works to be too mediocre.[54]

One of the difficulties with exhibitions of a large scale was the lack of adequate space for the proper display of paintings and sculpture. Apart from Geneva and Basel, no Swiss city during most of the nineteenth century had a museum with sufficient space for temporary installations. The *Turnus* in Bern, for example, was exhibited in the casino and sometimes in the choir of the French church.[55] As Gleyre noted, the museum was a crucial factor in developing artistic sensibility and continuity with the past, but the idea of a museum devoted to a fine arts collection — exclusive of the applied arts or history — came late in Swiss cultural history. The first public museum dedicated to exhibiting private and cantonal collections for this period was the Musée Rath

in Geneva, inaugurated in 1826.[56] Because of the nature of this city, both in terms of its ties to France and its prosperous economic stability, the new museum benefited from a rich collecting tradition which formed the basis of its holdings.[57] When a drawing school was incorporated into the museum complex, students could freely study the important works of French, Italian, and Dutch masters. As mentioned earlier, the first museum in Lausanne was the Musée Arlaud, established in 1841 with the private funding of Marc-Louis Arlaud. In the absence of a tradition of private collecting, the Musée Arlaud was limited to works left by Ducros and Arlaud himself.[58] In Neuchâtel, no permanent building for the cantonal collection existed until 1860, and no museum of fine arts until 1881.[59] In Bern, a permanent location for the public collection was not established until 1879: prior to this, it was installed first in the French church and in 1864, it was moved to four rooms of the Bundeshaus.[60] No permanent collection was on view in Zürich until 1910, despite the existence of a substantial public collection. Only at Basel did the public museum have any degree of continuity when Stapfer wrote his appeal: a museum building for the public had existed there since 1661, although it was not devoted exclusively to the fine arts.[61]

If the Swiss artist was forced by various cultural and economic circumstances into cultural migration, it is important to examine how he functioned in that exile. The ultimate goal of a Swiss artist was the Paris salon which afforded a large public and a greater possibility for commissions. Before the French Revolution, it was open only to members of the Academy; but after 1791 in the egalitarian spirit following the Revolution, salons were open to non-French artists as well.[62] Before 1840, more than 70 Swiss artists participated in the salon, and these mostly from French speaking areas; only three painters came from the geographically isolated central and eastern parts of the country while the salon *livrets* indicate that no painters from the Italian-speaking region were included.[63] Presumably, many of the latter favored Italian exhibitions, as often was the case with artists from the German-speaking regions, who in turn sent their works to Berlin, Munich or Düsseldorf. Other artists followed Füssli's example, and participated in the exhibitions of the Royal Academy in London, as did Agasse in 1800.

Not only were Swiss artists free to exhibit in Paris, but they were equally eligible to compete for the *récompenses,* various prizes and state commissions. Thus, painters like Louis Grosclaude (1784–1869) and Gleyre were awarded medals for their contributions to the salons and profited as a result from government commissions.[64] Töpffer accepted an important commission from Dominique Vivant Denon, the director of museums under Napoléon, while Diday and Calame found a ready market with French collectors, including the King Louis-Philippe.[65] The only prize which was officially closed to the Swiss was the Prix de Rome in history and historical landscape painting. Only French citizens, unmarried and male, under 30 years of age at the time of the first trial, could compete.[66] Yet the special political relationship of Geneva and Neuchâtel to

France permitted artists from these cities to participate; thus, Saint-Ours won the Prix de Rome in 1780,[67] and James Pradier (1790–1852) for sculpture, in 1813.[68] But when Léopold Robert attempted to enter a painting in the competition of 1816 he was barred from doing so because his native Neuchâtel had been placed under Prussian rule, and therefore he was no longer considered French.[69]

However, the strongest attraction of Paris for the Swiss, apart from the resources referred to by Gleyre in his report, was the possibility of advanced training at the Ecole des Beaux-Arts and in the private ateliers, none of which were limited to French citizens. In fact, statistics show that a great number of the students were from Germany.[70] Entrance to the Ecole required only a letter stating that some previous form of training had been accomplished, thus providing a certain artistic aptitude for passing the entrance examination. It should be understood that before the reforms at the Ecole in 1863, there was no specific planned curriculum.[71] The student would draw freely under the loose guidance of a teacher who generally came twice a week for corrections. After 1819 there were 15 teachers in residence, 7 painters, 5 sculptors, and three in the special subjects of perspective, anatomy and history. These latter specializations were of particular importance for the Swiss, since they rarely had this form of advanced instruction in their own academies.

Instruction was heavily based on drawing technique; only after 1863 was painting part of the curriculum as such. Students spent the morning in the ateliers of the Ecole, but were often required to copy in the Louvre in the afternoon, a practice which introduced the Swiss student to resources which he did not otherwise have. Within the internal structure of the ateliers of the Ecole, foreign students could participate in competitions in the various categories, such as perspective, history painting, and expression. The latter was especially significant since it implied the interpretation of the passions and temperaments through the figure alone, either from studies of plaster casts or the live model. In many instances, the Swiss artists' first contacts with professional models on a regular basis came from these ateliers. Very often they had little prior experience formulating large scale compositions on biblical or mythological subjects upon entering the Ecole.

All advanced students before 1863 who wished to pursue studies in painting were required to enter one of the many private ateliers run by professors of the Ecole. The most important of these offered instruction in color theory, composition, and the history of art, as well as in the technical practice of painting. Most Swiss painters passed through the system in this manner, some working under two masters, as was the case with Léonard Lugardon (1801–1884) who studied with Gros and Ingres, or Girardet who studied with Hersent and Cogniet. Later, free academies would serve a similar function, offering working space, but not always instruction. This was the case with the Académie Julian, where Amiet and Vallotton painted, the former in the company of Denis, Bonnard, Sérusier, and others.[72] Böcklin appeared to have worked for a short time in the Acadé-

mie Suisse, named after its founder, with no formal connection with Switzerland.[73]

After 1843, many Swiss students in Paris opted to work with Gleyre, who opened the atelier he inherited from Delaroche.[74] The atelier of Gleyre proved to be an attractive choice for Swiss artists not only because Gleyre himself was Swiss, but also because his teaching practice was solid, yet liberally oriented. It is no small measure of Gleyre's talent and tolerance as a teacher that he could accommodate students of diverse artistic interests and background, including those particularly interested in the applied and decorative arts. Not only did Anker and Bocion receive their basic training there, but so did Bazille, Renoir, Sisley, and Monet, all during the year 1863. Gleyre had at least 27 Swiss students — though none from the Italian speaking region — many of whom would later return to work in Switzerland.[75] It is no exaggeration to say that Gleyre helped to form a generation of Swiss painters who, in turn, passed on these traditions to other artists in Switzerland. Few painters from 1850 to 1870 were *not* influenced by Gleyre's art, ideas, or practice.

Gleyre's studio was unique in many ways. It was organized like a small republican government in which each student had an equal voice in the operation of the atelier, in effect a reduced version of his native country. Daily and practical matters were handled by an advanced student who was elected by his colleagues. Gleyre came twice a week to offer instruction, correction, and assignments. Unlike his French counterparts, Gleyre made it a point to advise each student individually; corrections were always made by the student himself rather than by the master as was the custom in other ateliers. No fees were charged except for the costs of hiring models and cooperative sharing of the student rent. Gleyre himself never accepted fees from his students for his services in over a quarter of a century of active teaching. In some instances, as in the case of the young Neuchâtel painter Albert de Meuron (1823–1897), Gleyre offered practical counseling in the student's own atelier when he thought it particularly beneficial. Gleyre's program included all aspects of drawing and painting — the latter only for advanced students, usually after the completion of two years of drawing instruction — as well as assignments involving subjects from classical and biblical literature. In all cases, Gleyre's objectives were to allow the student to develop his own artistic identity during the training process.

61 Otto Fischer, "Die Geschichte der Öffentlichen Kunstsammlung," in *Festschrift zur Eröffnung des Kunstmuseums* (Basel, 1936), 9ff. The basis of the collection was the cabinet of Basilius Amerbach and his successors which was bought by the city. It was the first museum to be founded by a collective society. It was originally installed in the university complex in 1661, and was moved to a private setting in 1671.

62 For documents pertaining to the opening of the salon after the Revolution, see C. Caubisens-Lafargues, "Le salon de peinture pendant la Révolution," in *Annales historiques de la Révolution* vol. XXXIII (1961):197.

63 Yvonne Boerlin-Brodbeck, "Zur Präsenz der Schweiz in Pariser Ausstellungen des 18. und frühen 19. Jahrhunderts," in *Zeitschrift für Schweizerische Archäologie und Kunstgeschichte* (Zürich) vol. XLIII, no. 4 (1986):353–361, and a list of Swiss artists who participated in the salons up to 1840 on 360–361.

64 Grosclaude's painting *Toast à la vendange de 1834*, painted in 1835 and exhibited in the salon of that year (no. 992 of the salon *livret*) won a third-class medal and was bought by the government for the collection of the Musée Luxembourg; see A. Bachelin, "Louis Grosclaude," in *Musée Neuchâtelois* (Neuchâtel) vol. VIII (1871):21–25,132–136 and William Hauptman, "Grosclaude and Courbet's *L'Après-Dînée à Ornans* of 1849," in *Gazette des Beaux-Arts* (Paris) vol. CV (March 1985):117–121. Gleyre won medals in 1843 and 1845, the latter a first-class medal, which led to various commissions from the government. On these, see Clément, *Gleyre* (see n. 15), 179ff.

65 On Diday, see Alfred Schreiber-Favre, *François Diday, 1802–1877* (Geneva, 1942), 75ff., including his *livre de commandes;* on Calame, see Valentina Anker, *Alexandre Calame, Vie et oeuvre, Catalogue raisonné de l'oeuvre peint* (Fribourg, 1987), 220.

66 Philippe Grunchec, *The Grand Prix de Rome. Paintings from the École des Beaux-Arts, 1797–1863,* exh. cat. (Washington, 1984–1985), 25.

67 The painting for which he won was *The Rape of the Sabines*; see Anne de Herdt, *Dessins genevois* (see n. 26), 111.

68 On Pradier, see *Statues de Chair: Sculpture de James Pradier (1790–1852),* exh. cat. (Geneva, 1985).

69 Pierre Gassier, *Léopold Robert* (Neuchâtel, 1983), 32.

70 For the important participation of the German students, and a list of those who exhibited in the salons, see Wolfgang Becker, *Paris und die deutsche Malerei, 1750–1840* (Munich, 1971).

71 Albert Boime, *The Academy and French Painting of the Nineteenth Century* (London, 1971), 7ff.

72 George Mauner, *Amiet* (see n. 2), 145.

73 Rolf Andree, *Böcklin* (see n. 2), 18, but it is not certain that Böcklin was actually associated with the school.

74 William Hauptman, "Delaroche's and Gleyre's Teaching Ateliers" (see n. 18), 79ff.

75 For a discussion of Gleyre and his Swiss students, see Brigit Staiger-Gayler, "Gleyre und seine Schweizer Schüler," in *Charles Gleyre ou les illusions perdues* (see n. 18), 126–139, and a list of his students (though incomplete) on 140–149.

[76] On Menn's teaching, see L. Guinand, *Notice abrégé des principes de Barthélemy Menn sur l'art et l'enseignement humaniste* (Geneva, 1893); see also Jura Brüschweiler, *Barthélemy Menn, 1815–1893, étude critique et biographique* (Zürich, 1960).

[77] "...la meilleure partie de son enseignement était dans son exemple." Eugène Rambert, *Alexandre Calame, Sa vie et son oeuvre* (Paris, 1884), 492–494. This represents one of the few sources on Calame's teaching activities.

[78] A list of Calame's students and their nationalities is provided in Valentina Anker, *Calame* (see n. 65), 266–267; 12 of them were from Italy, while the remainder were from Belgium, Holland, Russia, and even Portugal; the most important Swiss students were Böcklin and Zünd.

[79] The letter from Ingres, dated 17 January 1844, is reproduced in Jura Brüschweiler, *Barthélemy Menn* (see n. 76), 174.

[80] Deville (1803–1857) was himself a student of both Gros and Louis Grosclaude in Paris for a short period of time. After various conflicts with the officials in Geneva, he gave up his position in 1851.

14 Barthélemy Menn
Selfportrait with Straw Hat, c. 1867
Oil on paper on wood, 17 × 23⅝ inches (43 × 60 cm)
Musée d'art et d'histoire, Geneva

15 Barthélemy Menn
The Young Ferdinand Hodler, Drawing
Pen and ink study, with brown ink on white paper, 8½ × 7 inches (21.6 × 17.7 cm)
Musée d'art et d'histoire, Geneva

While it has been shown that the large majority of Swiss artists studied and practiced elsewhere, there are nonetheless two preeminent examples from the latter half of the century which may be cited here to illustrate the contrary. The case of Barthélemy Menn (Fig. 14) in this regard is almost unique, since at the height of his developmental years in Paris, he chose to return to Geneva to teach rather than accept an invitation to work at the side of a recognized master.[76] To be sure, other Swiss artists were already teaching in various local institutions; Diday and Calame either privately or in the Ecole des Beaux-Arts in Geneva, and Bocion in the Ecole Industrielle in Lausanne, to name but three exam-

ples. Yet for most of these painters, as for their French and German contemporaries, teaching was considered a secondary role, often only as a means of earning a fixed income. They generally provided instruction on a rudimentary level, in accord with common educational practice. Calame's instruction, although little documented, may be used as an example of the methods applied. His principles rested chiefly on drawing technique and the endless repetition of exercises which were frequently associated with his own specialization in landscape. Students were required to learn from and frequently to copy the master's example.[77] Theory or an awareness of the history of art and aesthetics never seemed to enter into his teaching, except in the context of assigned exercises. During his teaching career, Calame taught about 70 students — far fewer than the almost 600 students of Gleyre in Paris — but significantly, only 32 of Calame's were Swiss.[78]

Menn, on the other hand, may be regarded as a painter who saw teaching as a primary goal and applied his own artistic ideals in developing a pedagogical system with much broader implications than that of his contemporaries. Menn himself was trained in Geneva under Adam Wolfgang Töpffer, benefiting as well from the collection of the Musée Rath for copying exercises and the study of art history. In 1833, he left for Paris to work with Ingres. When the master left for Rome to direct the French Academy, Menn followed, making the customary tour of cities and museums. Finally returning to Paris in 1838, Menn associated himself with the younger members of the Barbizon School who would influence his own painting for the rest of his career. He was also introduced into the leading literary and artistic circles of the period: he knew George Sand, to whose son Maurice he gave drawing lessons, and Chopin, who purchased several of his works; he also became a close friend of Delacroix. In 1842, Delacroix even asked Menn to be his assistant on the commission to decorate the library of the Palais Bourbon. Although Menn declined the offer, his intimate relationships with the leading practitioners of avant-garde ideas had helped to shape his approach to teaching.

Menn returned to Geneva the following year hoping to secure a teaching position, but despite glowing letters of recommendation from Ingres[79] and Hippolyte Flandrin, both of whom were very much in favor in the artistic circles of Geneva, the position was given to the now-forgotten painter Joseph-Henri Deville.[80] Menn, however, took on private students, the most talented of which he would recommend to Gleyre in Paris. He traveled widely in Switzerland making *plein-air* studies, and most importantly, organized some of the first exhibitions in Geneva of the works of Corot, Daubigny, Diaz, Harpignies, Delacroix, and Courbet. These exhibitions were most often met with pointed negative criticism by conservative critics, forcing Menn to cease this aspect of his artistic activity.

However, in 1851, he finally secured the teaching post at Geneva when it was vacated by Deville, thus beginning a tenure at the Ecole des Beaux-Arts which would last almost 40 years. In 1859, he even stopped exhibiting his own paintings in order to further devote his full-time

energies to teaching. His program and philosophy of education were solidly based on technique and the craft of painting, but equally centered on the time-honored tradition of art as a humanistic discipline. He would later establish a humanist group, which included artists, writers, and a mathematician to debate daily the problems of aesthetics and pedagogy. He stressed in his courses a scrupulous study of the past masters as well as the modern ones, but he also emphasized the study of classical literature and Renaissance art theory, and in some cases, the sciences as well. For Menn, the painter was not only master of the technical demands of painting: he was also a creator in the largest possible sense, one who could make artistic decisions from a broad base of general education, where the wider the range of knowledge in all fields permits a greater aesthetic choice. Menn also considered teaching to be an independent means of reinforcing his own artistic integrity. He was well aware of the fact that through his teaching, he could establish an artistic continuity between his own experiences in Paris and that of Swiss artists who were still largely based in a tradition that stressed the picturesque, the anecdotal, and the descriptive.

Undeniably, Menn's most important student was Ferdinand Hodler, who arrived in Geneva from Bern in 1872, with only a slight knowledge of French (Fig. 15). Hodler had already served several years of apprenticeship with Ferdinand Sommer (1812–1901) producing small, touristic views of Swiss landscape. It is a measure of Menn's importance to the young Hodler that he remained in the atelier for six years. It may even have been at Menn's suggestion that Hodler expanded his knowledge of landscape by attending the classes in geography given at the University of Geneva by Carl Vogt.[81] Hodler wrote of his years with Menn that above all he had learned to discover himself; Hodler noted that Menn had permitted him to discover his being first and then awaken in him the gift of form, asleep in his sensibilities.[82] Menn often expressed his belief that the student should know his own capabilities first before attempting to enter into the lofty realms of fine art. In this sense, the idea of form was a product of the active and passive elements in the individual, and not always a fixed aesthetic tenet. Menn stressed the idea that beauty was likewise related to personal feelings and the artist's reaction to nature. Through an understanding of these sentiments, it was crucial for the student to conceive the intent and then allow it to become visually manifest in the painting. Yet Menn realized that as studies for a picture develop, the intention could change as a result of personal feelings or reactions to the scene painted; he thus put great emphasis on improvisation and spontaneity, practices Hodler maintained throughout his artistic career. Menn, like Gleyre, had a horror of artistic monotony and mere imitation. Nature, he noted, was an ample dictionary from which the artist could select elements in accord with his own vision and intention.[83] Unlike Calame's teaching, the master's examples did not necessarily serve as the principal artistic model to which the student must strive. Ideas such as these, which Hodler in turn applied, were new to Swiss art education and inevitably helped to fuse the more avant-

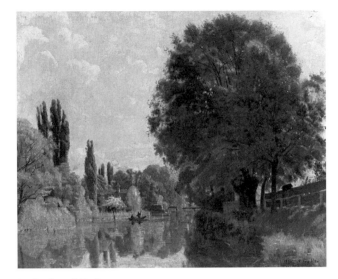

16 Ferdinand Hodler
River Landscape with Tree-lined Shore, 1880
Oil on canvas, 30¼ × 35¼ inches (76.5 × 89.5 cm)
Private collection

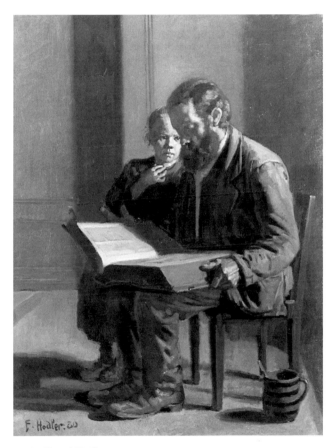

17 Ferdinand Hodler
Father, Reading the Bible, 1880
Oil on canvas, 28¾ × 20⅞ inches (73 × 53 cm)
Oskar Reinhart Foundation, Winterthur

garde tendencies of French and German art with the still moribund traditions of Swiss painting.

The practical application of Menn's ideas can be readily seen in Hodler's works after the late 1880s when his own personal style began to develop.[84] Coming from the tradition of descriptive or picturesque painting of "views" (Fig. 16), and the anecdotal iconography of unassuming peasant scenes in the manner of Anker (Fig. 17), Hodler began to explore the universal subjects inherent in his romantic sensibilities, subjects which probe, like the works of his contemporaries Van Gogh and Munch,[85] the invariable questions of the cycle of

81 See Oskar Bätschmann, "The Landscape *Oeuvre* of Ferdinand Hodler," in Oskar Bätschmann, Stephen Eisenman, and Lukas Gloor, *Ferdinand Hodler: Landscapes*, exh. cat. (Zürich, 1987), 28–29.

82 "Menn m'a en quelque sorte appris à *me découvrir moi-même* [. . .] il a éveillé le don de la forme qui sommeillait en moi." Jura Brüschweiler, *Barthélemy Menn* (see n. 76), 36.

83 "La nature n'est qu'un dictionnaire." Jura Brüschweiler, *Barthélemy Menn* (see n. 76), 35; note references here, also, to the importance for Menn of the intention ("la proposition") of a painting.

84 Hodler began working with the view painter Ferdinand Sommer in 1868, when he was only 15 years old, producing small alpine and lake scenes; see, Jura Brüschweiler, *Ferdinand Hodler als Schüler von Ferdinand Sommer* (Thun, 1984). In the mid-1870s he turned to genre subjects and humble religious scenes. See Franz Zelger, *Der frühe Hodler, Das Werk 1870–1890*, exh. cat. (Bern, 1981), 11–37.

85 For a discussion of Hodler in the context of his contemporaries, see Robert Rosenblum, *Modern Painting and the Northern Romantic Tradition: Friedrich to Rothko* (New York, 1975), 121–128.

86 On the symbolic aspects of Hodler's landscapes, see Guido Magnaguagno, "Landschaften: Ferdinand Hodlers Beitrag zur symbolistischen Landschaftsmalerei," in *Ferdinand Hodler*, exh. cat. Berlin/Paris/Zürich (Bern, 1983), 309–320.

87 Comparisons between Cézanne and Hodler go back to Fritz Burger, *Cézanne und Hodler: Einführung in die Probleme der Malerei der Gegenwart* (Munich, 1913).

88 Jura Brüschweiler, *Ferdinand Hodler, anthologie critique* (Lausanne, 1910), 10.

89 J.R. Taylor, review of Sharon L. Hirsh, *Ferdinand Hodler* (London, 1982) in *Art Book Review*, no. 4 (1983):40.

90 The question is reviewed anew in Oskar Bätschmann and Marcel Baumgartner, "Historiographie" (see n. 39), 347ff., and in Marcel Baumgartner, "'Schweizer Kunst' 1980–1987 - und überhaupt," in *Stiller Nachmittag, Aspekte junger Schweizer Kunst*, exh. cat. (Zürich, 1987), 205–211.

91 On Belgium, see *Art et société en Belgique, 1848–1914*, exh. cat. (Charleroi, 1980); on Denmark, see *L'Age d'or de la peinture danoise, 1800–1850* (Paris, 1984).

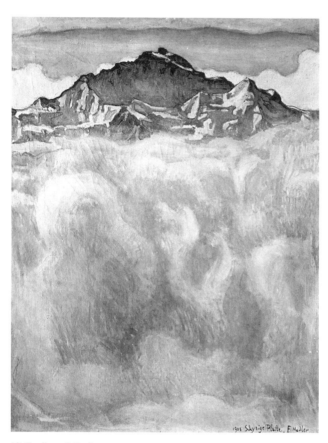

18 Ferdinand Hodler
The Jungfrau above the Fog, 1908
Oil on canvas, 36¼ × 16½ inches (92 × 67.5 cm)
Musée d'art et d'histoire, Geneva

life. It is no exaggeration to say that Hodler's interest in the themes of death and the infinite beyond could not have developed as they did without the training he received from Menn, or without his teacher's insistence on the importance of self-discovery. Even in the realm of landscape, the focal point of Swiss iconography, Hodler passed from the empirical to the symbolic, from the naturalistic to the magical, in such a way that metaphysical experience overtook physical description.[86] Whereas Diday, Calame, and Bocion were content to portray topographical exactitude, Hodler strove for the timeless, the remote, the mystic, in which topographical description was subservient to symbolic meaning. His mountain scenes, always devoid of humanity and frequently of traditional perspective, are no longer manifestations of ceaseless natural beauty, but rather become ethereal cosmic visions, not far removed from the symbolic landscapes of Caspar David Friedrich (Fig. 18). The intent — the word again recalls Menn — is opposed to that of Hodler's contemporary Cézanne.[87]

It may be argued that a large measure of Hodler's fame stems from his acceptance in Paris, Munich, and Vienna, rather than Geneva, Bern, or Zürich. Yet, while Hodler could complain bitterly that his works were little understood in his own country — as indeed was the

case with his provocative painting *Night* of 1891 — he nevertheless executed his most important works on his native soil, using Swiss subjects, which he exhibited in major Swiss museums. In the 1896 National Exposition at Geneva, he painted 22 figures to decorate the entrance to the Palais des Beaux-Arts,[88] but his *Night* was barred from the exhibition, although it would be purchased by the Kunstmuseum at Bern only five years later. Hodler also received a variety of commissions from Swiss societies and museums, including the controversial *Retreat from Marignano* commissioned by the Landesmuseum, Zürich, and a commission from the Swiss National Bank to redesign the 50 and 100 Swiss Franc notes. Despite his lack of critical success in Switzerland, Hodler's artistic vision was closely tied to the very country which could not always accept the modernity of his vision. This contradiction is at the heart of the comments of a critic regarding a monograph on Hodler published in English: "There is obviously a problem about being Swiss and an artist. Unless you are very decisive about it, like Giacometti or Böcklin, you do not quite belong to any of the major streams of art which swirl around the Alps, and at the same time do not have any clear national identity of your own. That, evidently, is why when we say 'Giacometti' *tout court*, everyone knows that we must mean Alberto [...] and not Augusto or Giovanni — though it could reasonably be maintained that Augusto was a far more interesting and important artist than his distant cousin, he chose to stay at home and get lost in Swiss-ness."[89]

This remark about the difficulty of being an artist in a country with four national languages and regional cultural and economic differences which prevent the existence of a single national identity may be understood and explained on several levels in relation to the cultural politics in Switzerland during the last two centuries. But the question of whether there is actually a Swiss art, or simply the "situation" of a Swiss artist active at home and abroad, is one which has been debated for generations and has found no easy solution.[90] The answer lies in the perspective taken: Bocion, who was born in Lausanne, painted Swiss subjects almost uniquely, while Klee, who was born near Bern, never did. Gleyre lived his entire life abroad, but considered himself to be Swiss; in the same way, Giacometti never totally severed the ties with his native village of Stampa. One can only wonder whether the question of national identity, artistic geography, and the limits of local cultural development may not be equally applied, for example, to the painters of Belgium or Denmark,[91] who were likewise removed from the mainstreams of European art during the period in question. Hodler, in any case, like Augusto Giacometti, exemplifies the Swiss artist who chose to confront his Swiss-ness rather than lose himself in it; and, in doing so, he was able to develop a pictorial iconography which ultimately transcended it.

Catalogue

with contributions by

AvS	Anne van de Sandt
BS	Beat Stutzer
BW	Bruno Weber
DHW	David H. Weinglass
DP	Danielle Perret
ES	Elisabeth Schreiber
FZ	Franz Zelger
GM	George Mauner
HAL	Hans A. Lüthy
LA	Laura Arici
MB	Marcel Baumgartner
MN	Mauro Natale
PC	Pierre Chessex
PL	Paul Lang
PM	Paul Müller
RL	Renée Loche
WH	William Hauptman
WK	Wolfgang Kersten

Giuseppe Antonio Petrini

The Liberation of Saint Peter from the Prison, c. 1735 – 1744

cat. no. 1
Oil on canvas
48 × 57 ⅛ inches (122 × 145 cm)
Foundation for culture, art, and
history, Küsnacht/ZH

Bibliography:
Mauro Natale, "Giuseppe Antonio Petrini:
Allegoria della Primavera, Allegoria
dell'Estate, Allegoria dell'Autunno," in
*Bericht der Gottfried Keller-Stiftung
1981 – 1984* (Bern, 1985): 96, ill.; Marco Bona
Castellotti, *La pittura lombarda del '700*
(Milano, 1986), ill. 491; Daria Caverzasio, "Le
opere giovanili di Giuseppe Antonio Petrini
in Valtellina e i suoi rapporti con la famiglia
Peregalli di Delebio", in *I nostri monumenti
storici,* vol. 38, no. 4 (Bern, 1987): 508.

[1] Louis Réau, *Iconographie de l'art chrétien,*
vol. III/3 (Paris, 1959), 1092 – 1093.
[2] Edoardo Arslan, *Giuseppe Antonio Petrini*
(Lugano, 1960), 125, 142.
[3] S. Colombo, "Nota su Giuseppe Antonio
Petrini," in *Arte antica e moderna,* vol. 19
(1962), 299; S. Colombo in *Dai Ligari al
Carloni, un momento della pittura lombarda
nel settecento,* exh. cat. (Como, 1979), 21.
[4] Arslan, 1960 (see n. 2), 58.

The painting depicts the episode of the miraculous liberation of Saint Peter from the prison of Jerusalem where he was confined by the order of Herod Agrippa. According to the text in the Acts of the Apostles (12, 3 – 11), an angel entered the cell, loosening the bonds which confined the apostle. The obvious metaphorical meaning of the subject, which proclaims the independent power of the Roman church from foreign political interference, was a major iconographical element during the sixteenth and seventeenth centuries.[1]

In this example the gloomy surroundings of the prison are suggested by the presence of the chain and an opening protected by a heavy metal-grating visible in the half-shadow behind the figure of the saint. A window of similar round form and of analogous compositional function appears in the *Vision of the blessed Giovanni da Meda,* which Petrini painted for the church of the Somaschi priests in Como in 1752.[2] This canvas, however, corresponds to the painter's final phase and shows a stylistic rhythm quite different from the one of the painting in question. Here the essence of the scene is focused on the two converging diagonals formed by the two foreshortened figures of Peter and the angel: a skillful and very elaborate compositional criterion which distinguishes the insistent research practiced in the studio, combining observation of the impact of light with experiments in perspective. Similar qualities present in this painting may be found in various mature works of the painter, from the figure of the *Mathematician* in a private collection at Varese[3], dated 1735, to the *Education of the Virgin* in Sant'Antonio Abate in Lugano, which according to documents is dated to 1744.[4] It is, therefore, possible that the *Liberation of Saint Peter* was executed in this span of time, although the chronological uncertainty of Petrini's paintings does not permit greater precision.

Distinctly perceptible traces in the pigments indicate that the composition was originally planned in oval form. *MN*

Giuseppe Antonio Petrini (Carona 1677 – c. 1758/59)
Biography, see p. 186

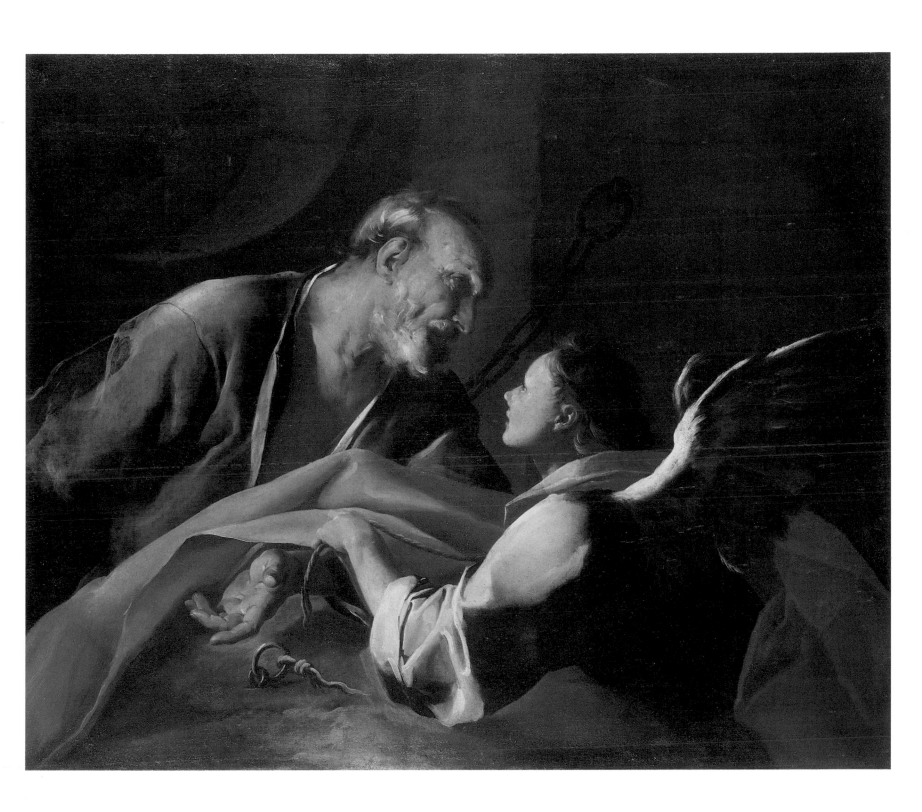

Giuseppe Antonio Petrini

Allegory of Spring, c. 1740

cat. no. 2
Oil on canvas
33 ½ × 27³/₁₆ inches (85 × 69 cm)
Museo cantonale di belle arti,
Lugano, inv. no. 1156
(Gift of the Swiss Bank
Corporation)

Bibliography:
Mauro Natale, "Giuseppe Antonio Petrini:
Allegoria della Primavera, Allegoria
dell'Estate, Allegoria dell'Autunno," in
*Bericht der Gottfried Keller-Stiftung
1981–1984* (Bern, 1985):88–97; Marco Bona
Castellotti, *La pittura lombarda del '700*
(Milano, 1986), ill. 494–495; Daria
Caverzasio, "Le opere giovanili di Giuseppe
Antonio Petrini in Valtellina e i suoi rapporti
con la famiglia Peregalli di Delebio," in *I
nostri monumenti storici*, vol. 38, no. 4
(Bern, 1987):508, 513.

¹ Cesare Ripa, *Iconologia, ovvero descrittione
d'imagini delle Virtù, Vitij, Affetti, Passioni
humane, Corpi celesti, Mondo e sue parti*
[1593] (Padova, 1611).
² Museo cantonale di belle arti, Lugano (Gott-
fried Keller Foundation). See Mauro Natale,
"Giuseppe Antonio Petrini: Allegoria della
Primavera, Allegoria dell'Estate, Allegoria
dell'Autunno," in *Bericht der Gottfried
Keller-Stiftung 1981–1984* (Bern, 1985), 90,
ill. 2.
³ Ripa, [1593] 1611 (see n. 1), 503.
⁴ Giuseppe Cattaneo and Emilio Ferrazzini,
ed., *Mostra delle opere del pittore Giuseppe
Antonio Petrini da Carona*, exh. cat. (Villa
Ciani, Lugano, 1960).
⁵ Edoardo Arslan, *Giuseppe Antonio Petrini*
(Lugano, 1960).
⁶ Canvases and frescoes in the chapel of Saint
Isidor in the parish church of Saint Peter and
Andrew at Dubino, dated 1703. The discov-
ery and the restauration are mentioned in
Natale, 1985 (see n. 2) and in Daria Caverza-
sio, "Le opere giovanili di Giuseppe Anto-
nio Petrini in Valtellina e i suoi rapporti con
la famiglia Peregalli di Delebio," in *I nostri
monumenti storici*, vol. 38, no. 4 (Bern,
1987):508–515.

Unknown until recently, these canvases are two of the most significant examples of Giuseppe Antonio Petrini's pictorial language.

Each of these pictures depicts a bust of a young woman. The first woman, the head crowned with a rose-garland, rests one hand on the broken edge of a big ceramic vase and holds in the other a small branch with leaves and little white buds; the other one, her hair tied at the nape with a shoot of vine, gazes on a few fruits and a bunch of grapes she has taken. These attributes correspond perfectly to those which Cesare Ripa, the author of the famous manual *Iconologia*¹ , recommended for the allegorical representations of *Spring* and *Autumn*. The two paintings, therefore, must be understood as being parts of a series of the *Four Seasons*. A third painting with the same provenance and of identical dimensions in fact depicts the allegory of *Summer*,² represented by a young woman with a few ears of corn inserted in her hair and holding a flaming torch. Missing, however, is the figure of *Winter,* which probably has the appearance, as suggested by literary tradition, of "a man, or an old, bald woman with wrinkles, dressed in rags and in leather sitting at an abundantly covered table by the fire, who seems to eat and to warm up."³

In the surviving paintings, the iconographic rules are adapted with great sobriety, differing from the redundant rhetoric and the artifice generally manifest in this theme. They reveal stylistic traits based on a subtle play of compositional and formal counterpoints; the foreshortened figures of *Spring* and *Autumn* facing each other suggest that the fourth element, Winter, may have had to obey the same compositional criteria. Contrasts also exist between the silver-grey of the sky and the bright background behind the garments, and between the women's graceful facial expression, and the jagged surface of the cloth.

Our knowledge about the Ticinese artist has increased notably since the exhibition organized in Lugano in 1960⁴ and the publication of Edoardo Arslan's monograph the same year.⁵ Recently, more significant paintings have been added to the catalogue of his works, which amounts to a respectable number. They have opened new fields of inquiry mainly in the question of taste and commissions. Nevertheless, the difficulty in preparing a reliable chronological sequence of his oeuvre still hinders our knowledge of the artist. This difficulty arises not so much on the scarcity of dated works and the shortage of documents we have at our disposal, but more on the tenacious continuity of expressiveness that marks his production. During the fifty years of his activity, the artist's style follows a relentless, although almost imperceptible progression, from the classicistic and Roman works of his youth to the chromatic rococo manner of his mature works.

The testimony of early biographers, that Petrini's artistic formation took place in Turin and Genoa in the workshop of Bartolomeo Guidobono, are contradicted by the data concerning the style of the recently found works in Valtellina by Paolo Venturoli.⁶ In fact, from the beginning his artistic vocabulary shows a spectrum of experience definitely vaster than the one of the provincial Genoese master — a spectrum which includes knowledge of the Lombardian masters (Filippo Abbiati, Andrea Lanzani, Giacomo Parravicini, and Paolo Pagani) and of the artists who were active at the Court of Sabaudo in Turin (particularly Andrea Pozzo and Daniel Seyter). But even their influence explains ony partly the definite formation of Petrini. The noble figurative

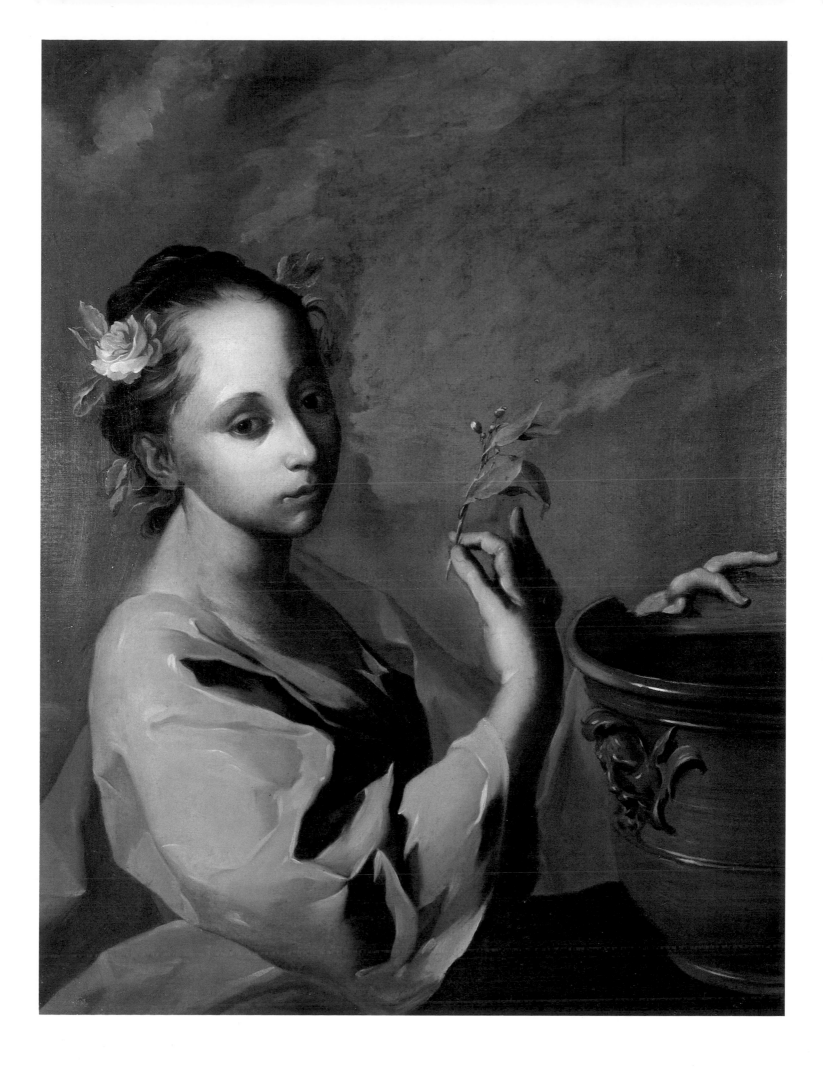

Allegory of Autumn, c. 1740

cat. no. 3
Oil on canvas
33 ½ × 27 ³/₁₆ inches (85 × 69 cm)
Museo cantonale di belle arti,
Lugano, inv. no. 1158
(Gottfried Keller Foundation)

[7] Giuseppe Martinola, *Inventario delle cose d'arte e di antichità del distretto di Mendrisio* (Bellinzona, 1975), 357–358.

[8] Parochial church, Melide, and private collection, Milan; see Arslan, 1960 (see n. 5), 85; Marco Bona Castellotti, *La pittura lombarda del '700* (Milan, 1986), ill. 490.

[9] Erich Schleier (ed.), *Disegni di Giovanni Lanfranco (1582–1647)*, exh. cat. (Cabinetto Disegni e Stampe degli Uffizi, Florence, 1983), 49–52.

[10] Andreas Pigler, *Barockthemen* (Budapest, 1974), 511–519.

[11] Luigi Brentani, *Antichi maestri d'arte e di scuola delle Terre Ticinesi. Notizie e documenti*, vol. 4 (Como, 1941), 120–135.

[12] Caverzasio, 1987 (see n. 6), 513.

"restauration" proclaimed by works like *San Isidoro Agricola* (1703) and *Saint Peter* at Dubino (1704), or *Saint Pius V Announcing the Crusade against the Turks* in the oratorio of San Giuseppe at Delebio (begun already in 1706) in fact presupposes not occasional but direct knowledge of Roman painting of the first quarter of the seventeenth century. The attraction exercised by the Roman models continued to be active also during the third decade of the eighteenth century: In a very unique way Petrini absorbed the compositional scheme of Caravaggio's *Madonna di Loreto* in the big canvas of the *Madonna of the Rosary* in Santa Maria dei Miracoli at Morbio Inferiore, delivered in 1726.[7] Even closer seem the connections between the two versions of *Saints Paul and Antony the Hermit*[8] and the Saints Augustine and William of Aquitania in the foreground of the *Coronation of the Virgin* by Giovanni Lanfranco (1616), a painting executed for the Saint Augustine church in Rome, now in the Louvre.[9] These are only the most obvious signs of a fact which seem to qualify, not in an exclusive, but certainly decisive manner, the early works of the Ticinese artist.

In the two present representations of the Seasons, the sober nobility of the baroque manner, however, seems eroded by a remarkable, almost eccentric liveliness similar to the more shady and more genuine expression of *Venetian rococo*. Analogous qualities may be seen in the figures of *Saint Theresa* and *Saint Peter of Alcantara*, frescoes in Saint Joseph's chapel at Morbio Inferiore, as well as in the *Dispute of Christ among the Doctors in the Temple*, a painting on a copper plate in the same chapel. The bright surface of the clothes and the virtuosity of the *chiaroscuro* parts suggest a period slightly later than *The Madonna of the Rosary*, a date around 1740, when the last, perhaps most exciting aspect of the artist's career began.

The two paintings shown here ought to be dated around the same time, too. It is interesting to note, that the subject constitutes an unique iconography in Petrini's oeuvre which is dominated by religious paintings. This loftier kind of subject, particularly appreciated by the European aristocracy during the seventeenth and eighteenth centuries,[10] may be considered as a revealing factor for the existence of a patron in the area where Petrini was active. The unique talent of Giuseppe Antonio Petrini is, in fact, quite incomprehensible due to our little knowledge on the history of collections of the seventeenth and eighteenth centuries in the Italian speaking part of Switzerland.

The scarce documents, which have come to light, nevertheless show the leading role — as buyers and collectors — played by the family Riva,[11] and, in Valtellina, by the family Peregalli of Delebio, to which a recently discovered manuscript-note[12] attributes "more than 30 pieces by Petrini, among which some are family portraits and two beggars from the land of Talamona in Valtellina and the four Seasons." These may in fact correspond to the very canvases we have described. *MN*

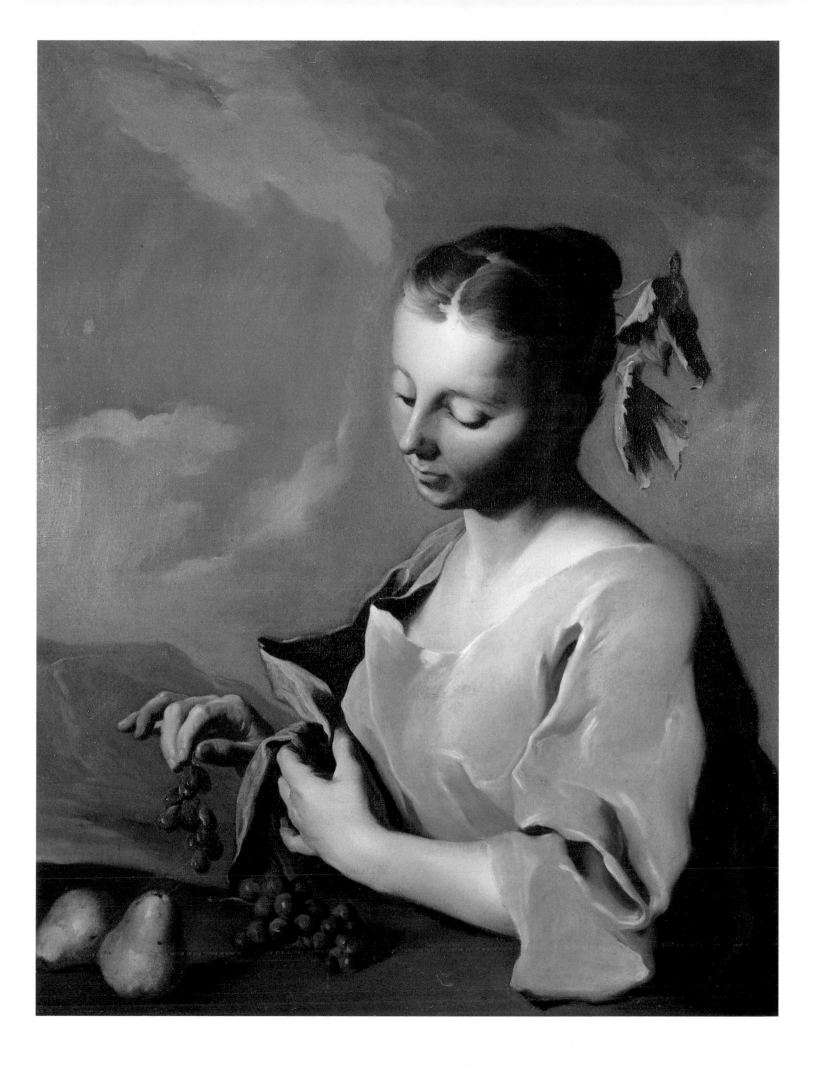

Jean-Etienne Liotard

Portrait of Richard Pococke, c. 1738 – 39

cat. no. 4
Oil on canvas
79 ¾ × 52 ¾ inches
(202.5 × 134 cm)
Musée d'art et d'histoire, Geneva, inv. no. 1948 – 22
(Gottfried Keller Foundation)

Bibliography:
Louis Hautecoeur, "Le portrait de Pococke par Liotard," in *Journal des Musées* (Geneva, 1949); François Fosca, *La vie, les voyages et les œuvres de Jean-Etienne Liotard* (Lausanne, 1956), 21; *Meisterwerke der Gottfried Keller-Stiftung*, exh. cat. (Zürich, 1965), no. 90; Renée Loche and Marcel Roethlisberger, *L'opera completa di Liotard* (Milan, 1978), no. 33, color ill. II; *Jean-Etienne Liotard, Genf 1702 – 1789: Sammlung des Musée d'art et d'histoire, Genf*, exh. cat. (Zürich, 1978), 24, no. 3; Brian de Breffany, "Liotard's Irish Patrons," in *Irish Arts Review*, vol. 4, no. 2 (Summer 1987): 31 – 32, and reproduction on front cover.

[1] William Windham, "Relations d'un voyage aux Glacières de Savoie", in *Mercure de Suisse*, vol. 3 (1743): 5 – 8.
[2] *Cabinet des tableaux. Explication des tableaux et dessins qui se voient rue Montmartre, vis à vis de l'Hôtel d'Usès, au second chez l'Epicier* (Paris, 1771). See Jan Lauts, "Jean Etienne Liotard und seine Schülerin Markgräfin Karoline von Baden," in *Jahrbuch der Staatlichen Kunstsammlungen in Baden-Württemberg*, vol. 14 (1977), 62 – 65 (texts are reproduced in extenso).
[3] Only one other example is known: the portrait of the *Earl of Sandwich*, his travelling companion to the Middle East, dressed in turkish costume (c. 1739, oil on canvas, 228 × 142 cm, Collection Earl of Sandwich, London).
[4] *Traité des Principes et des Règles de la Peinture par J.E. Liotard Peintre, Citoyen de Genève* (Geneva, 1945 first published Geneva 1781), 106 – 107, 110.

Richard Pococke (1704 – 1765), traveler, writer, pioneer of Middle Eastern archaeology, and theologian, was born in Southampton. An unusual character, with a decidedly independent mind, Pococke could not help but attract Liotard's interest and sympathy. Between 1733 and 1736 he made a long journey to the continent, traveling extensively in France and Italy. He departed for Egypt in the fall of 1737, and from there he visited Jerusalem, northern Palestine, and finally Constantinople where he stayed for several months during 1738. Pococke arrived in Geneva in June 1742, and continued on to Chamonix to visit the glaciers in the company, among others, of his compatriot William Windham (1717 – 1761). Dressed in the Turkish costume which he took with him on all of his excursions, Pococke climbed the Montanvers. According to contemporary sources,[1] he seems to have been the first foreigner to reach the "Mer de Glace". Returning to England in 1742, Pococke became bishop of Ossory in 1756, and of Meath in 1765. He owes his fame in particular to his *opus magnum* entitled *A Description of the East and Some other Countries* (1743 – 45), which was published in a French translation in Paris in 1772.

Pococke's portrait belongs to the most intriguing and most original period of Liotard's career, the time of his journey to the Middle East where he produced a great number of drawings. He recorded an accurate visual account of daily life as he observed it, depicting in minute detail his environment, the scenery and the people. This included, in particular, Englishmen like Sir Everard Fawkener; the Duke of Granby; Lady Tyrell, wife of the British Consul in Constantinople; and the Count of Bonneval, a former French officer who converted to Islam and assumed the name of Achmet Pacha.

Correct identification of the persons dressed in Turkish costumes and the exact dates of their portraits is a complicated problem in Liotard's *œuvre*. Like other artists of his time, Liotard paid tribute to the contemporary taste for *turqueries*. We know that he met Richard Pococke in Constantinople between 1738 and 1739. A sketch in black pencil and red chalk made around this time served, with minor changes, as an *esquisse* for the present oil painting. Now in the collection of the Cabinet des dessins of the Louvre, Paris, the sketch is described in the catalogue of Liotard's *Cabinet des ta-*

bleaux as follows: "no. 10: Bishop Pococ. English, in the Armenian dress which he wore when he traveled in the Middle East."[2] Taking into consideration the fact that Pococke remained in Constantinople for a very short time, it is safe to assume that the painting was completed after his departure.

Pococke is portrayed with monumental proportion against the landscape. The costume he wears is that of an official at the court of the Turkish Sultan: dark blue turban, brown cloak trimmed with fur, bright blue dress, under which brown and white striped underclothes are visible, and black boots. Pococke, holding a book in his hand, leans on an antique altar of a type known to be Roman, first century A.D. On the visible carved side of the altar are depicted instruments of sacrifice: the knife, the paten, and the bowl. The view in the background can be identified as the Tophane Quarter, and, on the other side of the Golden Horn, the rampart and kiosk of the Old Serail. On the far horizon, the islands of the Sea of Marmara are also visible.

Lifesize full-length portraits are very unusual in Liotard's *œuvre*.[3] In the portrait of Pococke, the whole composition is based on color oppositions: the light blue sky dotted with clouds, against which the figure in dark clothing stands out distinctly; the dark green of the trees in contrast to the softer green of the kiosk. In this painting, Liotard applies the theories which he will later develop in his *Traité:* "I claim myself to be one of the painters who succeeds well in producing extremely close resemblance in portraits. I owe this accomplishment, among others, to the fact that I always try to give a maximum of fullness and *relief* in my pictures, evenly balancing the *shadows* and the *light parts*. [. . .] *Paint clearly, appropriately and evenly*."[4]

Liotard's deliberately delicate, refined, and precise technique in the portrait of Pococke, as well as his objective and accurate vision, clearly signal the imminent developments of the nineteenth century, and especially the paintings of Ingres. It testifies to Liotard's precocious modernity in a milieu which was still clinging to the hierarchical order of the genres. *RL*

Jean-Etienne Liotard (Geneva 1702 – 1789 Geneva)
Biography, see p. 185

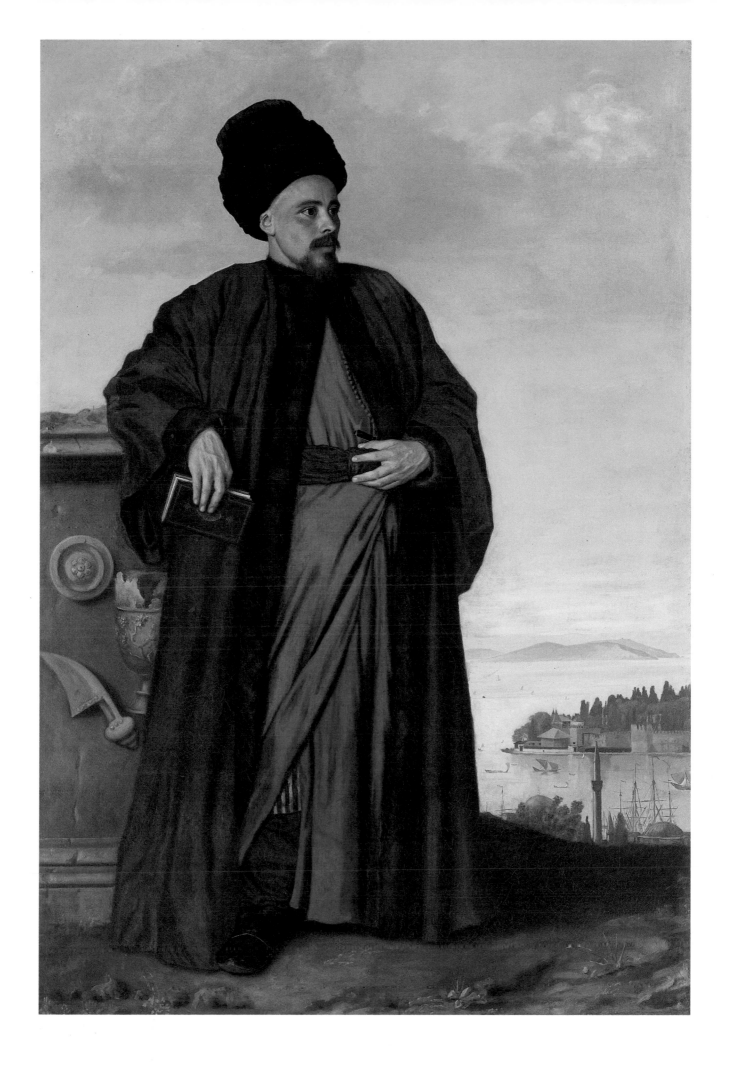

Angelika Kauffmann

Pliny the Younger and his Mother at Misenum, 79 A.D., 1785

cat. no. 5
Oil on canvas
40 ½ × 50 ¼ inches
(103 × 127.5 cm)
Signed and dated: "Angelica Kauffman Pinxt 1785"
Princeton University Art Museum, Princeton, inv. no. 69–89

[1] See "Memorandum of Paintings by Angelica Kauffmann, after her Return from England, which was in the Month of October 1781, when She went to Venice. A Literal Translation from the original Italian by Signora Vitelleschi," in Victoria Manners and George C. Williamson, *Angelica Kauffmann. R.A. Her Life and Her Works*, (New York, 1924: Reprint New York, 1976), 148.
[2] See *Letters to Tacitus*, book VII, letters XVI, XX. Gaius Plinius Caecilius secundus (62–113), nephew and adoptive son of Pliny the Older who died in the entombment in Pompeii.
[3] Peter Walch (University Art Museum, New Mexico), author of the forthcoming catalogue raisonné of the paintings by Angelika Kauffmann, was kind enough to provide me with those parts of his text which concern the present painting.
[4] The rediscovery was widely publicized by works such as *Le antichità di Ercolano*, published in ten volumes since 1775, whose etchings became elements of a standard repertory.

This composition is recorded in the "Memorandum of Paintings" written by the artist herself in 1785:[1] "Naples. 20th October. For Mr Bowles of London. On this date a case containing three pictures of 4 English feet by 3 feet 6 was sent from Naples to London on an English ship to the above gentleman. They represent [. . .] Pliny the younger at the time of the great eruption of Vesuvius retired with his mother to a courtyard of his house at Cape Miseno where he was staying. He retired there on account of the earthquake caused by the eruption, and taking with him a book of Tito Livy which he was studying, and sitting beside his mother he was attentively writing his notes when suddenly a friend of his Uncle, a Spaniard who happened to be there, interrupted him and scolded him for staying there reading instead of running away and saving himself. The picture depicts this moment one sees the mountain in the distance and the rough sea, and some far off figures flying for safety. 60 guineas." The source of this composition is the history of Pompeii and the eruption of Vesuvius in 79 A.D., or, more precisely, Pliny the Younger's account of the event as it is recorded in his *Letters to Tacitus*.[2]

In the present painting, the composite architectural elements are arranged without a unified scheme. None of the elements is parallel to the picture plane, and the diagonal shadow in the foreground to the left functions as a *repoussoir* rather than as a reliable indication of the light source. The three principal figures are bathed in a warm light, and the cool blue of the poet's costume off-sets the warm tints of red and gold in the dress of the other two persons. The effects of this color harmony compensate for a certain rigidity and awkwardness that the composition would otherwise suffer from. Framed by the arch, a view opens to the left on the turbulent sea and a distant landscape devastated by the catastrophe of the erupting volcano; also visible are two panic-stricken female figures descending the stairs, seemingly caught in a moment of frozen terror.

Peter Walch sees this painting as a response to the *Oath of the Horatii* by Jacques-Louis David (Fig. 5a), a work completed in Rome, in 1784, a year before the date of Kauffmann's painting.[3] In each painting, the action, which is based on the same coloristic scheme, occurs against an architectural backdrop like a theatrical stage set. Both compositions illustrate the polarity between the reactions of the two sexes in the face of a critical emergency; Kauffmann accentuates the passive timidity of the mother's posture by opposing it with the urgent pointing gesture of the "Spaniard".

With the choice of her subject Angelika Kauffmann points to the relationship between contemporary interest in this event from classical history and the rise of neoclassical art in the second half of the eighteenth century, at the time of the discovery and excavation of Pompeii and Herculaneum.[4] *PL*

Angelika Kauffmann (Chur 1741 – 1807 Rome)
Biography, see p. 184

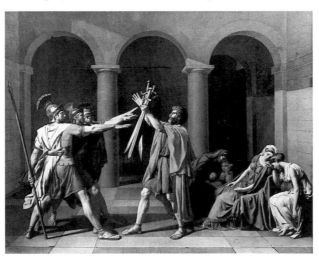

5a Jacques-Louis David
The Oath of the Horatii, 1784
Oil on canvas, 130 × 167 ³/₈ inches (330 × 425 cm)
Musée du Louvre, Paris

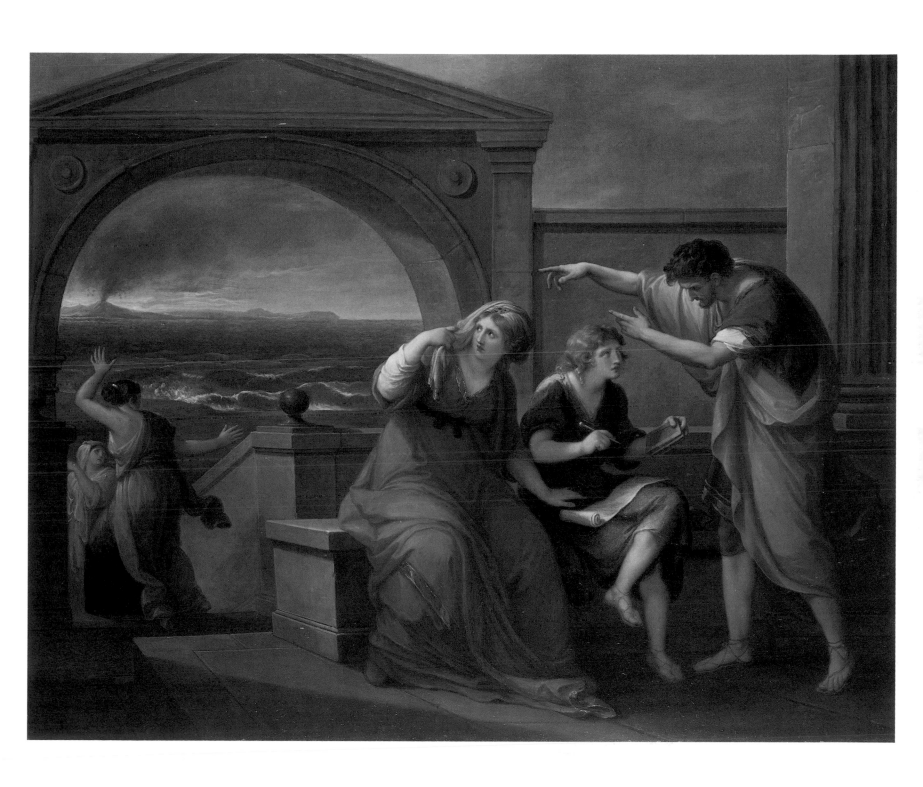

Angelika Kauffmann

Telemachus and the Nymphs of Calypso, 1787 – 1789

cat. no. 6
Oil on canvas
40 ⅜ × 50 inches (102.5 × 127 cm)
Signed lower center (on bronze plate): "Angelica Kauffmann"
Bündner Kunstmuseum Chur, inv. no. 70/797

[1] François Fénelon, *Les aventures de Télémaque,* translation: J. Hawkesworth (London, 1780), 12 – 13.
[2] "Memorandum of Paintings by Angelica Kauffmann, after her Return from England, which was in the Month of October 1781, when She went to Venice. A Literal Translation from the original Italian by Signora Vitelleschi," in Victoria Manners and George C. Williamson, *Angelica Kauffmann. R.A. Her Life and Her Works* (New York, 1924: Reprint New York, 1976), 143 ("Sept. 1783"), 171 ("1787 – 88"), 155 ("Finished in October, 1788"), 156 ("May, 1789"). Peter Walch, author of the forthcoming *Catalogue raisonné* of the paintings by Angelika Kauffmann, was kind enough to let me have his comments on *Telemachus and the Nymphs of Calypso,* at the Metropolitan Museum of Art, New York.
[3] In *The Age of Neo-Classicism,* exh. cat. (The Royal Academy/ Victoria & Albert Museum, London) (London, 1972), 907 – 908 (Addenda: Paintings, no. 163).
[4] The provenance of this picture can only be traced back to 1945: the painting belonged to German collectors who died in the Second World War. After having been transferred to a Swiss relation, it was identified and acquired by the Museum of Chur.
[5] *Telemachus and the Nymphs of Calypso,* oil on canvas, 82.6 × 112.4 cm, The Metropolitan Museum, New York, inv. no. 25.110.188.
[6] *The Sorrow of Telemachus,* oil on canvas, 83.2 × 114.3 cm, The Metropolitan Museum of Art, New York, inv. no. 25.110.187; see *Memorandum*: 142 ("Naples 1782"). The second version (1787/88) has as pendant *Bacchus dictating verses to the Nymphs of the Woods* (see *Memorandum*: 171); the pendant to the third version (1788) is *Venus and Adonis* (see *Memorandum*: 155).
[7] King Louis XIV censored the first edition in 1699, considering the publication an implicit attack of his reign.

The literary source of this painting is a late seventeenth-century French sequel to Homer's *Odyssey,* François Fénelon's *Les aventures de Télémaque,* published in 1699. It is a didactic novel as well as a book of travels and an adventure story. After leaving Troy, Ulysses' ship runs aground on the island of Ogygia where he is detained by Calypso, the nymph who promises him immortality if he will stay with her. In Homer's text, Ulysses remains on the island for seven years before he is freed through the intervention of Zeus. In the meantime, Telemachus, son of Ulysses and Penelope, leaves home in search of his father. But the classical text does not include Telemachus' encounter with the lover of his father: this occurs only in Fénelon's novel.

According to the text, Telemachus is accompanied in his search by the goddess Athena in the guise of Mentor, his tutor. When they are shipwrecked on the island, Calypso recognizes Telemachus as the son of Ulysses and welcomes him with hospitality, but also with coolness. She provides new clothes for the travelers in distress, and invites them for a meal and entertainment provided by her nymphs. The maidens sing of the Trojan war and inevitably praise the heroic deeds of Ulysses. This visibly saddens Telemachus, and it is precisely the moment Kauffmann chooses to represent: "When Telemachus heard the name of his father, the tears which stole down his cheeks added new lustre to his beauty: but Calypso, perceiving that he was too sensibly touched, and neglected to eat, made a signal to her nymphs, and they immediately changed the subject to the battle of the Centaurs with the Lapitae."[1]

Kauffmann produced four different versions of this painting between 1783 and 1789 as Peter Walch has established.[2] John Bunston has concluded that the painting in Chur, by virtue of its dimensions, cannot be any one of these pictures.[3] However, considering the often inadequate techniques employed for measuring paintings during this period, he admits that it could be possible that the painting is one of the four versions mentioned in the *Memorandum.*[4]

The *Memorandum of Paintings* further establishes that three of the four versions have pendants. Hence Walch considers the version at the Metropolitan Museum[5] to be an *a posteriori* pendant to the painting entitled *The Sorrow of Telemachus* in the same collection.[6] The two paintings are of equal dimensions, and were commissioned by the same patron. *Telemachus and the Nymphs of Calypso* at Chur thus may be one of the three copies described as having been painted between 1787 and 1789.

Aside from its interest as a tale of adventure and travel, *Les aventures de Télémaque* is a programmatic novel about the ideal sovereign.[7] It is typical that Kauffmann chose to depict an emotional sequence from a novel with broad political connotations. She further demonstrates her genuine independence of mind by choosing a clearly identifiable moment in a gradually unfolding drama, a moment of silence, marked by lyrical gestures: Mentor puts his left hand on Telemachus' shoulder, pointing to Calypso with the right, while she indicates to the maidens at the left. The artist stays close to the literary source, citing, for example, the garlands of vines elaborated by Fénelon, and the effeminate appearance of the hero, who at the same time conforms to the typical male figure represented in Kauffmann's oeuvre. She conjures up an atmosphere of eternal spring in her depiction of the island of Ogygia, combining spring and summer flowers, grapes and strawberries. This lends an ideal and Arcadian dimension to the picture as can be found in the classical landscapes of seventeenth-century masters. In order to preserve this ideal, the artist at a certain point even abandons the faithful illustration of Fénelon's text: while he describes an extremely animated setting, she depicts a tranquil landscape. The opening between the trees, looking toward the distant background, contributes depth and luminosity to the scene. The classical spirit is underscored by the introduction of a still life of amphora and plate, *repoussoir* elements recalling Poussin.

At the same time, Kauffmann departs from the purely neoclassical statement. By choosing a fleeting moment as the subject of her picture, and by emphasizing the femininity of a melancholy hero, but also in a certain mannerist tendency toward the elongation of figures, an undefined relationship between figure and ground, a shallow, theatrical space, and the pastel coloration, she achieves an ambiguity of style with this composition. *PL*

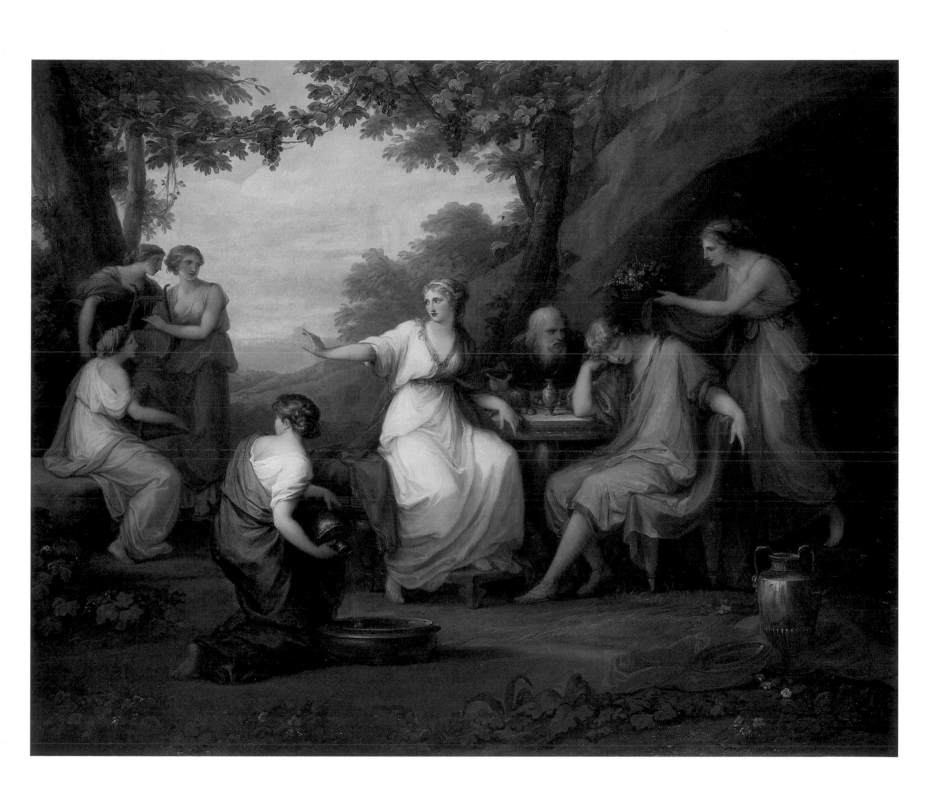

Jacques Sablet

Group Portrait with the Colosseum, 1791

cat. no. 7
Oil on canvas
23 ⅝ × 28 ⅝ inches (60 × 72 cm)
Signed lower right (on the stone):
"J. Sablet Roma/1791"
Musée cantonal des beaux-arts,
Lausanne, inv. no. 738
(Gottfried Keller Foundation)

Bibliography:
Conrad von Mandach, "François Sablet (1745 – 1819): Zwei Gesellschaftsstücke," in *Bericht der Gottfried Keller-Stiftung 1932 – 1945.* 3. Folge:17. und 18. Jahrhundert (Zürich, n.d.), 44 – 46; Anne van de Sandt, *Les frères Sablet (1775 – 1815),* exh. cat. (Nantes, Musées départementaux de Loire-Atlantique/Lausanne, Musée cantonal des beaux-arts/Rome, Museo di Roma, Palazzo Braschi, 1985), 65 – 67, nos. 24 and 25.

1 For example, the portraits of Lucien Bonaparte and his wife Christine Boyer in the collection of the Musée Fesch, Ajaccio, which are also set in a landscape.

2 In 1737, George Vertue has defined a conversation piece as follows: "small figures from the life in their habits and dress of the Time, well disposed graceful and natural easy actions suetable to the caracters of the persons and their portraitures welle touch't to likeness and Air, a free pencil good colouring and ornamented or decorated in a handsom grand manner every way Suitable to people of distinction." See "Vertue Note books, vol. 3," in *The Walpole Society,* 22 (1933 – 1934) (Oxford 1934), 81.

3 "Seine Conversations-Stücke sind mit viel Geschmack ausgeführt, und vereinigen alles Edle der italienischen Schule mit der Behandlung der Farbe der Niederländer." Conrad Gessner to Salomon Gessner, 22 June 1787, published in *Salomon Gessners Briefwechsel mit seinem Sohne: Während dem Aufenthalte des Letzteren in Dresden und Rom, In den Jahren 1784 – 85 und 1787 – 88* (Bern/Zürich, 1801), 211 – 212.

4 Jean-Pierre Cuzin, "Jacques Sablet, ou la peinture du temps qui s'écoule," in Anne van de Sandt, *Les frères Sablet (1775 – 1815)* (Nantes/Lausanne/Rome, 1985), 4 – 5.

5 The instrument is probably either a *lorgnette,* or a "Claude glass," a convex, black glass used as a mirror to reflect a landscape in reduced size, muted color, and merging detail. It is said to have been devised by Claude Lorrain and was popular among artists of the seventeenth and eighteenth centuries.

The *Group Portrait with the Colosseum,* of 1791, and the pendant *Group Portrait with the Basilica of Maxentius* of the same year were thought to be the work of François Sablet, elder brother of Jacques, when they were purchased by the Gottfried Keller Foundation in 1932. At the time, the group portrait with the Colosseum bore the signature "F. Sablet Roma, 1791." This authorship was never substantiated, and the paintings were eventually reattributed to Jacques Sablet when his signature emerged during restoration of the paintings.

As they were purchased at auction without clear provenance, the identity of the family portrayed remains unknown. The two group portraits are true pendants, precisely synchronized images representing the same landscape setting: the Farnese Gardens on the Palatine overlooking the Roman Forum, one portrait showing the Colosseum to the east, and the other, the Basilica of Maxentius to the west.

Serial images, suites of four or more, or pendant pairs, were quite common for eighteenth century history and landscape painting, but were quite rare for portraits. Jacques Sablet, however, produced other pendant portraits,[1] and in fact appears to have been very well received as a portraitist in Rome around the time that the present works were painted: "His conversation pieces,[2] are executed with exquisite taste, and combine the nobility of the Italian school with the handling of color of the Netherlandish painters," wrote Conrad Gessner in a letter to his father, Salomon.[3]

Sablet's portraits were commissioned by a cosmopolitan clientele vacationing in Rome, as had been the case with the paintings of Pompeo Batoni before him, of Anton von Maron, and of Angelika Kauffmann. Yet his small scale paintings express less of the grand and noble sensibility than that of an extremely pragmatic, mundane vision. Like his British predecessors, who with apparent ease integrated their models into the bucolic simplicity of rural surroundings, Sablet achieved an intimate type of portrait in opposition to the bombastic portraits of history painters. But he never gave way to naturalistic depiction: "The portraits by Sablet, with their inimitable discretion and sincerity, bear witness better than the works of any other artist to the great

need in the 1780s for simplicity, even candor, after a century fraught with portraits *mis en scène* with cascades of fabric; after too many winking glances and artificial smiles pretending satisfaction; after nothing more than empty politeness in the face of the comedy of social life."[4] In this period, Rome was the center of activity for full-length portraits set in an outdoor landscape. This genre was imported by British travelers making the Grand Tour and wishing to bring home a portrait souvenir as a record of the journey. Prices for such paintings were modest in Rome at the time, but even more important was the "surplus historical value" of having one's portrait done in front of a well-known antique backdrop.

Sablet takes great care to avoid the impression that his figures are sitting amid props on a stage. He composed the portraits out-of-doors, using atmospheric perspective. He succeeded in creating a space for the figures: they are positioned naturally, as they might be in a photograph; the pictorial planes flow logically from one to the other; the air seems to circulate and the atmosphere embraces and links the sitters; the delicate silhouettes stand out against the clear and bright backdrop of wide open skies broken only by a few faint clouds. Sablet established a privileged relationship between his figures and their natural surroundings.

Nothing could seem more natural, more "informal," than this stop after an archaeological excursion to the Forum, at a moment in time when the study of antiquity had become a veritable *sportive* performance under the direction of a *cicerone.* Like his compatriot Jean-Etienne Liotard, Sablet was uncompromising in his observations: a young man accompanied by his equally exhausted dog, succumbs to his weariness on an antique relief, whereas his companion, equipped with an optical instrument,[5] leans lazily on a fragment of a capital, a citation not without irony from a portrait by Batoni. A young woman, rather female companion than mother, stands nearby resting her elbow on the pedestal of a headless marble figure. Elegantly attired in her yellow dress decorated with garlands of roses, and her hat of white *tulle,* she wears an expression which is a bit strained.

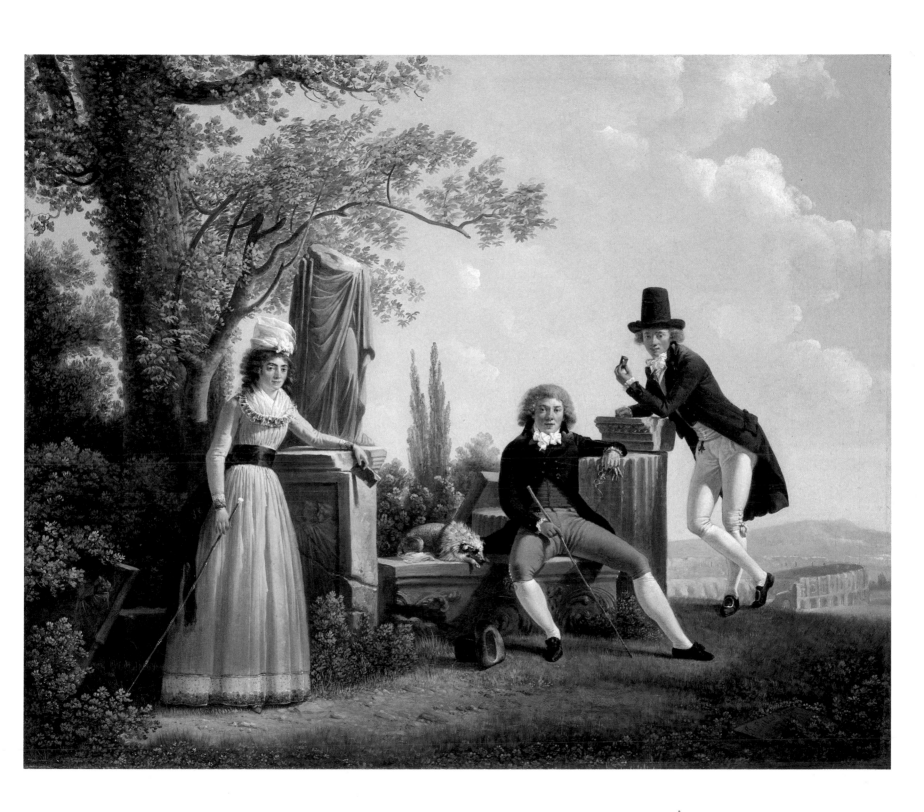

Group Portrait with the Basilica of Maxentius, 1791

cat. no. 8
Oil on canvas
23 ⅝ × 28 ⅜ inches (60 × 72 cm)
Signed lower right (on relief):
"Sablet Roma/1791"
Musée cantonal des beaux-arts,
Lausanne, inv. no. 739
(Gottfried Keller Foundation)

[6] Other examples are: *Le premier pas de l'enfance* (Municipio, Forli), *Une mère donnant une marotte à son enfant* (Private collection, Lucerne), *Portrait de famille dans un paysage* (Kunstmuseum Winterthur), and *Portrait de famille devant un port* (Musée des beaux-arts, Montreal).

[7] Bridel, a contemporary Swiss theologist commented on Sablet's extraordinary talent for rendering an expression: "it is the most remarkable trait in this artist; it is obvious that he knows the human heart, and how different feelings are perceived in the physiognomies: it is not only in the expression of passionate emotions that he displays this talent, but mainly in the articulation of an ambivalent mix of two or more passions taking hold of the soul: it is really true that rarely only one passion stirs our heart; out of their association grow the different expressions on our face, depending on the age, the sex, the temperament, the climate, the nation or the government; these are delicate nuances, but Mr. Sablet applies himself to express them; indeed, he does it so well that it may be said of his paintings that the least intelligent will be able to read them." Philippe Sirice Bridel, "Les artistes suisses maintenant à Rome, Lettre du 28 juillet 1789," in *Le Conservateur suisse, ou Recueil complet des Etrennes helvétiques,* vol. 2 (Lausanne 1813), 371 – 373. ("c'est la partie qu'on estime le plus dans cet artiste; on voit qu'il connoît le coeur humain, et la manière dont diverses émotions se peignent sur la physionomie: ce n'est pas seulement dans l'expression d'une passion violente qu'il développe ce talent, c'est surtout dans l'expression ambigüe du mélange de deux ou plusieurs passions agissant de concert sur l'âme: en effet, il est rare que nous ne soyons agités que par une seule passion; de leur mélange naît sur notre visage une alternative diverse, selon l'âge, le sexe, le tempérament, le climat, la nation ou le gouvernement; ce sont des nuances délicates, mais que Mr Sablet s'applique à exprimer; il le fait avec tant de succès, que l'on peut dire de ses tableaux, que le moins intelligent peut les lire").

In the pendant *Group Portrait with the Basilica of Maxentius,* a father leads his three daughters through the Farnese gardens. The eldest is seated, making a few notes in her travel diary. The girl's dresses are of white *mousseline,* a fashion established by Marie-Antoinette at Trianon, with generous pink and blue satin sashes. The colors of these delicate and vaporous costumes are set in contrast to the flagrant reds and yellows of the pendant.

The subject of familial life seems to have intrigued Jacques Sablet,[6] and he was capable of rendering the whole range of human emotions.[7] The penetrating directness of his observation, combined with his sensitivity to human emotions make these portraits, or "conversation pieces", decidedly moving and genuine.

At a time when contemporary events might have inspired images of the painful parting of a family from its homeland in search of a more peaceful existence, Sablet evokes the tenderness and affection of a father who is enlightened enough to preoccupy himself with the education of his daughters. The Palatine, site of the founding of ancient Rome and residence of the Emperors, provides him with an ideal setting. This preoccupation with classical history had temporarily eclipsed the appeal of the sixteenth-century Farnese gardens, but perhaps the lushness of the surroundings might eventually turn the conversation from antiquities to the themes of Rousseau. *AvS*

Jacques Sablet (Morges 1749 – 1803 Paris)
Biography, see p. 186

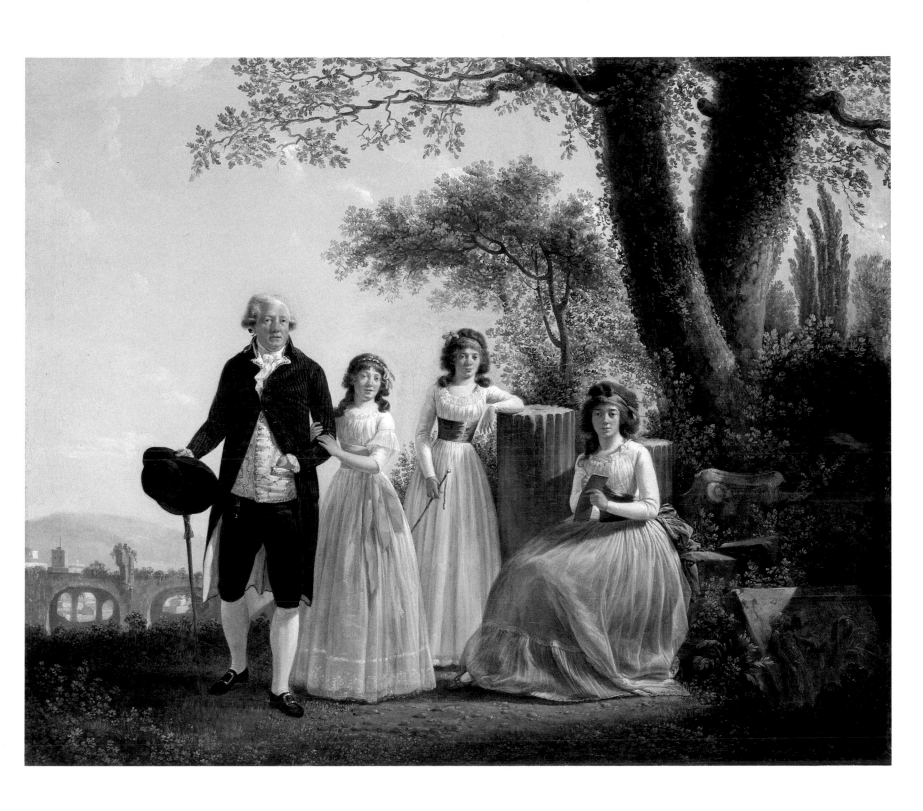

Jean-Pierre Saint-Ours

The Earthquake, 1806

cat. no. 9
Oil on canvas
55 7/8 × 72 13/16 inches
(142 × 185 cm)
Musée cantonal des beaux-arts,
Lausanne, inv. no. 1132

Bibliography:
Hugh Honour, *Neo-Classicism*
(Harmondsworth, 1986), 186, 188 (ill.), 207.

[1] Dated according to Jean-Pierre Saint-Ours, "Compte de mes ouvrages depuis mon arrivée en 1792. Août," in Daniel Baud-Bovy, *Peintres genevois 1702 – 1817,* première série (Geneva, 1903), 153.
[2] Jean-Pierre Saint-Ours, *The Earthquake,* 1799, oil on canvas, 265 × 215 cm, Musée d'art et d'histoire, Geneva, inv. no. 1825 – 1; ill. in *The Age of Neo-Classicism* (exh. cat.) (The Royal Academy and the Victoria & Albert Museum, London, 1972), 148, no. 231, pl. 36.
[3] The differences between the two versions concern mostly the main figures' lines of sight: in the earlier painting it is the woman who looks back in great fear, in the version of 1806 this part is taken over by the man.
[4] An oil sketch, dated 1802, formerly in the Marc Debrit Collection , already represents the enlarged concept of the composition, however with important differences in the details (ill. in Daniel Baud-Bovy, *L'ancienne Ecole genevoise de peinture* [Geneva, 1924], pl. XXIII).
[5] See *De David à Delacroix. La peinture française de 1774 à 1830* (exh. cat.) (Grand Palais, Paris, 1974/75), 358 and nos. 26, 63, 149 (hint provided by Mylène Koller, who is working on a thesis on Saint-Ours). An interesting British example in the context of Swiss painting is Philip James de Loutherbourg, *An Avalanche in the Alps,* 1803, oil on canvas, 43 1/4 × 63 inches, Tate Gallery, London. See also in this volume, cat. no. 5, and esp. cat. no. 15.
[6] Anne de Herdt, *Dessins genevois de Liotard à Hodler* (exh. cat.) (Musée Rath, Geneva/ Musée des Beaux-Arts, Dijon) (Geneva, 1984), 126 – 127 (no. 50: "Etude de femme et enfant pour le *Tremblement de terre,*" c. 1791).
[7] See also Hugh Honour, *Neo-Classicism* (Harmondsworth, 1968), 186.

The Earthquake, dated 1806,[1] is an extended version of a subject which Jean-Pierre Saint-Ours had treated years earlier in a vertical format.[2] In the earlier version, begun in Rome around 1792 and completed in Geneva seven years later, the artist focuses on the central group of figures and particularly on their reactions to and emotions evoked by the catastrophe.[3]

In the renewed interpretation of the subject,[4] the painter not only adds new figures and groups, but also elaborates on the actual event that caused this terror and fright. The internal drama, which is mirrored in the attitude of the figures and the expressions on their faces, is now associated with the dramatic unfolding of the dreadful event itself. The bursting boulder, where the family temporarily takes refuge from the raging forces of nature, represents an island amid the waves of crumbling buildings, collapsing bridges and temples disappearing in clouds of dust and smoke — a platform facing the gaping, engulfing abyss which opens in the foreground.

The skillful control of light supports a skillfully structured composition. The man, woman, and children stand out in full light against a background of shadowy figures shrouded in darkness. A diagonal suggesting a pronounced movement upwards to the right culminates in the horrified look of the man, directed toward the columns that are falling out of the painting toward the left. This diagonal is faintly echoed in a second oblique movement, formed by a crouching woman, a despairing girl and a bearded old man. The staging is compellingly emphasized by the use of color: the focal group is further accentuated by the primary colors red, yellow and blue, whereas the subordinate figures are clothed in muted secondary colors.

The threshold of the nineteenth century witnesses a great popularity of the representation of catastrophes.[5] In the case of Saint-Ours, Anne de Herdt has indicated the implications and connotations which suggest a genuinely relevant interpretation of the event apparently taking place in a timeless, classical setting.[6] In a letter dated 19 February, 1783, Saint-Ours talks about an earthquake which completely devastated Messina. Only four months later, his correspondence deals with the consequences of the revolution which compelled many citizens to escape and emigrate from his native town of Geneva. Against this background, a symbolical intention in selecting this theme again after ten years, during a period of continuous political insecurity, seems at least probable. For an artist who has become increasingly sceptical towards the Revolution, the image of a natural catastrophe becomes the metaphor for the terror man inflicts upon himself.[7] *MB*

Jean-Pierre Saint-Ours (Geneva 1752 – 1809 Geneva)
Biography, see p. 187

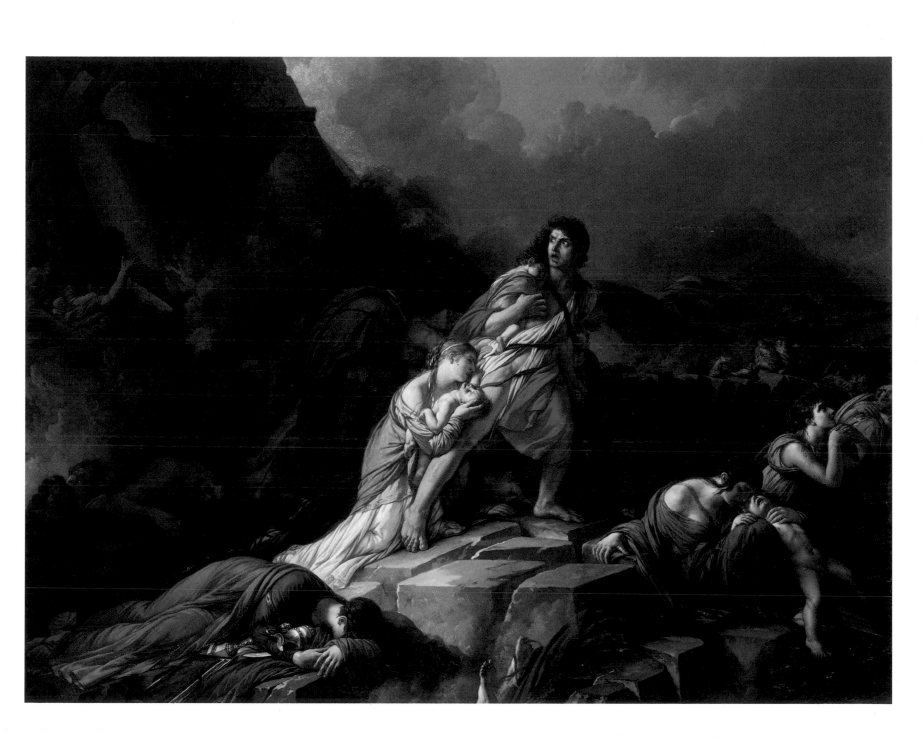

Johann Heinrich Füssli

Theseus Receiving the Thread from Ariadne, 1788

cat. no. 10
Oil on canvas
37 3/4 × 28 3/4 inches (96 × 73 cm)
Kunsthaus Zürich

Bibliography:
Gert Schiff, *Johann Heinrich Füssli, 1741 – 1825*, 2 vols. (Zürich, 1973), vol. 1, 135, 375, 487 – 488 (no.714), vol. 2, 162 (ill.).

[1] This seems somewhat more satisfactory as a source than the two lines in Ovid's *Metamorphoses*, VIII, 172 – 173, suggested by Gert Schiff, in *Johann Heinrich Füssli, 1741 – 1825*, 2 vols. (Zürich, 1973), vol. 1, 487.
[2] The lines "Hic Labor Ille Domus" (Here's the task, there the house), graven in the stone of the bottom stair in the lower right foreground (*Aeneid*, VI, 27) are to be taken to refer as much to the artist's accomplishment of his task, i.e. the work of art representing the fruit of his labors, as to Theseus' ordeal in negotiating the labyrinth.
[3] Bacchylides, *Dithyramb* 17. For this reference and other help I thank my colleague Professor Lois Spatz.
[4] H. Stuart Jones, *A Catalogue of the Ancient Sculptures of the Museo Capitolino* (London, 1912), pl. 53, no. 89. Füssli's drawing (Schiff, *Füssli* [see n. 1], no. 661) is in the Nationalmuseum, Stockholm.
[5] It might be noted here that vase paintings from Vulci dated to the sixth and seventh centuries B.C. depict the Minotaur rather arbitrarily in both fashions, while the Middle Ages almost always portrayed him as a centaur (A. G. Ward, et al., *The Quest for Theseus* London, 1970, 32, 165, 189).
[6] Discussed by Schiff in terms of Bartholomäus Spranger's mythological paintings and Füssli's debt to sixteenth-century Netherlandish mannerism, Schiff, *Füssli* (see n. 1), vol. 1, 136.
[7] Schiff, *Füssli* (see n. 1), no. 753.
[8] Schiff, *Füssli* (see n. 1), no. 790.
[9] Schiff, *Füssli* (see n. 1), no. 1488.

The story of Ariadne, Theseus, and the Minotaur is an oft-told tale that was embroidered upon throughout classical antiquity by both Greek and Roman authors. While particularly relying on Vergil's retelling of the myth in Book VI of the *Aeneid*,[1] in his painting *Theseus Receiving the Thread from Ariadne*, Füssli effectively demonstrates his remarkably detailed knowledge of the classics, but also his accomplished skill in translating such narrative *recondita* into dramatic pictorial terms.[2] While the image ostensibly represents an action taking place in a unique and specific moment in time, it is also intended to recall important details of Theseus' past and future career.

Theseus, a peripatetic hero in the mold of Hercules, has come to Crete to destroy the minotaur, to whom each year seven Athenian youths and maidens must be offered up as human sacrifices. This monster, half animal and half man, the fruit of Pasiphae's unnatural passion for a favorite bull, is confined in the labyrinth built by Daedalus. Füssli's picture, exhibited as "a finished sketch" at the Royal Academy in 1788, shows Ariadne in a diaphanous and revealing gown and in a state of half-swooning languor and desire, standing on the second step of the stairs leading down into the laby-

10a Johann Heinrich Füssli
Perseus and Andromeda, 1778
Pencil, pen and sepia, 6 1/8 × 4 3/8 inches (15.4 × 11 cm)
National Museum, Stockholm

rinth; she is handing the equally rapt and oblivious Theseus the clue, a ball of thread which will allow him to retrace his path after he has slain the monster. With her left hand she points the way. Around her head she wears a coronet of blue flowers — more like alpine blooms, for example, spring gentians, than any likely to be found on Crete. These star-shaped blossoms prefigure Theseus' desertion of her on the island of Naxos, and the transformation of her crown by Bacchus into the constellation Corona. This may be the crown of light, praised by one poet, with which Ariadne illuminates the darkness around her.[3]

Exemplifying Füssli's characteristic practice of "harmonizing" his borrowings so "that what he adopted might have been his own offspring though anticipated by another," the pose of Theseus and Ariadne is derived from a Roman relief depicting Perseus and Andromeda in the Capitoline Museum, Rome, via Füssli's paraphrase (Fig. 10a).[4] The two figures, entwined in harmonized *contrapposto*, dominate the center of the picture; such is the intensity of their self-absorption that the tiny minotaur, brandishing his club amid the gloom near the right edge of the picture, might seem little more than an afterthought. While Füssli's depiction of the minotaur as a centaur-like figure with a human torso and head (equipped with short curved horns) on a bull's body might seem to run counter to the more traditional rendering of the beast with a bull's head on a human body, Füssli has specifically followed the authority of Vergil in this detail, from the passage at the beginning of Book VI of the *Aeneid*.[5] At all events, the form he chose serves to remind us of Theseus' battle with the Centaurs, while the minotaur's club might seem to allude to the encounter with the brigand Periphates, nicknamed "Corynetes," the club-man.

Surprisingly, this linking of the figures in the pose of Ariadne and Theseus[6] is very rare in Füssli's corpus: the representation of couples in this fashion, where the woman plays an active loving role towards the man seems to be limited to *Titania and Bottom with the Ass's Head*,[7] and in reversed form, with the man sitting, *Aratus the Poet and Urania the Muse of Astronomy*.[8]

Not until circa 1815 – 1820 did Füssli return to the subject with a painting of *Ariadne Observing Theseus Battling the Minotaur*,[9] but this time with more emphasis on the actual contest with the minotaur rather than placing it almost exclusively on the romantic aspects of their relationship. A *mezzotint*, printed in both colored and uncolored versions, was engraved in 1788, by John Raphael Smith, after Füssli's original. *DHW*

Johann Heinrich Füssli (Zürich 1741 – 1825 London)
Biography, see p. 182

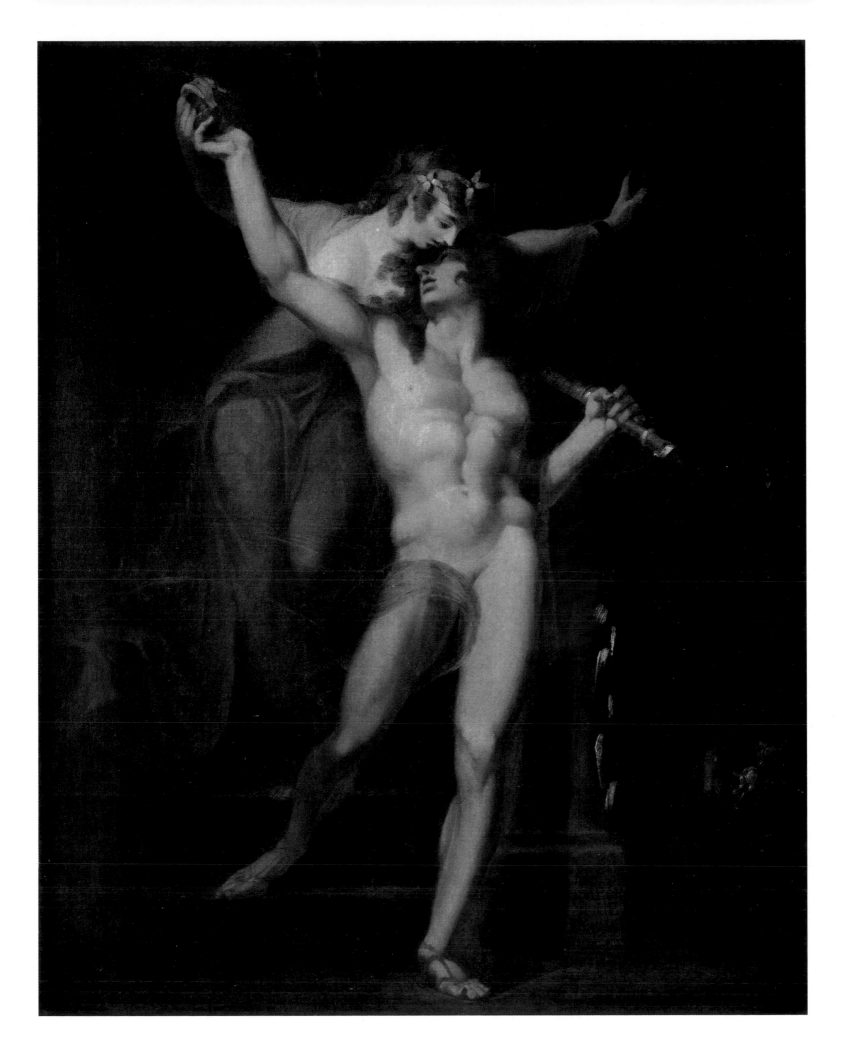

Johann Heinrich Füssli

An Incubus Leaving Two Girls, 1794

cat. no. 11
Oil on canvas
39 3/8 × 48 13/16 inches
(100 × 124 cm)
Muraltengut, Zürich

Bibliography:
Gert Schiff, *Johann Heinrich Füssli, 1741–1825,* 2 vols. (Zürich, 1973), vol. 1, 166, 228, 378, 526 (no. 929), vol. 2, 273 (ill.).

1 See Johann Heinrich Füssli to William Roscoe, 16 February 1795, in *Collected English Letters of Henry Fuseli,* ed. David H. Weinglass (Millwood, N.Y., 1982), 127, where this picture is listed among the works sold the previous year. It was purchased for 30 guineas by the engraver, Theodor Falckeisen (1765–1814) of Basel. Exhibited (1802/23) in the Zürich *Künstlergesellschaft,* it was reviewed in *Helvetisches Journal,* I (1802): 169–171.
2 Gert Schiff, *Johann Heinrich Füssli, 1741– 1825,* 2 vols. (Zürich, 1973), no. 757 (1781). For a review of all aspects of this work, see Nicolas Powell, *Fuseli: The Nightmare* (London, 1973), 48–51, 72–75, 84–86, 95–96. "Incubus" was the standard eighteenth-century term for nightmare, although in modern usage this refers rather to the male spirit or demon said to lie upon sleepers, particularly women, in the night.
3 For Erasmus Darwin's description of "the squab fiend [. . .] mark'd by *Fuseli's* poetic eye," see "The Loves of the Plants," III, in *The Botanic Garden,* Part II, 51–78.
4 Frederick Hart, *History of Italian Renaissance Art: Painting, Sculpture, Architecture* (Englewood Cliffs, N.J./New York, [?1972]), 488–491. Cf. also the figure of the Danish king in *Hamlet's Father Murdered by his Brother in the Garden* (Schiff, *Füssli* [see n. 2], no. 445).
5 Horst W. Janson, "Fuseli's *Nightmare,*" in *Arts and Sciences* (Spring 1963): 23–28; Powell (see n. 2), 60; Christian Klemm, *Johann Heinrich Füssli, Zeichnungen* (Zürich, 1986), 134.
6 Schiff, *Füssli* (see n. 2), no. 1445.
7 A phrase from Homer is written at the bottom left of the drawing (*Iliad,* X, 496–497); it reads in translation: "[s]he breathed hard for an evil dream there stood above his/her head that night."
8 Schiff, *Füssli* (see n. 2), no. 1768 (1794).

Unlike the two other works by Johann Heinrich Füssli in this exhibition, *An Incubus Leaving Two Girls,* has no literary precedent. Datable to 1794,[1] it may be viewed as a counterpart to his *Nightmare* (Fig. 11a),[2] although it depicts two female figures instead of a single one, and the persuasive details of the bedroom furnishings which could identify scene and subject as contemporary have been eliminated. While both paintings evoke the sensations of terror and suffocating oppression experienced during a nightmare, as well as the fusion of natural and supernatural elements which commonly occurs in the nocturnal world of the dreamer, this later version clearly lacks the dark sublimity and atavistic force of the erotic obsession Füssli invests in *Nightmare.*

In the place of the spectral horse peering through the curtains at the window, with its glowing eyes, and the baleful goblin squatting "erect" upon the belly of the "love-wilder'd Maid," deprived of all volition,[3] is the winged horse with the shaggy, bear-like incubus upon its back. The pair is seen disappearing at a flying gallop through the open window in the upper left of the picture, the generous hind quarters of the steed suggestively juxtaposed with the muscled rump of its rider.

With the peculiar appositeness that typified Füssli's "judicious adoption of figures in art," the large central figure of the young woman with half-opened eyes and

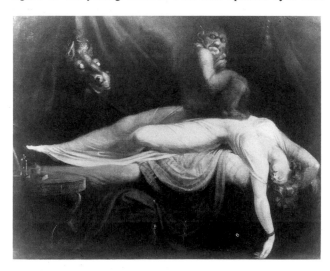

11a Johann Heinrich Füssli
The Nightmare, 1781
Oil on canvas, 39 3/4 × 50 inches (101 × 127 cm)
The Detroit Institute of Art, Detroit

knitted brows, a look of anguish on her face as she starts to awaken from her nightmare, recalls the mighty figure of Michelangelo's tragic *Dawn* on the tomb of Lorenzo de Medici in the Church of San Lorenzo, Florence.[4] At her side, unconscious of the maiden's distress, her companion sleeps peacefully.

If we see in the *Nightmare,* as Horst W. Janson has suggested, "the incubus demon taking the place of the artist himself,"[5] then the young woman's release from the thrall of the incubus would also represent the artist's liberation through art from a hopeless but obsessive passion. It would not be fully exorcized until 1810, when Füssli reworked this image in a drawing,[6] closely adapting the figures of his two young women to correspond with those of Goltzius' engraving of *Mars and Venus* (1585), implying through their pose, and the fashionable hat the sleeping companion wears to bed, that they should be seen as *demi-mondaines* and as a more (sexually) experienced couple than the maidens in this painting.[7] Füssli's preparatory sketch[8] shows only one female figure, whose pose, interestingly enough, is closer to that of one of the figures in the 1810 drawing than to the maiden in the painting. A print was engraved by Theodor Falckeisen *post* 1795; the drawing made for this purpose is in the Kunstmuseum, Basel.

DHW

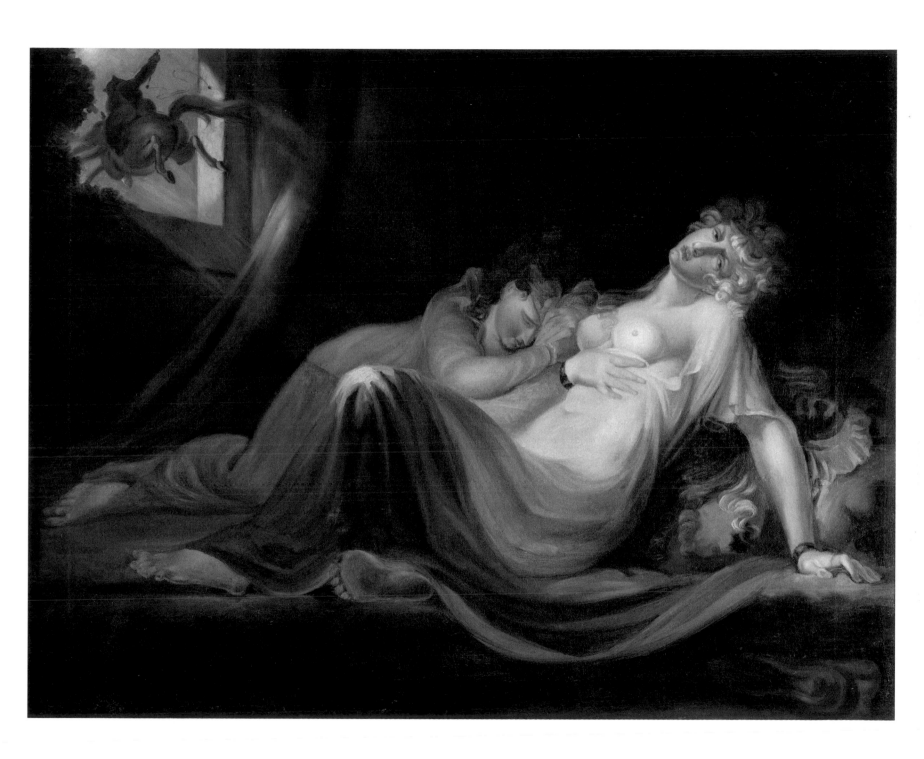

Johann Heinrich Füssli

Odysseus Between Scylla and Charybdis, 1794 – 1796

cat. no. 12
Oil on canvas
49 5/8 × 39 3/4 inches
(126 × 101 cm)
Aargauer Kunsthaus Aarau,
inv. no. 884

Bibliography:
Gert Schiff, *Johann Heinrich Füssli, 1741 – 1825,* 2 vols. (Zürich, 1973), vol. 1, 137, 197, 205, 517 (no. 894), vol. 2, 249 (ill.); Franz Mosele, *Gemälde und Skulpturen vom 18. Jahrhundert bis zum Ersten Weltkrieg* (Sammlungskatalog Aargauer Kunsthaus Aarau, Band 1) (Aarau, 1979), 66 – 67 (no. 33).

[1] See George deForest Lord, "Epic, *Paradise Lost* and the Classical," and Martin Mueller, "Homer," in *A Milton Encyclopedia,* ed. William B. Hunter, Jr. et al. (Lewisburg, 1978 – 1980), III, 48 – 62; IV, 13 – 20.
[2] See Johann Heinrich Füssli to William Roscoe, 9 August 1796, in *Collected English Letters of Henry Fuseli,* ed. David H. Weinglass (Millwood, N.Y., 1982), 155, where the painting is listed among works completed. See also the discussion in Gert Schiff, *Johann Heinrich Füssli, 1741 – 1825,* 2 vols. (Zürich, 1973), vol. 1, 205 – 206.
[3] *Paradise Lost,* II, 1016 – 1020, in John Milton, *Complete Poems and Major Prose,* ed. Merritt Y. Hughes (Indianapolis, 1980).
[4] *The Odyssey,* XII, 73 – 259, trans. A.T. Murray (Cambridge, Mass./London, 1942).
[5] The port or left side of the ship.
[6] Schiff, *Füssli* (see n. 2), 893.
[7] *Paradise Lost* (see n. 3), II, 900, 928.

Füssli's choice of *Odysseus Between Scylla and Charybdis* as a subject for the Milton Gallery is entirely in keeping with Milton's own consistent use in *Paradise Lost* of verbal, thematic and structural elements from Homer, which add sublimity, allusiveness, and moral weight to his epic.[1] Completed in 1796,[2] the painting illustrates Milton's simile, which draws an analogy between the unimaginable perils of Satan's voyage across the illimitable void of Chaos, and the recognizably human, though larger-than-life heroic figure of Odysseus caught between two ineluctably destructive forces, whereby the reference to the Argonauts intensifies our awareness both of Ulysses' plight and of how much "harder beset" is Satan,

> And more endanger'd, than when *Argo* pass'd
> Through *Bosporus* betwixt the justling Rocks:
> Or when *Ulysses* on the Larboard shunn'd
> *Charybdis,* and by th' other whirlpool steer'd.[3]

One of Füssli's hallmarks as a literary illustrator (or, as one should say, history painter) is that combination of textual precision and dramatic force which gives so much power to this rendering. For his pictorial details Füssli has here gone back to the original source of Milton's allusion, namely Book XII of Homer's *Odyssey*.[4] Although some telescoping and conflation of the action is inevitable, Füssli's painting is a remarkably literal translation of Homer's account of Odysseus' fearful passage through the narrow strait between the two rocky cliffs where, in order to avoid the complete destruction of his ship in Charybdis, the whirlpool (bottom foreground), he must face the loss of part of his crew.

In the center of the picture, Odysseus, captured in a few elemental brushstrokes in bright flesh tints, stands on the prow of a ship, also reduced to fundamentals, his shield raised defiantly over his head in a quintessentially Füssliesque heroic pose, derived from the figures of the *Borghese Gladiator* and the *Laocoon,* while the vessel drives on through a wall of ocean spray and mist, hugging the cliff on the "Larboard,"[5] where Scylla, the six-headed sea monster has her lair. All that can be distinguished of the crew within the "hollow ship" is the suggestion of the helmsman's muscular arm and the bent head of another oarsman as they ply the two long oars visible in the water on the starboard side. Even as Odysseus strains his eyes to locate the monster in the mist, Scylla has already (as foretold by Circe) snatched six of his comrades, "the best in strength and might." At the top of the canvas, below the dark pall of clouds that always surrounds the peak of the tower-shaped column of smooth rock, two of the heads on their long necks are seen devouring with terrible bloody teeth their still-struggling victims. Indicative of the fate of another crew member, who is apparently being swallowed up, an arm and hand can be seen disappearing into the dark maw in the face of the cliff, marking the inaccessible cave where Scylla's body and her twelve dangling feet lie concealed. Above this opening lours a foreboding and mask-like Medusa head.

At the bottom right, the "utter turmoil" of the water roars 'round the rock as Charybdis "sucks down the salt water of the sea," uncovering the black sand of the sea bed. Indeed, Gert Schiff suggests that Füssli's masterful handling of these swirling waters and massed spray anticipates J.M.W. Turner's treatment of his stormy seascapes.

It is interesting to note how simply yet palpably Füssli establishes this scene as a pendant to the preceding painting in the Milton Gallery, *Satan Bursting from Chaos*.[6] The dark cloud which veils the seemingly summitless cliff, and the impenetrable black and brown smoke with which it merges, coiling down the left side of *Odysseus Between Scylla and Charybdis* and concealing the entrance to the strait, are a continuation of the dark masses Füssli uses in *Satan Bursting from Chaos* to depict the mass of uncreated matter, shaped in the womb of Chaos from "embryon atoms" and "surging smoke,"[7] through which Satan has so painfully fought his way.

DHW

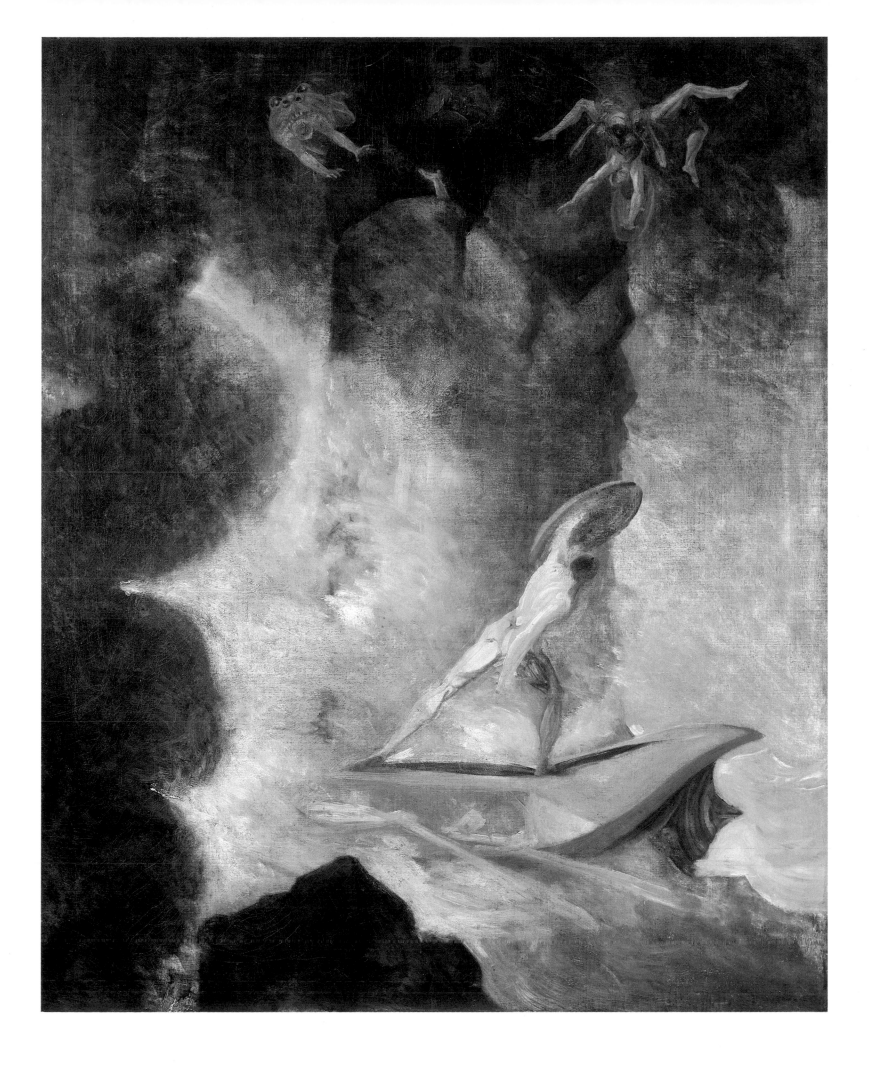

Louis Ducros

**Temple of Mercury, Baia,
1794 – 1799**

cat. no. 13
Watercolor and gouache on D&C
Blauw paper, mounted on canvas
26 ½ × 41 ⅛ inches
(67.5 × 104 cm)
Musée cantonal des beaux-arts,
Lausanne, inv. no. D-834

Bibliography:
*Images of the Grand Tour, Louis Ducros
1748 – 1810*, exh. cat. (The Iveagh Bequest,
Kenwood House, London/The Whitworth
Art Gallery, University of Manchester)
(Geneva, 1985), 66 – 68, no. 39.

[1] Abbé de Saint-Non, *Voyage pittoresque ou
description des royaumes de Naples et de Si-
cile*, vol. 2 (Paris, 1782), 215.
[2] Pierre Chessex and Francis Haskell, *Roma
romantica: Vedute di Roma e dei suoi din-
torni di A.L.R. Ducros (1748 – 1810)*, (Milan,
1985), 87 – 132.
[3] Giovanni Battista Natali (1698 – 1765): see
Giovanni Volpato's engraving after Natali in
*Avanzi delle Antichità esistenti a Pozzuoli,
Cuma e Baja*, reproduced in *Images of the
Grand Tour, Louis Ducros 1748 – 1810*, exh.
cat. (The Iveagh Bequest, Kenwood House,
London/The Whitworth Art Gallery, Uni-
versity of Manchester) (Geneva, 1985), 67.
Charles-Louis Clérisseau (1721 – 1820), *Le
Temple de Mercure*, reproduced in *Piranèse
et les Français 1740 – 1790*, exh. cat. (Rome,
1976), 40 fig. 39.
[4] Richard Colt Hoare, *The History of Modern
Wiltshire* (London, 1822), vol. 1, 83, quoted
in L. Stainton, "Ducros and the British," in
Images of the Grand Tour (see. n. 3), 28.

The ancient Roman city of Baïa on the gulf of Pozzuoli, near Naples, was one of the most lavish seaside resorts in Italy, as well as the most important thermal center of the Roman empire. In this watercolor, Ducros represents the circular hall measuring over 23 yards in diameter, probably used for thermal purposes. It belongs to a complex which was, at the end of the eighteenth century, still incorrectly identified as the *Temple of Mercury*. Frequently visited by travelers on the *Grand Tour*, it was also known as the *Temple of Echo*, because of the unusual acoustical effects produced by the vault covering the immense circular space. Ducros' watercolor makes reference to this tradition by showing a tourist (seen from the back), in the group to the left, who looks up at the vault while forming a megaphone with his hands. Located in a volcanic region, the site was subject to frequent earthquakes and flooding, which made access difficult for visitors. Ducros refers to this with the figures at the right, as is described by Dominique Vivant-Denon: "The water remaining in the roads would render access completely impossible, if it were not for the *lazzaroni*, or peasant farmers, who lend their shoulders and carry you through the water which reaches up to their belts."[1]

Ducros lived in Rome after 1776, as did John Robert Cozens (1752-c.1799), Pierre Henry de Valenciennes (1750 – 1819) and Thomas Jones (1743 – 1803). He had gained a solid reputation as a landscape painter among amateurs of this milieu, who had a great appreciation for his views of Rome, published with Giovanni Volpato around 1780,[2] as well as his grand landscapes executed in watercolor. These reflect the harmonious balance of Ducros' memories of Acadia, his taste for the picturesque, his archaeological enthusiasm, and his pre-romantic approach inspired by Piranesi. After leaving Rome in 1793, Ducros stayed for a short time in the Abbruzzi, finally settling in Naples where he worked between 1794 and 1800. The subjects he chose to paint were the picturesque sites of the Campagna, the recently discovered ruins of antique buildings, and Vesuvius, which was particularly sought out by tourists following the publications of Sir William Hamilton, who would become one of Ducros' most important patrons.

By depicting the building from the inside, Ducros emphasizes the monumentality of the vault to a degree which none of the previous representations, for example that of Natali and that of Clérisseau,[3] had attained. To further emphasize the heroic scale of the space, the painter reduces the size of the figures peopling the scene to that of toys. What surprised his contemporaries even further was Ducros' use of watercolor, a technique which up to this time was reserved for sketches or rough drafts. After 1783 – 1784, he had steadily increased the size of his paintings to compete with landscapes painted in oil on canvas. Sir Richard Colt Hoare, the eminent patron during Ducros' Roman years who later became one of the first supporters of the young Turner, commented that the "[...] advancement from *drawing* to *painting* in water-colours did not take place till after the introduction into England of the drawings of Louis du Cros, a Swiss artist, who settled at Rome; his work proved the force as well as the consequence, that could be given to the unsubstantial body of water-colours, and to him I attribute the first knowledge and power of water-colours."[4]

The Swiss watercolorists, such as the famous *petit-maîtres* Johann Ludwig Aberli (1723 – 1786), Balthasar Anton Dunker (1746 – 1807), and Gabriel Lory (1763 – 1840) who remained in their native country, continued undisturbed to paint their idealized and transparent views of pastoral Switzerland. Ducros, on the other hand, had an inquisitive personality beyond that of his compatriots, and moved in the stimulating cosmopolitan circles connected with the *Grand Tour*. His work demonstrates a dramatic development which gains momentum during the years immediately following the French Revolution. This is characterized by depictions of classical ruins being overgrown by vegetation, by a predilection for enclosed spaces, and by the ever-increasing complexity of his compositions. The interior view of the *Temple of Mercury* is the expression of a new trend in sensibility occurring at the end of the eighteenth century. The imagery is still closely related to the Piranesian *mise en scène*, but now the more direct experience of *plein-air* observation is clearly seen in the agile handling of the watercolor medium. *PC*

Louis Ducros (Moudon 1748 – 1810 Lausanne)
Biography, see p. 182

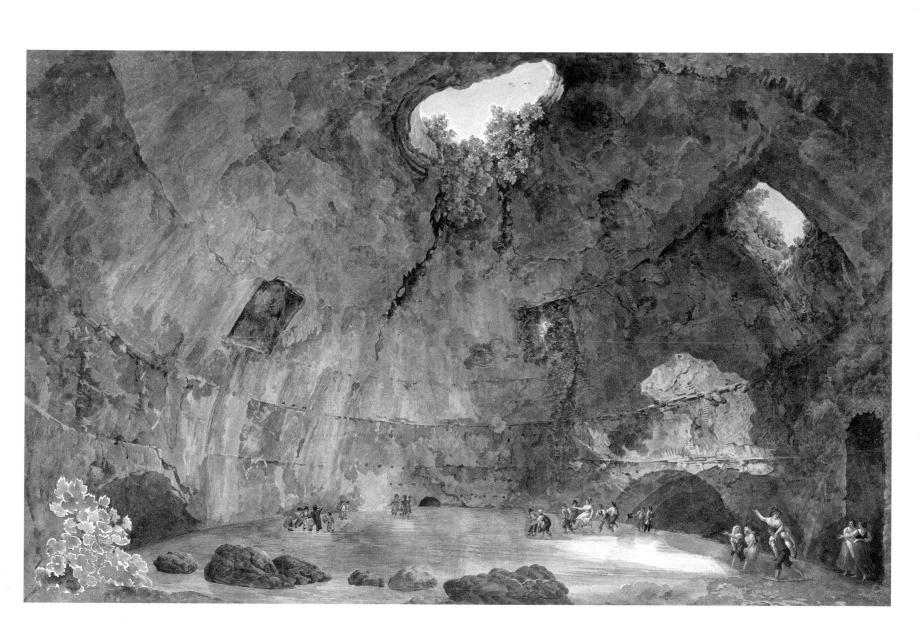

Louis Ducros

View of Grand Harbor, Valletta, 1800 – 1801

cat. no. 14
Pen and black ink, watercolor, and gouache on paper, mounted on canvas
30 ⅞ × 50 ¼ inches
(78.5 × 127.5 cm)
Musée cantonal des beaux-arts, Lausanne, inv. no. D-802

Bibliography:
Images of the Grand Tour, Louis Ducros 1748 – 1810, exh. cat. (The Iveagh Bequest, Kenwood House, London / The Whitworth Art Gallery, University of Manchester) (Geneva, 1985), 69 – 70, no. 43.

[1] A.L.R. Ducros to Sir Richard Colt Hoare, his British patron, 22 December, 1800, in *Images of the Grand Tour, Louis Ducros 1748 – 1810,* exh. cat. (The Iveagh Bequest, Kenwood House, London / The Whitworth Art Gallery, University of Manchester) (Geneva, 1985), 99 – 100.

[2] André Corboz, "Le ciel de l'Arcadie se couvre," in *A.L.R. Ducros (1748 – 1810), Paysages d'Italie à l'époque de Goethe,* exh. cat. (Musée cantonal des beaux-arts, Lausanne) (Lausanne, 1986), 42.

[3] Over 300 watercolors from this tour through the south of Italy and Malta are preserved at the Rijksprentenkabinet, Amsterdam. See J.W. Niemeijer, *A Tour in Words and Watercolour: the Swiss Artist Louis Ducros Accompanies Dutch Tourists in Italy in 1778* (Amsterdam, 1986).

[4] Watercolors by Ducros hang next to landscape paintings in oil in English castles like Stourhead, Dunham Massey, and Coughton Court.

[5] Ducros preferred to exhibit his work in his studio in Rome, and later in Naples. Nevertheless, he also sent some works to Geneva for the first Salons. See Pierre Chessex, "Documents sur la première exposition d'art en Suisse, Genève 1789," in *Zeitschrift für Schweizerische Archäologie und Kunstgeschichte,* (Zürich) vol. 43, no. 4 (1986): 362 – 367.

"I find myself transferred to Malta at the moment in order to produce some views for General Graham who conquered this place [. . .]. I am ravished by the beauty of the ports, by the elegance of the lines, by the nobility of the architecture — in one word, I encounter Claude Lorrain and Vernet at each step."[1]

The painter arrived at La Valletta shortly after the British army had expelled the French troops of Bonaparte from the island. He remained in Malta for a few months, between November of 1800 and May of 1801, completing numerous landscape renderings of La Valletta and the terrain immediately surrounding it.

This view of the Grand Port is drawn from a vantage point above the Upper Barracca, depicting La Valletta in great detail: the houses of the city to the left, the bastion of Santa Barbara and its watchtower in the center of the composition, the arcades of the Lower Barracca in the background, Fort Ricasoli closing off the port at the rear, and Fort Saint-Ange at the far right. Ducros rediscovers "the fascinating qualities of geometry: in his marvellous views of Malta, he enacts a sophisticated play of vertical planes, slopes, quais and terrasses, holding together their layered and diverging directions in a coherent composition strongly articulated by the fluid light [. . .]."[2] His landscape is skillfully composed and, while it demonstrates great precision in the rendering of details, it also reveals Ducros' manipulations of the features of the site. The most obvious is the relocation of Fort Saint-Ange, which Ducros obviously employed to bring it into the frame of the picture.

Ducros had been in Malta in 1778, as draughtsman for an expedition of Dutch tourists.[3] A comparison between a watercolor from that period (Fig. 14a) and the present work is helpful in charting the development of Ducros during this period of twenty-two years: from the transparent view of his youth, a mere souvenir of the journey, to an accomplished painting, powerful and laden with cultural references (Vernet, Lorrain), in accordance with his patrons' taste for the picturesque and the sublime.

Of course, these two works were intended for very different purposes, and this plays an important role in distinguishing them from one another. The watercolor of 1778 was destined for private use, relegated to a picture album, whereas the large watercolor from the mature period is far more ambitious in its intentions. Painted on paper, with several sheets neatly joined together to produce one large surface, the work was later mounted on canvas, attached to a stretcher, covered with glass, and framed. Thus, the watercolors of Ducros could stand comparison to any oil painting, a fact which proved to be a selling point when collections[4] and exhibitions[5] opened up to the idea of mixed-media techniques.

PC

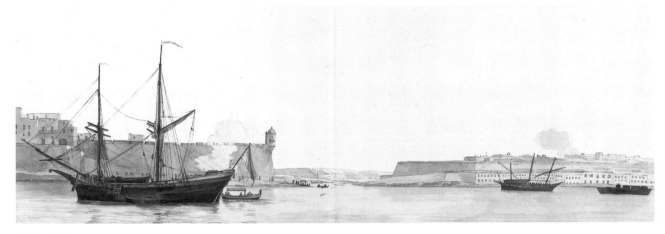

14a Louis Ducros
Vue prise sous le château St-Ange dans le port des Galères à Malthe, 1778
Watercolor, 10⅛ × 28¾ inches (25.6 × 73.1 cm)
Rijksprentenkabinet, Amsterdam

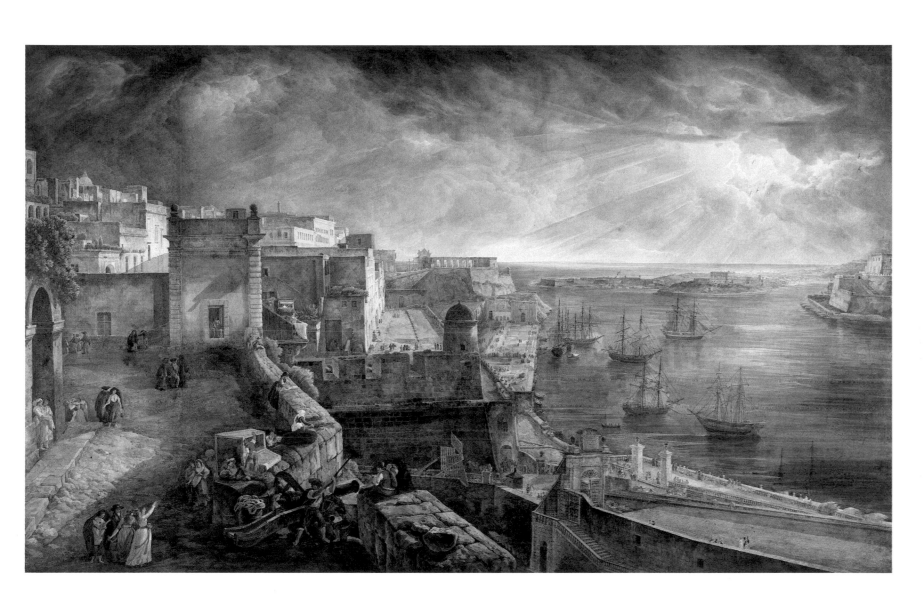

Louis Ducros

Storm at Night, Cefalù, 1800 – 1805

cat. no. 15
Watercolor, gouache, and oil on papers, mounted on canvas
37 ⅞ × 29 ⅛ inches (96 × 74 cm)
Musée cantonal des beaux-arts, Lausanne, inv. no. D-812

Bibliography:
Images of the Grand Tour, Louis Ducros 1748 – 1810, exh. cat. (The Iveagh Bequest, Kenwood House, London/The Whitworth Art Gallery, University of Manchester) (Geneva, 1985), 68 – 69, no. 41.

[1] André Corboz, "Le ciel de l'Arcadie se couvre," in *A.L.R. Ducros (1748 – 1810), Paysages d'Italie à l'époque de Goethe,* exh. cat. (Musée cantonal des beaux-arts, Lausanne) (Lausanne, 1986), 49.
[2] Pierre Chessex, "A Swiss Painter in Rome: A.L.R. Ducros," in *Apollo* (London, June 1984), vol. CXIX, no. 268, 430 – 437; Lindsay Stainton, "Ducros and the British," in *Images of the Grand Tour, Louis Ducros 1748 – 1810,* exh. cat. (The Iveagh Bequest, Kenwood House, London) (Geneva, 1985), 26 – 30.
[3] Edward Young, *The Complaint, or Night Thoughts on Life, Death, and Immortality,* published 1742 – 1745.
[4] Horace Walpole, *The Castle of Otranto, a Gothik Story,* published in 1764.
[5] Federico Zeri, "La percezione visiva dell'Italia e degli italiani nella storia della pittura," in *Storia d'Italia,* VI (Torino, 1976), 98 – 99.
[6] Giuliano Briganti, *I pittori dell'imaginario: Arte e rivoluzione psicologica* (Milano, 1977), fig. 35 on 76.

Effects already present to varying degrees in works Ducros produced after 1785 are brought to a culminating point in this watercolor dating from his later years. These effects reflect the aesthetics of the "sublime": violent contrasts, predilection for the unusual, an "attraction" to the horror of the raging elements. Topographical representation is not the primary goal of this composition. Instead, Ducros focuses on a coincidence of several catastrophes: thunderstorm and explosion, storm and ship-wreck chase each other from the top to the bottom of the painting.

Ducros began to demonstrate an interest in the representation of destructive elements in nature, like storms, volcanic eruptions, etc., during his neapolitan period. These were seen as metaphors for the primitive forces of nature, or even the political upheavals engulfing Europe toward the end of the Ancien-Régime (Fig. 15a). Ducros thus contributed to the development of an iconography of natural catastrophe which began around 1800 and included images of floods, avalanches, earthquakes, etc. However, *Storm at Night, Cefalù* could have a more literary source. This is suggested by the ambiguous appearance of medieval turrets crowning the steep cliffs which rise above the clouds and seem to hover in another space of exalted atmosphere. André Corboz has suggested a connection between the painting and the *Ossianic Poems* of James Macpherson (1736 – 1796).[1] This interpretation seems quite plausible in view of the fact that Anglo-Saxon circles in Rome,[2] in which Ducros circulated freely, were influenced by a gothic literary milieu in addition to their infatuation with antiquity. The *Night Thoughts* by Edward Young (1683 – 1765),[3] the *Meditations among the Tombs* by James Hervey (1714 – 1758), or the *Castle of Otranto* by Horace Walpole (1717 – 1797)[4] all preceded the *Ossianic Poems* in shaping the sensibilities of Ducros' friends and clients: William Hamilton, Richard Colt Hoare, and Lord Breadalbane, among others. Ducros was commissioned by Colt Hoare to paint not only views of Roman antiques, but also savage, desolate landscape scenes: his *Orage dans la vallée de la Néra,* which hangs today at Stourhead castle, depicts a lightning bolt which diagonally traverses the painting, striking a medieval tower lodged in the corner of an enclosed valley. *Storm at Night, Cefalù* also invokes this spirit, albeit more complex in its compositional elements. Since there is no documentary evidence for the painting — patronage, circumstances of the commission, date, preliminary studies — a conclusive historical interpretation does not seem safe. Nevertheless, the painting was widely discussed by art historians as an example of the new "meteorological sensitivity" in landscape painting of around 1800,[5] as well as of the "fantastic" imagery in the art of the late eighteenth century.[6] *PC*

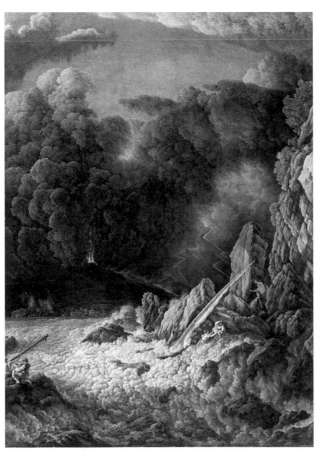

15a Louis Ducros
Eruption of Mount Vesuvius and Shipwreck, c. 1800
Watercolor, 40½ × 28⅝ inches (103 × 72.7 cm)
Musée cantonal des beaux-arts, Lausanne

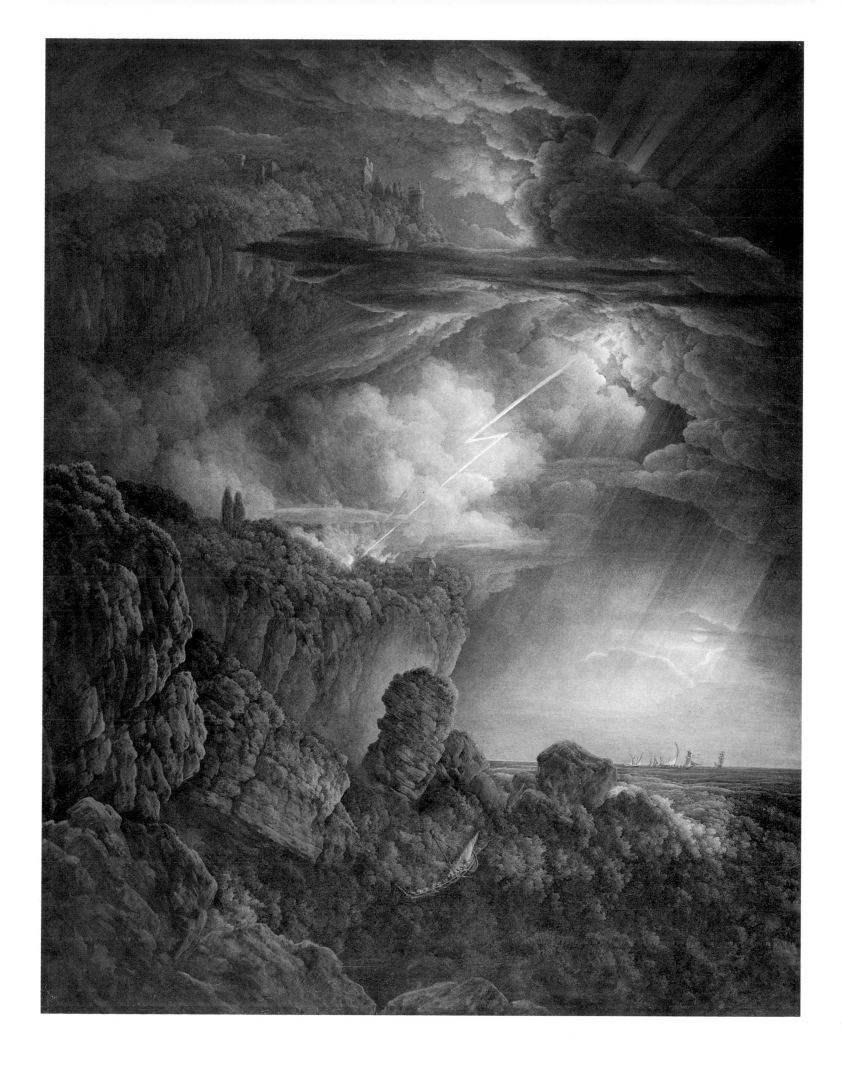

Caspar Wolf

Thunderstorm with Lightning at the Lower Grindelwald Glacier, c. 1774

cat. no. 16
Oil on canvas
20 ⅞ × 32 ¼ inches (53 × 82 cm)
Signed lower center: "Wolf"
Aargauer Kunsthaus Aarau,
inv. no. 1947/242

Bibliography:
Willi Raeber, *Caspar Wolf 1735–1783. Sein Leben und sein Werk* (Aarau, 1979), 216–217 (no. 199, ill.), 361 (no. 31); Yvonne Boerlin-Brodbeck, *Caspar Wolf (1735–1783). Landschaft im Vorfeld der Romantik,* exh. cat. (Kunstmuseum Basel) (Basel, 1980), 50, 61, no. 103, color pl. VI; Heinz Jürg Zumbühl, *Die Schwankungen der Grindelwaldgletscher in den historischen Bild- und Schriftquellen des 12. bis 19. Jahrhunderts, ein Beitrag zur Gletschergeschichte und Erforschung des Alpenraumes* (Denkschriften der Schweizerischen Naturforschenden Gesellschaft, 92), (Basel, 1980), 28, 29, 96, 97 (n. 48), 138 (no. K.24), 211 (ill.).

The lower glacier of Grindelwald is one of the best documented glaciers of the Alps due to its relative accessibility. Landscape painters even before Caspar Wolf had produced accurate views for alpine researchers, or for art collectors, some of which are still preserved.[1] Wolf, a pioneer of topographical mountainscape painting, was in Bern between 1774 and 1777 working on a series of Swiss views commissioned by the publisher Abraham Wagner (1734–1782). Wagner and Wolf embarked every summer, and perhaps even in winter of the year 1774–75, on dangerous excursions into the glacial regions of the Bernese Oberland, the Valais, and central Switzerland, as well as into the western regions and the Jura.[2] Little is known about Wagner, the expert who determined which routes would be followed and what subjects — even exact vantage points — his companion and draughtsman would record *ad naturam.*

They traveled through Grindelwald in 1774 and 1776, where Wolf recorded the front of the lower glacier in an impressive close-up view.[3] His color sketch is not preserved, but a preliminary outline for the composition shows the steep glacial front as it looked in 1774.[4] The finished painting[5] depicts this front, but with the enlarged glacier gate as it appeared in 1776, and according to Wagner's description of 1779: "In 1774 there was only a wall of ice with sharp edges, however, in 1776 there was a beautiful opening in its front, vaulted and hollowed out by the [river] Lütschinen."[6] At this time the front may already have been diminished as is shown in an engraving by Michel Picquenot afer a drawing by Alexandre-Charles Besson, dated 9 September 1777.[7] The painting in Winterthur thus combines several aspects of the glacier during 1774 and 1776. Wolf probably corrected it on location, as it was his custom to do.[8] A copy dated 1777, with a more restrained composition,

is almost identical, despite the fact that it depicts the glacier gate as it had looked in 1774.[9]

The *Thunderstorm with Lightning at the Lower Grindelwald Glacier,* depicting the peak of the *Mettenberg* at the upper left with unnaturally jagged edges and an almost insignificant glacier gate, comes closest to Wolf's preliminary sketch. It may have been painted in 1774, like the picture in Winterthur, but without any later reworking. Wagner obviously did not count the image among the "most important and very best pieces"[10] of his collection, and did not designate it for reproduction. Nevertheless, it holds special interest as the only one of Wolf's three nocturnal views to have survived.[11] It recalls his *Storm in an Ocean Harbor* of 1772, a primordial landscape lit by a flash of lightning very much in the manner of Joseph Vernet (1714–1789) and Philip James de Loutherbourg (1740–1812).[12] In the nocturnal *Thunderstorm,* the bolt of lightning — probably the first representation of this phenomenon in a painted topographical view — is not depicted naturalistically but rather as a broken, jagged line. The deserted landscape is thus a counterpart to Titian's *Christ on the Cross* in the Escorial of c. 1555, where a bolt of lightning has been reproduced accurately, probably for the first time.[13] In both cases, lightning is a manifestation of divine power. By reducing it to an abstract, formulaic sign, Wolf's depiction of a thunderstorm becomes a metaphor for the four elementary forces: earth, water, air, and fire. Only in the 1820s is lightning treated in a naturalistic manner, in the visionary landscapes of J.M.W. Turner.[14] *BW*

Caspar Wolf (Muri/AG 1735–1783 Heidelberg)
Biography, see p. 188

[1] Zumbühl, 1980 (see Bibliography), *passim;* Andrew Wilton, *William Pars: Journey through the Alps/Reise durch die Alpen/Voyage dans les Alpes* (Dübendorf, 1979), 32, 65 (no. 18), 41 (color ill.); Bruno Weber, *Graubünden in alten Ansichten, Landschaftsporträts reisender Künstler vom 16. bis zum frühen 19. Jahrhundert* (Schriften des Rhätischen Museums, 29) (Chur, 1984), ns. 17 and 121.

[2] For a hypothetical compilation of number and sequence of the excursions see Zumbühl, 1980, 94 (n. 41) and 98–99 (n. 58).

[3] For the exact location of the artist see Zumbühl, 1980, 137 (K.22.1).

[4] Raeber, 1979 (see Bibliography), 216 (no. 197, ill.); Zumbühl, 1980, 28–29, 137 (K.22.1), 210 (ill.).

[5] Oil on canvas, 53,5 × 81 cm, Oskar Reinhart Foundation, Winterthur; Raeber, 1979, 216 (no. 196), 217 (ill.), 361 (no. 30); Zumbühl, 1980, 28–29, 137 (K.22.3), 210 (ill.).

[6] "En 1774, on n'y voyoit qu'un parois de glace coupé à pic; mais en 1776 parut derechef une belle ouverture voutée, & creusée par les eaux de la Lutschinen." Quoted from Raeber, 1979, 361 (no. 30). It is clear that the author of the text of this *Description* dating from 1779 (in Raeber, 358–367), is not Wyttenbach (as Raeber, 78, Boerlin-Brodbeck, 1980 [see Bibliography], 94, and Zumbühl, 1980, n. 60, presume) but Wagner himself, according to the indications concerning nrs. 1, 55, 56, 60, 105, 109, 115, 122.

[7] Published in Beat Fidel Anton Zurlauben, *Tableaux de la Suisse* (Paris, 1780), vol. 1, no. 123 to p. XLVII; see Zumbühl, 1980, 30, 138–139 (K.27), 209 (ill.).

[8] Raeber, 1979, 64–65, n. 148.

[9] Oil on canvas, 54 × 82 cm, Kunstmuseum, Bern; Raeber, 1979, no. 280; Boerlin-Brodbeck, 1980, no. 138; Zumbühl, 1980, 28–29, 137 (no. K.22.2), 190 (color ill.).

[10] Raeber, 1979, 66, n. 155.

[11] Representations of the Kanderbrücke and the iron-foundry at Mühletal near Innertkirchen, according to Wagner's *Description* of 1779, in Raeber, 1979, 358 (no. 5), 361 (no. 38).

[12] Raeber, 1979, no. 108; Boerlin-Brodbeck, 1980, no. 46, ill. 15.

[13] Adolf Rieth, *Der Blitz in der bildenden Kunst* (Munich, 1953), 26, pl. 16; Harold Edwin Wethey, *The paintings of Titian, complete edition,* vol. 1 (London, 1969), 36, 85 (no. 29), pl. 113.

[14] The watercolours *The Bass Rock,* c. 1824, *Paestum in a Thunderstorm,* c. 1825, *Stonehenge,* c. 1827. See *William Turner und die Landschaft seiner Zeit,* exh. cat. (Hamburger Kunsthalle, 1976), no. 49, color pl. VII (*Paestum*); Andrew Wilton, *The life and work of J.M.W. Turner* (Fribourg, 1979), 1.069, color ill. on 159 (*Bass Rock*), no. 769 (*Paestum*), no. 811 (*Stonehenge*); Andrew Wilton, *Turner and the sublime* (London, 1980), no. 75 (*Paestum*), no. 79 (*Stonehenge* in mezzotinto by Robert Wallis, 1829).

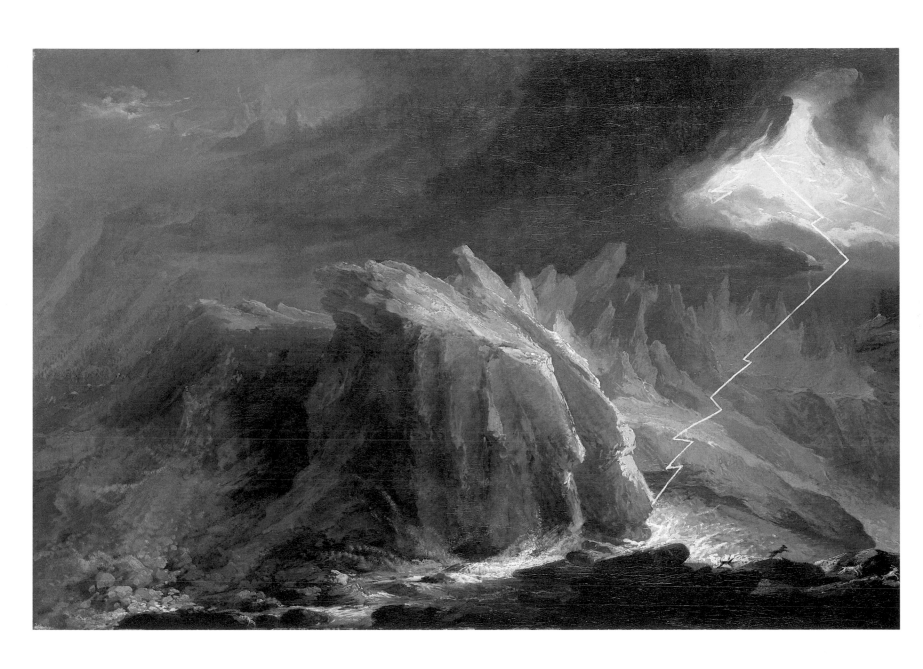

Caspar Wolf

Lower St. Beatus Cave with Ivy, 1776

cat. no. 17
Oil on canvas
21 × 29 ⅞ inches (53.5 × 76 cm)
Signed lower right: "C Wolf./1776"
Aargauer Kunsthaus Aarau,
inv. no. 1951/811

Bibliography:
Willi Raeber, *Caspar Wolf 1735 – 1783. Sein Leben und sein Werk* (Aarau, 1979), 258 (no. 273, ill.), 359 (no. 8), color ill. 16; Yvonne Boerlin-Brodbeck, *Caspar Wolf (1735 – 1783). Landschaft im Vorfeld der Romantik,* exh. cat. (Kunstmuseum Basel) (Basel, 1980), 99 – 100 (no. 248).

[1] Jakob Stammler, *Der hl. Beatus, seine Höhle und sein Grab* (Bern, 1904); *Beatushöhlenforschung* (Sundlauenen, 1979).
[2] 1776, Aargauer Kunsthaus Aarau, in Raeber, 1979 (see Bibliography), no. 271.
[3] 1776, Aargauer Kunsthaus Aarau, in Raeber, 1979, no. 277.
[4] n.d., Aargauer Kunsthaus Aarau, in Raeber, 1979, no. 276.
[5] 1776, Kunstmuseum Basel, in Raeber, 1979, no. 278.
[6] Lost. In Wagner's *Description* of 1779, no. D (Raeber, 1979, 359, no. 9).
[7] 1777, in the collection of the city of Lenzburg, in Raeber, 1979, no. 279.
[8] On the number of Wolf's paintings in Wagner's collection, see Raeber, 1979, 65, and the review by Bruno Weber in: *Kunstchronik* (Munich), 33 (1980):259 – 269.
[9] They are related to the painting mentioned in n. 4 (Raeber, 1979, no. 275) and to the present painting (Raeber, 1979, no. 272).
[10] The natural scientist Adolf Traugott von Gersdorff of Oberlausitz mentions after visiting Wyttenbach in Bern in July 1786: "The most interesting were the oil-sketches by Wolf, certainly far more than 100 pieces, from the most interesting parts of Switzerland, which are not only supposed to be accurate, but most certainly very accomplished." Quoted from Ernst-Heinz Lemper, *Adolf Traugott von Gersdorff (1744 – 1807), Naturforschung und soziale Reformen im Dienste der Humanität,* (Veröffentlichungen des Staatlichen Mathematisch-Physikalischen Salons, 6) (Berlin, DDR, 1977), 109.
[11] After the painting mentioned in n. 2.
[12] Raeber, 1979, no. 279 (see n. 7).
[13] n.d., Kunstmuseum Solothurn, in Raeber, 1979, 73 (ill.), 289 (no. 352).

Only a small part of the system of caves near Beatenberg, on the northern shore of Lake Thun, has ever been explored. Two openings in the chalk formation at the foot of the *Balmwand* below the village of Beatenberg serve as passageways: to the east is the entrance to the lower cave, the larger of the two and the source of the Beatenbach River; to the west is the entrance to the upper cave, which is dry. St. Beatus the dragon slayer is said to have lived there as a hermit, and the grotto is thought to be the site of his grave. It served as oratory for the worship of the saint from the thirteenth century until an order of the Bernese government in 1530 caused it to be closed. Four years later, the pilgrimage chapel on the site was destroyed.[1] The memory of Beatus lingered on, however, and was revived when travels through Switzerland were popularized by a new taste for the picturesque: visitors were attracted by the panoramic view from the caves, and by the abundant cascades of the Beatenbach.

Caspar Wolf visited the St. Beatus Caves in summer of 1776 with his patron Abraham Wagner, the natural scientist Jakob Samuel Wyttenbach, and the 14-year-old student painter Caspar Leontius Wyss. Obviously deeply moved by the *genius loci* of the site, Wolf made an unknown number of color sketches which served as the basis for at least seven paintings: an exterior view of the two caves, with himself sketching in front of the lower cave and Wyss drawing in front of the upper one;[2] a first pair of pendants with the view from a vantage point near the upper cave looking west-southwest,[3] and east-southeast;[4] a second pair with views from the inside of the upper cave looking through two openings to the southwest toward Leissigen and the *Niesen,*[5] and to the southeast toward Leissigen and Weissenau;[6] and a third pair with an exterior view of the entrance to the lower cave from the southwest — the present picture, and a view from the inside of the lower cave looking south-southeast across the Lake Thun.[7] Five of the paintings are dated 1776, the last, 1777.

The series comprising the seven paintings of the caves represents the largest group of works on a single subject in Wolf's oeuvre, representing five percent of about 140 paintings he executed for Wagner between 1774 and 1778.[8] In connection with these paintings, Wolf made *plein-air* color sketches on the site, with thin oil paint over initial pencil studies on cardboard. Of these, only two are preserved.[9] Wyttenbach fervently admired Wolf's work, and, at the time of the artist's death he owned a large collection of these color sketches.[10] Only a small part of the collection is known today. Between 1777 and 1779, four printed editions based on the studies were published by Wagner. These included a total of 31 views, less than a quarter of the number of paintings by Wolf in Wagner's private collection. Wagner's editions only include exterior views of the caves with the members of the traveling party,[11] which is surprising considering the epochal importance of Wolf's depictions of crevices and underground vaults. The series was not assembled randomly, but rather according to a set program; yet its exact purpose has not yet been conclusively established, and may in fact never be.

The mysterious view in the present picture, leading into the netherworldish darkness of the lower cave, is the most daring of Wolf's interpretations of this subject. The painter sits near the deeply eroded rocks bearing their offering of water, and across from an old climbing ivy bush: the ivy, symbol of eternal life in antiquity, is posed at the entrance to the underworld, where no glimmer of sunlight reaches. With this painting, Wolf consciously intended to depict the inverse realities of interior and exterior. This proposition is strengthened by the pendant, which depicts a view from the inside looking out at the glistening surface of the lake.[12] These two paintings are related by the introspective view they take. In Wolf's *œuvre,* they are the only examples of landscape without sky, and looking at them the viewer finds himself plunging from an objective view into the sphere of introspection. Wolf's last image of himself, the theatrically lit *Interior of the Bärenhöhle near Welschenrohr* of 1778, depicts the painter full-figure, standing on a rock formation in the center of the cave. The painting fuses insight and outlook in a single symbolic image.[13] This revealing self-portrait of the painter sheds a ray of light back onto the earlier image of the tiny figure sketching at the mouth of the lower St. Beatus Cave: a portrait of the artist poised at the threshold of the inner world. *BW*

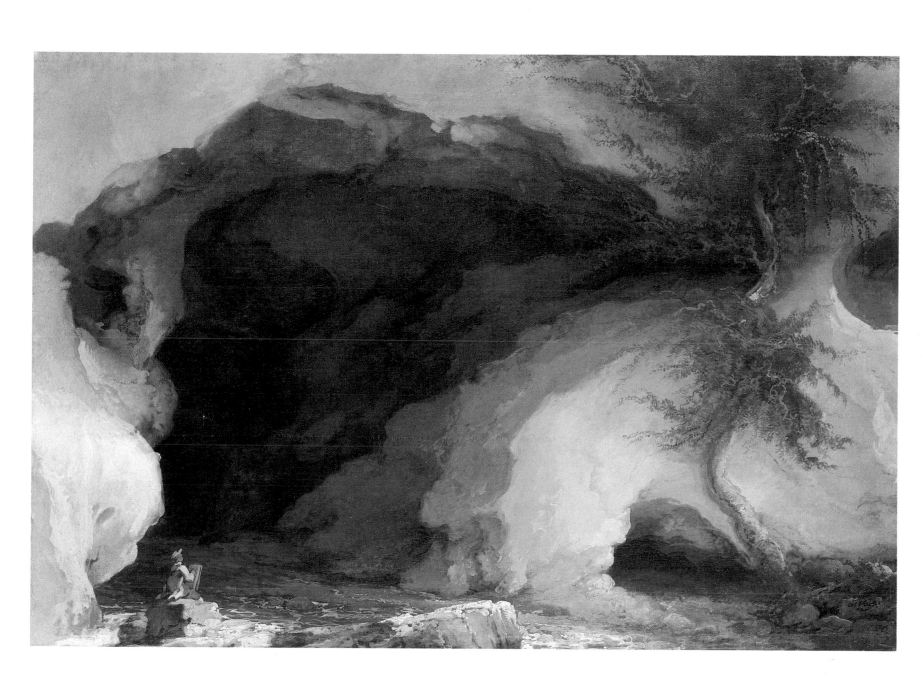

Johann Heinrich Wüest

The Rhone Glacier, 1775–1780

cat. no. 18
Oil on canvas
49 ⅝ × 39 ⅜ inches
(126 × 100 cm)
Kunsthaus Zürich, inv. no. 286

Bibliography:
Frieda Maja Brandenberger, *Ludwig Hess 1760–1800. Zur zürcherischen Landschaftsmalerei des 18. Jahrhunderts* (Zürich,1941), 33; Erwin Gradmann/Anna Maria Cetto, *Schweizer Malerei und Zeichnung im 17. und 18. Jahrhundert* (Basel, 1944), 31, 42–43, color pl. 5; Paul Wescher, *Die Romantik in der Schweizer Malerei* (Frauenfeld, 1947), 71–72, ill. 39; Yvonne Boerlin-Brodbeck, *Caspar Wolf (1735–1783). Landschaft im Vorfeld der Romantik,* exh. cat. (Basel, 1980), 88–89, no. 217 (Bibliography); Bruno Weber (ed.), *Die Alpen in der Malerei* (Rosenheim, 1981), 126, 331, color ill. 96; Ruth Vuilleumier, *Zürcher Festräume des Rokoko. Gemalte Leinwandbespannungen in Landschaftszimmern* (Zürich, 1987), 38, 46, 92, 110 (no. 9), color ill. following 66.

In the nineteenth century, the river of ice on the north side of the Furka pass was considered one of the most impressive glaciers in Switzerland. The spectacular tongue of the glacier and its convex, deeply creviced frontal shell were the subject of scientific studies by early alpine researchers such as Johann Jacob Scheuchzer, Abraham Wagner, Horace Bénédict de Saussure, John Strange, and Alexandre-Charles Besson. Having receded continuously since the last growth period in 1856, today the Rhone glacier ends short of the cliffs towering over the valley of Gletsch.

The vantage point Wüest chose for his frontal portrayal seems to have been influenced by earlier representations,[1] such as the illustration in Gottlieb Sigmund Gruner's *Die Eisgebirge des Schweizerlandes* of 1760, which fall somewhere between view and cartography. The reproduction in Gruner's book was based on a drawing by Scheuchzer published in his *Beschreibung der Natur-Geschichten des Schweizerlandes* of 1707. On 31 July 1770, William Pars made what was perhaps the first precise survey of the frontal shell and the glacier gate. He worked at close range, just north of the huts of the village of Gletsch. Pars' traveling companion de Saussure was probably instrumental in choosing this vantage point.[2]

Although they never actually met, the two most important contemporary topographers of the alpine landscape completed portraits of the Rhone Glacier at the same time, August 1777, and from vantage points near one another, just south of Gletsch and southwest of the spot Wüest chose for the present picture. Caspar Wolf painted the spectacular phenomenon for Abraham Wagner,[3] and Besson was commissioned by Jean-Benjamin de Laborde to produce a view for Zurlauben's *Tableaux de la Suisse*.[4]

Wüest's *Rhone Glacier* was also painted for a commission. The natural scientist and archaeologist Lord John Strange (1732–1799) traveled through Switzerland during summer of 1772, spending September in Zürich, where he met Salomon Gessner who probably introduced him to Wüest.[5] Wüest traveled at Strange's expense to the glacier in November in order to sketch this and other landscapes.[6] When Lord Strange died, his vast art collection was sold, and the paintings Wüest produced from these sketches disappeared.

The 1772 view of the glacier is preserved in a copy, a small horizontal painting at Winterthur which clearly depicts light shed from the left, or northwest, onto the front shell and two semicircular glacier gates.[7] This particular painting, or perhaps a very similar one, was reproduced as the frontispiece to the third part of Johann Gottfried Ebel's *Anleitung, auf die nützlichste und genussvollste Weise die Schweitz zu bereisen* of 1805.[8]

The painting in Zurich is not a copy, but rather another interpretation of the same subject, intended for a different purpose. Its vertical format and its dimensions are unusual for a glacierscape,[9] pointing to the fact that the painting was originally part of a decorative scheme for an interior. Wüest probably painted the *Rhone Glacier* during the 1770s in connection with seventeen other paintings of forest and river views, intended as parts of an arcadian series commissioned for the *Wollenhof* in Zürich. The decoration of the hall was undertaken at the expense of the silk manufacturer Salomon Escher (1743–1806), who was secretary and later master of his guild. Along with four other paintings of the series, the *Rhone Glacier* became part of the collection of the Zürich *Künstlergesellschaft,* the local society of artists, in 1877. The other paintings went to private collections.[10]

This radiant mountain landscape must have been resplendent in the somber setting at the *Wollenhof*. It was the only painting in the series depicting a topographically accurate view, a fact which Wüest underscored by introducing a draughtsman among the tiny figures in the foreground.[11] The artist succeeds in evoking the glistening cascade of frozen pyramids and needles which concentrate the reflected light. A blue summer sky with storm-threatening cloud formations covers more than half of the picture above the ice. The contours of the nebulous cliffs and valleys flanking the glacier are illuminated with light which falls here and there, lending a dreamlike character to the picture. Though Wüest achieved a successful topographical view in his *Rhone Glacier* the coloration and formal composition of this painting must have blended perfectly with the idealized landscapes which complete the series and the interior setting at the *Wollenhof.* *BW*

Johann Heinrich Wüest (Zürich 1741–1821 Zürich)
Biography, see p. 189

[1] The painting represents an impressive view of the glacier seen in the state of its largest extension between the two culminating points in 1602 and 1818. The topographical situation may be identified despite the vague rendering of the outline of the mountain peaks. The painter is situated southeast of Gletsch at an altitude of approximately 1900 meters, above the old Furka Pass route. About the Rhone Glacier, see Robert Christian Bachmann, *Gletscher der Alpen* (Bern, 1978), 224–226; *Die Schweiz und ihre Gletscher. Von der Eiszeit bis zur Gegenwart* (Zürich, 1979), 72–77.
[2] n.d., British Museum, London. Andrew Wilton, *William Pars: Journey through the Alps/Reise durch die Alpen/Voyage dans les Alpes* (Dübendorf, 1979), 29 (color ill.), 31, 65 (no. 14).
[3] 1778, Aargauer Kunsthaus Aarau. Boerlin-Brodbeck, 1980 (see Bibliography), 50, 74 (no. 174), color pl. XIII.
[4] Etching by Claude Niquet in vol. 1/1780, no. 181, XXXVI. Bruno Weber, *Städte und Berge der alten Schweiz* (Basel, 1973), ill. 87. In reference to the artist, see Weber, 1981 (see Bibliography), 308.
[5] Claire-Eliane Engel, "John Strange et la Suisse," in *Gesnerus,* 6 (1949): 34–44; Gavin Rylands de Beer, "John Strange, F.R.S., 1732–1799," in *Notes and Records of the Royal Society of London,* 9 (1952):
96–108; same author, "Un Anglais dans le Jura neuchâtelois," in *Musée neuchâtelois,* 4 (1967): 87–94.
[6] Wüest relates the story in his autobiography of 1813. See Boerlin-Brodbeck, 1980, 89.
[7] n.d., Kunstmuseum Winterthur, inv. no. 713 (acquired 1942 from anonymous collection). On reverse two paperstrips with inscription in handwriting (19th century): "Ursprung des Rhodan aus dem Gletscher der Furca. No. 271" (Source of the Rhodan in the glacier of the Furca) and "Nach der Natur gemahlt von h: Wüest" (painted according to nature by h: Wüest). Unpublished.
[8] "Instruction on how to most successfully and most pleasurably travel through Switzerland." Aquatint by Franz Hegi, inscribed "Mar. Füssli del."; no known member of the family bears this name.
[9] Comparable only with a view of the lower Grindelwald glacier painted by Emanuel Handmann (1748/49), private collection, Zürich. *Die Schweiz und ihre Gletscher,* 1979, 57 (color ill.).
[10] Hans Hoffmann/Paul Kläui, *Die Kunstdenkmäler des Kantons Zürich,* vol. 5 (Basel, 1949), 224–226.
[11] Bruno Weber, "Die Figur des Zeichners in der Landschaft," in *Zeitschrift für Schweizerische Archäologie und Kunstgeschichte* (Zürich) vol. 34 (1977): 44–82.

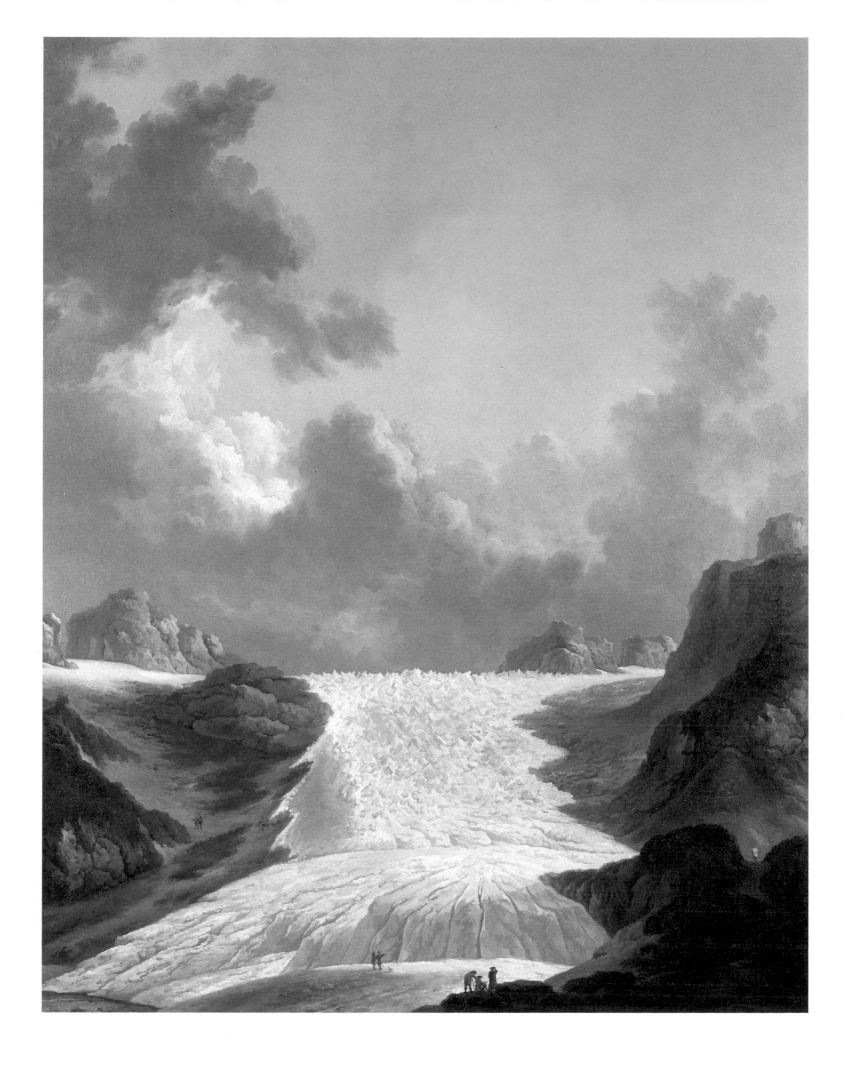

Wolfgang-Adam Töpffer

Rural Picnic, 1808

cat. no. 19
Oil on canvas
24 × 26 ½ inches (61 × 67.2 cm)
Signed lower left:
"A Töpffer à Genève/1808"
Private collection

[1] "[...] Peu de contrée, telle cette zone basse qui ceint les Alpes et la Savoie et sur la lisière de laquelle Genève est assise, offrent à l'artiste plus de richesses agrestes, plus de ressources flamandes, plus de poésie en même temps expressive et familière qui, sans rejeter à un certain degré d'élégance et de noblesse, s'associe mieux encore à la naïveté, à la grâce, à l'agrément, à ces traits de spirituelle observation par lesquels le paysage à figures touche au tableau de genre [...]. Töpffer, mon père, est parmi les paysagistes de notre école celui qui a été l'interprète le plus complet de ce paysage savoyard, dont nous-mêmes, à vrai dire, nous n'avons appris qu'à son aide et sur ses traces à connaître et à apprécier la riche et piquante variété [...]." Quoted from Rodolphe Töpffer, *Du paysage alpestre. Réflexions et menus propos d'un peintre genevois* (Geneva, 1843) [Pierre Cailler, ed., 1957], vol. II, 126.

[2] This concerns the following paintings: *The Fishermen with their Nets*, 1805; *The Hay*, 1805; *The Preaching in the Open Air*, c. 1810; *The Re-establishment of the Worship in France after the Revolution*, 1811; *The Village Wedding*, 1812; and *Coming out of the Church*, 1812.

Contrary to Pierre-Louis de la Rive, Töpffer abandoned the conception of the ideal landscape early, leaving behind him compositions enhanced by the imperative addition of ruins or antique monuments inspired by Italy. He chose rather the landscapes around Geneva and of the nearby Savoie to evoke the bucolic poetry of the village squares, the rural festivals, or pastoral reunions. He combined the groups which he studied and observed attentively, without ever disrupting the overall harmony. The vegetation, the sky, and the atmosphere are interpreted with a keen sense of truthfulness and originality, which lend the composition an undeniable charm, as his son Rodolphe would indicate later: "[...] There are indeed few landscapes like this lower region between the Alps and the Savoie, on whose border Geneva sits, which offer to the artist more rural riches, more Flemish resources, more poetry, at once expressive and familiar. Without rejecting a certain degree of elegance and nobility, they certainly blend even better with ingenuousness, with grace, delight, and with those specific traits of spiritual observation which the landscape with figures has in common with the genre painting [...]. Töpffer, my father, is certainly the most accomplished interpreter of this Savoyard landscape among the landscape painters of our school. We others, really, only learned, with his help and following his steps, to know and appreciate the rich and stimulating variety [...]."[1] The *Rural Picnic* belongs to a series of paintings which Töpffer com-

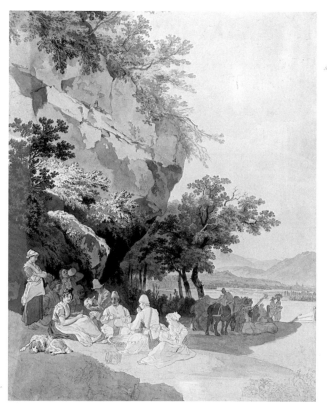

19a Wolfgang-Adam Töpffer
Preparatory drawing for *Rural Picnic*, 1808
Pencil, pen and ink, 20⅞ × 16⅝ inches (53 × 42.2 cm)
Musée d'art et d'histoire, Geneva

pleted between 1805 and 1815, upon his return to Paris. The most important works of the series are part of the collections of the Musée d'art et d'histoire of Geneva.[2]

The painting represents a rural picnic in a landscape. In the foreground to the left of the composition, a group of farmers and their wives sit on the grass in the shadow of a rock, having already taken out of the baskets the food for their meal. The woman to the right is about to taste a bowl of soup, whereas a man in the background pours down his drink from a bottle, while another one lifts his knife to cut the bread. A woman standing on the left with her arms crossed, seems to observe the scene attentively. In the middle ground, a peasant on a horse supervises a plough pulled by two big work-horses. This rural scene is set in a landscape which is very likely situated in the Haute-Savoie, in the region of the valley of Chamonix. It is a composed landscape, assembled from combined sketches, which the artist reworked in his studio. Such drawings were often accompanied by notes regarding colors and were used in the studio to construct the background of landscapes, which is indeed based on actual views. This is also true of the figures, as seen here, where the group was elaborated by the artist in a careful preliminary study of marvellous freshness and liberty of line (Fig. 19a).

The artist introduced a few changes in the completion of the actual painting: the dog to the left of the composition is omitted, the attitudes of some of the figures are changed slightly, the couple in the back, on the right near the working team, is left out altogether. The rock under which the picnic takes place, is also slightly modified: it is much more carefully elaborated and structured in the preliminary sketch than in the accomplished painting. Even if the completed work lacks some of the remarkable freedom of its preparatory drawing, it is still convincing in its exquisite composition of the group of figures set off to the left and in its harmonious diffusion of the light. *RL*

Wolfgang-Adam Töpffer (Geneva 1766 – 1847 Geneva)
Biography, see p. 187

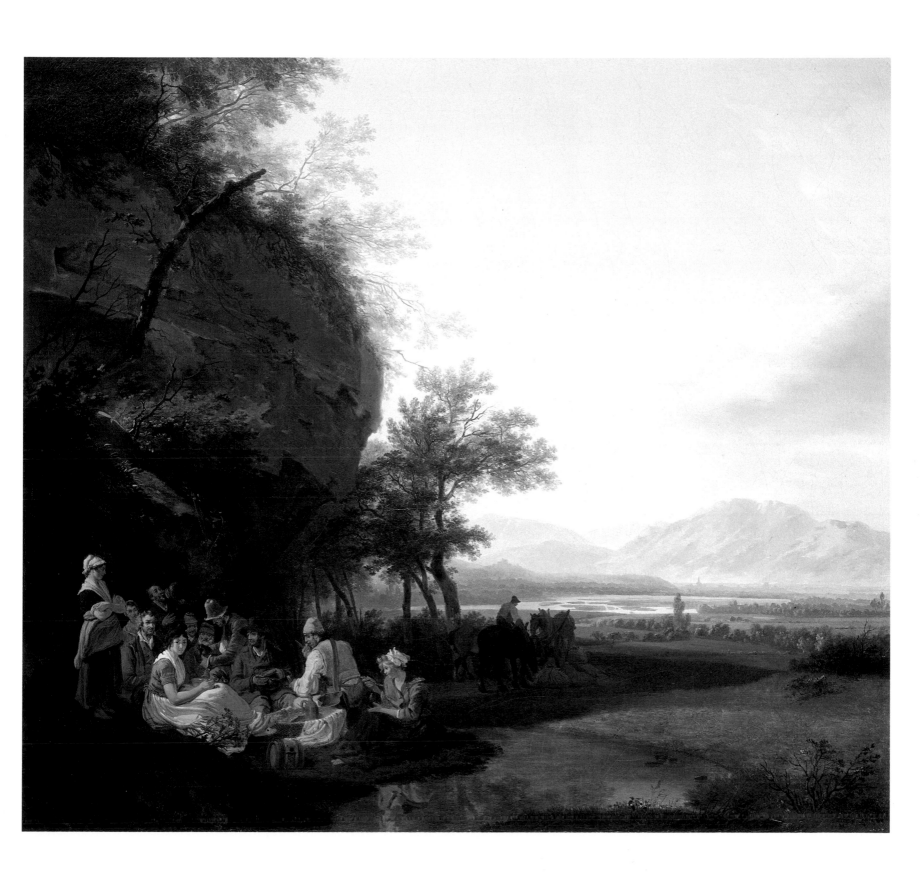

Wolfgang-Adam Töpffer

The Village Wedding, 1816

cat. no. 20
Oil on canvas
26 3/8 × 35 5/8 inches
(67 × 90.5 cm)
Signed lower right:
"ATöpffer. Genève/1816"
Private collection

Bibliography:
Daniel Baud-Bovy, *Peintres genevois 1766 – 1849,* deuxième série (Geneva, 1904), 135.

[1] "Les qualités éminentes de composition, de peinture et de dessin qui vont caractériser dès ce moment le talent de Töpffer se font jour ici de toutes parts. [...] Les figures accessoires de la droite, bien qu'au premier plan, sont traitées en groupe secondaire. La lumière sagement tempérée qui les éclaire laisse aux figures principales tout leur éclat, toute leur valeur, et, sans parti pris, sans recherche préconçue de l'effet qu'il veut atteindre, le peintre conserve l'unité ainsi que l'harmonie dans une composition qui, par sa diversité prodigieuse était la plus faite, semble-t-il pour lui faire perdre l'une et l'autre [...]." Quoted from Charles Dubois-Melly, *Töpffer le peintre* (Geneva, 1857), 8 – 9.
[2] Exhibition list no. 898: "Töpffer de Genève. Vue du village de Frangy près Genève on y a représenté une noce de village."
[3] The artist mentions this in a letter to his wife, dated 21 June 1816, where he writes to her about the success of his paintings in England: "[...] the one of my paintings which finds the most acclaim is the one with the view of the mountains of Bex [...]. *La Noce* also was quite a sensation [...]". ([...] celui de mes tableaux qui fait le plus fortune est la vue des montagnes de Bex [...]. La noce ensuite a fait sensation [...]".) Bibliothèque publique et universitaire, Geneva, Ms suppl. 1638, fol. 107.
[4] "[...] Il m'a été extrêmement utile de voir les peintres de Londres et tu verras quand je peindrai à Genève comme j'ai gagné en vigueur et en coloris [...] je prends de bon tout ce que je vois autant que je peux regrettant de n'avoir pas eu le bonheur de voir plus tôt l'Angleterre [...]." Bibliothèque publique et universitaire, Geneva, Ms suppl. 1638, fol. 107.

This painting belongs to the series of pictures, executed between 1812 and 1816, in which Töpffer described the daily life in the countryside and the events that belong to it. In *The Village Wedding,* the figures are of essential significance, while the landscape recedes into a mere background, even though the site may still be identified as Frangy near Seyssel, in the Haute-Savoie. The attention focuses on a rural procession which emerges from the church and proceeds across the village square. A small world comes together in these animated figures: the happy newly-weds, the old parents, the merry friends, the pretty village maidens, all of whom are escorted by a musician playing his violin surrounded by a pack of boisterous dogs. The innkeeper of the "Cheval-Blanc" stands on the steps of his house, looking on indifferently, while a young woman and some old men watch the scene with great interest, sitting on chairs they have brought out for the occasion.

It is important to mention the artistic ability of the painter in creating this scene, where, according to Dubois-Melly, the first biographer of Töpffer, "the eminent qualities of composing, painting and drawing, which will distinguish Töpffer's talent from now on, are already all revealed [...]." He insists that "the secondary figures to the right, although in the foreground, are treated as supporting elements. The light which falls on them is carefully moderated, in order to leave the main protagonists in full light and prominence. The painter succeeds [...] in retaining a sense of unity as well as a sense of harmony in a composition, which seems predisposed, through its fabulous diversity, to make him lose the one and the other [...]."[1]

The same subject was interpreted by Töpffer in two versions: the first painting, dated 1812 (Fig. 20a), with a slightly different composition of figures and landscape, was acquired by the Empress Joséphine, and later purchased back by the family of the artist, who bequeathed it to the Musée d'art et d'histoire of Geneva in 1910. It was shown at the Salon of 1812 in Paris.[2] The painting won for Töpffer the grand gold medal awarded by the Emperor.

The second version was painted in Geneva in 1816, immediately before Töpffer left for England. It was purchased by his friend Divett, with whom Töpffer stayed in London, and subsequently, in his manor at Bystock, from May to June, 1816. Töpffer brought this painting with him, along with several other works, in order to introduce his artistic production to the British public. Divett purchased *The Village Wedding*, as well as other paintings, in particular *The Village Market* (1815); later they came into the collections of Artherton Byron at Culver, who purchased all the works by Töpffer which were held by Divett's family.[3]

The painting of 1816 is particularly interesting from the point of view that it already manifests a definite modification in Töpffer's pictorial conception: he renounces the smooth and meticulous treatment, which still had prevailed in the earlier version. He also makes better use of the pictorial space, which results in improving the unity of the composition itself. This aesthetic evolution will become even more apparent in the works which follow his stay in England, and Töpffer, fully conscious of the importance of the discovery of English painting, was to write to his wife in June, 1816: "[...] It was extremely useful to meet with the painters in London, and you will see, when I will paint in Geneva, how much I have improved in strength and colorfullness ... I take in what I see as much as I can, and I only regret not having had the chance of discovering England earlier on [...]."[4] *RL*

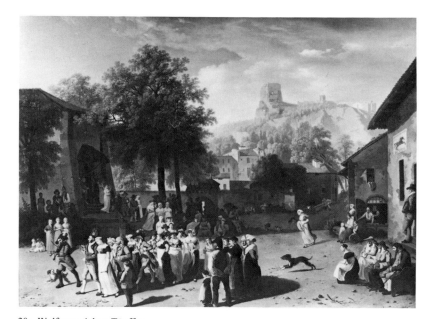

20a Wolfgang-Adam Töpffer
The Village Wedding, 1812
Oil on canvas, 25 3/4 × 35 7/8 inches (68.5 × 91 cm)
Musée d'art et d'histoire, Geneva

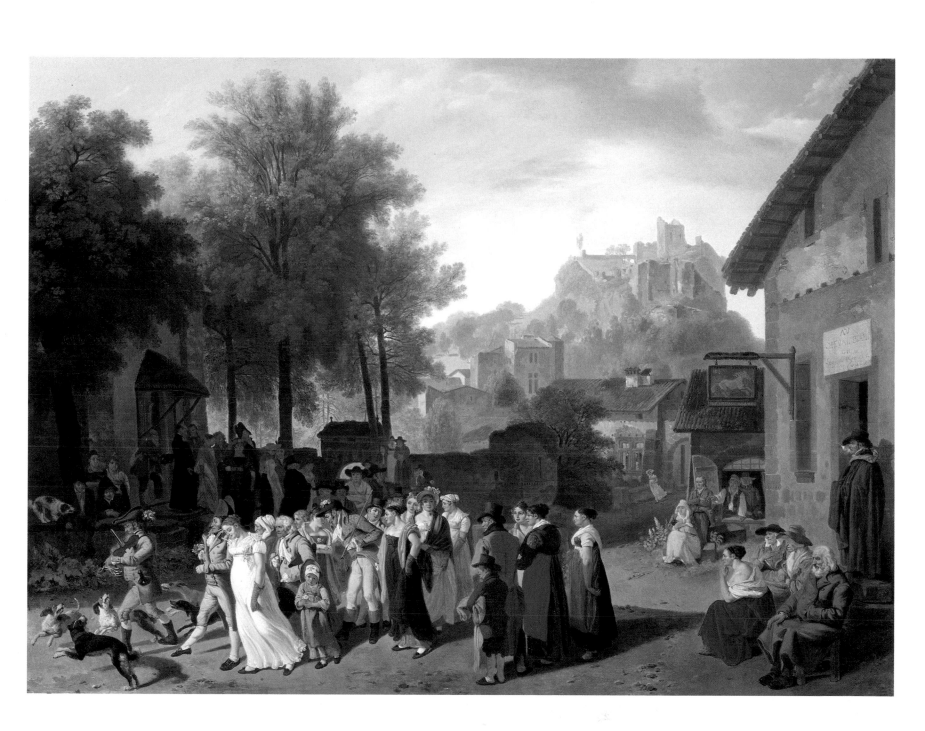

Jacques-Laurent Agasse

Portrait of Francis Augustus Eliott, 2nd Lord Heathfield, 1814

cat. no. 21
Oil on canvas
37 ¾ × 33 ½ inches (96 × 85 cm)
Kunstmuseum, Lucerne,
inv. no. E 59 x
(Gottfried Keller Foundation)

Bibliography:
Conrad von Mandach, "Jacques-Laurent Agasse (1767–1849), Lord Heathfield," in *Bericht der Gottfried Keller-Stiftung, 1932–1945, Das 17. und 18. Jahrhundert* (Zürich, n.d. 1945), 50–52 (ill.); Arnold Neuweiler, *La peinture à Genève de 1700 à 1900* (Geneva, 1945), 69 (ill.); Beat Wyss, "Jacques-Laurent Agasse, Lord Heathfield on Horseback (ca. 1810)," in *Kunstmuseum Luzern, Permanent Collection, Paintings from the 15th to the 20th Centuries* (Lucerne, 1983), 50, no. F. 17, color pl. 51.

[1] Jacques-Laurent Agasse, *Catalogue autographe,* manuscript (Musée d'art et d'histoire, Geneva), no. 1906–1.
[2] No. 529 in the exhibition.
[3] 15 January: Royal Collections, Windsor; 15 May: Collection Sir G. Tappas-Gervis-Meyrick, Bodorgan.
[4] See Adrien Bovy, *La peinture suisse* (Basel, 1948), 89.

Francis Augustus Eliott, 2nd Lord Heathfield (1750–1813), was the son of General George Augustus, the Protector of Gibraltar. Like his father, he rose through the ranks in the cavalry, becoming first a commander in 1795, and later a general. An excellent horseman as well as the friend of Lord Rivers and the Prince of Wales, he took Agasse under his protection. He was the vice-president of the Royal College of Surgeons of England in London, in which he introduced Agasse, providing him access to this institution where he frequented the lecture room of dissection, the museum, the forgery, and the paddocks which belonged to the establishment. In 1821, Agasse was commissioned to paint a series of six pictures representing the results of certain biological crossings obtained in the course of some medical experiments conducted by Lord Morton.

Agasse painted the portrait of Lord Heathfield in four versions which differ essentially only by the treatment of the landscape; all four works are listed in the handwritten catalogue which the painter edited himself in 1800, upon his arrival in London, and which he updated until his death in 1849.[1] The prototype, most probably the version at the Musée d'art et d'histoire in Geneva, is dated 26 March 1811 and was exhibited in London at the Royal Academy the same year;[2] two others followed in 1813,[3] and a last one in February, 1814, the version of the Kunstmuseum in Lucerne, painted a year after Lord Heathfield's death.

This particular portrait resembles in many details the portrait of *Lord Rivers and his Friends,* of which a first version — Agasse had painted three — was started in 1811 and completed in March, 1815. As in the portrait of Lord Heathfield, it is important to note the difference in treatment and sensitivity which the artist applied toward the representation of the man and the animal: a stereotyped profile of the one, an actual psychological portrait of the other, which prompted Horace Vernet to say: "He draws animals like nobody did before him."

In the foreground of the composition Lord Heathfield, as horseman, is rendered as a gentleman with a florid complexion. He wears a dark frock-coat, a white scarf, a black cylindrical top-hat, suede pants, and high boots. He is represented in profile slightly to the right, well set up on a magnificent bay horse whose reins he holds with ease. In the background to the left, the groom of the Lord, on horse as well, can be seen accompanying him. The imposing outline of the horseman and his steed stand out in front of a landscape, which opens towards meadows and a few trees; an extent of water glistens in the far.

But, as always with Agasse, the main interest of the composition is centered on the horse, and, as Adrien Bovy has appropriately stated, "the horseman is there only to show off the mount."[4] The bundled, nervous energy and the splendor of a thoroughbred are represented with accomplished mastery, based on precise observation, a marvellous truthfulness and naturalness. Agasse retained the technical assurance from the lessons with his master David, necessary for a clean and accurate drawing. He captured the horse in its entire mobility, stressed the nervous tension of the muscles in a truly naturalist expression which makes no concession to the conventions of his time, and rendered to perfection the shifts in color and the brilliance of the animals' coat. He knew how to combine his thorough knowledge of anatomy with a keen sense for the psychology of the animal. He was not content with reproducing shapes, but rather in his painting the love for the creature, the tenderness which he feels, always flow into his attempt to achieve a true sculptural expression.

It is certain that the English environment and its animal painters had influenced Agasse, as far as his subject matter is concerned, as well as a general renewal of his approach. But it is no less certain that he was a completely independent artist in his very personal and genuine perception of the subject he represents. *RL*

Jacques-Laurent Agasse (Geneva 1767 – 1849 London)
Biography, see p. 179

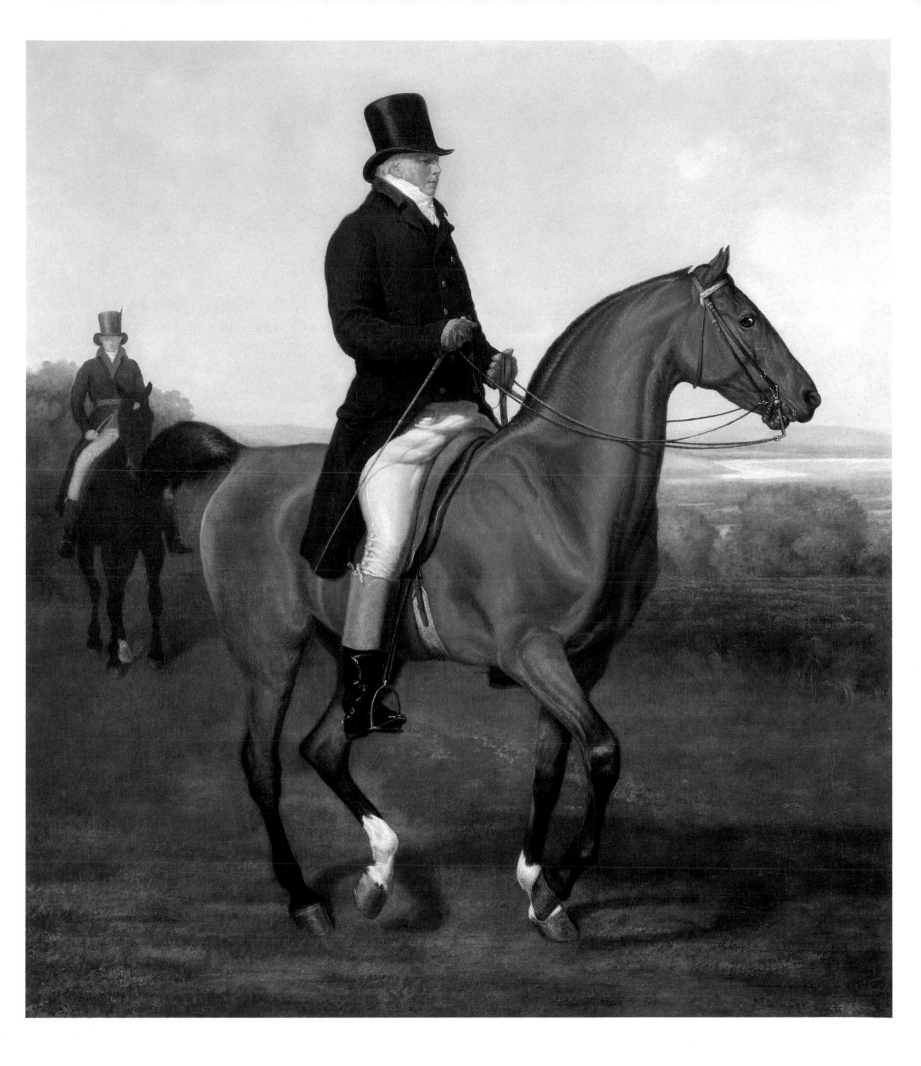

Jacques-Laurent Agasse

The Place of Recreation, 1830

cat. no. 22
Oil on canvas
17 ½ × 14 ³/₁₆ inches
(44.5 × 36 cm)
Signed lower right: "J.L.A."
Musée d'art et d'histoire, Geneva,
inv. no. 1892−13

Bibliography:
Daniel Baud-Bovy, *Peintres genevois,*
deuxième serie (Geneva, 1904), 119 (ill.), 122,
123, 128; Charles Frédéric Hardy, "The life
and work of Jacques-Laurent Agasse," in
Connoisseur (January 1917):9, 11; *The Age of
Neo-classicism,* exh. cat. (The Royal Academy
and the Victoria & Victoria & Albert Museum, London,
1972), no. 5, pl. 38.

[1] A small oil portrait of her is in the collection
of the Musée d'art et d'histoire in Geneva.
[2] Jacques-Laurent Agasse, *Catalogue auto-
graphe,* manuscript (Geneva, Musée d'art et
d'histoire), inv. no. 1906−1.
[3] Cat. no. 46 (1832); cat. no. 295 (1833).

Agasse was primarily known as a painter of animals; however he also produced some excellent genre paintings brilliantly representing narrative scenes with, often enough, literary allusions, which conjure up the familiar and picturesque images of everyday life in the first half of the nineteenth century. *The Place of Recreation,* along with *The Cart Covered with Flowers* (1822), two versions of *The Morning of the Snow* (1819 and 1822), and *The Contrast* (1829) belong to the compositions which flow quite effortlessly from a great number of preliminary sketches, for which Agasse finds use on several occasions.

The scene takes place in a somber setting— probably Hampstead Heath — whose dark trees stand out against the illuminated fields and woods of the background. In the foreground is the wheelbarrow of a gardener, who has also carelessly left his hat nearby along with his shovel and his rake, while he rests on a bench in the shadow of a majestic tree. He turns to look at a little girl high up on a swing, with a young boy vigorously pulling at the rope. With her back to the viewer, and holding her bonnet behind her, another girl impatiently awaits her turn on the swing. Two small girls sit at her feet on the grass, seemingly absorbed in an animated conversation. Meanwhile, two small children supervised by their nanny play with the wheelbarrow of the gardener. One has already climbed into it, while the other one tries to push it. As he does not succeed, the child in the wheelbarrow would fall were it not for the providential help of the nanny who stretches her hands out towards her. In the background, almost hidden by the trunk of a big tree, a white dog lies seemingly unconcerned with the ungoing scene.

From 1810, Agasse lived in an apartment which he sublet from the Booth family at no. 4, Newman Street, in London. He soon became a close friend of the fam-ily, and was especially attached to the young children who loved him dearly. This relationship would deeply influence his art, since he attempted on a number of occasions to reproduce their features in sketches, as well as in finished paintings such as *The Difficult Word* or *The Important Secret,* with the same concern and passion for truthfulness which distinguish his animal scenes.

And so it is not surprising that we find the little Louisa Booth[1] in *The Place of Recreation.* She can be identified as the little girl, seen from the back sitting next to the swing with her sister Ellen, who in turn is also portrayed in *The Important Secret.* To further emphasize the familiar character of this composition, Agasse endows the gardener with his own features, just as he had done previously in *The Cart Covered with Flowers.*

Agasse painted *The Place of Recreation* in two versions at the same time, in July 1830.[2] The paintings differ in size, the first one, in the collection of the Oskar Reinhart Foundation in Winterthur, is slightly larger. It was exhibited at the British Institution in London in 1832, and at the exhibition of the Society of British Artists in London, during the winter, 1833.[3]

The main attraction of the present composition is its genuine feeling of happiness, unrestrained freedom, and simplicity inherent in childhood itself. Agasse has achieved the expression of poetry, very British indeed, and perhaps sentimentality, but nevertheless free from all affectation. Of course the painting may lack a certain unity due to the many unrelated details of the composition which are arranged without hierarchical order. But Agasse succeeds in conveying all the love he felt for the Booth children in these scenes, where each one of the many figures is minutely studied and rendered with great care.

RL

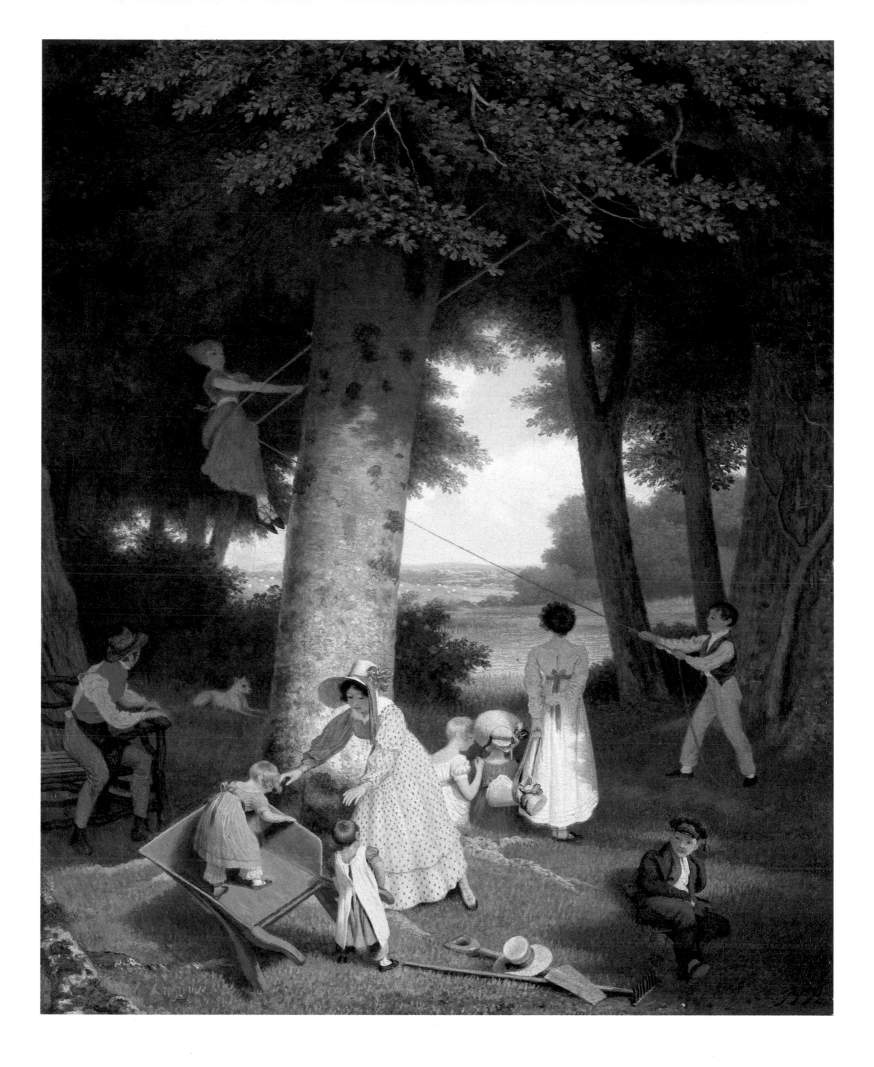

Léopold Robert

A Brigand Woman Guarding her Sleeping Husband, 1825

cat. no. 23
Oil on canvas
21 5/8 × 17 7/8 inches
(55 × 45.4 cm)
Signed lower right: "Robert Rome/1825"
Musée cantonal des beaux-arts, Lausanne, inv. no. P-666

Bibliography:
Pierre Gassier, *Léopold Robert* (Neuchâtel, 1983), 300−301 ("Femme de brigand veillant sur le sommeil de son mari. Exemplaires de ce tableau actuellement inventoriés").

[1] The most recent monograph on the artist, which contains an incomplete but useful bibliography, is Pierre Gassier, *Léopold Robert* (Neuchâtel, 1983).
[2] The statistics come from Feuillet de Conches' catalogue of Robert's paintings which is reproduced in Gassier, *Robert* (see n. 1), 278−280.
[3] The letter is of August 14, 1820 to his mother, first published in 1848; see Gassier, *Robert*, 86−87.
[4] The versions are catalogued by Georges B. Ségal, *Der Maler Léopold Robert 1794 − 1835. Ein Beitrag zur Geschichte der romantischen Malerei in der Schweiz* (Basel, 1973); see also Gassier, *Robert* (see n. 1), 298−301.

When Robert committed suicide in Venice on March 20, 1835, almost exactly a decade after the death of Füssli in London, he was perhaps the most widely known and popular Swiss painter in Europe.[1] His works were exhibited regularly in Rome and in Paris and were eagerly sought after by the most important collectors and museums from Scotland to Russia. Robert was an extremely prolific painter whose supply of pictures often equalled the extraordinary demand: in 1827 alone he produced no fewer than fifteen paintings, although some of these were copies or variations of works completed years before for the burgeoning art market.[2]

Like his compatriot Ducros, Robert spent virtually his entire artistic career in Italy, after having first received his basic art training in Paris in David's prestigious private studio. When he arrived in Rome in 1818, he aligned himself with painters who themselves exploited the rich subjects of the local peasants. Robert accordingly began to examine aspects of local genre which at times he painted with clear religious overtones, but always blending the strict academic tradition of drawing and composition with Romantic sensibility and the love of local color and costume. It is no exaggeration to say that Robert's work helped to popularize the taste for the Italian genre scene in France in the first half of the nineteenth century from which there would be innumerable offshoots for generations.

Decisive in the development of Robert's iconography was the decision in 1819 by the Papal authorities to purge the countryside of the brigands, or bandits, who had terrorized travelers for years. The stronghold of the brigands was in the village of Sonnino in the Ausoni hills east of Anzio which was raided by state troops and the inhabitants — men, women, and children — were all imprisoned in Rome.

Robert seized the opportunity of their presence to draw and paint directly from these legendary figures, noting in a letter that he worked and lived in the prison for two months without missing a day of work.[3] What attracted Robert was not only their exotic costumes and robust, peasant physiognomy, but also the notion, already well established in Romantic literature by Schiller and Byron, of the Italian bandit as a heroic, fierce warrior and individualist at odds with his society. Through the dozens of scenes of brigand life, almost always romanticizing the actual danger and sadistic practices of the bandits, Robert added directly to the European glorification of the bandit which would exist even into the twentieth century.

The work represented here is a variation of a composition showing the heroic role of the brigand's wife which Robert in fact repeated at least fourteen times since 1821, and of which nine versions are known to be extant.[4] The scene shows the exhausted brigand asleep, clad in customary outfit with the distinctive conical hat, peasant shoes, and patterned scarves, and with his right hand around the musket in an anticipatory gesture, while his wife assumes the watch.

In this version, the wife is shown leaning forward and at the same time bending down to awaken her husband, as though she had just perceived the approach of their enemy, thus highly accentuating the dramatic elements of the picture. The painting technically exemplifies Robert's style of the period with a tight, academic drawing and studied attitudes, but also with a clear interest in exotic materials, as can be noticed in the almost too lavishly painted textures of the dress and the sparkling gold trim and glistening jewelery. *WH*

Léopold Robert (Les Eplatures 1794 − 1835 Venice)
Biography, see p. 186

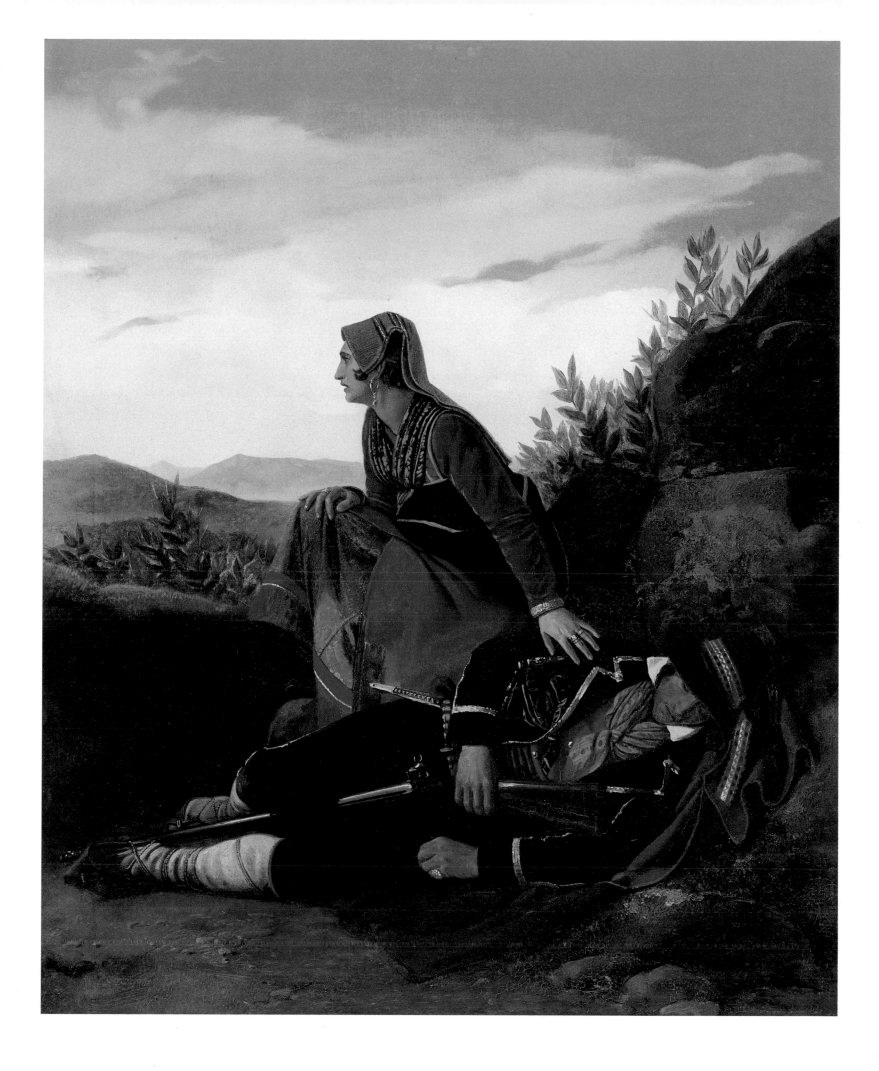

Léopold Robert

Women with a Basic of Oranges, 1827

cat. no. 24
Oil on canvas
18 ½ × 14 9/16 inches
(47 × 37 cm)
Signed lower right: "Lld. Robert. Roma. 1827"
Aargauer Kunsthaus Aarau,
inv. no. D 1348
(Gottfried Keller Foundation)

Bibliography:
Franz Mosele, *Gemälde und Skulpturen vom 18. Jahrhundert bis zum Ersten Weltkrieg* (Sammlungskatalog Aargauer Kunsthaus Aarau, Band 1) (Aarau, 1979), 111 (no. 68).

[1] Charles Clément, *Léopold Robert, d'après sa correspondance inédite* (Paris, 1875), introduction.
[2] Etienne Delécluze, in *Journal des Débats,* January 7, 1828.
[3] Pierre Gassier, *Léopold Robert* (Neuchâtel, 1983), reproduces many of these compositions.

While much of Robert's substantial reputation rested on the series of brigand scenes which occupied him continually through the 1820s, he was nevertheless interested in a wide range of subjects drawn from his Italian experiences. At times, this interest included subjects of peasants at work, scenes of natural tragedy and disaster, and even disguised allegory, as in the example of the incompleted series of large paintings depicting the four seasons using different types of laborers set in varying Italian regions.

In all of Robert's efforts, from the pure genre to the loftier, universal themes in his late work, contemporary critics rightly perceived his style as one that merged strict Davidian principles with a Romantic outlook, a blend that insured his continued acceptance with the public.[1] It should be noted as well that in his sensitivity for the commonplace, contemporary dress, and banal events, Robert also obliquely prefigured the Realist movement which began to become manifest in French art more than a decade after his death. It is therefore proper to view Robert's oeuvre as a synthesis of artistic trends at a crossroad when David's pupils clashed with Delacroix's ideals. It would introduce a *juste-milieu* attitude of artistic compromise between the two strains.

This painting of 1827, a highly charged year in Robert's artistic career, illustrates these tendencies well and reveals equally the painter's inherent lyrical style, in contrast to his sometimes brutal brigand, or bandit imagery. The work depicts a poetic pastoral in which two women rest after having harvested oranges in a grove near the Bay of Naples, a site Robert painted often. The subject is directly related to Robert's fascination with I-talian peasant labor, but here wholly subordinated to the melancholy and the sentimental, with a clear emphasis on the lyrical rather than the harsh reality. The relaxed position of the women, perhaps here identified as two sisters who listen to the song of a musician partially hidden at the extreme left, recalls classical models transposed into nineteenth-century Neapolitan peasants, as though they form modern counterparts to the ancient muses. The dreamy effect of the music, the brilliant summer light, and the introspection of the models combine to create a languorous, seductive composition without pretense or profound philosophic intention.

Because of Robert's abundant production, some critics, such as the influential Etienne Delécluze, believed the painter's talent to have been effortless and natural, devoid of the need for extensive study.[2] In fact, his compositions, while sometimes appearing facile and even mundane, are actually conceived through intensive formal calculation and composition. This has been well perceived in the present painting which is in fact part of a series of variations on the theme of two women in a landscape setting that Robert treated since 1821. In dozens of works, Robert provided innovative pictorial ideas on the theme and the manner of integrating figure with landscape,[3] rarely repeating himself in the process. Here the central figures are composed in a tightly-knit pyramidal form that finds its echo in the distant shape of the dormant Mount Vesuvius and the carefully positioned *sabots* in the foreground. The colors as well reflect the muted intent of the scene and add to the overall element of pictorial harmony. *WH*

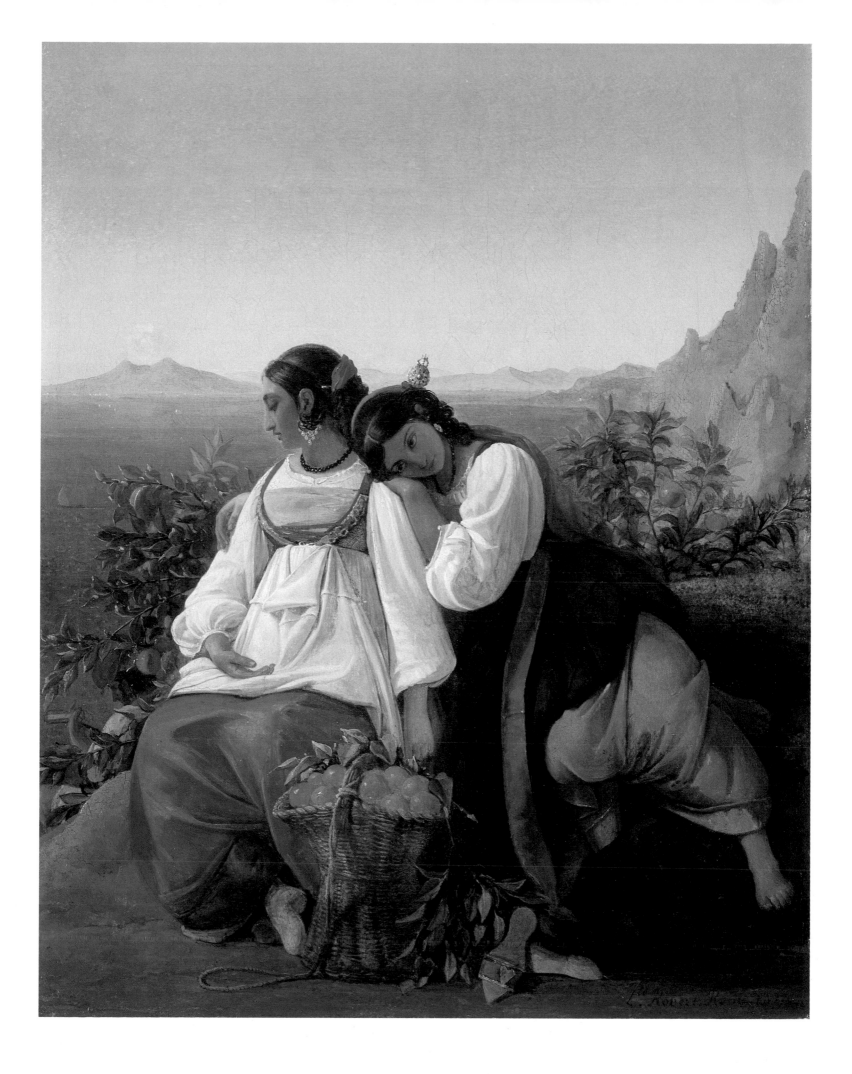

Charles Gleyre

Turks Pursuing an Arab, c. 1840

cat. no. 25
Oil on canvas
11 × 9 ¼ inches (28 × 23.5 cm)
Musée cantonal des beaux-arts,
Lausanne, inv. no. 1335

Bibliography:
Charles Clément, *Gleyre: Etude biographique et critique* (Paris, 1878), 136 – 137, pl. II (reversed), 396 no. 30.

[1] Nancy Scott Newhouse, "From Rome to Khartoum: Gleyre, Lowell, and the Evidence of the Boston Watercolors and Drawings," in *Charles Gleyre: 1806 – 1874,* exh. cat. (Grey Art Gallery, New York University/The University of Maryland Art Gallery, College Park, Maryland) (New York, 1980), 79 – 117.
[2] Charles Clément, *Gleyre: Etude biographique et critique* (Paris, 1878), 136 – 137, and 396, no. 30.
[3] Cogniet's drawing, *Cavalier se jetant dans un précipice,* is in the Musée Bonnat, Bayonne; Millet's drawing, *Le Saut du Major McCollach,* is in the Musée Thomas Henry, Cherbourg.
[4] See Clément, *Gleyre* (see n. 2), 457, no. 216, which refers to a lost drawing.

Between 1834 and 1838, Gleyre traveled extensively in the Near East, for the most part in the employ of his American patron John Lowell, Jr., for whom he had produced a substantial quantity of drawings and watercolors *in situ.*[1] While it is true that Gleyre spent more time in the Orient than many of his contemporaries, he cannot be considered a true Orientalist as he never fully exploited this iconography in his paintings. Only a small group of works attest to his Egyptian experience, all of them executed upon his return to Paris and presumably made for the lively trade in Near Eastern themes. This example is one of Gleyre's most interesting efforts in the genre, and is especially noteworthy in demonstrating his early exuberant and romantic style.

The title of the painting originated with Gleyre's friend and biographer, Charles Clément. He described the scene as two Turks chasing an Arab rider, who makes his miraculous escape with a spectacular leap from the edge of a steep cliff.[2] The source of Clément's title is not known, since none of the costumes are particularly indicative of Turkish dress. A pencil study for the painting, recently discovered in one of Gleyre's private Egyptian sketchbooks, depicts the same scene drawn from another perspective, indicating the possibility that the painter may actually have witnessed such a scene. When he translated the sketch for the present painting, he did so in an effort to appeal to the popular European conception of the Arab as an exceptionally skilled equestrian in both chase and battle. This image would later be used with great frequency in the works of Horace Vernet (1789 – 1863), Eugène Fromentin (1820 – 1876), and Eugène Delacroix (1798 – 1863), to name but a few examples. Even the image of horse and rider making a heroic leap from a steep precipice would appear later, in other contexts, in the works of Léon Cogniet (1794 – 1880) and Jean-François Millet (1814 – 1875).[3]

The composition of this painting is decidedly more expressive than those of Gleyre's later works. The unusually distinct application of the thrusting diagonal in the form of the leaping horse and rider, the latter contorted uncomfortably to heighten the effect of the motion, is counterbalanced by another bold, energetic diagonal, the shadow cast by the Arab and his horse on the rocks at the right of the painting. The two lines of force are adroitly resolved by the abrupt halting of the Turks at the top, and form a subtle triangle which is echoed in the shape of the mountain to the left. The action within the scene is further emphasized by the turtle doves in flight, a detail Gleyre probably added only in the painting as it appears in none of the studies.[4] The whole effect, as Clément remarked, is one of vigor and finesse, recalling some of the dynamic compositions of Alexandre Gabriel Decamps (1803 – 1860). The critic Hippolyte Taine was perhaps more astute in comparing the intensity of the painting to the energy of Delacroix's works. Gleyre himself pointed to the work as a retort to the critics who often commented on his tendency toward monochromatic coloration. This vivacity and richness of color would be, for the most part, abandoned by Gleyre after the 1840s in favor of a more sober composition and a greater emphasis on linear form. *WH*

Charles Gleyre (Chevilly 1806 – 1874 Paris)
Biography, see p. 183

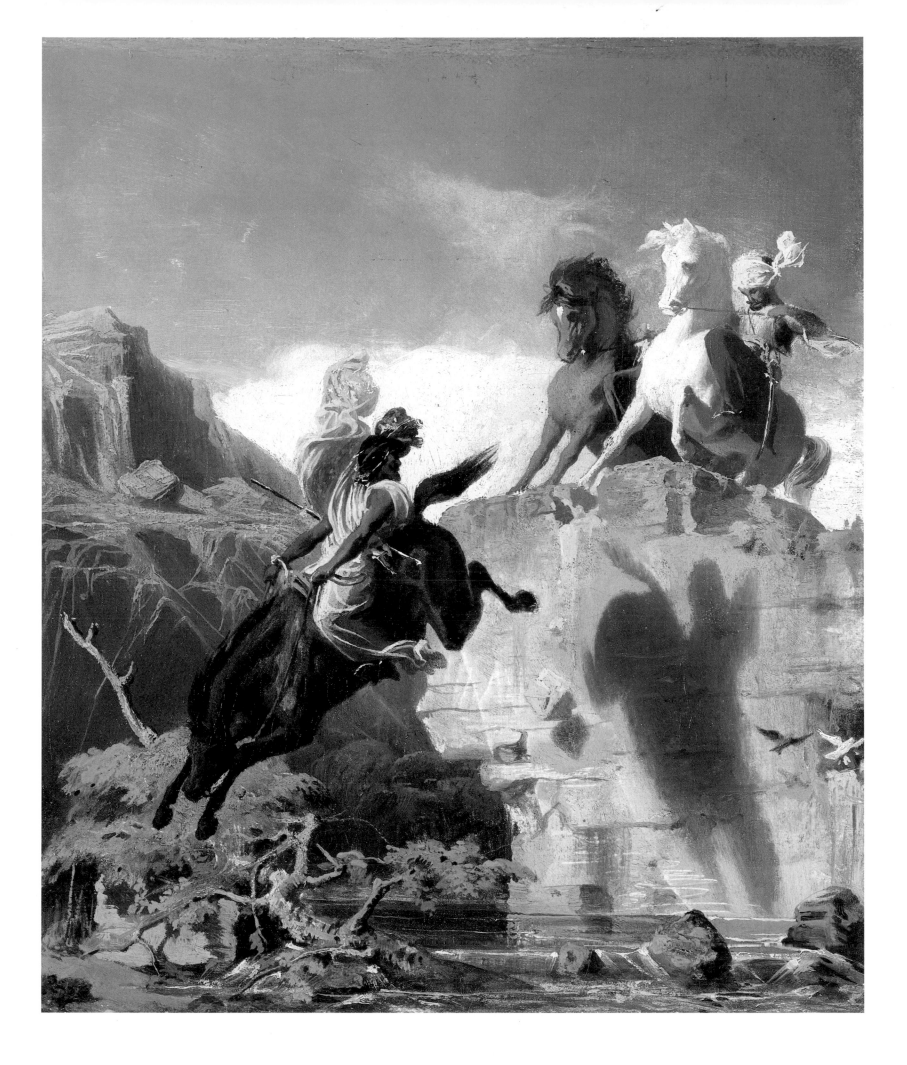

Charles Gleyre

Le coucher de Sappho, 1867

cat. no. 26
Oil on canvas
42 ½ × 28 9/16 inches
(108 × 72.5 cm)
Signed lower left: "C. GLEYRE."
Musée cantonal des beaux-arts,
Lausanne, inv. no. 1332
(Gottfried Keller Foundation)

Bibliography:
Charles Clément, *Gleyre: Etude biographique et critique* (Paris, 1878), 340–344, pl. XXVI, 427 no. 107.

[1] See William Hauptman, "Charles Gleyre: Tradition and Innovation," in *Charles Gleyre: 1806–1874,* exh. cat. (Grey Art Gallery, New York University/The University of Maryland Art Gallery, College Park, Maryland) (New York, 1980), 43ff.
[2] Charles Clément, *Gleyre: Etude biographique et critique* (Paris, 1878), 341–342.
[3] Jules Michelet, *Journals* (Paris, 1959–1976), vol. III, 535, under journal entry for December 24, 1867.

After completing two large history paintings which were commissioned for the city of Lausanne in the 1850s, Gleyre returned to classical themes in accord with his own aesthetic ideals. This development is exemplified by the present work, as well as the *Bath* of the following year.[1] Gleyre's friend Charles Clément was witness to the origins of *Le coucher de Sappho,* and recorded the following anecdote: During the summer of 1866, a poor adolescent girl presented herself to the atelier seeking a modeling job. Gleyre had no immediate need for a young model, but took pity on her and asked her to pose. When she removed her garments and took the pose, Clément was stunned to see that Gleyre was literally moved to tears by her beauty and aura of innocence; the painter made several sketches of her, but without a specific subject in mind. At the end of the modeling session, Gleyre discussed with Clément the difference between the proportions of the girl and those of classical prototypes, noting that those seen in life were significantly different and in themselves beautiful and true. Gleyre would, however "correct" the proportions later, using a more mature model, in order to arrive at the composition as we have it here.[2]

Gleyre completed the canvas rather quickly, contrary to his typically slow and methodically tedious practice. The painting was in fact finished by December of 1867 rather than March of 1868, as Clément later reported, since by the end of 1867, it was already hanging in the apartment of its owner, the publisher Charpentier, who proudly showed it to the celebrated historian Jules Michelet.[3] At this time, the work bore the undistinguished title of *The Muse,* without any reference to the poetess of Lesbos. This was fully in accord with Gleyre's intention, as he told Clément that his goal was only to portray a young girl, in a classical setting, preparing her lamp before retiring. The designation of the figure as Sappho was accidental, and was applied to the painting only after the painter's death.

The canvas is an especially fine example of Gleyre's popular *neo-grec* style, which was widely imitated by artists during the Second Empire, not the least important of which was Gérôme. While the composition is on the surface a simple one, balanced around the central figure who is turned away from the viewer, there is nonetheless a subtle interplay between the vertical and horizontal forms, themselves artfully echoed in the patterns of the Pompeian walls in the background. Also noteworthy is Gleyre's refined sense of color harmony, for example in the arrangement of the red, white and blue-green drapery, set against the burgundy and ochre tones. Like the compositions of Ingres, this example demonstrates Gleyre's elegance and grace in the unaffected and unpretentious style to which he aspired. *WH*

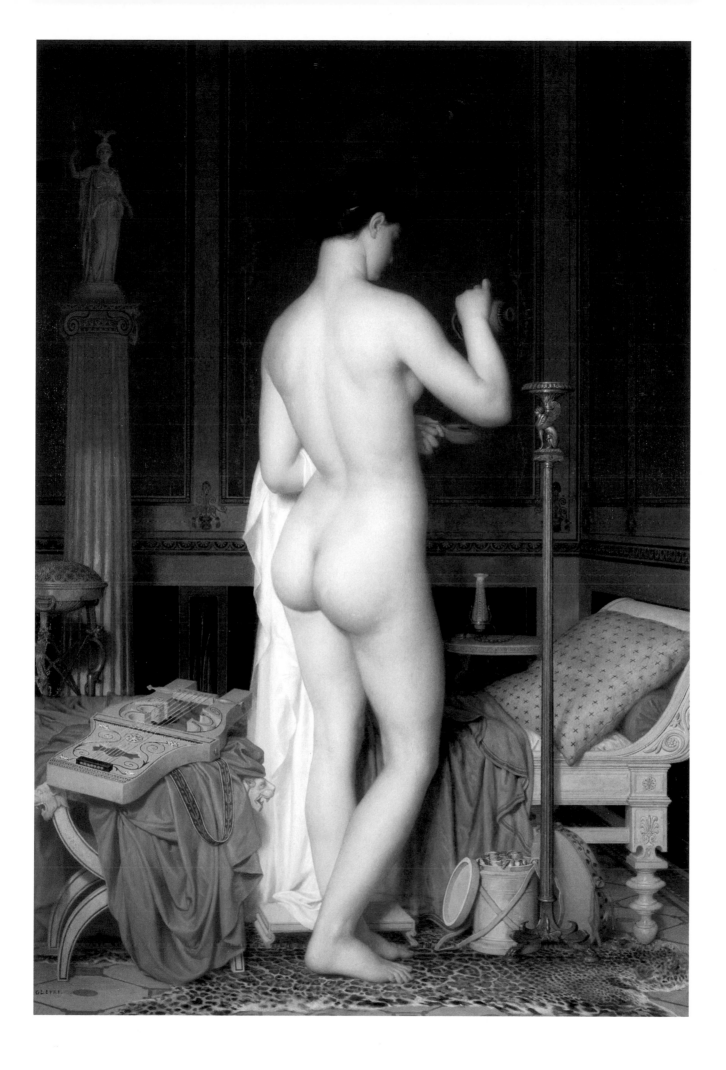

Charles Gleyre

Study for *The Bath*, 1868

cat. no. 27
Oil on canvas
18 ⅛ × 15 ⅛ inches
(46 × 38.5 cm)
Musée cantonal des beaux-arts,
Lausanne, inv. no. 1327

Bibliography:
Charles Clément, *Gleyre: Etude biographique et critique* (Paris, 1878), pl. XXVIII, 429 no. 111.

[1] See Charles Clément, *Gleyre: Etude biographique et critique* (Paris, 1878), 344−345.
[2] Gleyre's closest friends, Charles Clément, Sébastien Cornu, and Dominique Alexandre Deneulle, were all associated with the Musée Campana installation in Paris. See Clément, *Gleyre* (see n. 1), *passim;* see also *Etat de Travaux, Musée Campana* in the Archives Nationales, Paris, fol. 21, 486 verso.
[3] Johnston's papers are published in Katharine Baetjer, "Extracts from the Paris Journal of John Taylor Johnston, First President of the Metropolitan Museum," in *Apollo*, vol. 238 (December 1981):410−417, see especially 414 ("I was delighted to find that it was really a remarkable picture of great power & sweetness, & such as I am perfectly satisfied to take"); see also Lucas' notes in Lilian M.C. Randall, ed., *The Diary of George A. Lucas: An American Art Agent in Paris 1857−1909*, vol. II (Princeton, 1979), 279.
[4] Charles Gleyre, *Le Soir, ou: Les illusions perdues*, 1865−1867, copy after the original painting in the Louvre (1843, oil on canvas, 156.5 x 238 cm), oil on canvas, 86.5 x 150.5 cm, The Walters Art Gallery, Baltimore, inv. no. 37'184.

As with Gleyre's *Le coucher de Sappho* of 1867 (cat. no. 26), his painting *The Bath* (Fig. 27a) typifies the artist's more poetic canvases of the 1860s, which frequently portray activities of daily life disguised in classical settings. In this painting, Gleyre depicts the bathing of an infant by a woman in classical dress, at the left, and a younger nude woman who prepares to dry the baby with a towel, at the right. Clément was correct in pointing out the tender interaction of these figures around the translucent marble basin in the center, the whole of which he characterized as one of Gleyre's masterpieces.[1] It has been said that the inspiration for this scene was a terracotta relief Gleyre had seen in the Musée Campana, an assumption that is all the more likely as three of the painter's closest associates were involved in the formation of the museum in the 1860s.[2]

The completed work, like so many by Gleyre, was never exhibited in Paris. It had been commissioned by the American art collector, and first president of the Metropolitan Museum of Art, John Taylor Johnston, through his Paris agent George Lucas. Johnston first saw the completed work in Gleyre's studio on October 12, 1868, and pronounced himself entirely satisfied with the result.[3] Shortly afterward, the painting was sent to New York, where it was lavishly praised by critics. After the copy of *Lost Illusions*,[4] commissioned by William T. Walters the year before, it was the second painting of Gleyre's to be seen in the United States; however, it was the first representing an original composition.

This is one of several studies Gleyre made for the picture, at least four of which were studies of the young woman on the right. Clearly, the figure depicted here was drawn from a live model. In this context, it may be recalled that Gleyre had used an adolescent girl for his *Sappho* just the year before. Therefore, it may be speculated that the present study in fact derived from that series of drawings, a proposition which is supported by similarities in anatomy and proportion. Apart from its relationship to the finished painting, this study bears a sense of simplicity which moved Clément to pronounce it one of Gleyre's finest, especially from the point of view of workmanship, or "facture." *WH*

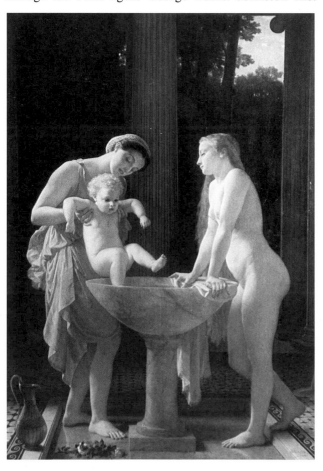

27a Charles Gleyre
Le Bain, 1868
Oil on canvas, 36 × 21 inches (91.4 × 53.4 cm)
The Chrysler Museum, Norfolk, Virginia
(Gift of Walter P. Chrysler, Jr.)

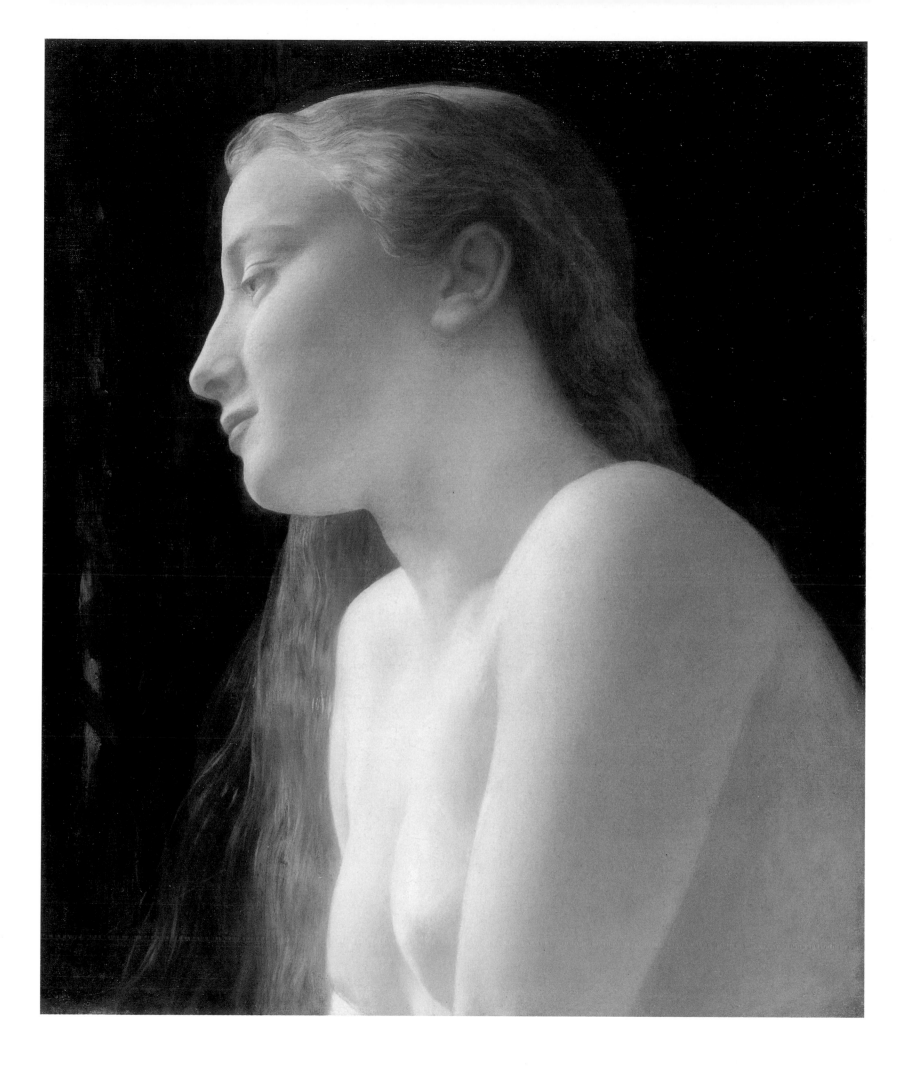

François Diday

Thunderstorm, 1858

cat. no. 28
Oil on canvas
39 ¾ × 51 ⁹/₁₆ inches
(101 × 131 cm)
Signed lower left: "F. Diday 1858"
Kunstmuseum Solothurn,
inv. no. A 47

Bibliography:
Peter Vignau-Wilberg, *Museum der Stadt
Solothurn: Gemälde und Skulpturen*
(Solothurn/Zürich, 1973), 91 – 92 (no. 84),
with detailed bibliography and list of
exhibitions.

1 A. Schreiber-Favre, *François Diday. Fonda-
teur de l'école suisse du paysage* (Geneva,
1942), 95 – 96, ill. 11.
2 Liselotte Fromer-Im Obersteg, *Die Entwick-
lung der schweizerischen Landschaftsmalerei
im 18. und frühen 19. Jahrhundert* (Basler
Studien zur Kunstgeschichte, vol. III)
(Basel, 1945), 138 – 139.
3 A. Schreiber-Favre, 1942 (see n. 1), 35.
4 Marcel Roethlisberger, "Holländische Ma-
lerei in der Westschweiz, Sammlungs- und
Wirkungsgeschichte," in *Im Lichte Hollands*,
exh. cat. (Kunstmuseum Basel) (Zürich,
1987), 41 – 48.

The painting depicts the tense moments immediately preceding a downpour: a cluster of huge oak trees resists the high winds, harbingers of the rising thunderstorm. In the middleground we perceive a horseman on a white mount, his coat billowing, accompanied by his servant and two dogs. They are fighting the wind. Beside the road stands a cross, its angle echoed in the sheet of rain falling in the distance, in the rider and his party, in the broken trunk of the oak tree, and in the branches bent back by the gale. This formal device relates man, animals, and vegetation, with the notion that all are subject to the same divine rule. In Romantic landscape painting the cross symbolizes a pantheistic view of the universe. In the paintings of the early Romanticists, the sacred landscape became a separate motif, with the cross often "illuminating its environment like a monstrance" (Werner Hofmann), such as in the *Altar of Tetschen* by Caspar David Friedrich. In the present picture, the cross at the roadside is reduced to a quotation, an element merely suggesting a "romantic" mood. The horseman and the oak trees play the same part. The storm-whipped branches looking like disheveled hair give the trees a strangely anthropomorphic appearance. The contrast between the immense trees and the tiny figures, and between the very light and very dark zones, emphasizes the turmoil of the scene.

The subject of the thunderstorm had already appeared in a lithograph by Diday entitled *The Oak and the Reed*, dated 1856. It represents the same motif as the present painting, yet the stormy clouds and the cross are missing.[1] This lithograph was based on an earlier version in oil painted in 1843.[2] According to Schreiber-Favre,[3] the title *Oak and Reed* alludes to the cautious politics of the republic of Geneva in the years round 1815. Unlike the oaktree, Geneva is not breaking under the storm, but redresses herself in the manner of a reed after the torrent of the revolution.

Diday became famous as a painter of mountainscapes. The often menacing world of the High Alps and its sudden atmospheric changes provided rewarding motives for his dramatic images. But he also used the softer landscapes of the lower regions as a stage for torrential scenes, such as the present one, or as an idyllic backdrop for picturesque subjects. The narrative, anecdotal aspect always dominates in these pictures. The natural phenomenon is staged like a theatrical production, and not used as an opportunity for close observation. The details, in particular the branches of the oak trees, are painted in a conventional manner.

Diday is even more influenced by the established standards than Calame, a painter eight years his junior. The scene of the thunderstorm is obviously closely related to seventeenth-century Dutch landscape painting. This influence already exists in works of Pierre-Louis de la Rive (1753 – 1817), Jean-Daniel Huber (1754 – 1845), Wolfgang-Adam Töpffer (1766 – 1817), and other artists in the second half of the eighteenth century, which is partly due to the presence of important collections of Dutch art in Geneva.[4] In paintings like *Thunderstorm*, however, Diday transcends the realistic interpretation of nature of Dutch landscape painting by dramatically exaggerating the visual perception. *PM*

François Diday (Geneva 1802 – 1877 Geneva)
Biography, see p. 181

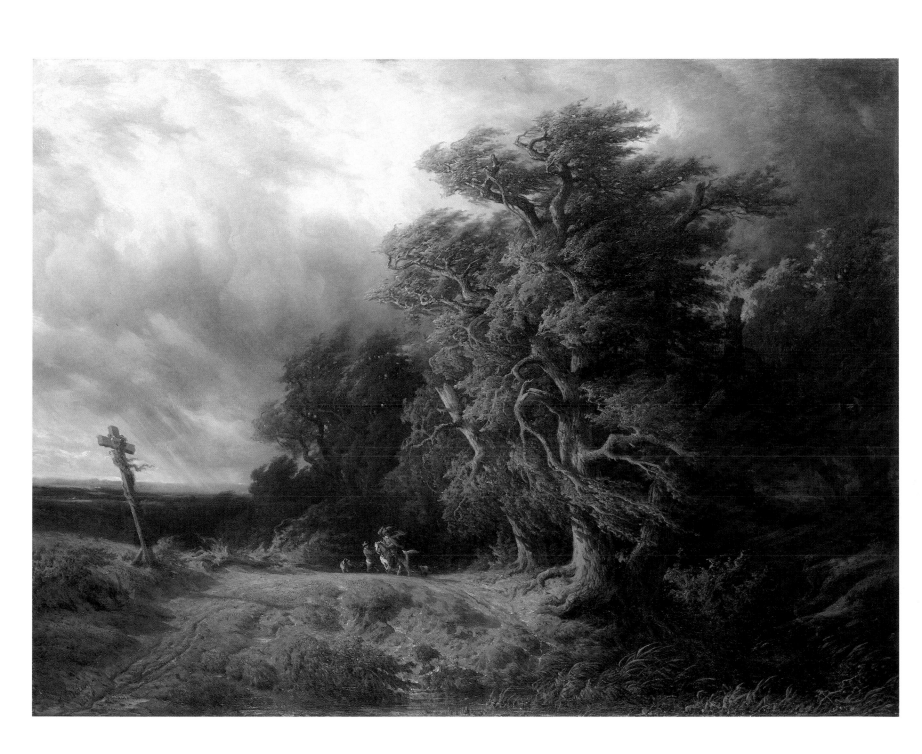

Alexandre Calame

Swiss Landscape (The Zermatt Valley), 1854

cat. no. 29
Oil on canvas
29 9/16 × 35 7/16 inches
(75.1 × 90 cm)
Musée d'art et d'histoire, Geneva,
inv. no. 1984 – 157

Bibliography:
Eugène Rambert, *Alexandre Calame, sa vie et son oeuvre d'après les sources originales* (Paris, 1884), 551, no. 279; Valentina Anker, *Alexandre Calame: Vie et oeuvre, Catalogue raisonné de l'oeuvre peint* (Fribourg, 1987), 420, no. 578.

[1] Valentina Anker, *Alexandre Calame: Vie et œuvre, Catalogue raisonné de l'œuvre peint* (Fribourg, 1987), 420, no. 578.
[2] Valentina Anker, *Alexandre Calame,* 420.
[3] These representations include paintings by Josef Anton Koch, Maximilien de Meuron, Franz Niklaus König, but also views by the so-called Swiss *Kleinmeister* (Gabriel Lory father and son, Johann Ludwig Aberli, and others); on this subject, see Walter Hugelshofer, *Schweizer Kleinmeister,* (Zürich, 1943).
[4] Franz Zelger, "Alexandre Calame," published as an offprint of *Palette,* no. 40 (Basel, 1972), 14, n. 10.
[5] See note 3.
[6] Charles Baudelaire, *Curiosités esthétiques* (Paris, n.d. [1845]), 57 – 58.

Calame lists the present painting, ordered by a certain Maurice Gontard of Frankfurt, in his *Livre de commandes* with the following note: "A Swiss landscape, imminent thunderstorm, clouds running along the mountain; in the background a snowy peak; rocks, a torrent, pine trees, etc."[1] This description reflects the wishes of his client and reads like a programmatic formula for a late Romantic mountain landscape. The precise site is identified by a tag on the stretcher: "Section of the Zermatt Valley in the Valais [...]. The snowy peak in the distance is the Liskamm, which is connected to the Monte Rosa mountain chain."[2]

In 1840, Calame traveled for the first time into the region of the Monte Rosa, at the time a locale hardly visited by painters due to extreme difficulties of access. The situation was different in the Bernese Oberland, a region already somewhat developed whose peaks and valleys had been represented since the beginning of the century by numerous artists.[3] Calame's tutor, François Diday, often traveled to the Oberland to paint the awesome mountain ridge, albeit from a safe location down in the valley. Calame was drawn to the heights of the wilderness above the timberline.

In his attempt to produce less conventional renderings of nature which would bring into accord realistic observation and glorification of the mountains, Calame was encouraged by his friend, the art critic and draughtsman Rodolphe Töpffer. Calame's paintings responded to Töpffer's call for a national landscape painting, expressed as early as 1832: "Switzerland, so genuine and beautiful in its alpine landscapes, Switzerland with its peaks, glaciers, lakes and torrents, its wild, religious, and sublime aspects, this Switzerland has not yet seen its great painters."[4] Töpffer compares the sav-age and exalted views of the "zone supérieure des alpes" with the trivial, picturesque subjects of the Swiss *Kleinmeister.*[5] The Romantic program of the writer, which aims at expressing the divine sublimity of the high mountain region, was echoed in an intrinsic belief of Calame's: In the remote regions of the high Alps exposed to the forces of nature, the painter saw a symbol of Mount Sinai, where a punishing God appeared to Moses. There are passages in his correspondence which document this interpretation, and even the title of one of the last paintings alludes to the mountain of Jahwe.

Calame and Diday became engaged in a fierce competition for critical acclaim and the patronage of wealthy clients after their initial international successes: Calame received the Gold Medal for *L'orage à la Handeck* at the Paris Salon of 1839; Diday's *Soir dans la vallée, Oberland bernois* was purchased by King Louis-Philippe in 1840. The difference between the two painters became ever more obvious. Baudelaire commented on it in his review of the Salon of 1845: "Calame and Diday: For a long time one believed that it was the same artist suffering from chronic dualism; in the meantime, one notices that he preferred the name Calame on the days he painted well [...]."[6] But the difference is not limited to the issue of quality. Diday was essentially limited to the subjective view of Romanticism, thrilling the viewer with dramatic visions of the atmospheric power of nature; Calame, on the other hand, moved toward a more precise observation of nature, which would be taken up by Robert Zünd, for example. *PM*

Alexandre Calame (Vevey 1810 – 1864 Mentone)
Biography, see p. 181

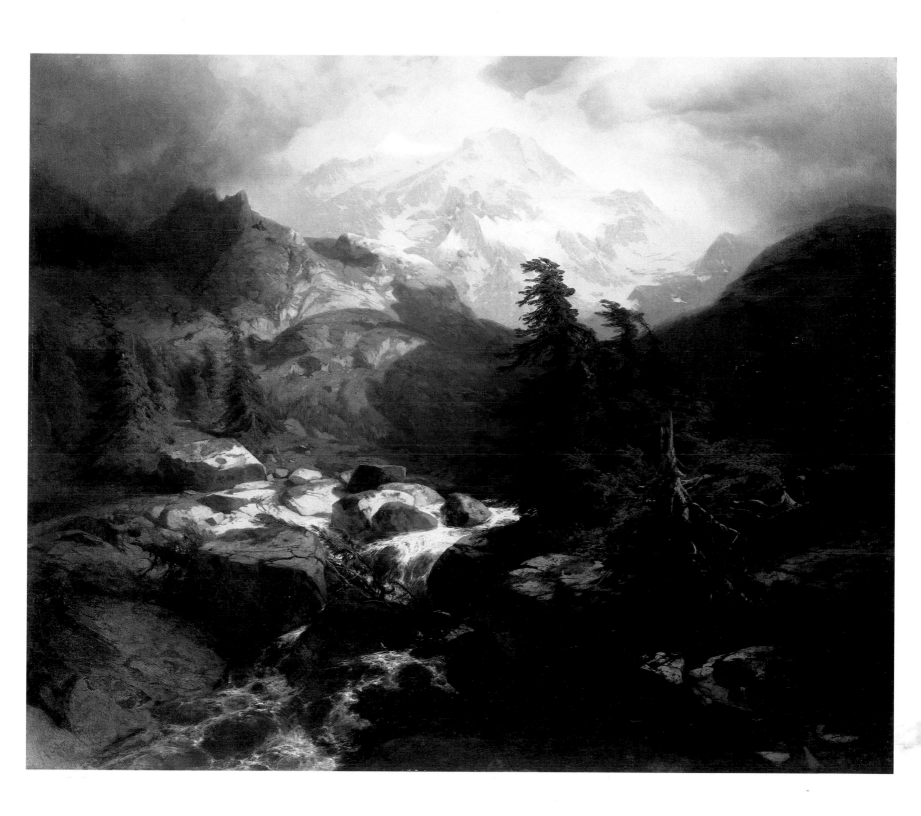

Karl Girardet

Tourists in the Bernese Alps, with the Eiger in the Background, c. 1850

cat. no. 30
Oil on canvas
20 1/8 × 27 3/4 inches
(51 × 70.5 cm)
Signed lower right: "KARL GIRARDET"
Private collection

[1] *Die Schweizerreise. Aus der Frühzeit des Fremdenverkehrs im Berner Oberland,* exh. cat. (Stiftung Schloss Oberhofen, 1983), 5.
[2] An excerpt from Töpffer's review appears in *Kunstgeschichte der Schweiz,* Joseph Gantner and Adolf Reinle (ed.), vol 4: Adolf Reinle, *Die Kunst des 19. Jahrhunderts: Architektur, Malerei, Plastik* (Frauenfeld, 1962), 150. See also *Maximilien de Meuron et les peintres de la Suisse romantique,* exh. cat. (Musée d'art et d'histoire, Neuchâtel, 1984), 20–21.
[3] Auguste Bachelin, *Karl Girardet* (Bern, c. 1883), 27.

The massif of the snow-covered Eiger serves as the backdrop for a little intermezzo captured by Girardet in *Tourists in the Bernese Alps, with the Eiger in the Background.* Two tourists riding mules and accompanied by guides, have just come upon an alpine pasture. A dairymaid stands beside the rugged path observing their arrival. The travelers, one of them a woman holding a parasol, have embarked on an outing in the mountains following a route charted by the natural scientist Jakob Samuel Wyttenbach (1748–1830) as early as in 1777, and in fact a tour still popular today: Lauterbrunnen, Kleine Scheidegg, Grindelwald, Grosse Scheidegg, and Meiringen are the stations along the way which no less than Goethe would follow a few years later.[1]

For his painted view, Girardet chose a vantage point somewhat south of the Kleine Scheidegg, looking toward the western face of the huge mountain. In order to emphasize the monumental effect he eliminated the middle ground, achieving thus an immediate juxtaposition of near and far and an abrupt change in the atmospheric quality from the clear bright colors of the foreground to the hazy grey of the distant background.

Girardet's *Tourists in the Bernese Alps* no doubt reflects the impact of a painting by his friend and mentor Maximilien de Meuron (1785–1868), executed in 1825, which represents the view of the Eiger seen from Wengernalp (Fig.30a). De Meuron's painting was soon made famous by the enthusiastic acclaim of the Geneva writer Rodolphe Töpffer, who made it a canon of romanticist alpine painting.[2] His vertical format and compositional symmetry impart to the rather small canvas a more monumental character than the horizontal format and looser composition of the somewhat larger painting by Girardet. De Meuron's Eiger towers as an isolated giant above the mist, whereas Girardet reduces the same view to a pleasant genre scene by the addition of pastoral figures. Figures were hardly ever absent in the landscapes of the younger painter, who used them primarily as vehicles for effects of color, as had Corot, for example. Girardet was in contact with the Barbizon painters through Louis Français (1814–1897).[3] Girardet's delicate handling of pigment, showing great painterly sensitivity, is largely due to the influence of these *plein-air* painters.

Before the king's deposition, Girardet had been a respected history painter at the court of Louis-Philippe. After the revolution of 1848 he returned to his native Switzerland where he and his brother Edouard founded a workshop which became recognized as the *Ecole de Brienz.* It must have been during these years, shortly after Girardet established himself in the Bernese Oberland, that he executed the present painting. *PM*

Karl Girardet (Le Locle 1813–1871 Versailles)
Biography, see p. 183

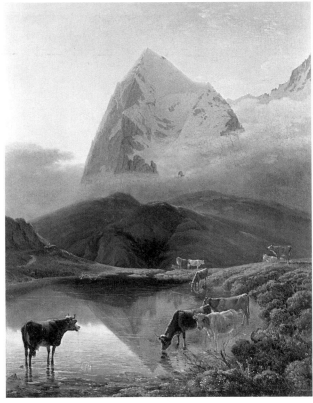

30a Maximilien de Meuron
Le Grand Eiger, 1825
Oil on panel, 20 1/8 × 15 7/8 inches (51 × 40.3 cm)
Musée des beaux-arts, Neuchâtel

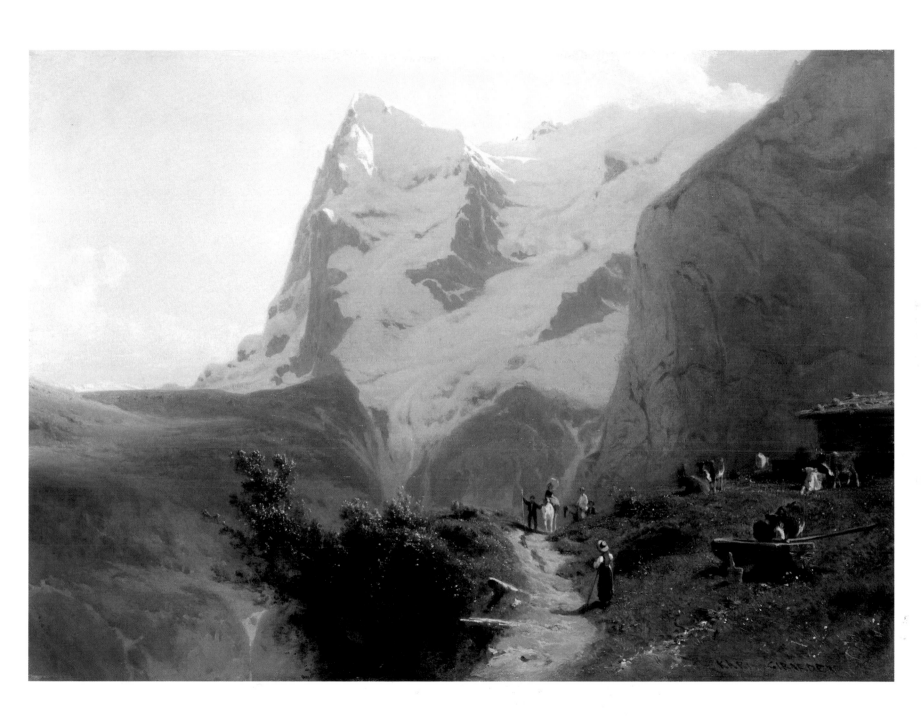

Robert Zünd

The Harvest, 1860

cat. no. 31
Oil on canvas
44 ⅛ × 61 ⅝ inches
(112 × 156.5 cm)
Signed lower left: "Robert Zünd"
Öffentliche Kunstsammlung,
Kunstmuseum Basel,
inv. no. 660

Bibliography:
Franz Zelger, "*Die wahre ideale
Reallandschaft oder die reale Ideallandschaft.
Formale und inhaltliche Aspekte der Kunst
von Robert Zünd,*" and "*Katalog der
Gemälde und Zeichnungen von Robert
Zünd,*" in *Robert Zünd in seiner Zeit,* exh. cat.
(Kunstmuseum Luzern, 1978), 28 – 30, 79 – 80
(no. 8) (with detailed bibliography).

[1] See Franz Zelger, "*Die wahre ideale Real-
landschaft oder die reale Ideallandschaft.
Formale und inhaltliche Aspekte der Kunst
von Robert Zünd,*" in *Robert Zünd in seiner
Zeit,* exh. cat. (Kunstmuseum Luzern, 1978),
28 – 30.
[2] "Vielleicht entsteht so die wahre ideale
Reallandschaft oder die reale Ideallands-
chaft wieder einmal für eine kurze Zeit," in
"Ein bescheidenes Kunstreischen" (A Mod-
est Little Art Trip) [1882], in Gottfried
Keller, *Aufsätze zur Literatur und Kunst.
Miszellen. Reflexionen,* (Sämtliche Werke,
vol. 22) (Bern, 1948), 299.
[3] Letter to Rudolf Koller, dated 25 November,
1855 (Zentralbibliothek, Zürich), file Kol.
108.38 a, 9.
[4] Jules Coulin, "Der Landschaftsmaler Robert
Zünd," in *Neujahrsblatt für 1910 der Zürcher
Kunstgesellschaft,* 26.
[5] Coulin, 1910 (see n. 4), 28.

Robert Zünd painted nature in a very personal, idio-
matic way, where the inherent harmony of his paintings
gives a true image of his way of life. If his mentors Di-
day and Calame depicted heroic mountainscapes, Zünd
himself was drawn more to the pastoral, idyllic regions

31a Alexandre Calame, *The Wheatfield (Lake Thun),* 1853
Oil on canvas, 78 × 118 cm, Kunstmuseum, Lucerne

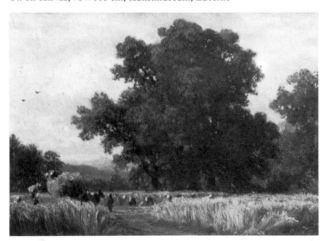

31b Robert Zünd, *The Harvest*
Oil on canvas, 13 × 18 cm, Private collection

31c Robert Zünd, *The Harvest*
Oil on panel, 14 × 18 cm, Private collection

of the Lower Alps and the *Mittelland.* Not striving after
artistic innovations, his approach to nature was rather
religious and contemplative.

Zünd studied with Alexandre Calame, but his con-
tacts with contemporary painters were sparse and indi-
rect. Influenced by the works of Dutch and French mas-
ters of the seventeenth century, he developed his own
talent, and became thus a painter of distinct individual-
ity. *The Harvest* of 1860 is a major work which exempli-
fies the unique character of Zünd's style.

The painting depicts an expansive wheatfield which
recedes into the background between large, somber
trees. A deep blue summer sky with towering clouds di-
rects the eye toward the background. A young peasant
woman, carrying on her head a large basket probably
filled with breakfast for the reapers, walks along a road
which disappears into the grain field. The uncompli-
cated narrative is equalled by the simplicity of the com-
position. The picture is composed of three zones of ex-
pressive, bright color: the modulated yellows in the field
of the wheat, the browns and greens of the trees, and the
blue, white and grey of the sky.

Zünd's working process was very time-consuming,
and it is not surprising that he left a very small body of
completed works. For him, the most intensely creative
part of the process was the preliminary sketch. Without
doubt, *The Harvest* was inspired by the *Wheatfield* of
Alexandre Calame of 1853 (Fig. 31a). An early sketch
for the composition of *The Harvest* depicts a wheatfield
on a vast plain, with dominating oak trees and very
small figures, all closely related to Calame's painting
(Fig. 31b). For his own painting, Zünd chose a lower
vantage point, thus placing the viewer much nearer to
the wheatfield with the harvesters working by a wagon
loaded with sheaves of grain. Step by step the artist
structured the composition toward a final statement.[1]
He makes the trees more dense and impenetrable, the
clouds more compact, giving the painting a stagy effect
and enhancing its immediate impact (Fig. 31c).

At the end of his *Bescheidenes Kunstreischen,* Gott-
fried Keller noted the following about a visit to Zünd :
"Maybe this is the way the true ideal realistic landscape
or the real idealistic landscape emerges once again for a
short while."[2] *The Harvest* seems to provide a striking
example for this combination. While Zünd was devel-
oping the motif, he wrote to his friend Rudolf Koller: "I
try very hard to emulate my supreme ideal of *simple and
purified truth.*"[3] A picture, according to Zünd, does not
necessarily have to be "absolutely true," but rather
"probable."[4] In the museums of Paris, Dresden, and
Munich, he studied and sketched after paintings by
Claude Lorrain, Poussin, and Ruisdael, producing
many copies in various formats, in pen as well as in oil.
Exploring the works of these artists, Zünd learned to
emphasize the experience of nature as well as to pro-
duce an ideal expression. "Classical, i.e. of permanent
value" are the words used in the minutes of the negotia-
tions of the *Schweizerischer Kunstverein* in 1860 to char-
acterize *The Harvest.*[5] FZ

Robert Zünd (Lucerne 1827 – 1909 Lucerne)
Biography, see p. 189

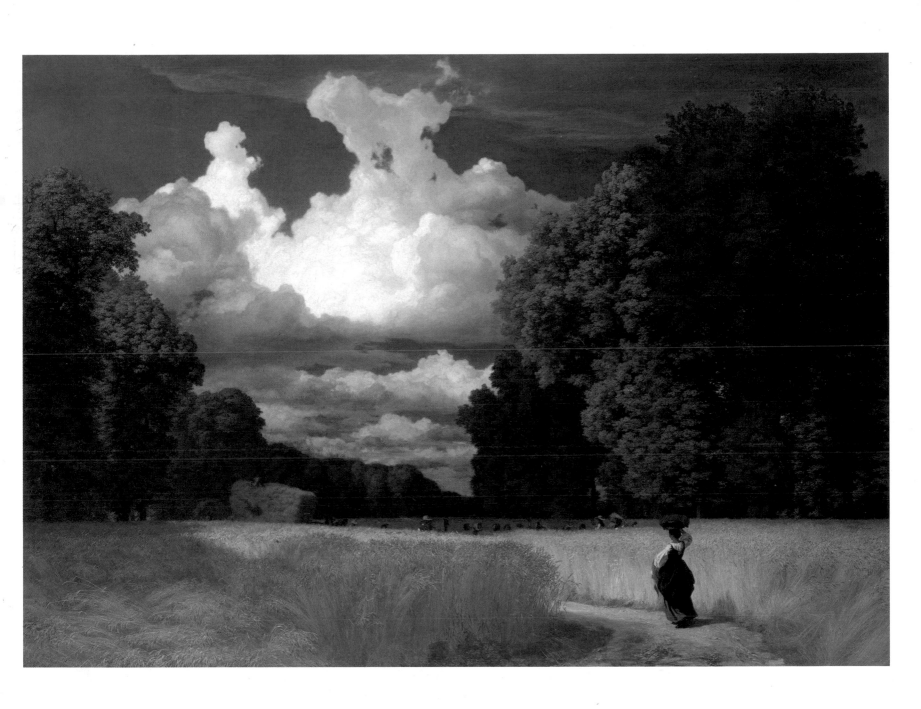

Johann Jakob Ulrich

Cloud Study, c. 1830 – 1835

cat. no. 32
Oil on paper, mounted on
cardboard
13 3/16 × 17 3/4 inches
(33.5 × 45 cm)
Private collection

Bibliography:
Hans Armin Lüthy, *Der Zürcher Maler Johann Jakob Ulrich II. 1798 – 1877. Ein Beitrag zur Geschichte der schweizerischen Landschaftsmalerei in der ersten Hälfte des 19. Jahrhunderts* (Zürich, 1965), 45 – 46, 123, (no. 56).

[1] Hans Armin Lüthy, *Der Zürcher Maler Johann Jakob Ulrich II. 1798 – 1877. Ein Beitrag zur Geschichte der schweizerischen Landschaftsmalerei in der ersten Hälfte des 19. Jahrhunderts* (Zürich, 1965), 45.
[2] Kurt Badt, "Johan Christian Clausen Dahl, Karl Ferdinand Blechen, Johann Georg von Dillis, Johann Jakob Ulrich," in *Wolkenbilder und Wolkengedichte der Romantik* (Berlin, 1960), 45 – 56, esp. 55 – 56.
[3] Lüthy, 1965 (see n. 1), 46 – 47.
[4] Lüthy, 1965 (see n. 1), 25.
[5] Lüthy, 1965 (see n. 1), 24. Compare this concept also with a later remark of Gottfried Keller, regarding Robert Zünd: "Maybe this is the way the true ideal realistic landscape or the real idealistic landscape emerges once again for a short while." (Vielleicht entsteht so die wahre ideale Reallandschaft oder die reale Ideallandschaft wieder einmal für eine kurze Zeit), in "Ein bescheidenes Kunstreischen" (A Modest Little Art Trip) 1882, in Gottfried Keller, *Aufsätze zur Literatur und Kunst. Miszellen. Reflexionen,* (Sämtliche Werke, vol. 22) (Bern, 1948), 299; see also cat. no. 31 in this volume.

The view of Ulrich's study is determined by an unusually wide angle of vision. Of course, the eye is drawn towards the narrow strip of coast, the sailing boats, and the ships, which populate the sea at the lower edge of the painting; but these are "a pretext at best, or possibly scale-models,"[1] since the principal preoccupation of the painter is the cloudy sky which dominates the composition.

Studies of this kind dating from the 1830s stand on the border between two spheres of influence. Kurt Badt[2] sees these paintings by Ulrich, which in his opinion were painted in Italy (1818 – 1830), as successors of its cloud paintings encouraged by Goethe and executed by Johann Georg Dillis (1759 – 1841), Johan Christian Dahl (1788 – 1857), and Karl Blechen (1798 – 1840). Hans Lüthy situates the present cloud study in the period of Ulrich's travels to Holland and England, suggesting that the influence of John Constable is far more relevant. Ulrich had seen Constable's work already in 1824 in Paris and he saw it again in England in 1832 and 1835.[3]

It is certain that Johann Jakob Ulrich's predilection for coastal landscapes and his neglect of topographical accuracy in favor of atmosphere dates back to the time of his stay in Italy. Due to external circumstances, the painter found himself — by chance more than by conscious planning — in Naples rather than in Rome, which was traditionally the destination in Italy. Seven years earlier, the Norwegian artist Johan Christian Dahl had painted landscapes in Naples which were ahead of their time in abandoning the character of *vedute* and emphasizing the immediate experience of light, air and water.[4] In Italy, Ulrich abandoned the direction he had been following up to then in attempting a "combination of realism and ideal landscape."[5] The paintings executed in this period establish him as one of the eminent precursors of *pleinairism*.

The present *Cloud Study* is mainly concerned with rendering the atmospheric mood. Blue and grey tones dominate the picture, which Ulrich daringly sets off in contrasting yellow. The dark grey of the gathering clouds is echoed in the grey, horizontally layered brushstrokes of the water. The coast, southern in its character, is covered by dark shadows to the left, glistening in the light in the central part, and evenly lit by the sun to the right. The sudden changes of light evoke the impression of fast moving clouds. However, the systematical, almost scientific preoccupation with the meteorological phenomena is missing in Ulrich's paintings, as is the complete abandon of all borders, which Turner achieved in his artistic expression of atmospheric appearances.

Thus, even Ulrich's most daring paintings reveal a certain inhibition — his clinging to the realistic details must probably be seen in this context. In fact, after his return to Switzerland, Ulrich never actually made good on the promise which his development in the late twenties and the early thirties seemed to hold. *ES*

Johann Jakob Ulrich (Andelfingen 1798 – 1877 Zürich)
Biography, see p. 188

Barthélemy Menn

Lakeside near Bellerive, c. 1860

cat. no. 33
Oil on canvas
18 ½ × 32 ⅛ inches (47 x 81.5 cm)
Museum zu Allerheiligen,
Schaffhausen, inv. no. 558

[1] "Faire chanter les silhouettes," see Jura Brüschweiler, *Barthélemy Menn. 1815 – 1893. Etude critique et biographique* (Zürich, 1960), 40.
[2] "Cuber un tableau." In the courses Menn conducted during 42 years at the Ecole des beaux-arts in Geneva, cardboard cubes were of utmost importance for the study of volumes. See Brüschweiler, 1960 (see n. 1), 40.
[3] Fritz Schmalenbach, "Barthélemy Menn. Zu seinem 50. Todestag," in *Werk* (Zürich), vol. 30, no. 10 (October, 1943): 303 – 304.
[4] "Dans un buisson, je vois tout," see Brüschweiler, 1960 (see n. 1), 39.
[5] "Le maître des valeurs justes," Brüschweiler, 1960 (see n. 1), 30.

The painting represents a view of the right shore of Lake Geneva near Bellerive, a small town in the vicinity of the town of Geneva. The eye of the viewer moves from the right across a shady bank to the left, towards a sunny small beach, and further on to the roof of a house bearly visible between the trees. The child sitting in the grass, protected by a hat against the sun, the dog in the water, and the strollers in the background, are all figures of small importance, but which nevertheless succeed in conveying the impression of a leisurely and quiet summer afternoon. Neither the landscape itself, nor its details, contain any moment of surprise. On the contrary, by making it the focus of the picture, Menn accentuates the unspectacular which seems not worthy of contemplation. The seemingly insignificant plane of the earth bank to the right is treated by the artist with a sophisticated differentiation of the colors, and so it becomes an independent motif. The trees animate the line of the horizon — Menn speaks of letting "the silhouettes sing"[1] — and create points of reference in the spatial organization of the picture. However, they are not as obvious as some of the trees used by the landscape painters of late Romanticism quite often to enhance the drama of their images.

Lakesides, such as the present one, showing more of the shore than of the water, are typical subjects for a painter who favors the modest charms of a "paysage intime," rather than the spectacular view of the high mountains. The fluid, at times translucent, at times opaque brushstrokes, are particularly suitable to render the texture of the stones, grass, or cut wood. Where Calame and his disciples seek to create the illusion of the material through accurate drawing, Menn achieves the same effect by painterly means. Light, in his paintings, serves not as an accentuating beam which emphasizes the expressive qualities, as in the landscapes of late Romanticism; rather, it is used to model the objects, shaping them into points of reference. Menn prefers to paint with the sun in low position on the horizon, when the distinct shadows mould the landscape more clearly. He primarily understood landscape in its material appearance. Painting was for him "to cube a picture."[2] Fritz Schmalenbach compared the landscapes of Menn to crystals, due to their density and lucidity.[3]

Menn reminds one of Camille Corot in his predilection of the simple, modest motif ("in a bush I see everything," Menn used to say[4]), in his interest in the atmospheric changes of evening and morning hours, as well as in the glittering *contre-jour* light. Menn owes the release from the primacy of drawing — taught by his mentor Ingres — to the unrestricted use of the brush of Corot, who was a close friend of him. It was also through him that the Geneva painter got in contact with the Barbizon circle. He organized exhibitions of their paintings in Geneva, but without great success. The work of the two friends was most closely related in the years between 1851 and 1857, when both Menn and Corot were engaged in painting decorations for the castle of Gruyère. And so, if Menn calls Corot "the master of the just values,"[5] the same could equally be applied to him. *Lakeside near Bellerive* seems to have been painted after the Gruyère period, around 1860, when the differences to Corot became evident: the serene personality of Corot finds its expression in intuitively conceived atmospheric landscapes, basked in an airy silver-grey, whereas the melancholic and brooding nature of Menn tends more towards rationally constructed compositions with earth colors prevailing. *PM*

Barthélemy Menn (Geneva 1815 – 1893 Geneva)
Biography, see p. 185

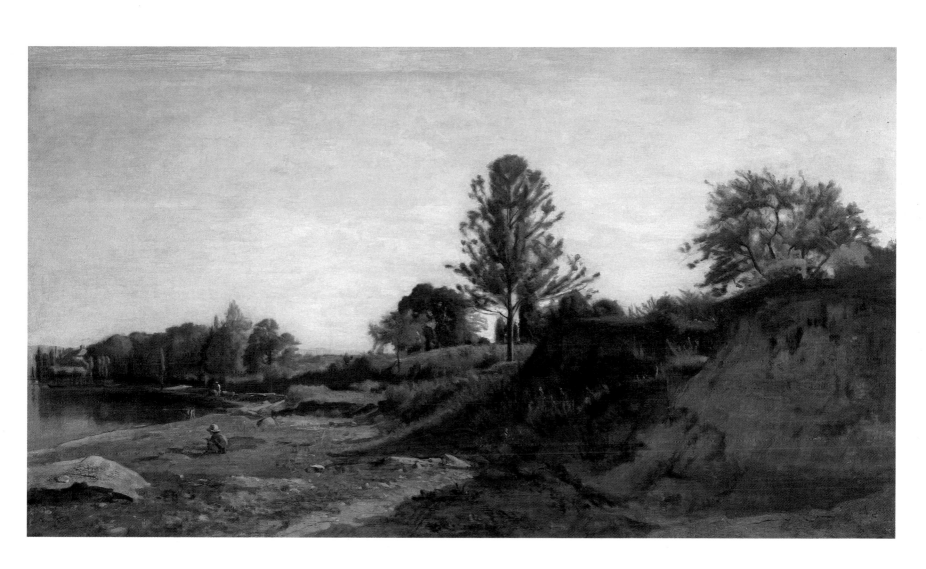

François Bocion

Bocion and his Family Fishing, 1877

cat. no. 34
Oil on panel
12 ⅝ × 19 ⅛ inches
(32 × 48.5 cm)
Signed lower left:
"F. BOCION. 1877"
Musée cantonal des beaux-arts,
Lausanne, inv. no. 250

Bibliography:
Béatrice Aubert-Lecoultre, *François Bocion*
(Lutry, n.d. [1977]), 41 (ill.).

[1] After settling in Switzerland, Courbet lived
only a short distance from where Bocion's
picture was painted and would die only a
few months after it was completed. On Cour-
bet's stay in Switzerland, see *Courbet et la
Suisse,* exh. cat. (Vevey, 1982). Not only did
Courbet make several references to Bocion
in his letters, but upon the death of Courbet,
Bocion was asked to assess the contents of
his studio, thus implying an intimate friend-
ship between the two.

After having studied in Paris in 1845 with Louis Gros-claude and Charles Gleyre, François Bocion returned to Lausanne where he produced portraits, anecdotal genre and history paintings, and also caricature studies for a local satirical review. It was only after 1860, following several trips to Italy and a period of direct contact with Barthélemy Menn in Geneva, through whom he became acquainted with Corot and the Barbizon painters, that Bocion began to devote himself almost exclusively to landscape. For nearly three decades, he focused his attention on the region surrounding the Lake of Geneva, capturing the changing light and atmospheric effects in all seasons and climatic conditions. Bocion, in fact, was known as the unofficial painter of the environs of Lake Geneva and the surrounding mountains as a result of the hundreds of studies he produced. His works are marked by lyrical expression and luminous effects, closer in spirit to Corot than to Calame, but always drawn from studies of the natural landscape itself. Like Menn, Bocion considered direct contact with nature to be essential for his art. He frequently made detailed sketches in watercolor or oil *en plein air*, but very often these were later transferred to finished paintings on canvas in the studio. Only in the 1880s did Bocion permit the exhibition of these *esquisses,* which demonstrate a remarkable vitality.

Because of Bocion's preoccupation with the effects of light and atmosphere of a fixed subject, it is tempting to refer to him as the Swiss Impressionist *par excellence.* While the effects achieved in the finished paintings are often similar to those of his more renowned French contemporaries of the 1870s, Bocion's work is more closely related to that of Bazille than to that of Monet. While Bocion's paintings retain the fresh luminosity of *plein-air* observation, his works are decidedly more structured and controlled with regard to composition, framing, and perspectival axes, and thus are more aligned with a classical tradition. While the colors reveal a brilliant in-candescence worthy of the greatest masters of the Impressionist movement, they are more calculated. In this painting, the muted range of colors in the lake and mountains forms a radiant backdrop against which Bocion has delicately applied areas of pink, red, and green. The result bears witness to Bocion's method of blending open air freshness with the sound structure of a well composed scene.

Bocion and his Family Fishing is rather unusual in that it effortlessly amalgamates the modes of genre, self-portrait, and landscape painting. The painter has represented himself standing in a boat at the left, assuming a pose reminiscent of that of atelier models. His wife, Anna-Barbara Furrer, is found at the far right beneath a parasol, while their five children complete the composition in a manner recalling the unassuming works of Anker. Because Bocion habitually depicted the landscape and topography of the region with great accuracy, the exact site represented here can be identified: the profile of the mountains, particularly the *Dents du Midi* forming the background at the right, make it clear that this is the port of Corseaux near Vevey. The composition illustrates Bocion's method of rendering spatial design by positioning the viewer directly in the work, in this case, as though he were in an adjacent boat observing the fishing scene. The horizon line is placed low in the picture, producing the effect of distance which both recedes into the background and extends outward toward both sides. This breadth is solidly reinforced by the oar at the left and by the jutting rocks at the right.

The skilled combination of naturalistic elements and carefully constructed composition unsurprisingly appealed to Courbet, who was among Bocion's most fervent admirers.[1] *WH*

François Bocion (Lausanne 1828 – 1890 Lausanne)
Biography, see p. 180

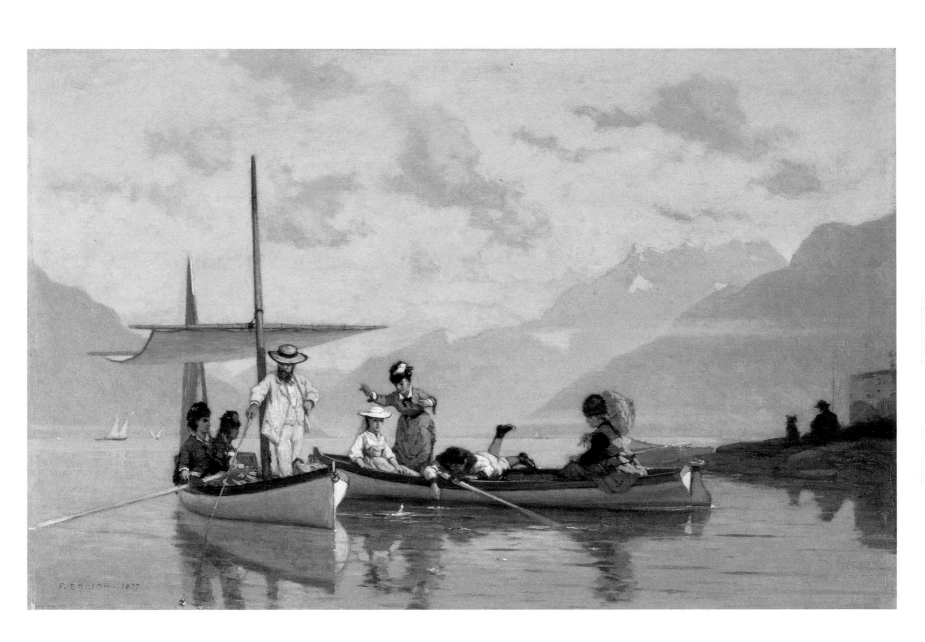

Frank Buchser

The Song of Mary Blane, 1870

cat. no. 35
Oil on canvas
40 ¾ × 60 ⅝ inches
(103.5 × 154 cm)
Kunstmuseum Solothurn,
inv. no. C 13
(Gottfried Keller Foundation)

Bibliography:
Peter Vignau-Wilberg, *Museum der Stadt Solothurn: Gemälde und Skulpturen* (Solothurn/Zürich, 1973), 75—76, no. 64, with detailed bibliography and list of exhibitions.

[1] See Johannes Stückelberger, "Die künstlerische Ausstattung des Bundeshauses in Bern," in *Zeitschrift für Schweizerische Archäologie und Kunstgeschichte* (Zürich) vol. 42 (1985):188—189.
[2] Hugh Honour, *The European Vision of America*, exh. cat. (The Cleveland Museum of Art) (Cleveland, 1975), no. 335 (*William H. Seward in His Garden,* 1869) and no. 336 (*Robert E. Lee,* 1869); see also ill. 7 and 8 on page 27 in this volume.
[3] 7 February 1871, in Gottfried Wälchli (ed.), *Frank Buchser, Mein Leben und Streben in Amerika. Begegnungen und Bekenntnisse eines Schweizer Malers. 1866—1871* (Zürich/Leipzig, 1942), 87.
[4] Honour, 1975 (see n. 2), 354, no. 320 (*Negro Home in Virginia*).

Frank Buchser was one of the most colorful Swiss artists of the nineteenth century. After traveling widely in Europe and North Africa, he wished to visit the United States, mainly because of reports he had heard about the American Civil War. He was especially interested in the passionate battles between North and South, and the newly-won freedom of the Blacks. Buchser was a passionate man himself, and fought where he could for the democratic rights of the Swiss citizen. When he heard about plans to decorate the Bundeshaus in Bern with portraits of leaders of the American Abolitionists,[1] he decided to paint them himself in Washington. A public subscription enabled him to embark on the *City of New York* on 9 May 1866; he reported to the Swiss consul in Washington, D.C., on 28 May.

Buchser was well-received by official circles in the American capital, and he painted portraits of President Andrew Johnson, Secretary of State William H. Seward, the Generals Nathaniel Banks and William T. Sherman, and even of General Robert E. Lee.[2] His desire to travel west was fulfilled when he received an invitation to do so by prominent citizens. In 1867, he visited Virginia for the first time, and began to develop ideas for a major composition on the present and future of the black peoples of America. Several studies from 1869 testify to Buchser's interest in this project and his ambition to paint a portrait of American life.

The Song of Mary Blane speaks both of the tragic past and the tenuous idyllic present of Blacks after their emancipation. While the painting depicts a contemporary scene, the ballad of Mary Blane recounts an earlier event. A banjo player sings about the lovely Mary Blane and her fate: After an unscrupulous white philanderer has violated her, her former lover discovered Mary Blane dishonored on the slave market. The ballad mirrors the lament of the Blacks' struggle to escape slavery. In a letter of 1871, Buchser himself calls the painting a "first-rate masterpiece."[3] He hoped to sell it at exhibitions in Boston (1870) and New York (1871), but no buyer could be found. The canvas was again exhibited in London (1872), Vienna (1873), and Paris (1875), where it won a medal and was reviewed in French art periodicals. But its success was limited; the rather crude naturalism did not suit the taste of the contemporary public. An additional handicap was the novelty of the motif: the depiction of a rural scene peopled only by poor blacks could not be compared with the exotic oriental subjects *en vogue* in European painting of the time. There was not the same comfortable distance, and thus these scenes stirred up deep emotions regarding the question of slavery. Buchser's view of black people's everyday life are quite unique in Western art.[4] *ES*

Frank Buchser (Feldbrunnen 1828—1890 Feldbrunnen)
Biography, see p. 180

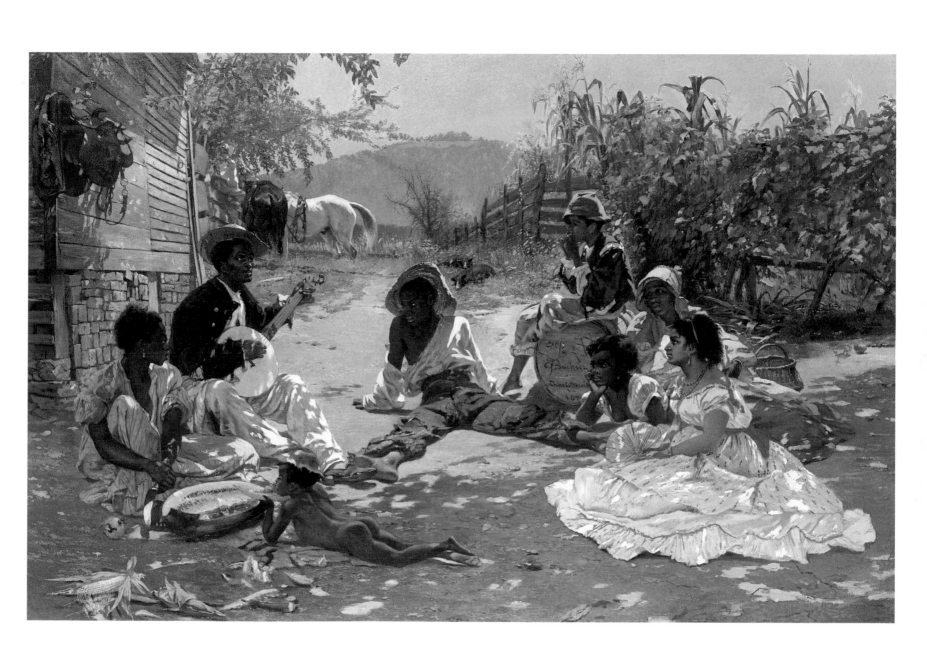

Frank Buchser

Red Indians on Horseback in a Snowstorm, c. 1868

cat. no. 36
Oil on canvas
9 ¼ × 13 inches (23.5 × 33 cm)
Öffentliche Kunstsammlung,
Kunstmuseum Basel

Bibliography:
Frank Buchser. Zwölf Reproduktionen nach Naturstudien in den Vereinigten Staaten im Kunstmuseum Basel, with an introduction by Walter Hugelshofer (Solothurn, 1974), pl. I-4

After his arrival in the United States, Buchser spent the months of June and July, 1866 in Washington, D.C., where he became acquainted with the Governor of Rhode Island, W. Sprague. Sprague invited Buchser to accompany himself, General William Tecumseh Sherman (1820–1891), and the latter's brother Senator John Sherman (1823–1900), to the Midwest to inspect the construction of the Transcontinental Railroad. Sprague had to drop out of the group, and Buchser left Washington alone in early August to join the general and the senator. Together they traveled via Kearny and Julesburg to Fort Laramie, Wyoming, where they arrived on 31 August.

Buchser's interest in visiting the Great Plains of America was focused on the native Indian peoples and their ways of life; but he also hoped to complete his painting on the history of the United States for the Bundeshaus in Bern. Buchser spent nearly three weeks in the southern Laramie hills, where he painted several sketches in oil of the immense, monotonous Plains landscape, and the picturesque Indian peoples.

On his first trip to the then unsettled areas of America, Buchser was impressed by the natural terrain, something completely new and unfamiliar, even exotic. As a result, he modified his earlier conception of landscape painting as seen in the present sketch where the sky covers more than half the canvas. Broad brushstrokes accentuate the infinite expanse of the land. Indians and their horses animate the scene, but every trace of anecdotal description is avoided. His view of nature turns into pure painting, although the figures provide a human dimension to the composition. In the foreground, the brushstrokes are shorter and more lively, sharpening the contrast between the isolated figures and the snow-covered plains. *ES*

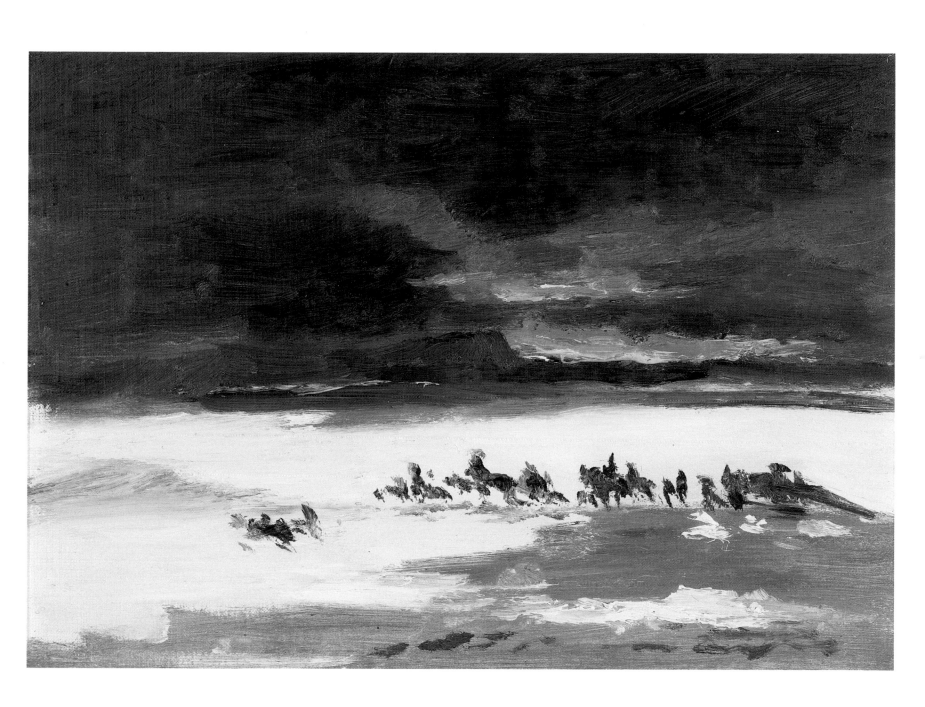

Frank Buchser

Portage, 1868

cat. no. 37
Oil on canvas
10 7/16 × 19 11/16 inches
(26.5 × 50 cm)
Signed lower center:
"Portage 29 July"
Öffentliche Kunstsammlung,
Kunstmuseum Basel

Bibliography:
Frank Buchser. Zwölf Reproduktionen nach Naturstudien in den Vereinigten Staaten im Kunstmuseum Basel, with an introduction by Walter Hugelshofer (Solothurn, 1974), pl. II-5.

[1] H. Lüdeke, *Buchsers amerikanische Sendung* (Basel, 1941), and Gottfried Wälchli (ed.), *Frank Buchser, Mein Leben und Streben in Amerika. Begegnungen und Bekenntnisse eines Schweizer Malers. 1866 – 1871* (Zürich/Leipzig, 1942).
[2] Peter Vignau-Wilberg, *Museum der Stadt Solothurn: Gemälde und Skulpturen* (Solothurn/Zürich, 1973), 74, no. 63.
[3] *The Detroit Free Press,* 4 October 1868.

Since the first half of the nineteenth century, *plein-air* painting had a strong base in Switzerland. During his frequent travels, Buchser had acquired a personal manner of capturing in a quick sketch the interesting aspects of nature, and he achieved a special mastery in this *metier*. Especially fascinated by the immense vastness of the American landscape, Buchser drew and painted virtually hundreds of travel sketches in the United States and in Canada between 1866 and 1871.[1]

In the summer of 1868, Buchser decided to seek out the unspoiled American Indians, away from the big cities in the East. He traveled to the territory of the Chippewa tribe near Sault Sainte-Marie, in the region of the Great Lakes. There he even erected a provisional studio on a rock in the middle of the rapids. The natural beauty of the various phenomena produced by effects of light on the water seduced him into painting several spectacular landscapes dominated by the red of the sinking sun. The view of Portage, on the peninsula of Keweenaw, in Lake Superior, depicts the dissolving of earth and sky into a cosmic unity imbued with light.

Buchser's efforts culminated in three large-scale sketches of the rapids, painted between September and October of 1868, in the provisional studio.[2] The style of these pictures is rather conventional, even narrative, and Buchser clearly hoped to sell them in the United States. To encourage publicity, he invited a critic from *The Detroit Free Press* to his studio: the journalist praised one of the finished landscapes as an "unmatched masterwork."[3] Nevertheless, Buchser sold not a single one of the paintings.

ES

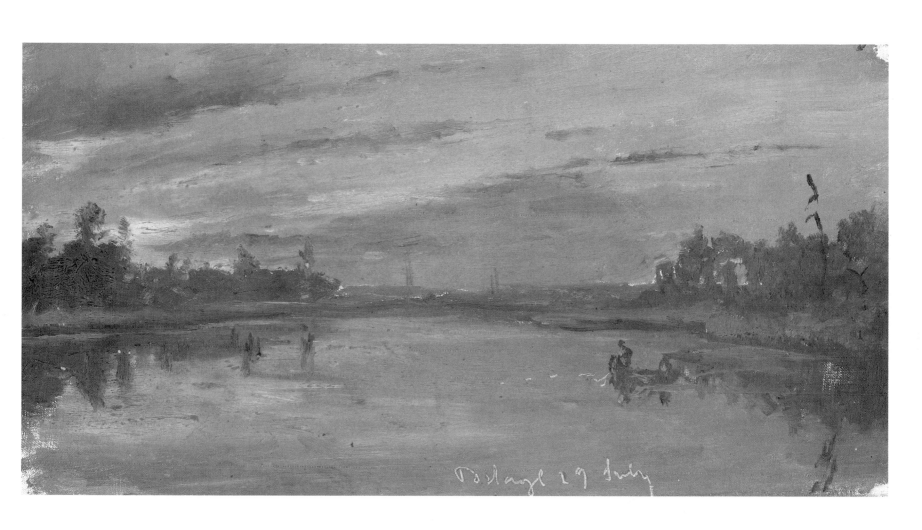

Arnold Böcklin

Roman Landscape, 1852

cat. no. 38
Oil on canvas
29 ³/₈ × 28 ½ inches
(74.5 × 72.3 cm)
Signed lower left:
"A. Böcklin fec[it]"
The Brooklyn Museum, New York,
inv. no. 21.94
(Bequest of A. Augustus Healy)

Bibliography:
"Museum Notes," in *The Brooklyn Museum Quarterly,* vol. 15, no. 3 (July 1928): 96, with ill. on front cover; Rolf Andree, *Arnold Böcklin: Die Gemälde* (Basel/Munich, 1977), no. 71, with detailed bibliography; *Arnold Böcklin,* exh. cat. (Mathildenhöhe, Darmstadt, 1977), vol. 2, no. 9.

[1] See Winfried Ranke, "Böcklinmythen," in Rolf Andree, *Arnold Böcklin: Die Gemälde* (Basel/Munich, 1977), 64–91; see also Franz Zelger, "Invention, Realisation, Degeneration, Böcklin-Motive und ihre Umsetzung auf Postkarten," in Christoph Heilmann, ed., *In uns selbst liegt Italien. Die Kunst der Deutsch-Römer,* exh. cat. (Munich, 1987), 45–59.
[2] Arnold Böcklin to Jacob Burckhardt in a letter, dated 28 July 1861, published in Rudolf Oeri-Sarasin, "Beiträge zum Verhältnis zwischen Jacob Burckhardt und Arnold Böcklin," in *Basler Jahrbuch* (Basel, 1917), 267. Böcklin assures Burckhardt that he "had finally gotten to know Germany, German mentality, German education, German art, German poetry, and so forth to such extent that he would like just to take the first train tomorrow to the uncivilized south."
[3] See Heinrich Alfred Schmid, *Arnold Böcklin, Handzeichnungen* (Munich, 1921), 1 (ill.), 3, 16, (pl. 10 of index 67); the first version belonged to a private collection in Leipzig in 1962, the second one is in the collection of the Kupferstichkabinett, Kunstmuseum Basel (inv. no. 1916.255).
[4] Heinrich Alfred Schmid, *Arnold Böcklin,* (see note 3), 16.
[5] See Hans Holenweg, "Arnold Böcklins gespenstische Visionen," in *Basler Stadtbuch* (Basel, 1985), 133–140.
[6] Rolf Andree, *Arnold Böcklin* (see n. 1), 211, no. 71.
[7] See Paul Ortwin Rave, ed., *Karl Blechen: Leben, Würdigungen, Werk,* exh. cat. (Nationalgalerie Berlin, 1940), nos. 1305–1310.
[8] See Rolf Andree, *Arnold Böcklin* (see n. 1), 211, no. 71.
[9] *Pan in the Reed,* 1856–57, oil on canvas, 138 x 99.5 cm, Oskar Reinhart Foundation, Winterthur, and *Pan in the Reed,* 1859, oil on canvas, 199.7 × 152.6 cm, Bayerische Staatsgemäldesammlungen, Munich.

Böcklin's enthusiasm for Italy was not of the traditional sort: he did not long for places rich in art and culture, but rather for remote landscape settings, far from civilization, without historical traces, or where nature had nearly obscured them.[1] In March of 1850, he arrived in Rome for the first time. Rather suddenly, the dark, heroic, and romantic northern landscapes Böcklin had painted up to that point were eclipsed by clear, light-filled views of the Roman *Campagna.* In the company of his friend Heinrich Franz-Dreber he roamed for days through the "uncivilized south,"[2] sketching in the outdoors. Slowly, he began to introduce figures and mythological characters into his landscapes, even if the first figures were still diminutive compared with the enormous clusters of vegetation. The *Roman Landscape,* destined for Böcklin's brother Werner, belongs to this particular series of works.

The artist modified the conception for this composition as he worked on it. In two preliminary sketches (Figs. 38a and b), Böcklin depicts a satyr observing two women bathing.[3] He abandons this subject in the painting, where the viewer replaces the satyr, and only one woman remains. Comparing the studies with the finished work, Heinrich Alfred Schmid noted that the satyr

has been replaced by "a light patch similar in shape to the demi-god's back."[4] Such puzzling visual effects are typical of Böcklin.[5] The second of the studies, in the collection of the Kunstmuseum Basel, despite the fact that it retains the horizontal format, is much closer to the painting than the first. The left side of the painting is already defined; the woman seen from the front and the satyr, both of whom will eventually be omitted, are already smaller and less important in relation to the entire composition.

Rolf Andree correctly points to the suggestive power of the dark interior of the forest landscape with its untamed vegetation.[6] It is to be assumed that Böcklin knew one of the versions of *Park at Terni with Bathing Girls* (Fig. 38c) by Karl Blechen.[7] The subject of bathers in the woods was a popular motif of the time.[8]

Böcklin's works dating from the first half of the 1850s, like *Roman Landscape,* suggest that the figures have slipped almost unnoticed into the landscape. Landscape and mythological figure will find an equilibrium for the first time in the two versions of *Pan in the Reed,* of 1856–57 and 1859.[9] In his later work, the figures would gain increasing importance until they finally become the true subject of the painting. *FZ*

Arnold Böcklin (Basel 1827 – 1901 Fiesole)
Biography, see p. 180

38a Arnold Böcklin, Preparatory drawing for *Roman Landscape*
Crayon, 30 × 40 cm, Private collection

38b Arnold Böcklin, Preparatory drawing for *Roman Landscape*
Pencil, 26.6 × 40.8 cm, Kunstmuseum Basel

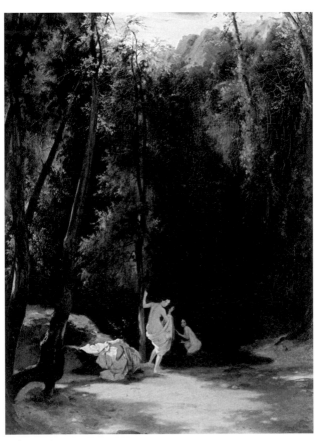

38c Carl Blechen, *Park at Terni with Bathing Girls,* c. 1830
Oil on canvas, 107 × 77 cm, Nationalgalerie, Berlin

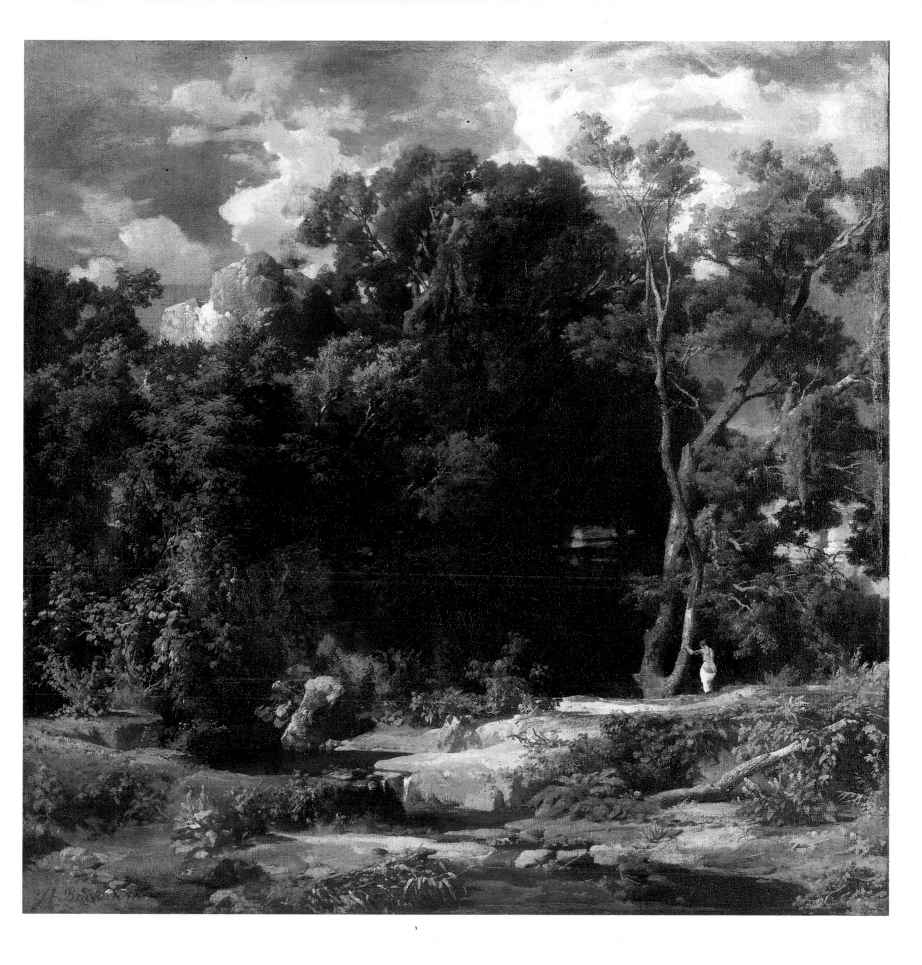

Arnold Böcklin

The Muse of Anacreon, 1873

cat. no. 39
Oil on canvas
31 1/8 × 23 5/8 inches (79 × 60 cm)
Signed upper right: "A.B"
Aargauer Kunsthaus Aarau,
inv. no. 873/13

Bibliography:
Rolf Andree, *Arnold Böcklin: Die Gemälde*
(Basel/Munich, 1977), no. 270, with detailed
bibliography; *Arnold Böcklin,* exh. cat.
(Mathildenhöhe Darmstadt, 1977), vol. 2, no.
86; Franz Mosele, *Gemälde und Skulpturen
vom 18. Jahrhundert bis zum Ersten Weltkrieg*
(Sammlungskatalog Aargauer Kunsthaus
Aarau, Band 1) (Aarau, 1979), no. 13.

[1] The Greek poet Anacreon was born around
the middle of the 6th century B.C. and lived
in Samos and Athens.
[2] *Meyers Konversations-Lexikon,* 1874, 579.
[3] Alfred Berner, "Einige Erläuterungen zu
Musikinstrumenten in den Werken Arnold
Böcklins," in Rolf Andree, *Arnold Böcklin:
Die Gemälde,* (Basel/Munich, 1977), 542.
[4] Rudolf Schick, *Tagebuch-Aufzeichnungen
aus den Jahren 1866, 1868, 1869 über Arnold
Böcklin,* Hugo von Tschudi and Cäsar
Flaischlen, eds. (Berlin, 1901), 73.
[5] "Da auf einmal — mit Beginn der siebziger
Jahre — reisst der Wolkenschleier und die
Welt entzündet sich in leuchtender farbiger
Glut. Wie ein helles Trompetensignal tönt
die *Muse des Anakreon* aus ihrer Umgebung
heraus, und das mächtige Blau und Rot ist
hier nur die Begleitung zu der sprühenden
Kraft des Auges." Heinrich Wölfflin, "Ar-
nold Böcklin: Festrede gehalten am 23.
Oktober 1897," in *Kleine Schriften,* Joseph
Gantner, ed. (Basel, 1946), 114.
[6] Alfred Lichtwark, "Die Böcklin-Ausstellun-
gen in Berlin und Hamburg," in *Pan* (Ber-
lin), vol. 1, no. 4 (1898):50.
[7] Oil on canvas, 78 × 58.5 cm, Hessisches
Landesmuseum, Darmstadt.
[8] Claudia Pohl, "Die Muse des Anakreon," in
Arnold Böcklin, exh. cat. (Darmstadt, 1977),
vol. 2, 196; see also *Arnold Böcklin: Doku-
mentation, Böcklin-Zeitung,* Ergebnisse einer
Übung am Kunstgeschichtlichen Seminar
der Universität Hamburg (Kunsthalle Ham-
burg) (Hamburg, 1976), 2, where it is pro-
posed that "if the source for the image of the
muse is the daughter, then he [Böcklin] is
Anacreon."

The painting was originally produced for a competition sponsored by the Aargauischer Kunstverein in 1872. Since the jury could not decide whether to award the first prize to Böcklin's *The Muse of Anacreon* or to Robert Zünd's *Lake of Sempach,* it proceeded to purchase both of them, one an example of "idealism," the other of "realism."

Euterpe, the muse of lyrics and poetry, is usually identified as the muse of Anacreon.[1] Most of "Anacreon's Songs" are dedicated to "love, wine, and merry conviviality; but, with a genuine gracefulness, he always succeeded in maintaining the balance between discipline and passion."[2] His verses were a source of inspiration for German-speaking lyric poets of the late eighteenth century, in particular, Salomon Gessner and the young Goethe.

Böcklin's muse is painted in a nearly-frontal pose, and is seen from below. Euterpe wears what appears to be an antique *chiton,* and over that is draped a lavishly gold-embroidered red cloak. The locks of her long, wavy hair echo the texture and shapes of the clouds. Her concentrated gaze is fixed on something in the distance; she seems serene, yet in her eyes there is a trace of melancholy. In her hands she holds a musical instrument generally attributed to her: it undoubtedly represents the *aulos* of antiquity, which produces a "sharp, nasal sound quite different from the mellow, singing voice of the flute."[3] Euterpe stands before a pair of foliated tree trunks, one of which serves as backdrop for her head. "It is most opportune to introduce vertical elements in the composition of portraits, since they accentuate the slightest turn of the head," noted Böcklin.[4] The use of such vertical elements in his compositions derives from the Pompeian mural paintings which had so deeply impressed him. They tend to frame the figure, which seems so near and accessible to the viewer, and thus accentuate the portrait quality of the picture. Comparison with Böcklin's portraits of his daughter, Clara, reveals that the muse is conceived as an idealized image of her.

Böcklin's use of intense colors in this picture deserves special attention: "All of a sudden, at the beginning of the 1870s, the veil of clouds dissipates, and the universe is engulfed by a bright colourful glow. *The Muse of Anacreon* sings like a high trumpet signal; and the powerful blue and red hues here are only an accompaniment to the sparkling power of her eyes."[5] Wölfflin's comment on the painting applies as well to other intensely colored pictures Böcklin produced in those years which, according to Lichtwark, "paled entire exhibitions."[6] This holds particularly true for *Euterpe with Doe* of 1872.[7]

The *Muse of Anacreon* must be seen in connection with a pendant *Self Portrait* of the same year (Fig. 39a). There, the artist depicts himself against a backdrop of marble columns which are also encircled by leaves. Hence the muse with the features of his daughter becomes Böcklin's own muse.[8] FZ

39a Arnold Böcklin
Self-Portrait, 1873
Oil on canvas, 24 × 19 1/4 inches (61 × 48.9 cm)
Kunsthalle, Hamburg

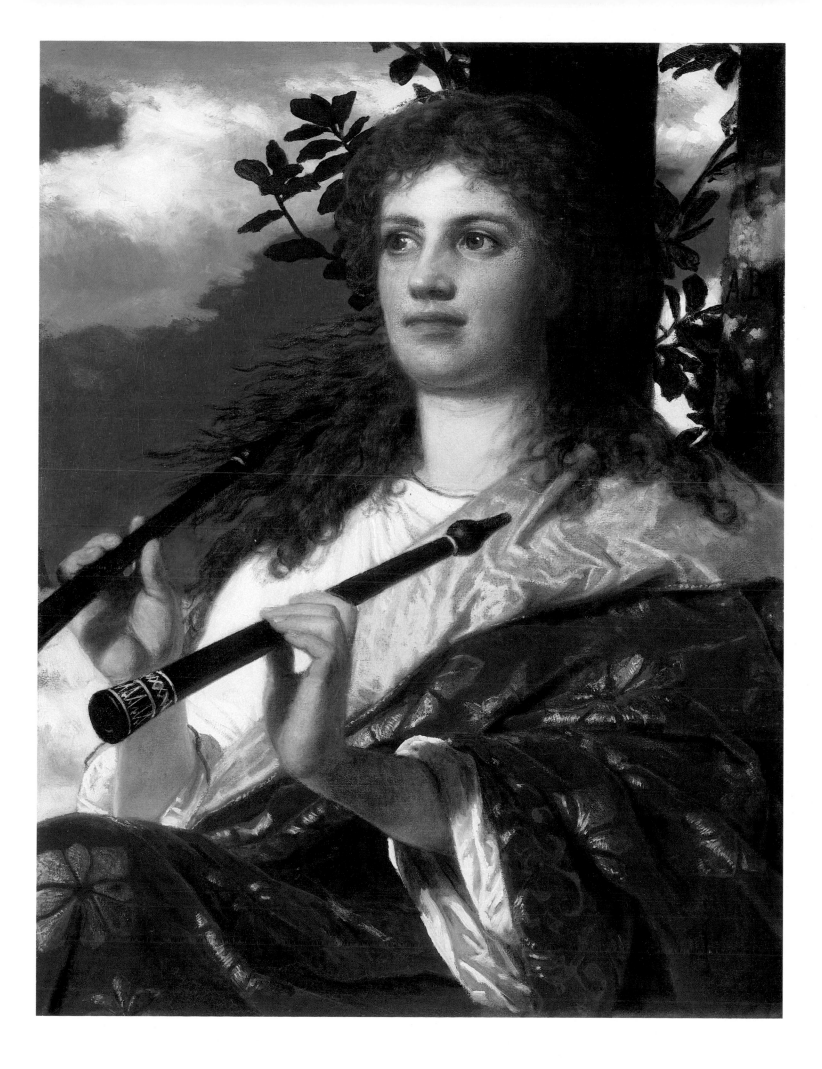

Albert Anker

Girl Peeling Potatoes, 1886

cat. no. 40
Oil on canvas
28 × 20 ⅝ inches (70.5 × 52.2 cm)
Signed lower left: "Anker 1886"
Private collection

Bibliography:
Albert Anker: Katalog der Gemälde und Ölstudien, Introduction by Max Huggler (Bern, 1962), no. 236; Sandor Kuthy and Hans A. Lüthy, *Albert Anker* (Zürich, 1980), 109 (color plate).

[1] Hans A. Lüthy, "Albert Anker: Welt im Dorf, Dorf in der Welt," in Sandor Kuthy and Hans A. Lüthy, *Albert Anker* (Zürich, 1980), 11–25.

[2] See Hans A. Lüthy, "National and International Aspects of Realist Painting in Switzerland," in Gabriel P. Weisberg, ed., *The European Realist Tradition* (Bloomington, Indiana, 1982), 145–186.

[3] See Sandor Kuthy, *Albert Anker: Fayencen* (Zürich, 1985).

[4] For example, Théodule Ribot, *La Servante studieuse,* n.d., oil on canvas, 73 × 59.7 cm, Glasgow Art Gallery and Museum. See illustration in Gabriel P. Weisberg, *[François] Bonvin* (Paris, 1979), 61, ill. 23.

[5] For example, François Bonvin, *La Cuisinière,* 1861, charcoal on paper, 41 × 31 cm, private collection, Paris; see illustration in Gabriel P. Weisberg, *Bonvin* (see n. 4), 274, ill. 269bis. Another example is Bonvin's *L'Ecureuse,* 1873, oil on canvas, 60.7 × 42.4 cm, Musée St-Denis, Reims; see illustration, also in Weisberg, *Bonvin,* 189, no. 57.

The manner in which Anker conducted his own life reflects in an exemplary way the contradiction between the cosmopolitan world and the Swiss homeland.[1] Trained in Paris and moving comfortably in Parisian circles, he nevertheless faithfully returned every summer to his native village of Ins, in the Bernese Seeland.

This "double life" is reflected in his paintings as well. On first examination, it seems that Anker took his subjects from the familiar rural environment, and later translated them into paintings executed according to the French academic painting tradition.[2] This notion may not be entirely incorrect, but it certainly fails to take into account the deeper connotations of Anker's imagery. It was the painter's first priority to provide for the material needs of his family, consistent with his own middle-class bourgeois upbringing. He therefore geared his career toward the production of easel paintings, but also painted porcelain plates for the Théodore Deck Company, thereby assuring himself of a steady income.[3] After his first exhibition at the Paris Salon of 1859, Anker concentrated on a carefully defined range of subject matter for his paintings. His subjects were determined according to the tastes of an affluent art public with money to spend, in Switzerland, France, England, and also the United States. Goupil, Anker's Paris dealer, established not only the necessary contacts in London and New York, but also included etchings and photographs of Anker's paintings in his very popular catalogues.

The *Girl Peeling Potatoes* is conceived entirely according to the formal rules of composition according to French academic training. Two studies, one outlining an empty interior, the other an interior and figure, make it possible to trace the process by which the image was made. They clearly demonstrate how Anker modified reality until a perfectly harmonious unity between figure and space was achieved. The miscellaneous objects portrayed are arranged in the manner of a still life, and clearly serve only the purpose of accessorizing. Their only function is to enhance the frail figure of the girl. In this, Anker again follows the French tradition as it was practiced by his contemporaries, for example Eugène Lepoittevin (1806–1870) or Théodule Ribot (1823–1891),[4] and especially François Bonvin (1817–1887) whose paintings of cooks and kitchen maids attest to a similar infatuation with the materiality of kitchen utensils and foodstuff.[5]

However, Anker's work still stands out against contemporary French painting in terms of his ability to represent a contemplative mood. Here, the girl is completely absorbed with her task which suggests the daily cycle of working, eating, and sleeping. The scene also reflects the spiritual harmony afforded by the undisturbed course of daily life. The maiden's blouse, her light blond hair, as well as the color of her skin serve to capture the luminosity of the interior setting. At the same time, the traditional costume of the Bernese farmer's wife, a detail frequently employed by Anker, and the particular style of her hair refer to traditions which bind a human being to a way of life determined by a conservative hierarchy. *HAL*

Albert Anker (Ins 1831 – 1910 Ins)
Biography, see p. 179

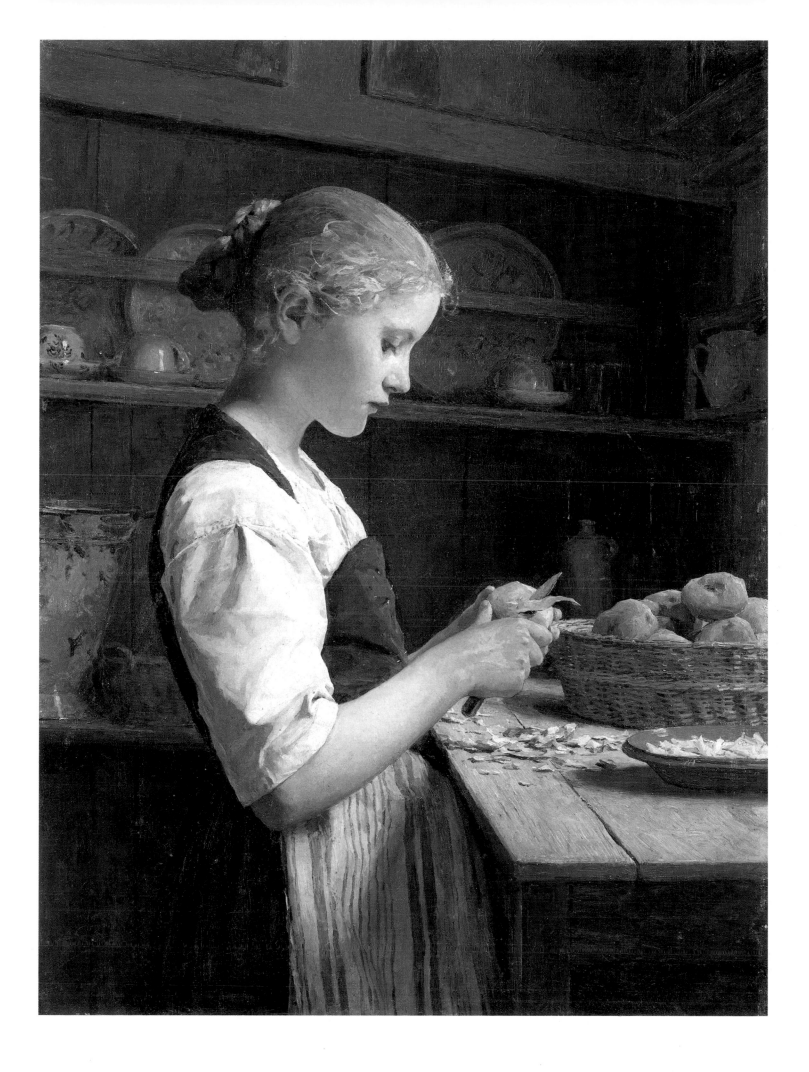

Albert Anker

Boy Sleeping in the Hay, c. 1890

cat. no. 41
Oil on canvas
21 ⅝ × 28 inches (55 × 71 cm)
Signed lower left: "Anker"
Öffentliche Kunstsammlung,
Kunstmuseum Basel, inv. no. 1390

Bibliography:
Albert Anker: Katalog der Gemälde und Ölstudien, Introduction by Max Huggler (Bern, 1962), no. 299; Georg Schmidt, *Museum of Fine Arts, Basle: 150 Paintings, 12th-20th century* (Basel, 1964), 104—105, color ill.; Sandor Kuthy and Hans A. Lüthy, *Albert Anker* (Zürich, 1980), 123 (ill.).

1 *Girl Sleeping beside the Chimney,* in *Albert Anker: Katalog der Gemälde und Ölstudien,* (Kunstmuseum Bern, 1962), no. 131.
2 *Sunday Afternoon,* 1862, in *Albert Anker: Katalog der Gemälde und Ölstudien,* no. 69.
3 *Albert Anker: Katalog der Gemälde und Ölstudien,* no. 124.
4 *Albert Anker: Katalog der Gemälde und Ölstudien,* no. 152, color ill. 1.
5 *Albert Anker: Katalog der Gemälde und Ölstudien,* no. 107 (1878), no. 146 [1861], no. 148 (1870); and the two versions of the *Sick Girl:* no. 158 (1871), no. 159 (1877).
6 Charles Chaplin, *Le Rêve,* 1857, oil on canvas, 106 x 92 cm, Marseille, Musée des Beaux-Arts. See, *L'Art en France sous le Second Empire,* exh. cat. (Paris, Grand Palais, 1979), 322, no. 189 (ill.).
7 Jules Bastien-Lepage, *Jeune femme dans un lit,* 1880, oil on canvas, 38 × 46.5 cm, private collection, Paris. See Gabriel P. Weisberg, *The Realist Tradition: French Painting and Drawing 1830—1900,* exh. cat. (Cleveland, 1981), 254—255, no. 226 (ill.).

Throughout his career, Anker frequently painted sleeping children. Already in 1857, he had portrayed a girl slumbering near an open fireplace;[1] in 1862, he depicted a girl reading the bible to her grandfather, her sister, and her brother who sleeps on the banquet of the oven.[2] Children sleeping next to the warmth of the stove recur later. Perhaps the most accomplished of the works treating this subject is the painting of *Two Sleeping Girls on the Banquet of the Oven,*[3] dated 1895.

The picture most closely related to the *Boy Sleeping in the Hay* is certainly the *Girl Sleeping in the Woods* (Fig. 41a).[4] Exhibited at the Paris Salon of 1866, the painting was purchased the same year by the Musée des Beaux-Arts, Lille. A child, tired from gathering wood, lies at the foot of a large tree. The treetrunk and faggots create a small shelter. The image is devoid of the erotic overtones perceived in contemporary French paintings of similar subjects. There, such overtones are evoked through neglected and torn clothing, or on the contrary, by fashionably decorative attire. The same may be said of representations of figures lying in bed: in Anker's

paintings, people in bed are obviously ill. This distinction is illustrated in the comparison of Anker's *Young Convalescent,*[5] with, for example, the circular composition by Charles Chaplin (1825—1891), *Le Rêve,*[6] or the painting of Jules Bastien-Lepage (1848—1884), entitled *Jeune Femme dans un lit.*[7] Chaplin shows a girl sleeping in a suggestive pose, intimating a no less sensual dream, whereas Bastien-Lepage blends the sensual stimulation induced by the delicate shading of his palette with the appeal of the model herself.

The *Boy Sleeping in the Hay* is a work typical of late Realism. With such a simple subject, the artist has no further ambition than to provide the viewer with a glimpse of daily life far removed from the city, which is precisely the reason these paintings could often be found decorating the walls of bourgeois drawing rooms. Such images of rural life very soon became popular in Switzerland, where the result was a national identification with Anker's subjects. This led, in the following decades, to a deep misunderstanding of the artist's intentions which has not yet been vanquished. *HAL*

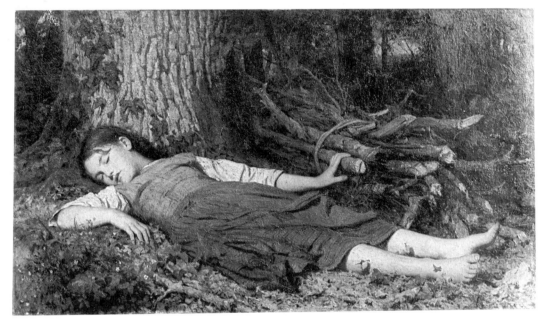

41a Albert Anker
Girl Sleeping in the Woods, 1865
Oil on canvas, 33 ⅞ × 57 inches (84 × 145 cm)
Musée des beaux-arts, Lille

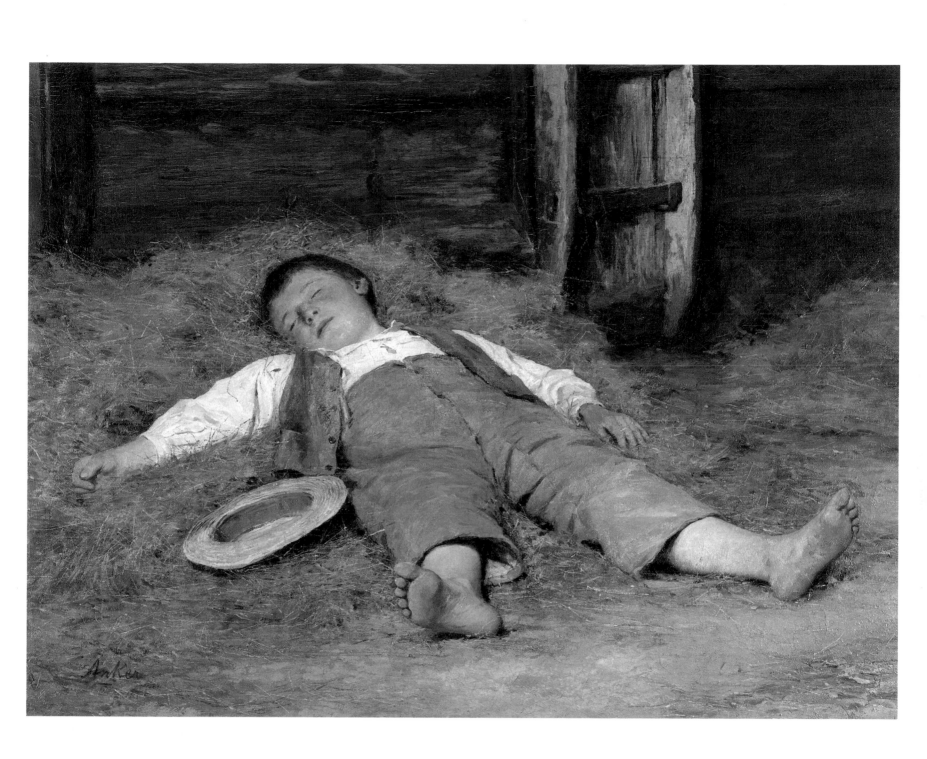

Ferdinand Hodler

The Prayer, 1880

cat. no. 42
Oil on canvas
31 ½ × 39 ⅜ inches (80 × 100 cm)
Signed lower right: "F. Hodler"
Private collection

Bibliography:
Carl Albert Loosli, *Ferdinand Hodler. Leben, Werk und Nachlass*, 4 vols. (Bern, 1921–1924), Vol. 1, 25, 55, Vol. 2, 119; Ewald Bender, *Die Kunst Ferdinand Hodlers* (Zürich, 1923), vol. 1, 94, 111, ill. 92; Hans Mühlestein and Georg Schmidt, *Ferdinand Hodler, Sein Leben und Werk* (Zürich, 1942 [Reprint Zürich, 1983]), 170–171; Walter Hugelshofer, *Ferdinand Hodler* (Zürich, 1952), 21, pl. 15; *Der frühe Hodler, Das Werk 1870–1890*, exh. cat. (Pfäffikon, Seedamm Kulturzentrum, 1981), 50, no. 66, ill. 39; Sharon L. Hirsh, *Ferdinand Hodler* (Munich, 1981), 28, ill. 24; Robert Rosenblum, *Modern Painting and the Northern Romantic Tradition. Friedrich to Rothko* (London, 1975), 121–122; *Ferdinand Hodler*, exh. cat. (Berlin/Paris/Zürich, 1983), 66, no. 8.

[1] It is not conclusively established whether Hodler ever wanted to become a preacher as van Gogh did. See Sharon L. Hirsh, *Ferdinand Hodler* (Munich, 1981), 54, n. 24. In reference to Hodler's life crisis, see Carl Albert Loosli, *Ferdinand Hodler. Leben, Werk und Nachlass*, 4 vols. (Bern, 1921–1924), vol. 2, 117–124.
[2] Ferdinand Hodler, *The Prayer in the Canton of Bern*, 1880/81, oil on canvas, 81 × 109 inches (207 × 277 cm), Kunstmuseum Bern, Gottfried Keller Foundation (see ill. 9 on page 39 in this volume).
[3] Ferdinand Hodler, *The Prayer in the Cathedral of St. Pierre*, c. 1853, oil on canvas, 14⁹/₁₆ × 10 ¼ inches (37 × 26 cm), Kunstmuseum Winterthur.
[4] *St. Philip*, 1526, engraving.

Immediately following his stay in Spain (1878–79), Ferdinand Hodler, not unlike the young van Gogh, lived through a religious crisis.[1] His sister, who by 1880 was the only surviving member of his four siblings, convinced him to accompany her to a religious sect, sensing the yearning for shelter and security of the homeless young man who had lost his father at the age of seven and his mother at the age of fourteen. In the religious community Hodler searched and found temporary consolation. The experience of the shared collective ritual led the 27-year-old painter to explore intensely the subject of meditation. In this spirit he painted *The Prayer, The Prayer in the Canton of Bern*[2] and *The Prayer in the Cathedral of St. Pierre*[3] in the early 1880s.

In the composition of *The Prayer*, a priest, five men and five women are joined in a close group. The priest occupies the left of the three vertical subdivisions which structure the image. He is clothed in a all-enveloping coat, representing the powerful father-, or even God-father-figure who dominates the men in the central part, as well as the women in the right zone of the painting. The plain and godfearing people not only evoke the ideal of unity in silent prayer, but they equally represent the elusive feeling of familial warmth and closeness, which the artist so painfully lacked. Lost in themselves and aware of the transitoriness of life, they symbolize the hope for the redemption of their souls through their collective prayer.

Not only the earth-bound character of these simple people, but even more their pious demeanor attracted the young Hodler. In striving to escape from darkness he sought to liberate himself from the burden of the soil, in order to finally discover in the light the symbol of knowledge. This search is expressed in the development of his art from dark tones to a brighter palette, from the brown of the earth to the blue of the sky. In regard to its color scheme, *The Prayer* is a transitional painting. The black of the priest's cloak and the white of the woman's dress frame the brown tones of the background, as well as the muted blue in the gown of the man in the middle-ground and the brighter blue in the dress of the woman in front.

With this painting Hodler fulfills the full scope of his talent as a painter, which leads to the question of his artistic roots and sources. The black of the coat seems to have its origins in the black paintings of the later Goya, whereas the white is reminiscent of the refined painting of Degas, whose ballet dancers may also have served as models for the lost profile of the woman who is seen from the back. The figure of the priest could be related formally to the priest in Gustave Courbet's *A Burial at Ornans* (1849), to Albrecht Dürer's Apostle Philip[4] or even to Raphael's figure of Aristotle in the *School of Athens*. As far as the motif is concerned, the painting may be a reply to François Millet: *The Prayer* could be seen as the Swiss parallel to the latter's famous *The Evening-Prayer* (*L'Angélus*), painted in 1859. However, all comparisons to works of other artists remain vague: Hodler's creation is essentially original. LA

Ferdinand Hodler (Bern 1853 — 1918 Geneva)
Biography, see p. 184

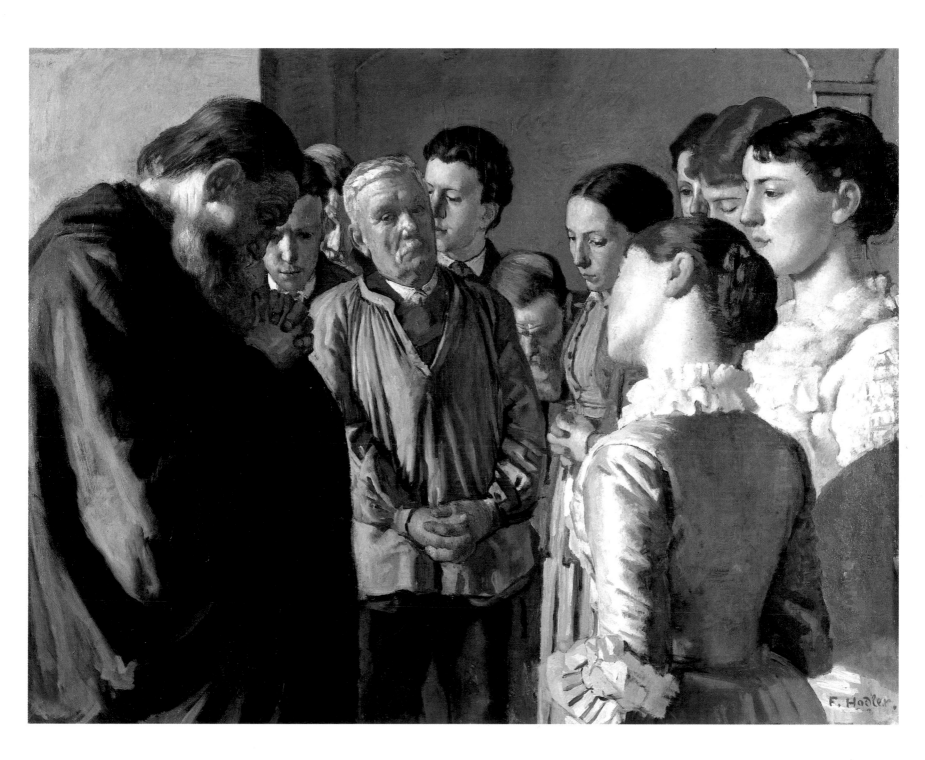

Ferdinand Hodler

Lake Geneva from St-Prex, c. 1901

cat. no. 43
Oil on canvas
28 ⅛ × 42 ⅛ inches
(71.5 × 107 cm)
Signed lower right: "F. Hodler."
Private collection

Bibliography:
Ferdinand Hodler-Gedächtnis-Ausstellung,
exh. cat. (Kunstmuseum Bern, 1938), no. 102;
Werner Y. Müller, *Die Kunst Ferdinand
Hodlers* (Zürich, 1941), 133, ill. 90; *Ferdinand
Hodler,* exh. cat. (Berlin/Paris/Zürich, 1983),
315, no. 77; Oskar Bätschmann, Stephen F.
Eisenman and Lukas Gloor, *Ferdinand
Hodler. Landscapes,* exh. cat. (Los
Angeles/Chicago/New York) (Zürich, 1987),
no. 9.

[1] Jura Brüschweiler, *Ferdinand Hodler. Einige
 Werke aus der Sammlung Karl G. Steiner*
 (Zürich, 1981), 76–98, esp. 78.
[2] Jura Brüschweiler, *Ferdinand Hodler als
 Schüler von Ferdinand Sommer* (Thun, 1984).
[3] Hans Mühlestein and Georg Schmidt, *Ferdi-
 nand Hodler. Sein Leben und sein Werk*
 (Zürich, 1942 [Reprint, Zürich 1983]), 444.
[4] Mühlestein and Schmidt, 1942 (see n. 3),
 437.
[5] Hodler's sharp eye encouraged Carl Albert
 Loosli to an exact botanical identification of
 the plants and flowers of the foreground; see
 Carl Albert Loosli, *Ferdinand Hodler. Leben,
 Werk und Nachlass,* 4 vols. (Bern, 1921–
 1924), vol. 3, 64.
[6] Loosli, 1921–1924 (see n. 5), vol. 3, 64.

Lake Geneva from St-Prex is of particular importance to the development of Hodler's landscape painting. It asserts essentially a new vision, which he recreates in progressively radical statements and which will occupy the painter to the very end of his life. In the confrontation with a version ten years older of the same subject, the *Shore of Lake Geneva,* dated 1891, it becomes apparent how this new idea is manifest (Fig. 43a).[1]

Despite all the compositional reductions which distinguish Hodler's earlier work from contemporary Swiss painting, *Shore of Lake Geneva* still follows the traditional pattern of landscape painting in one crucial point: the shrubs at the edge of the image, which serve as a *repoussoir,* give the composition a frame and an anchor — it seems like a reminder of Hodler's training with his first teacher Ferdinand Sommer, where he learned to paint "beautiful views" according to the rules of art.[2]

43a Ferdinand Hodler
Shore of Lake Geneva, 1891
Oil on canvas, 15¾ × 24 inches (40 × 61 cm)
Whereabouts unknown

However, in *Lake Geneva from St-Prex* this last reminder of such a traditional conception has vanished — except that the obvious clustering of small trees to the right could still be considered a distant memory of the pictorial convention. The painting, which is divided into four horizontal layers — meadow, water-surface, mountain-range, and sky — was considered a "classical work," and an "example for the realistic-expressive intensification of given natural elements" even by Hans Mühlestein and Georg Schmidt,[3] who did not hold back their scorn and mockery when Hodler's application of the "parallelistic" principle became too heavy-handed for their tastes.[4]

In *Lake Geneva from St-Prex,* the precise rendering of the site in minute detail[5] is in no way incompatible with the composed rhythm which articulates the line of the trees and — as a sophisticated counterpoint — the artificially modulated clouds aligned in a row. The seemingly antagonistic elements are rather blended into the expressive statement of a unity which heightens the suggestive force of the image and make this painting an "intimate, sweet dream", a vision "which captures all the senses and does not disengage them again".[6]

During the following years, Hodler deepened his view of the lake and the Savoyan Alps, trained in *Lake Geneva from St-Prex,* on two levels: in *Landscape Rhythm of Forms,* dated 1909 (Fig. 43b), it led him to a very high degree of stylizing. However, Hodler attained a last climax of his visionary power in those pictures, which he painted as an ailing man in the solitude of his room on the Quai du Mont Blanc in Geneva, a few months before his death (Fig. 43c). *MB*

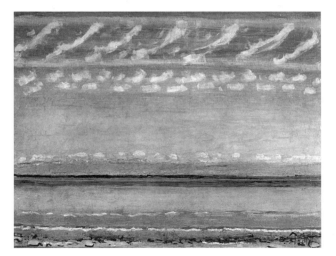

43b Ferdinand Hodler
Landscape Rhythm of Forms, 1909
Oil on canvas, 18⅞ × 25¼ inches (48 × 64 cm)
Aargauer Kunsthaus Aarau

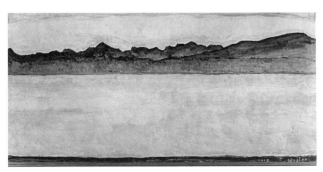

43c Ferdinand Hodler
Lake Geneva with Mont-Blanc at Sunrise, 1918
Oil on canvas, 24 × 49⅝ inches (61 × 126 cm)
Collection of Mr. and Mrs. Joseph Pulitzer, jr., St. Louis, Miss.

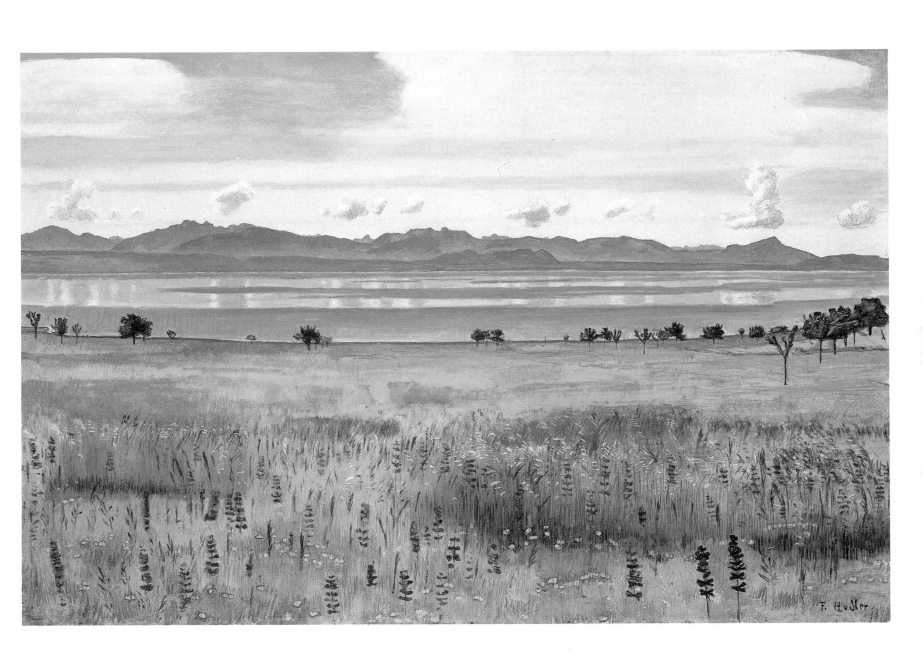

Ferdinand Hodler

The Breithorn, 1911

cat. no. 44
Oil on canvas
27 ¾ × 30 ⅛ inches
(70.5 × 76.5 cm)
Signed lower right:
"1911. F. Hodler"
Kunstmuseum, St. Gallen,
inv. no. G 1972.29
(Dr. Max Kuhn Foundation)

Bibliography:
Carl Albert Loosli, *Ferdinand Hodler. Leben, Werk und Nachlass*, vol. I-IV (Bern, 1921 – 1924), vol. III, 125, 133; Werner Y. Müller, *Die Kunst Ferdinand Hodlers* (Zürich, 1941), 183, ill. 165; Hans Mühlestein and Georg Schmidt, *Ferdinand Hodler 1853 – 1918. Sein Leben und Werk* (Zürich, 1942 [Reprint Zürich 1983]), 460; *Ferdinand Hodler*, exh. cat. (Berlin/Zürich/Paris, 1983), no. 123.

[1] See Jura Brüschweiler, *Ferdinand Hodler als Schüler von Ferdinand Sommer* (Thun, 1984).
[2] Ferdinand Hodler, *Ascent*, 1894, destroyed (three fragments in the Kunstmuseum Bern, Gottfried Keller Foundation).
[3] Ferdinand Hodler, *Precipice*, 1894, destroyed (four fragments in the Kunstmuseum Bern, Gottfried Keller Foundation).
[4] Ferdinand Hodler, *View into the Infinity*, 1902 – 03. There are several versions of this painting known. For its interpretation, see Jura Brüschweiler, "Ferdinand Hodler und sein Sohn Hector," in *Neujahrsblatt der Zürcher Kunstgesellschaft* (Zürich, 1966 – 67), especially 37 – 43.
[5] Another version of *Breithorn* is part of the collection of the Kunstmuseum Lucerne.
[6] Oskar Bätschmann, "The Landscape Oeuvre of Ferdinand Hodler," in Oskar Bätschmann, Stephen F. Eisenman and Lukas Gloor, *Ferdinand Hodler. Landscapes*, exh. cat. (Los Angeles/Chicago/New York) (Zürich, 1987), 37.

The mountain can be considered a *Leitmotiv* in Ferdinand Hodler's oeuvre, and the metaphor of conquering the mountain may be applied to his artistic development as well as to his journey through life. An innocuous outline of a mountainscape stands at the beginning of his career; it ends with magical incantations of the mountain.

The young Hodler learned the craft of producing idyllic views for tourists — entire series of views of the Wetterhorn or the Jungfrau, complete with *Chalets* and cows — in the studio of Ferdinand Sommer.[1] In copying the representations of mountain-views by the Geneva painters François Diday and Alexandre Calame, the emerging artist acquired a deeper understanding of the Alps and of nature in general.

In 1894 Hodler attempted the *Ascent*;[2] however, the mountain rejects him: symbolically, Hodler expressed his defeat in the painting *Precipice*.[3] In 1902 – 03 Hodler positioned his son on the summit of the mountain,[4] and in 1908 he himself reached the peak. From the Schynige Platte, a favorite excursion point reached by mountain railway from Interlaken, he looks across to the Eiger, Mönch and Jungfrau. Three years later, in the summer of 1911, the 58-year-old artist faces the *Breithorn*.[5]

The journey Hodler traveled from the postcard landscape to the summit of the mountain equals the journey from exterior view toward interior vision, from civilization into solitude. During this course, he left the tracing of mankind behind; just as he left the security of the valley behind and was drawn to the icy summits, he also left the flowering vegetation.

The composition of the *Breithorn* consists of one part mountain and two parts sky: one part rock, ice and snow, and two parts pure blue expanse. The flat pyramid rests immovably on the nearly perfect square of the picture plane, towering above the world, inaccessible, unattainable. Its mass sheds the last mist of night, and in the infinity of the blue space the mountain exudes eternal peace. Based on the geological structure of the massif,[6] Hodler emulated the snow-fields glistening in the sun, the abysses in dark shadow, the harshly cleft rocks, and the icy crests in a nearly sculptural way. He measured his strength on the mountain, just as the mountain climber does. Hodler applied the paint, fully conscious of the power of the rock, setting brushstroke next to brushstroke, as the mountain climber puts pick after pick into the rock face, following the laws of the mountain in order to master it.

But the mountain remains unassailable. The challenge of the mountain becomes a symbol for Hodler's lonely combat with himself. In the silence and the solitude of the mountain top he fights his own war of mind and matter. The mountain, as part of the earthly matter, and the sky, as part of the mental universe, come together. The mountain in its timelessness and the eternity of the sky form a new unity. But, like Nietzsche's Zarathustra, Hodler had to continue on his journey. In the eternal stillness of the peak, where every sound is swallowed without an echo, Hodler started out towards his last solitude.

Standing high above the world on top of the mountain he found his freedom in the blue of the sky, as Munch had found it in the midnight-blue shores of the sea. Both of them are the successors of Romanticism, which had found in the impeccable blue of the southern sky the expression of a sensual-intellectual openness. For Kandinsky, blue conveys the vision of the abstract-spiritual, which became the theme of the *Blaue Reiter*. Yves Klein quenches the longing for a blue sky in his blue paintings. Hodler as well professes in the blue the belief of their order: they both were Rosicrucians.

LA

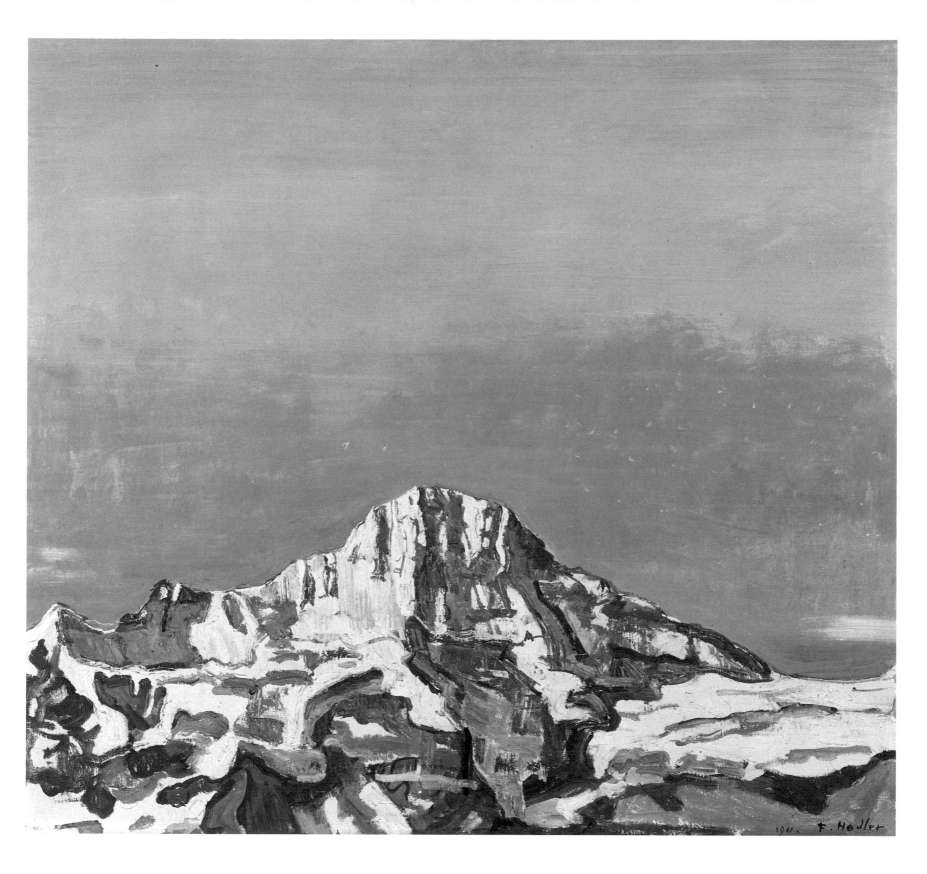

Ferdinand Hodler

Self-Portrait, 1916

cat. no. 45
Oil on canvas
24 3/8 × 23 7/16 inches
(62 × 59.5 cm)
Signed lower right: "F. Hodler"; on
reverse: "Selbstbildnis Dez. 1916"
Kunstmuseum Winterthur,
inv. no. 652

Bibliography:
Jura Brüschweiler, *Ferdinand Hodler. Selbstbildnisse als Selbstbiographie,* exh. cat. (Kunstmuseum Basel) (Bern, 1979), 130–145, no. 97 ("Selbstporträt, lächelnd VII").

[1] In 1979, Jura Brüschweiler counted 113 self-portraits by Hodler, 47 oil paintings and watercolors, and 66 drawings. See Jura Brüschweiler, *Ferdinand Hodler. Selbstbildnisse als Selbstbiographie,* exh. cat. (Kunstmuseum Basel) (Bern, 1979), 7.
[2] Brüschweiler, 1979 (see n. 1), 99–163.
[3] Brüschweiler, 1979 (see n. 1), 182–184.
[4] *L'autoportrait à l'âge de la photographie: Peintres et photographes en dialogue avec leur propre image/Das Selbstporträt im Zeitalter der Photographie: Maler und Photographen im Dialog mit sich selbst,* exh. cat. (Musée cantonal des beaux-arts, Lausanne/Württembergischer Kunstverein, Stuttgart, 1985), 33.

Hodler portrayed himself continually during his career, producing more than one hundred self-portraits.[1] These images all represent different stages in his perpetual search for an understanding of his own personality, both as man and as artist.

In periods when his ego was endangered, at the beginning of his career and again in his last years, the probing of his inner being through the self-portrait became even more compulsive. During the formative years of the artist when material sacrifices were necessary, Hodler portrayed himself sitting at the easel or in the pose of historical role-models such as Rubens or Velasquez. In times of critical rejection, this posture of self-assertiveness took on the character of stubborn self-defence.

But in the last decade of his life, it was Hodler the man, who was distraught over the sickness and death of his lover Valentine. In painting, he searched for his inner self, cutting through his despair, without false pretense or gesture. Hence, the late series of self-portraits[2] reflect his fear of his own death, his personal experience of the transience of life and, in particular, his boundless solitude. The present picture, dated 1916, belongs to this chain of interior monologues. Over twenty self-portraits, drawn, painted, and lithographed, dating from the same year,[3] represent a kind of personal journal.

Hodler gives himself over mercilessly to the mirror-image he faces. The half-length portrait leaves an unusually large portion of the nearly-square surface of the canvas void. The eyes stare directly out of the center of the picture with a fixed expression. Each crease in his face is delineated in minute detail. The artist observes himself from a remote inner vantage point, almost like an objective observer. Against the monochrome background, he portrays himself like one of the mountains he painted against a limitless sky. The brushstrokes of the face appear to be as hard as metal-shavings, and the powerful application of paint corresponds to the energy in the forceful turn of the body. In contrast to the face, the shoulders and torso are painted in broader, looser brushstrokes. This disparity of technique in the handling of paint divulges a sense of Hodler's fight for inner survival. It finds expression on his face showing mixed emotions of wisdom, skepticism, joy, pain, suffering, and grief.

"If we cannot free ourselves, we can at least free our vision."[4] This sentence by Piet Mondrian could sum up Hodler's late self-portrait. By painting himself like a mountain, he seems to acknowledge the petrification of his soul: Hodler remained a prisoner of his loneliness, yet he succeeded in formulating his vision. His sight is unobstructed, as if he were looking from the summit of the mountain into the far distance. This is the painter's freedom; using all the colors, yellow, purple, maroon, greyish-green, and black, he reconstructs his face which finally becomes the revelation of life itself. *LA*

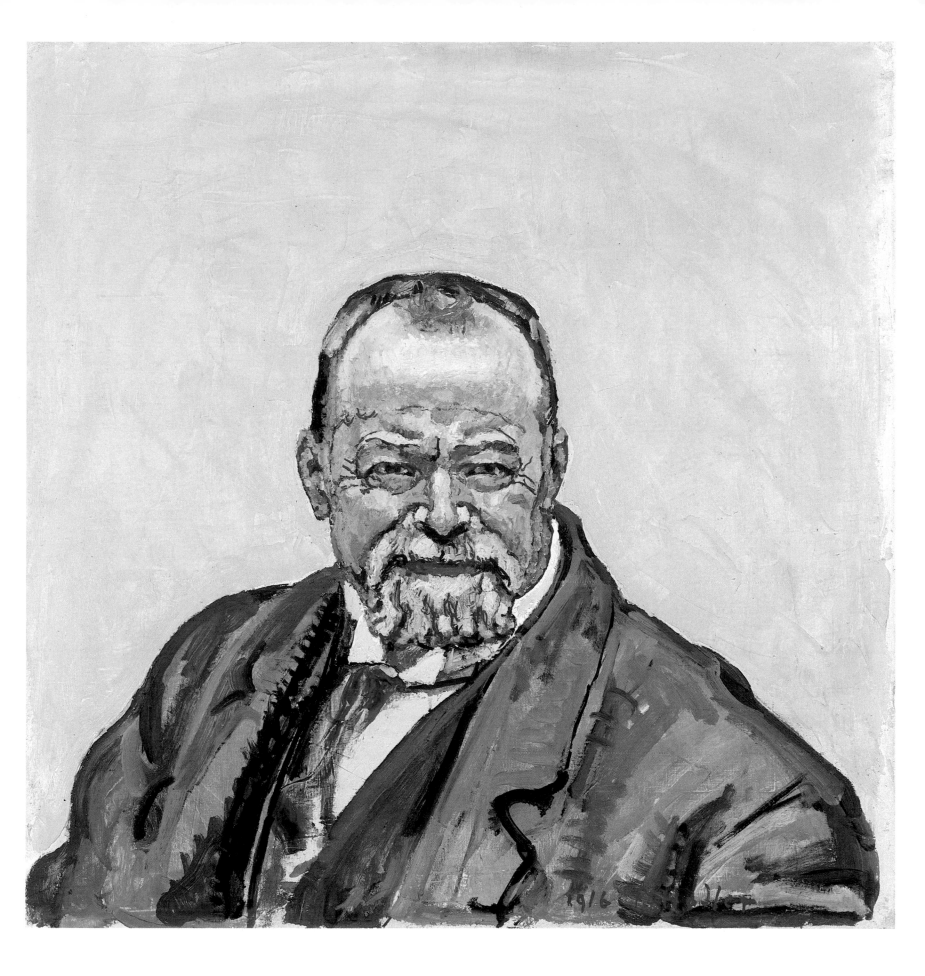

Max Buri

The Two Card-Players, 1913

cat. no. 46
Oil on canvas
47 ⅝ × 59 inches (121 × 150 cm)
Signed and dated lower right:
"MAX BURI/1913"
Private collection

Bibliography:
Gedächtnis-Ausstellung Max Buri, exh. cat.
(Kunsthaus, Zürich) (Zürich, 1915), no. 109;
Hans Graber, *Max Buri: Sein Leben und Werk*
(Basel, 1916), 70, 55 no. 160; *Max Buri*
1868 – 1915 (Kunsthalle, Bern) (Bern, 1928),
no. 98.

[1] Hans Graber, *Max Buri: Sein Leben und*
Werk (Basel, 1916), no. 160; Graber lists an
earlier painting, *Card-Players,* 1908, as no.
88, pl. 27.
[2] For Buri's autobiography, see Hans Graber,
Max Buri (see n. 1), 17 – 20, especially 19.
[3] For example, Buri's painting entitled *The*
Village-Politicians, dated 1904, in the collec-
tion of the Kunstmuseum, Basel, is directly
connected to a painting by Leibl of the same
title, dated 1877; for an illustration of Buri's
painting, see Hans Graber, *Max Buri* (see n.
1), no. 48, pl. 13.
[4] Hans Trog, *Max Buri* (Neujahrsblatt der
Zürcher Kunstgesellschaft) (Zürich, 1917), 4.
[5] C.A. Loosli, *Max Buri 1868 – 1915,* exh. cat.
(Kunsthalle Bern) (Bern, 1928), 5.
[6] Max Buri to Max Vollenweider, 27 April
1913, Archive of the Estate of Max Vollen-
weider, Köniz (Bern).

After extensive travels during his youth which took him as far as the Mediterranean coast of Africa, Max Buri settled in the village of Brienz which lies halfway between Lucerne and Interlaken in the heart of the Swiss Alps. Dissatisfied with life in Paris and Munich, he finally discovered a new homeland in the environs of Brienz. The mountain landscape, perpetually covered with snow, and the village people became the subjects of his paintings. Buri, who had always lived in cities, painted the mountains in an idealized way, bathed them in eternal sunshine, and depicted farmers only in their Sunday clothes. His mountains, whether they peek through living room windows, or tower majestically above the landscape around Lake of Brienz, never loom menacingly; on the contrary, they seem to offer shelter and protection. After having accomplished a day's work, Buri's farmers rest in their drawing rooms, or treat themselves to a glass of wine in a tavern, engaging in friendly conversation or a card game. This is the subject of *The Two Card-Players* dating from 1913.[1]

The two men playing cards, genuine characters from the local mountain region, sit opposite one another at a table, each filling a third of the canvas. Large, burly figures, they completely occupy the space of the picture, which seems to barely contain them. The men rest their heavy hands on the table, which appears squeezed between them; each one awkwardly holds his cards. A bottle standing precisely in the middle of the table marks the central axis of the composition. This compositional point is even further defined by a small, framed picture hanging on the wall. The closed structure and symmetrical organization of the picture lend a stylized quality to the scene, and transform the farmers into characters who seem like actors in an amateur play.

The popular subject matter and its appeal represent a clear break with the workshop of Buri's teacher Albert von Keller (1844 – 1920) and the *demi monde* of his courtesans. If we did not know directly from Buri himself about his residence at the Académie Julian in Paris, and about his training with Bouguereau,[2] we would surely doubt it in view of the common people he paints. The direct approach to the subject and to the picture plane, the balanced symmetry of the composition, the crispness of the silhouettes, and the simple treatment of volumes all point to the example of Hodler. However, Buri's farmers remain actors in painted scenes, never attaining the symbolic and monumental bearing of Hodler's figures. Subject matter borrowed from the paintings of Wilhelm Leibl (1844 – 1900),[3] Wilhelm Trübner (1851 – 1917), Benjamin Vautier (1829 – 1898), or Albert Anker is here further reduced to essential limits by the "painter of Brienz". The French tradition of the card-player as a motif, surely known to Buri from the exemplary work of Paul Cézanne, does not seem to be an immediate source. The only element which reflects innovative contemporary attitudes or techniques is the color scheme Buri introduces to his wholesome figures, perhaps borrowed from Cuno Amiet.

The universe of Max Buri is uncomplicated and healthy. His art is, as Hans Trog has noted, an art without shadows, psychologically as well as artistically.[4] It represents a kind of *Volkskunst,* as straightforward and cheerful as the artist himself, who used to close his letters with the salutation "prosit," meaning: to your health,[5] and who wrote to his painter friend Max Vollenweider in 1913, the same year in which he painted the *The Two Card-Players:* "It seems to me that everything gets more and more uncomfortable; to hell with all these cubists and futurists and other animals!"[6] *LA*

Max Buri (Burgdorf 1868 – 1915 Interlaken)
Biography, see p. 181

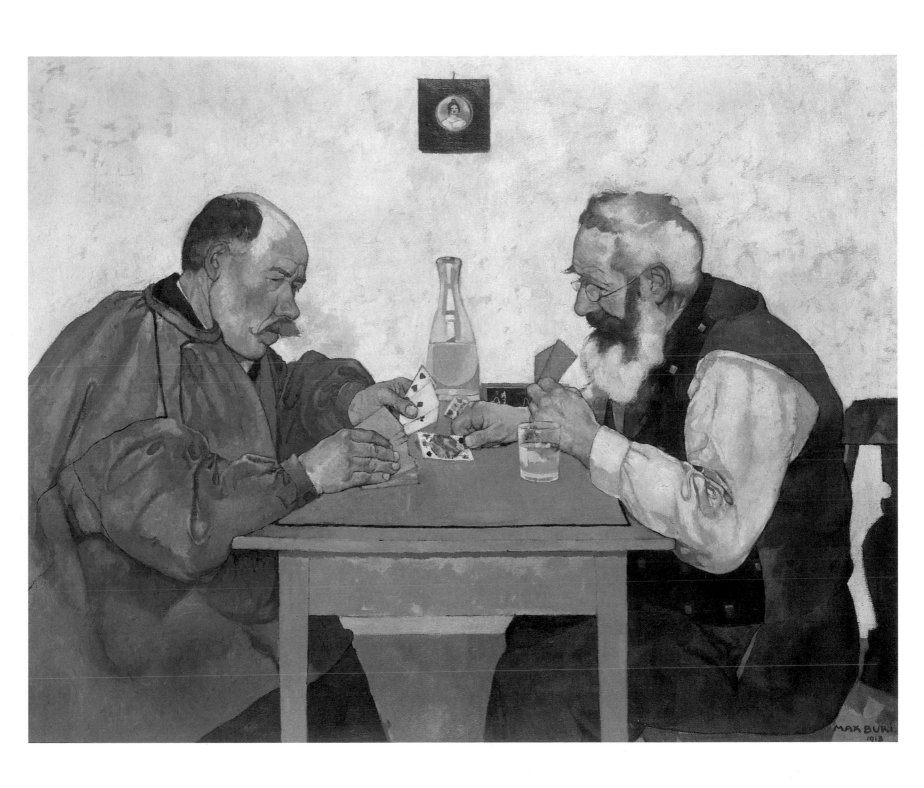

Félix Vallotton

Woman in Bed Playing with a Cat, 1899

cat. no. 47
Oil on cardboard
18 ⅞ × 24 ¾ inches (48 × 63 cm)
Signed lower right:
"F. VALLOTTON"
Private collection

Bibliography:
Listed in Vallotton's catalogue of his own work, the *Livre de raison,* as no. 406, "Femme couchée jouant avec un chat. peinture;" *Félix Vallotton,* exh. cat. (Kunsthaus Zürich, 1938), no. 39.

The year 1899 marks an important turning point in Vallotton's life and work. The 34-year-old painter married a widowed Parisian woman, slightly older than himself, the sister of the art dealers Josse (1870–1941) and Gaston (1870–1953) Bernheim-Jeune, who was used to the comfortable life of a fashionable society. Vallotton left his modest apartment in the Latin Quarter and moved to a more spacious, comfortable one at the Rue de Milan. The open, light-filled rooms of the elegantly appointed apartment immediately seduced him. He took full advantage of his new environment in a series of paintings which depict the warm atmosphere of the interior. These works belong to the most pleasurable and delightful images in Vallotton's oeuvre.

The present picture stands at the beginning of this series. The image is still considerably stylized, emphasizing the purely decorative elements, and the colors are still dark and muted. It is related to the wood-cuts which preoccupied him in the late 1890s, in particular the famous sheet *La Paresse,* dating from 1896 (Fig. 47a). However, *Woman in Bed Playing with a Cat* is much lighter and more humorous. Charming anecdotal details, such as the slippers next to the bed, or the open book on the comforter, ease the rigidity of the composition. The casual perspective has a similar effect, but also adds an ironic touch. A clearly defined vanishing point is missing, as can be seen in the detail of the headboard of the bed which stands nearly parallel to the picture plane. Such primitivism is also evident in the heavy contours and the manner in which Vallotton renders the shadows.

Unlike the wood-cut, the painting is illuminated by a clearly defined light source; but it lacks the modeling effect of traditional painting in muted colors. The fact that there is no transition between the flat ornamental bands of the shadows and the illuminated parts only further emphasizes the flatness of the picture space in this composition. *RK*

Félix Vallotton (Lausanne 1865 – 1925 Neuilly/Paris)
Biography, see p. 188

47a Félix Vallotton
La paresse, 1896
Woodcut, block 7 × 8¾ inches (17.2 × 22.2 cm)

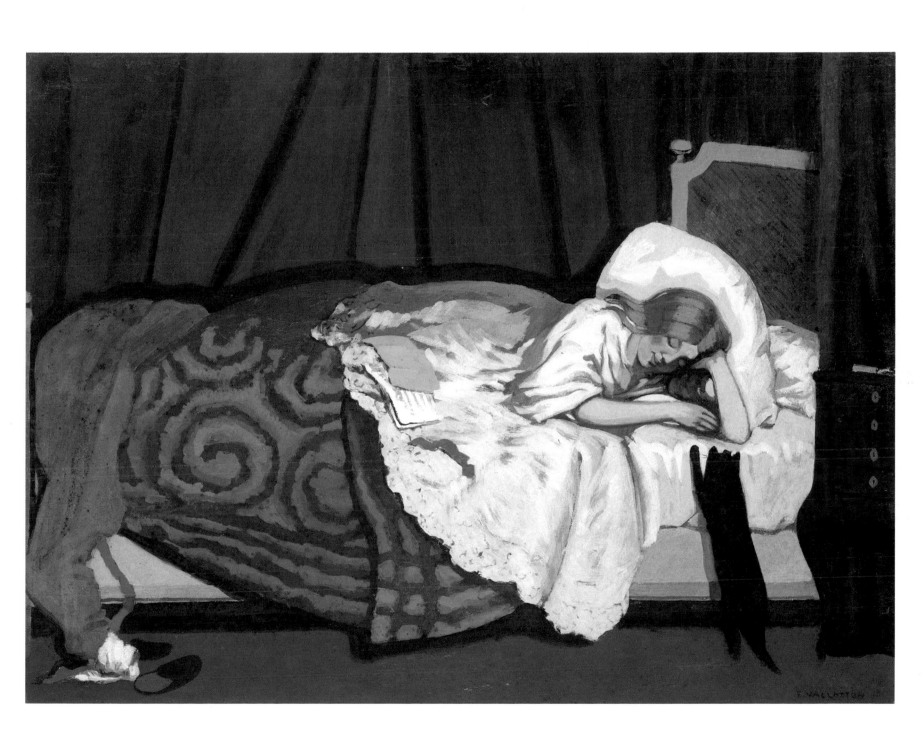

Félix Vallotton

Solitaire (La réussite), 1912

cat. no. 48
Oil on canvas
35 ¼ × 46 1/16 inches
(89.5 × 117 cm)
Signed lower right:
"F. VALLOTTON. 12"
Kunsthaus Zürich, inv. no. 2459

Bibliography:
Recorded in Vallotton's catalogue of his own work, the *Livre de raison,* as no. 902 under the title "Femme nue accroupie, de dos, la tête à droite, faisant une réussite sur un coussin rouge. tapis et fond bleu (T 50)"; Rudolf Koella, *Félix Vallotton im Kunsthaus Zürich* (Zürich, 1969), Sammlungsheft 1, 90–93; *Félix Vallotton,* exh. cat. (Kunstmuseum Winterthur, 1978), no. 112, ill. 52; Anton Friedrich and Rudolf Koella, *Félix Vallotton* (Zürich, 1979), 109 (ill.); Günter Busch, Bernard Dorival, Patrick Grainville, Doris Jakubec, *Vallotton* (Lausanne, 1985), 109 (ill.).

Vallotton liked to call himself a "peintre de nus," and in fact, with the exception of landscapes, nudes constitute the largest single corpus of paintings in his oeuvre. Vallotton's preoccupation with the theme can be traced back to the early years of his apprenticeship at the Académie Julian. However, he began to experiment in a more concentrated way with the portrayal of the female body only around 1904. Its evolution culminates in the later years, between 1909 and 1925.

As may be learned from Vallotton's catalogue of his own work, with few exceptions his nudes were painted during the winter months which he spent in his Paris studio. During the warmer seasons he concentrated on landscapes and still lives. For the most part, the nudes were painted without preliminary sketches, as was also the case for his still lives. In a few cases, small yet brilliant pencil studies have survived which capture the essence of the figure with a few lines.

The present painting, depicting a woman crouching on the floor and playing a game of *réussite,* or solitaire, is typical of Vallotton's mature work. The female body is projected onto a large canvas, and is depicted in close-up, extending almost to the lateral edges of the painting. The surrounding area is treated as a flat, decorative surface; by contrast, the plasticity of the nude is enhanced so that it appears to float in space.

As with all his nudes from the late period, Vallotton consciously elects not to integrate the figure of *La réussite* into an interior genre setting. However, neither does he abandon the anecdotal context altogether. The rather unusual position of the model is accounted for by the addition of the cushion and the deck of cards; yet these objects do not succeed in relieving the contrived artificiality of the pose, nor in transforming it into gesture or movement. On the contrary, in this context the figure appears even the more stylized, as if locked in this particular pattern of body movement. The handling of the paint further emphasizes this impression: the body is rendered in a flat, ashen color which absorbs all lustre; the skin seems strangely lifeless, even though every crease is depicted with acrimonious precision. In any case, nowhere is there the quality of shimmering feminine skin.

Vallotton seems to treat the female body as an object, similar to the approach of the painters of *Neue Sachlichkeit* who greatly admired his work. He deprives the body of its sensual aura and insists on its purely formal qualities: volume and contour. His nudes, as a result, maintain the inherent properties of still life painting. *RK*

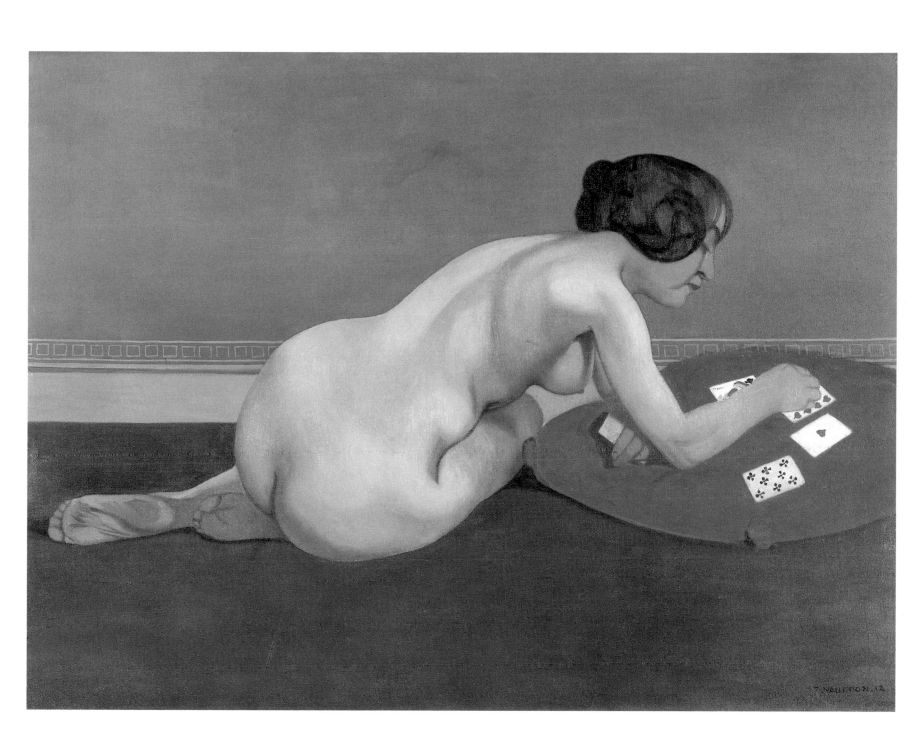

Félix Vallotton

Sunset, 1918

cat. no. 49
Oil on canvas
21 ¼ × 29 inches (54 × 73.5 cm)
Stamp of the estate, lower right:
"F. VALLOTTON. 18"
Private collection

Bibliography:
Recorded in Vallotton's catalogue of his own work, the *Livre de raison,* as no. 1180 under the title "Coucher de soleil, grands nuages bleus, ciel rose et jaune. 1ᵉʳ plan terres labourées (T 10)"; *Félix Vallotton,* exh. cat. (Kunstmuseum Winterthur, 1978), no. 143, ill. 64; Hans A. Lüthy and Hans-Jörg Heusser, *Kunst in der Schweiz 1890−1980* (Zürich, 1983), 185 (ill.).

[1] "Dem *Horizontalparallelismus* steht gegenüber das *Prinzip der gedoppelten Symmetrie. Gedoppelt* deswegen, weil sowohl die linke wie die rechte, als auch die untere und die obere Bildhälfte einander symmetrisch entsprechen." Hans Mühlestein and Georg Schmidt, *Ferdinand Hodler. Sein Leben und sein Werk* (Zürich, 1942) Reprint, Zürich 1983, 442.

After 1910, sunsets appear in Vallotton's oeuvre in great numbers. They are counted among his most innovative, and certainly also among his most daring creations.

A niece of the painter recalls the magic he saw in evening light, especially on the coast of Normandy where he spent most of his summers. Nearly every evening Vallotton would ride his bicycle to a small hill, the Côte-de-Grâce, from where he would contemplate the entrancing spectacle of the setting sun. At home in his studio, he recreated his visions, sometimes from tiny sketches, but mainly from memory; sometimes he even painted the pictures in Paris, months after his stay in Normandy. This may account for the repression of the narrative, descriptive element in favor of pure form, rendering images reduced to the most fundamental formal principles. The artist often takes a single element as the basis of his painting: the horizontal layering of colored bands, for example, which are clearly differentiated by painterly qualities. Into these bands he would often integrate the last glow of the sun and its reflection on the water. Sometimes — as in the painting seen here — he framed the distant view with a *repoussoir:* a slope in the foreground and the dark silhouettes of tree branches in the upper right corner, standing out against the dazzling glare of the sunset like paper cut-outs.

The constriction of all natural expression is pushed to the limit, bordering on abstraction. Hence it becomes very difficult to explain the construction of the decorative pattern. Where does the sea end, and where does the sky begin? Why is the surface of the water divided into distinct horizontally layered zones? Other, more realistic paintings by Vallotton can help to answer some of these questions. They show that his language of decorative patterns is based on the observation of natural phenomena. In the evening at low tide, the wide sandy beaches are dry in many parts, and the shallow water reflects the light quite differently than deeper water.

The daring geometry that Vallotton applied to the sunset paintings recalls the symbolist parallelism developed by Hodler and Munch around the turn of the century. However, Vallotton further restricts the compositional and pictorial means. He completely abandons the ornamental line originally inspired by *Art Nouveau.* Vallotton fully concentrates on the primary structure of the painted surface. The dominating horizontal is frequently offset by a vertical element in the center of the canvas: the glowing sun above the horizon and the light beams emanating from it. Nevertheless, Vallotton's paintings are devoid of any rigidity or monotony. While Hodler, in his pictures of Lake Geneva, attempts to emulate the sublime goal of perfect "doubled symmetry" — " 'doubled,' because the right side of the image corresponds to the left side, as well as the upper part to its lower part"[1] — Vallotton balances the elements of his composition in a fragile equilibrium. The all too facile or too proportional is rejected with admirable subtlety; in these images the light is absorbed by the color, in order to release a "naive," sometimes humorous effect. *RK*

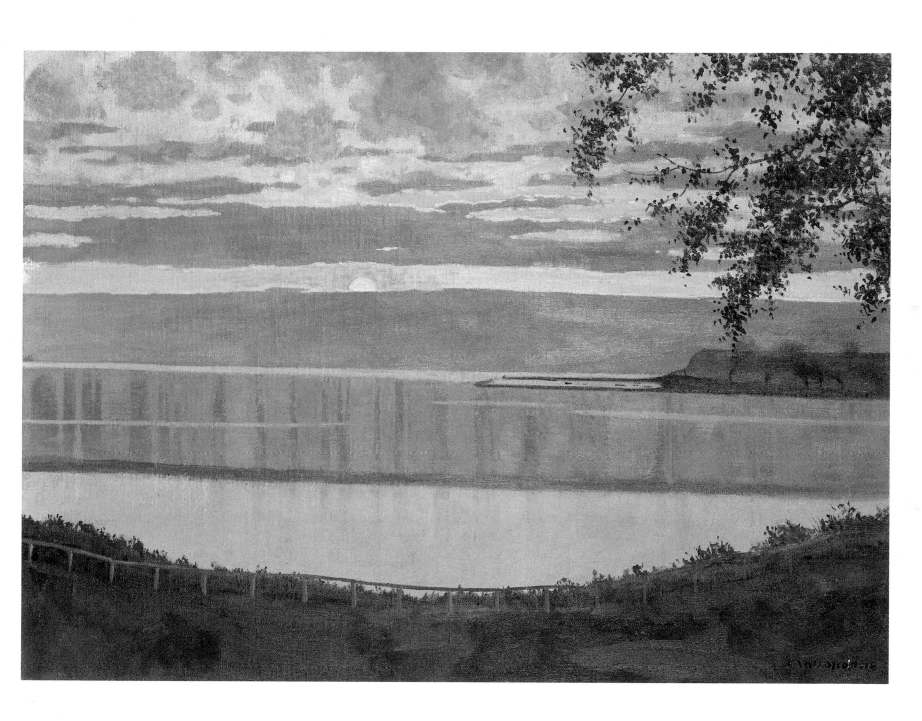

Félix Vallotton

Still Life, 1921

cat. no. 50
Oil on canvas
31 ½ × 25 ⅝ inches (80 × 65 cm)
Signed lower right:
"F. VALLOTTON. 21"
Private collection

Bibliography:
Listed in Vallotton's catalogue of his own work, the *Livre de raison,* as no. 1348a under the title "nat[ure] morte, une grosse jarre de terre, un broc en [sic] verre plein d'eau, une assiette de petites poires, deux œufs et un couteau sur un linge blanc. (T 25)."

[1] Hedy Hahnloser-Bühler, *Félix Vallotton et ses amis* (Paris, 1936), 251.

Still lifes do not belong to Vallotton's favorite mode of expression, despite the fact that he painted them in great number after 1905. To his friends he often referred to these works in a slightly pejorative tone, saying that he painted them only for his private enjoyment, when he was not in the mood for better or greater things. In 1920, however, he wrote in a letter: "I find in tasks which I used to consider childish, an enhanced sensation of pleasure. More than ever I am amused by objects, by the perfection of the egg, the moistness of the tomato, the varnish of a hydrangea leaf; all are problems which I am to resolve. I try to go ahead without pedantry, to remain an artist as long as possible without falling into the paradox of purism; it seems to me that I am painting for people who are well balanced, but not — deep down — completely devoid of a hint of vice, though perhaps unavowed. Besides, I love this kind of work: It is an excellent exercise in discipline. In our days, too many things get spoiled; it is very important for me to be the one who does not shy away from working hard and, as Poussin said, taking everything into consideration".[1]

This remarkable quotation which summarizes Vallotton's understanding of his art to perfection, dates from the same period as the present *Still Life*. It is therefore no surprise that the picture may be regarded almost as an illustration to the statement. In his still lifes, Vallotton stays closer to the appearance than in the contemporary nudes and landscapes. He depicts only what he has assembled on the floor of his studio: a large clay jug, a pitcher filled with water, a plate of small pears, two eggs, and a knife. One gets the impression that Vallotton chose the objects above all for their difference in texture, and only then tried to compose them into a whole — achieving this, of course, exquisitely well. The sophistication of the composition allots a precise location to the smallest object, sometimes with the help of the white napkin which serves as a contrast to the surrounding background. Furthermore, Vallotton restricts his range of colors to a few cool shades, and basks his image in a harsh, unemotional light. Thus he achieves a shift in expression, similar to his nudes and landscapes, towards the surrealistic and the magical. *RK*

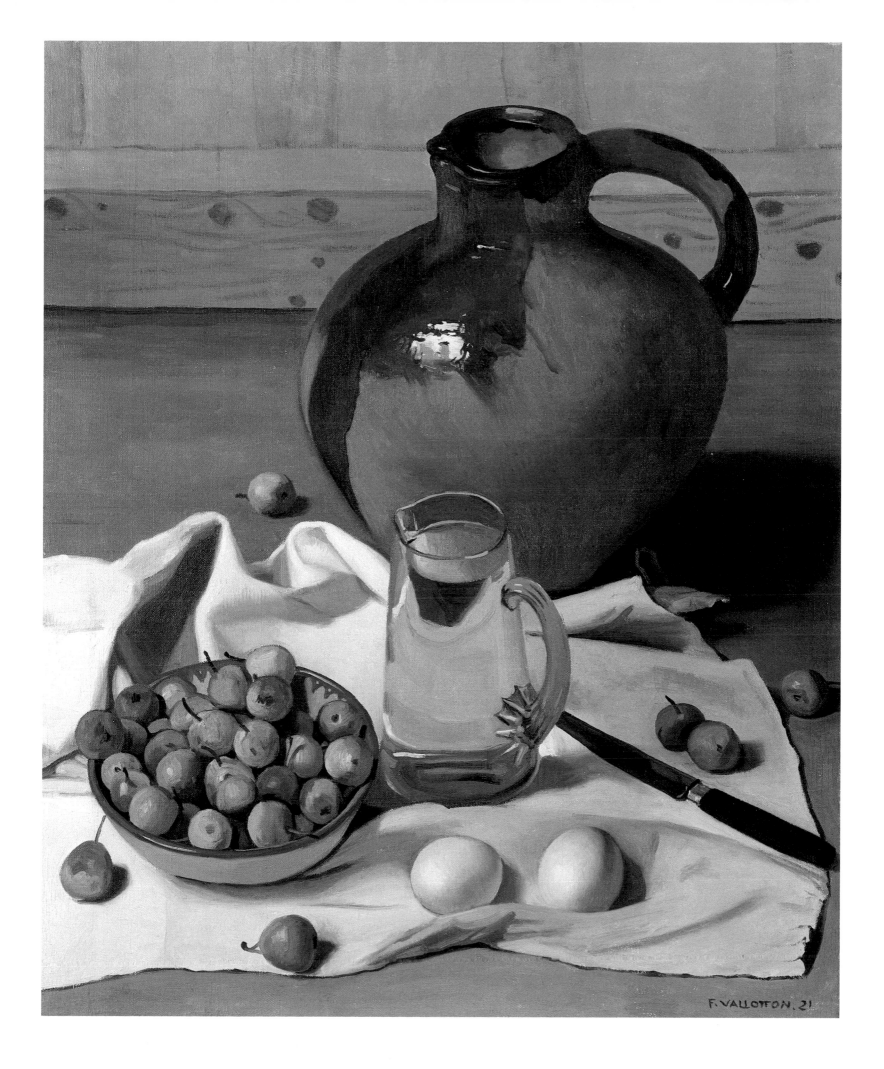

F. VALLOTTON. 21

Félix Vallotton

Sandbanks on the River Loire, 1923

cat. no. 51
Oil on canvas
28 ³/₄ × 39 ³/₈ inches (73 × 100 cm)
Stamp of the estate lower left:
"F. VALLOTTON. 23"
Kunsthaus Zürich, inv. no. 2456

Bibliography:
Recorded in Vallotton's catalogue of his own work, the *Livre de raison,* as no. 1456 under the title "Des sables au bord de la Loire, au centre un bouquet de saules reflétés dans une petite anse. fond côté bleu-noir (T 40 P).";
Rudolf Koella, *Félix Vallotton im Kunsthaus Zürich* (Zürich, 1969), Sammlungsheft 1, 100 – 103; *Félix Vallotton,* exh. cat. (Kunstmuseum Winterthur, 1978), no. 166, ill. 75; Anton Friedrich and Rudolf Koella, *Félix Vallotton* (Zürich, 1979), 114 (ill.).

[1] See Rudolf Koella, " 'Le retour au paysage historique'. Zur Entstehung und Bedeutung von Vallottons später Landschaftsmalerei," in *Beiträge zur Kunst des 19. und 20. Jahrhunderts, Jahrbuch 1968/69,* Schweizerisches Institut für Kunstwissenschaft, ed., (Zürich, 1970), 33 – 52.

[2] "Je rêve d'une peinture dégagée de tout aspect littéral de la nature; je voudrais reconstituer des paysages avec le seul secours de l'émotion qu'ils m'ont causée, quelques grandes lignes évocatrices, un ou deux détails, choisis sans superstition d'exactitude, d'heure ou d'éclairage. Au fond, ce serait une sorte de retour au fameux paysage 'historique'. Pourquoi pas?" Quoted from Hedy Hahnloser-Bühler, *Félix Vallotton et ses amis* (Paris, 1936), 120 – 121.

In the last years of his life, from 1923 to 1925, Vallotton painted a series of magnificent riverscapes along the lower part of the Seine and the Dordogne, which he called *paysages composés,* referring to an ancient term used in French art theory. The views are usually painted from a slight high-angle vantage point, be it a bridge or a sloping bank along the river; the water appears leaden and dull, opaque, with an almost metallic surface which reflects the surrounding terrain: yellow sand dunes, fresh green meadows and massive dark green clusters of trees, as in *Sandbanks on the River Loire;* or golden fields of corn, pale green bushes and chains of bright violet hills in other works. Yet these landscapes have a strangely alienated atmosphere, supernatural to the point that they seem charged with stifling mystery. The forms of nature are coerced into decorative patterns, and bask in a light which melts all surface texture, a light which smoothes and cleanses. The colors, contained by sharp contours, glow in an almost spectral luminosity. The atmospheric qualities of space dissolve: the sky assumes the same color value as its mirror image reflected in the water; and the contrast of the shapes which comprise the background are as distinct as those of the foreground. Spatial depth is evoked only by gradually receding planes, by the body-like protrusion of individually modulated shapes, and by the accentuated shadows they cast on their surroundings. The three-dimensional elements are in contradiction with the two-dimensional space of the picture, and thus they heighten the impression of contrivance and artifice. The experience is like that of a *paradis artificiel* which cannot be perceived with the senses, nor does it have physical properties: it can only be grasped intellectually.

Vallotton's *paysages composés* follow a tradition in French painting which reaches back for its origins, past Cézanne and Corot, to the classicists, to the heroic landscapes of Nicolas Poussin.[1] They are landscapes of a cool, well-tempered beauty, more constructed than perceived, existing beyond the hazards of the here-and-now, conceived *sub specie aeternitatis.* "Refaire le Poussin d'après la nature" is a well-known expression of Cézanne's, but it could just as well have been Vallotton's maxim. In fact, as early as 1917, he expresses a similar sentiment: "I dream of a painting free of all literary aspects of nature; I would like to reconstruct a landscape exclusively from the emotions it inspires in me: a few broad, suggestive outlines, one or two details chosen without superstitiously clinging to precise reproduction, to time, or to conditions of light. Essentially, this would mean some sort of return to the famous *paysage historique.* And then, why not?"[2] *RK*

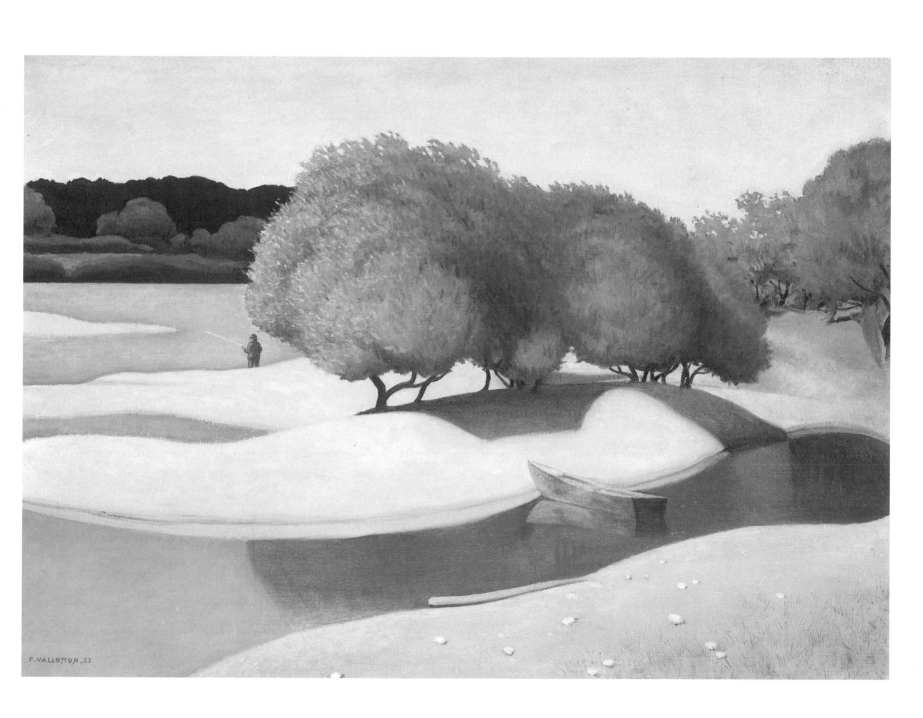

Giovanni Segantini and Giovanni Giacometti

The Two Mothers, 1898 – 1900

cat. no. 52
Oil on canvas
27 3/16 × 49 5/8 inches
(69 × 126 cm)
Signed by Giacometti lower left:
"cominciato/Giovni Segantini/
1899/completato/Giovni Giaco-
metti/1900"
Bündner Kunstmuseum, Chur,
inv. no. 54/471

Bibliography:
Annie-Paule Quinsac, *Segantini, Catalogo generale*, 2 vols. (Milan, 1982), 451, no. 549; *Giovanni Giacometti im Bündner Kunstmuseum Chur. Katalog zur Ausstellung Giovanni Giacometti zum 50. Todestag: Werke im Bündner Kunstmuseum, Chur*, exh.cat. (Bündner Kunstmuseum, Chur, 1983) 20 – 21 (color ill.); Beat Stutzer, "Giovanni Giacometti und die *Brücke:* Voraussetzungen einer Berührung," in *Pantheon* (Munich), 44 (1986), 95 (ill.); *I Giacometti e gli altri*, exh.cat. (Bellinzona, Civica Galleria d'Arte di Villa dei Cedri, 1987) 16, 29 (color ill.).

Giovanni Giacometti met Giovanni Segantini, ten years his senior and originally from Trentino, in 1894, as the latter moved from Oberhalbstein to the Engadine. For nearly a decade, Giacometti was under the influence of the Symbolist and had fully adopted his characteristic divisionist painting technique. This exceptional painting, representing two mothers, reflects explicitly the connecting link between mentor and disciple: Giacometti completed the picture which had remained unfinished, after the sudden death of the 41-year-old Segantini on 27 September 1899. In completing it, Giacometti pays his final tribute to the revered master, after having previously painted two portraits of the deceased friend.[1] However, it must be assumed that Segantini had entrusted his younger collegue with the completion of the unfinished work already in 1898. Giacometti mentioned in a letter to Cuno Amiet that he had consented to finish a painting started by Segantini who thus far had only painted the mountain range.[2] It is generally accepted that it was Segantini who had in fact painted the chain of mountains in the background in his typical divisionistic hatching technique. The pasture in the foreground, with the stonewall dividing the landscape diagonally into two parts, was added by Giacometti in a much more opaque painting manner. The different shades of color are closely interwoven and no longer applied in strictly parallel brushstrokes. The sky as well, with the glowing yellow cosmic aureole, has been conceived by Giacometti.

Annie-Paule Quinsac supports the thesis that Giacometti had painted a barely begun painting nearly from its inception,[3] whereas Hans Lüthy defends anew the older opinion that the conceptual layout as well as the upper part of the painting was accomplished by Segantini himself.[4] A letter by Giacometti, dated 22 November 1899 provides the following insight: "After a long search on the Longhino I finally found the precise location where the dear master first began the picture. Now I could continue to paint all the missing parts exactly as he had it in front of his eyes. The landscape is nearly completed, only the sky is still missing and the figure. I found the right figure who suits the picture perfectly. She is taken from the painting *The Two Mothers*. A woman carrying a small child walks up a mountain path, followed by an ewe and her lamb. I also want to bask the whole image in an evening glow."[5]

Since his stay in Brianza, Segantini was intensely occupied with the explicitly symbolic theme of motherhood, which, by the duplication of the motif for humans and animals, is seen as part of the cosmic law of nature. Here, this theme is revealed in front of a grandiose mountainscape,[6] where the group of the two mothers moves along the path from the right towards the center of the picture. It is almost completely integrated into the rock-cluttered pasture of the foreground which is clearly separated from the backdrop by the stone wall. Only the woman's head reaches above the wall, protruding into the dominating backdrop of the mountain chain. The topography can be identified, despite the almost complete absence of perspective depth: represented are the spring pastures of Grevaselvas high above the Lake of Sils; to the left we recognize the Piz dei Rossi, while to the right the Piz Bacun, and behind the woman the Piz Salacina, situated above the pass of Maloja. *BS*

Giovanni Segantini
(Arco, Italy 1858 – 1899 Schafberg/Pontresina)
Biography, see p. 187

[1] Esther Elisabeth Köhler, *Giovanni Giacometti 1868 – 1933. Leben und Werk*, Diss. University of Zürich (Zürich, n.d. 1968), 109 (no. 39); *Giovanni Segantini (1858 – 1899) — Giovanni Giacometti (1868 – 1933). Vergleichsausstellung*, exh. cat. (Museum Segantini, St. Moritz, 1983), ill. on front cover.
[2] Köhler, 1968 (see n. 1), 93, n. 89. Köhler quotes this letter, dated 26 November 1898, and suggests that the date must be wrong, since the content indicates that the letter has been written only after Segantini's death. However, the indication that he (Giacometti) wanted to complete a painting by Segantini does not imply the previous death of

the artist. We suppose that Giacometti made an error in dating the work, or rather, that he intentionally chose the year of Segantinis death as a kind of homage. This would mean that Segantini conceived the painting in 1898 and gave it to Giacometti already at that time.
[3] Annie-Paule Quinsac, *Segantini, Catalogo generale*, 2 vols. (Milan, 1982), 451, no. 549.
[4] Hans Lüthy, (Review of the catalogue raisonné published by Annie-Paule Quinsac and the letters edited by the same author), in *The Art Bulletin*, June 1987, 309 – 310: "Marcel Roethlisberger provided us with a theory for this work in the catalogue for the

exhibition *The Alps in Swiss Painting* (Tokyo and Chur, 1977, no. 83). He assigns the overall composition and the entire upper part to Segantini; and has Giacometti completing the painting by providing foreground and figures, using a deliberately softer and broader technique. Quinsac, on the other hand, minimizes Segantini's contribution, asserting that Giacometti painted practically the whole work upon a canvas on which Segantini had done only an underdrawing. Roethlisberger's more convincing opinion is supported by the author of the Giovanni Giacometti catalogue raisonné, Elisabeth Köhler."

[5] Letter by Giovanni Giacometti addressed to Dr. Oskar Bernhard dated 22 November 1899 (Staatsarchiv Graubünden, Chur). The letter is first mentioned in: Dora Lardelli/ Elisabeth Schreiber, *Das Flimser Panorama (1904) von Giovanni Giacometti für die Park Hotels Waldhaus in Flims* (Flims, 1987), 7, 10 (n. 7). I am grateful to the two authors to have drawn my attention to the existence of this letter.
[6] Four works by Segantini, two paintings, one pastel and one drawing, represent an almost identical configuration of the two mothers. See Quinsac, 1982 (see n. 3), 449 – 451, no. 545 – 548.

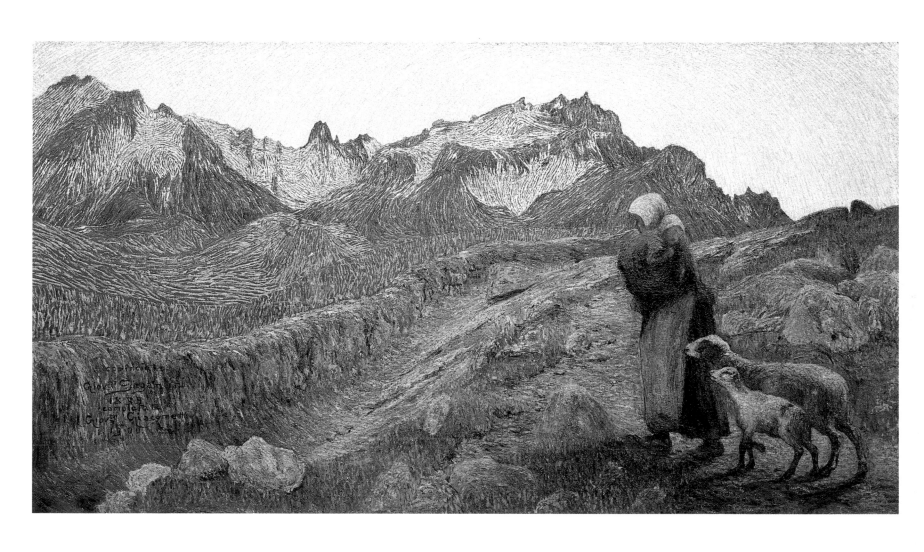

Giovanni Giacometti

Self-Portrait with the Bregaglia Valley in Snow, 1899

cat. no. 53
Oil on canvas
15 ¾ × 23 ⅝ inches (40 × 60 cm)
Signed lower right:
"Gvni Giacometti/1899"
Musée d'art et d'histoire, Geneva

Bibliography:
Jubiläumsausstellung Giovanni Giacometti 1868 – 1933, exh. cat. (Bündner Kunsthaus, Chur) (Chur, 1968), no. 12; *Cuno Amiet - Giovanni Giacometti. Two Swiss Painters of the Hodler Circle,* exh. cat. (Kettles Yard Gallery) (Cambridge, 1971), no. 29; *Giovanni Segantini (1858 – 1899) - Giovanni Giacometti (1868 – 1933): Vergleichsausstellung,* exh. cat. (Segantini Museum, St. Moritz) (St. Moritz, 1982 – 83), 15 (color ill.).

1 Giovanni Giacometti to Cuno Amiet, 4 January 1899 and 17 January 1899, cited by Elisabeth Esther Köhler, *Giovanni Giacometti 1868 – 1933: Leben und Werk,* Ph.D. diss., University of Zürich (Zürich, n.d. [1968]), 93, n. 87.
2 Elisabeth Esther Köhler, *Giovanni Giacometti* (see n. 1), 17, discusses the painting of this portrait in connection with Segantini's death on 27 September 1899; this hypothesis contradicts the assumption that it was painted at the beginning of 1899. Whether or not the detail of the funeral procession was added after Giacometti witnessed Segantini's funeral can only be demonstrated conclusively through technical examination of the painting. It seems more logical to relate the portrait to the death of Giacometti's father Alberto at the beginning of 1900. Alberto was actually buried in Borgonovo, wheras Segantini's grave is at the cemetery in Maloja; see James Lord, *Giacometti, A Biography,* (New York, 1983), 4 – 5.
3 *Von Photographen gesehen: Alberto Giacometti,* exh. cat. (Chur/Zürich, 1986), 128 (ill.).

Throughout his career as a painter, Giovanni Giacometti found it necessary to confront his own image, and he produced self-portraits as reflections of momentary states of mind. The *Self-Portrait with the Bregaglia Valley in Snow* serves as one of the best examples of this aspect of his activity. It was painted in Stampa in the first month of the year 1899. Two letters from the artist to his painter friend Cuno Amiet refer to his progress with this painting.[1]

The face which looks straight out at the viewer is neatly framed by a woolen cap, and the head sits on shoulders which are dressed in dark green and turned slightly forward. This type of portrait showing head and shoulders, composed with symmetrical and axial precision, also occurs in portraits by Ferdinand Hodler, in particular, as well as in those of Giovanni Segantini, Edvard Munch, or Vincent van Gogh. In the present painting the figure is depicted slightly to the left of the central axis, and the horizontal composition gives ample room for a panoramic view of the snow-covered Bregaglia Valley. The mountain range unfolds freely over the head, framing it and linking the two halves of the landscape. The artist with his characteristic red beard is sharply outlined against the surrounding landscape, and dominates the frontal plane of the picture. Hence, the viewer cannot escape the serious, probing gaze of the painter, which is filled with a mute sorrow. A diagonal axis extends along Giacometti's sloping right shoulder, and along the path which leads past houses on the outskirts of the village of Stampa. This axis leads the eye into the background. A horizontal line divides the scene into two parts: the wide expanse of the valley below, and the towering wall of the mountains with its peaks reaching almost to the upper edge of the painting, leaving only a narrow streak of sky.

In the middle ground a funeral procession makes its way along the path leading away from the village; four men carry a coffin toward a distant church. In this self-portrait, the 31-year-old Giacometti captures the notion of the futility of life and of the transience of all being in front of the powerful and immutable forces of nature. The event he depicts was commonplace enough in this mountainous valley: the bearing of a corpse in a coffin from Stampa to the nearby cemetery of Borgonovo.[2] The ritual was re-enacted on 15 January 1966, when Alberto Giacometti, the famous son of Giovanni, was laid to rest at Borgonovo. Herbert Maeder photographed the funeral, and one of the images records the procession passing the very same houses that Giacometti has depicted in his self-portrait.[3]

Giovanni Giacometti obviously employed a mirror to portray himself, hence the image of the landscape behind him is inverted as it would have appeared in the reflection. In this scene, we are looking out of the painter's studio, toward Maloja. The picture is one of the most stirring tributes Giacometti paid to his homeland. Beyond this, the painting succeeds as an expression of Giacometti's understanding of his own existence through an allegory which transcends his personal experience. Stylistically, the influence of the formidable Segantini shows up clearly. It manifests itself in the subtle hatching technique, as well as in the profound nature of the subject which the younger artist treats with somewhat less pathos, more in the manner of a genre picture. The pale, cool colors suggesting the brisk atmosphere of an icy winter morning are set off against the vibrant glow of the painter's face, and this is echoed in the light orange color of the house on the path. *BS*

Giovanni Giacometti (Stampa 1868 – 1933 Glion)
Biography, see p. 183

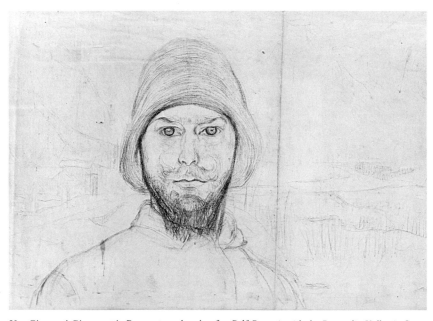

53a Giovanni Giacometti Preparatory drawing for *Self-Portrait with the Bregaglia Valley in Snow*
Colored pencils on paper, 17¾ × 24¼ inches (45 × 61.5 cm) Private collection

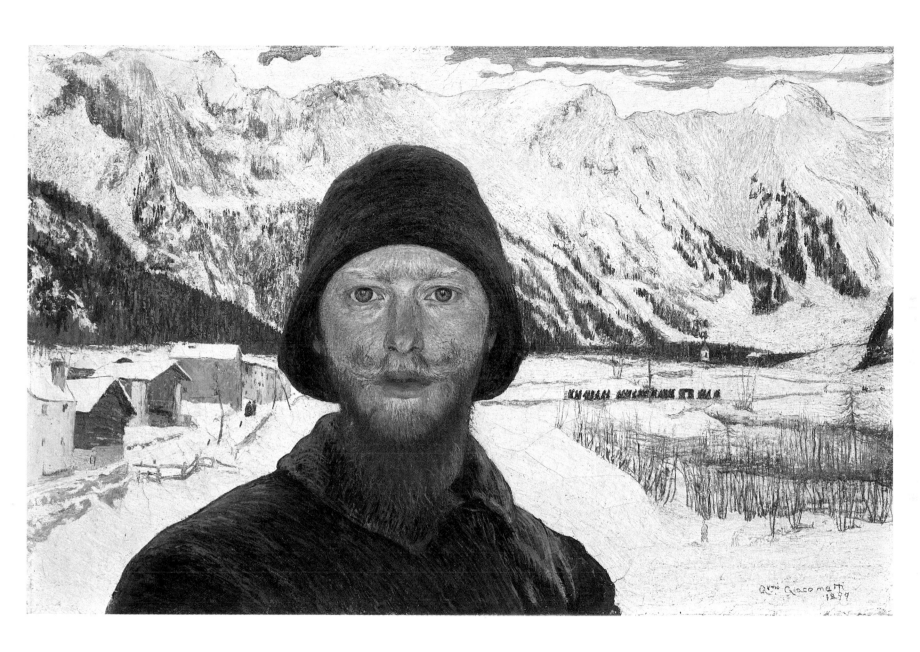

Giovanni Giacometti

Laburnum, c. 1907

cat. no. 54
Oil on canvas
24 ¾ × 19 ¾ inches (63 × 50 cm)
Signed lower left: "G/G"
Private collection

Bibliography:
Grosse Kunstauktion in Luzern, exh. cat. (Galerie Fischer, Lucerne) (Lucerne, 1984), 89, no. 1412, color ill. 8.

[1] See Beat Stutzer, "Giovanni Giacometti und die *Brücke*: Voraussetzungen einer Berührung," in *Pantheon: Internationale Jahreszeitschrift für Kunst* (Munich), vol. 44 (1986):92 – 101.
[2] See George Mauner, *Cuno Amiet,* (Zürich/Schwäbisch Hall, 1984), 20, 24, 88, and 104.

This painting was produced during a period which was very important for Giacometti's development as an artist, but also for Swiss art. Between 1905 and 1908, Giovanni Giacometti analyzed the progressive trends in art and responded with works which helped to establish modernity in Switzerland. His reception of international avant-garde tendencies at the beginning of the twentieth century is closely related to his friendship with Cuno Amiet, who was born in the same year. The two first met in Munich in 1887, and subsequently shared an apartment and studio in Paris between 1888 and 1891. Later, when he returned to his native Bregaglia Valley, Giacometti came under the influence of Giovanni Segantini; Amiet went to Pont-Aven, where he came into contact with the innovative circle of artists around Gauguin as well as the paintings by Vincent van Gogh and the Neo-Impressionists. He faithfully conveyed his experiences and discoveries to his friend, and, upon returning to Switzerland, he showed his most recent work to Giacometti, who in turn arranged a meeting between Segantini and Amiet. After 1905, parallels in the work of the two painters became apparent once again, certainly due to their mutual interest in Fauvism. At Amiet's studio in Oschwand, they both copied two of Van Gogh's paintings, *Two Girls* and *The Guardian at Saint-Rémy,* during the year 1908. It is hardly surprising that members of the "Brücke" took notice of Giacometti's work and invited him to participate in one of their group exhibitions at the Salon Richter in Dresden.[1]

Giacometti's *Laburnum* dates from this period of intense preoccupation with the work of Van Gogh. Contemporary French art is reflected in his understanding of the picture as an autonomous plane and in his use of pure, undiluted color, full of luminosity, which evokes bright, glistening sunlight. It is also apparent in his application of pigment in *impasto* dabs, with rough brushstrokes, resulting in the building up of structural effects in the composition. The subject of the painting is a single, immense laburnum tree. The violet stem rises as a central axis in the foreground, and is truncated by the lower edge of the picture. However, the focal point, visually as well as sensually, is the glowing and radiant splendor of the yellow and ochre blossoms. The crown of the tree nearly fills the canvas, fanning out toward the edges of the painting and gradually lowering its branches downward. The surrounding meadow and background are depicted with large dabs of green, brown, and blue paint, sometimes applied in parallel strokes which allow the lightly-primed canvas to show through here and there. By contrast, the resplendent brilliance of the laburnum is rendered with a dense pattern of much smaller brushstrokes of yellow and green paint. An opposition of complementary colors is achieved with the violet of the stem and the yellow of the blossoms.

The artist's primary objective is pure painting. He begins with an ordinary subject, utterly unspectacular in itself. Transforming it through handling of color and expressive application of pigment, he conjures up a heightened atmospheric sensuality. The significance of the single blooming tree as a metaphor for the awakening of spring and the budding of new life is diminished here. Cuno Amiet, on the other hand, explored the theme of the blooming tree in several paintings where he concentrated on this more recondite aspect of the subject.[2] *BS*

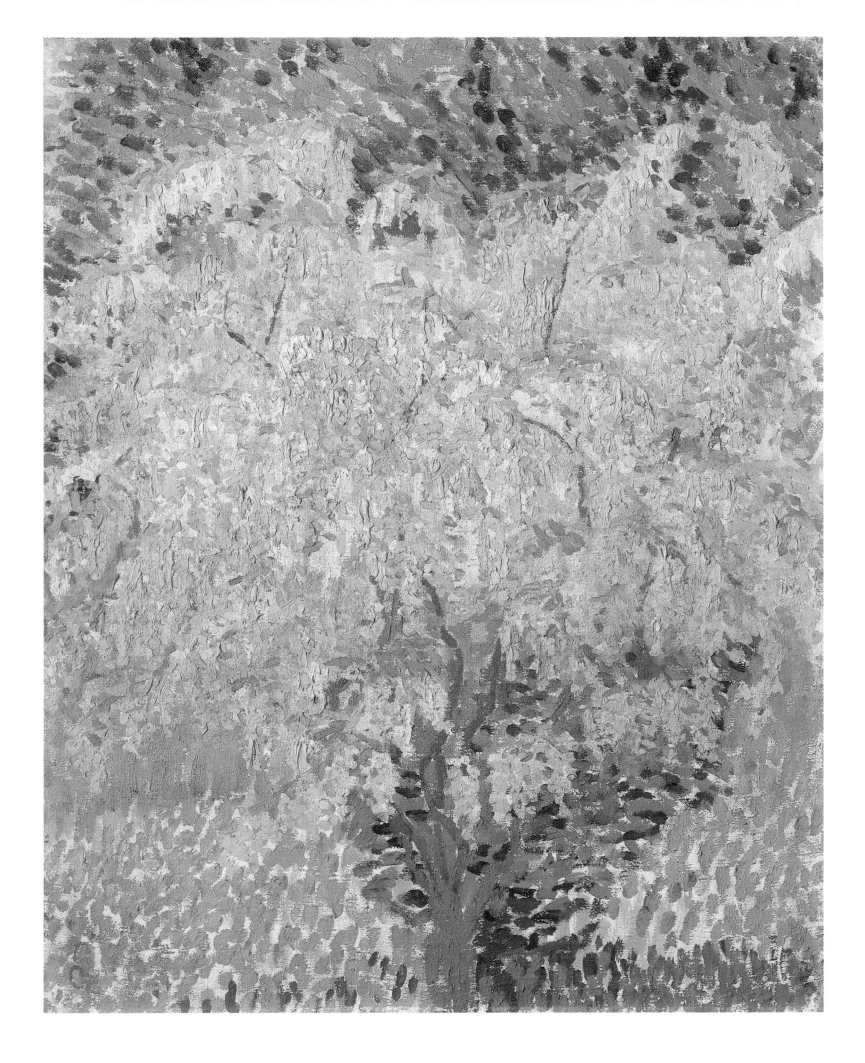

Cuno Amiet

**Portrait of Anna Amiet
("The Green Hat"), 1898**

cat. no. 55
Oil on canvas
24 × 19 $^{11}/_{16}$ inches (61 × 50 cm)
Signed lower right: "CAmiet.";
lower left: "m.l. Freund Max Leu"
Kunstmuseum Solothurn,
inv. no. B 39
(Bequest of Max Leu, 1899)

Bibliography:
Peter Vignau-Wilberg, *Museum der Stadt
Solothurn: Gemälde und Skulpturen*
(Solothurn/Zürich, 1973), 111 – 113, no. 109,
with detailed bibliography and list of
exhibitions.

[1] Cuno Amiet, *Portrait of Ferdinand Hodler in
Front of his Marignano Painting,* 1898, oil on
canvas, 70 × 47 cm, Kunstmuseum Solo-
thurn, Dübi-Müller Foundation.
[2] "Warum Annas Porträt Ihnen als kein ei-
gentlicher Amiet vorkommt, ist mir eigent-
lich nicht so recht klar. Ich habe doch mit
Einsetzung *meiner* ganzen Kraft versucht
Anna charakteristisch wiederzugeben u.
zwar in einer möglichst einfachen, dekora-
tiven Bildwirkung. Vielleicht aber nur ver-
sucht?" Cuno Amiet to Oscar Miller, 16 Sep-
tember 1898, Private Archives, Solothurn.

This portrait of Anna Amiet-Luder was painted in 1898, the year of her marriage to the painter. It is closely related to a group of other portraits, all executed within the same year, which mark a turning point in Amiet's style. He was amused by the eccentric hats his wife favored and which set off her renowned beauty. This popular portrait has been described as cheeky and charming, but, in truth, the artist has avoided adding to the face any expression of self-consciousness. It is a serious, nearly-frontal portrait in which the hat makes its own definite statement about Anna's personality.

Here, Amiet's technique is refined and reveals his new interest in the draughtsmanship of the sixteenth-century German masters. This tendency was certainly influenced by Ferdinand Hodler, whose portrait Amiet had painted earlier in that year.[1] It was only in late 1897 that Hodler and Amiet became friends, and from this time until 1904, Amiet's admiration for the older artist led him to restrain his natural penchant for luminous, freely-applied color which has been fostered during his residence among the painters of the Gauguin circle at Pont-Aven in 1892/93. Amiet's color sensibility is undoubtedly his greatest strength as an artist, and even during the years when he emulated Hodler, it continued to lend an individual note to his paintings. In this portrait of Anna, the dominant green of the ribbon on her hat, and the complementary red of the flowers are

found sensitively distributed in the modeling of her face. Despite the importance given to the green ribbon, and the subtlety of the color harmony, it is nevertheless Amiet's careful draughtsmanship which dominates the portrait. This change in Amiet's style was noted with displeasure by his only patron in those days of struggle, Oscar Miller. In a letter to Miller dated 16 September 1898, the painter took up the defense of his picture:

"Why Anna's portrait does not seem to you to be a real Amiet is not very clear to me. After all, I did try with full *personal* commitment to represent Anna characteristically and in the most simple, decorative, pictorially effective way. But perhaps I only tried?"[2]

The painting is dedicated to the sculptor Max Leu, who at the time was completing the Adrian von Bubenberg monument in Bern. Amiet had painted a portrait of Leu shortly before undertaking this one of Anna (Fig. 55a). It is the most interesting of the portraits done in 1898, and is almost surreal in its fusion of figures of disparate scale: the figure of Leu in the painting proper, and the much smaller standing figure painted on the frame. In this portrait, Amiet appears to have sensed Leu's impending death, which indeed occurred early in 1899.
GM

Cuno Amiet (Solothurn 1868 – 1961 Oschwand)
Biography, see p. 179

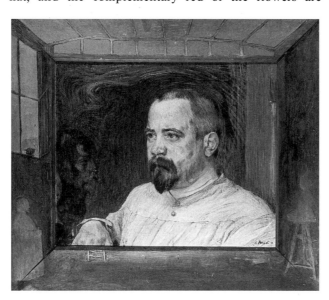

55a Cuno Amiet
Portrait of Max Leu, 1898
Oil on canvas, 29 × 33 inches (73.5 × 84 cm) (including frame)
Kunstmuseum Solothurn

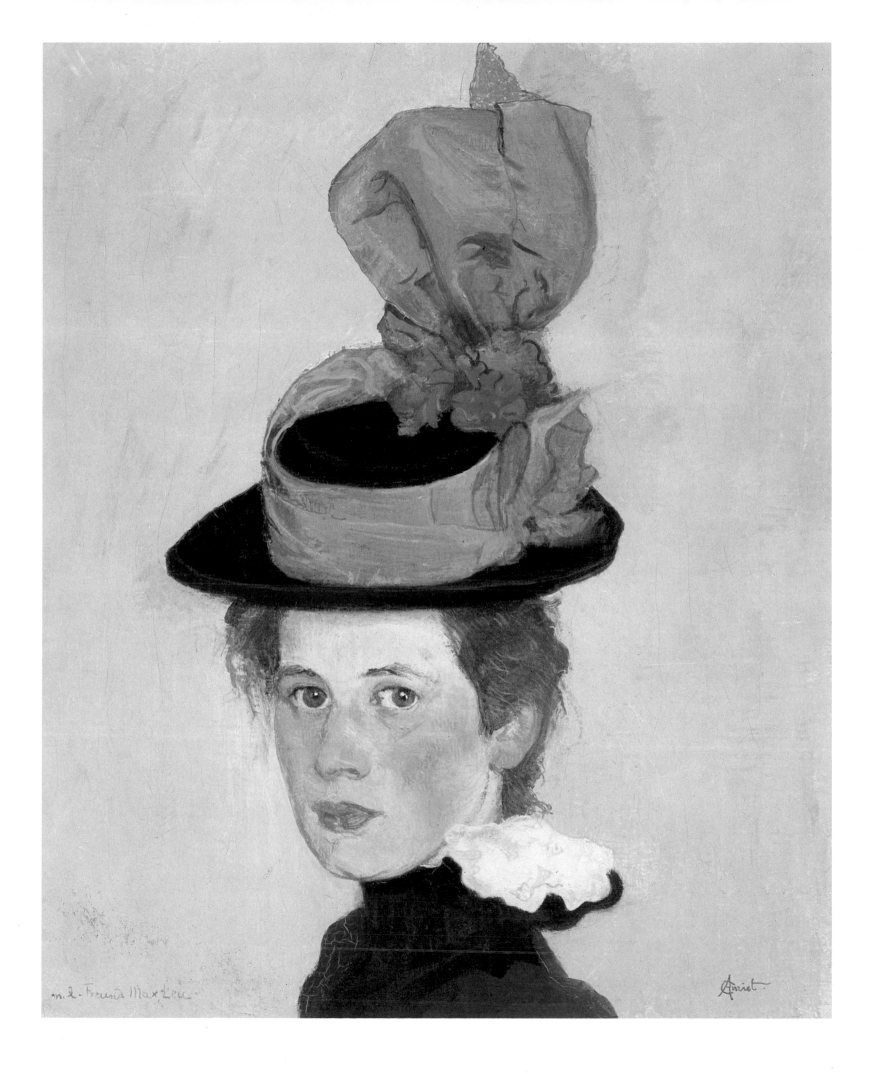

Cuno Amiet

Moonlit Landscape (Föhn), 1904

cat. no. 56
Oil on canvas
21 ¼ × 25 ³/₁₆ inches
(54 × 64 cm)
Signed lower right: "CA/1904"
Franz Meyer, Zürich

Bibliography:
Three Swiss Painters: Cuno Amiet, Giovanni Giacometti, Augusto Giacometti, exh. cat. (Pennsylvania/Cambridge/Utica/New York, 1973–74), no. 14, ill.; George Mauner, "Three Swiss Painters," in *Art International: The Lugano Review* (October 1974):15–23, color ill.; *Cuno Amiet und die Maler der Brücke,* exh. cat. (Zürich/Berlin, 1979), no. 17, color ill.; George Mauner, *Cuno Amiet* (Zürich, 1984), 44, color ill. no. 21.

[1] "Ich habe verschiedenes angefangen. Eine Mondscheinlandschaft und zwei grosse Bilder." Cuno Amiet to Carl Moll, Schweizerische Landesbibliothek, Bern.

[2] "Ich habe so vieles über Bord geworfen, das mir das Vorwärtskommen so schwer gemacht hatte. Ich gehe jetzt mit leichtem Gepäck meinen Weg . . . Ich habe den Weg wieder gefunden, den ich in der Bretagne gegangen war. Ich bin auch überzeugt, dass das für mich sehr gut ist." Cuno Amiet to Carl Moll, 30 May 1905, Schweizerische Landesbibliothek, Bern.

[3] See *Cuno Amiet und die Maler der Brücke,* exh. cat. (Zürich/Berlin, 1979) and Günter Krüger, "Die Künstlergemeinschaft Brücke und die Schweiz," in *Zeitschrift des Deutschen Vereins für Kunstwissenschaft* (Berlin) vol. 34, 1/4 (1980):131–161.

The level of visionary power achieved in this moonlit landscape marks a culminating point in Amiet's development. The fantastic conception of the nocturnal sky invaded by oppressive, bulbous, white-rimmed clouds owes its impact to the artist's imaginative exaggeration of a common climatic phenomenon, the *Föhn,* a warm southerly alpine wind. Such a vision of the illuminated heavens bears a generic relationship to the *Starry Night* of van Gogh, whose work Amiet had first admired at Pont-Aven in 1892 and whose technique he would study and adapt between 1907 and 1908. The free handling of the brushwork and pure color are, generally speaking, indications of Amiet's return to the French Post-Impressionism he had discovered in Brittany, but had suppressed in his works between 1898 and 1903 in favor of emphasis on drawing and structure. Only in 1904, when Hodler and Amiet were the featured artists at the Vienna Secession, was Amiet made to feel that his dependency on the older Swiss master had become excessive and stifling. Shortly after that experience, Amiet wrote to the Viennese painter, Carl Moll, "I have begun several things: a moonlit landscape and two big paintings."[1] The reference is almost certainly to the painting exhibited here, and the state of mind in which Amiet had painted it is clearly conveyed in his next letter to Moll: "I have thrown overboard so much that had burdened me for so long, and that has made my moving forward so difficult. I am now following my own path with a light load . . . I have again found the way I had pursued in Brittany, and I am also convinced that this is very good for me."[2]

Throughout 1905 and the years immediately following, Amiet was in top form and produced the finest works of his career. *Moonlit Landscape* is one of the pictures which stands at the beginning of this exceptional period.

In the slight curvature of the hill, we find an echo of Hodler's favorite reference to cosmic unity, although the free, staining technique of the paint, especially the deep, absorbing blue is pure Amiet. Precisely at the center, and nearly touching the top of the canvas, a yellow moon peers through a little open space in the compact, advancing cloud formation, providing both an organizational point and a touch of warmth which is picked up in the coloration of the clouds at the right.

Certainly one of Amiet's most dramatic paintings is *The Great Winter,* also painted in 1904 (Fig. 56a). It shares with the *Moonlit Landscape* a Jugendstil simplification of flattened shapes which are greatly enlivened by constant variations in touch and gradations of color. Although the *Moonlit Landscape* was never intended to approach the scale of *The Great Winter,* it achieves a similarly monumental effect. Just as the little skier in *The Great Winter* serves to amplify the expanse of snow, making it seem even more vast, the diminutive but glowing moon in the *Moonlit Landscape* makes the approaching clouds seem awesomely large.

A watercolor of the night sky by Henry-Edmond Cross in the Lehman Collection of the Metropolitan Museum of Art in New York, and *La Vigne,* a painting of 1905 by van Dongen in the Musée Picasso, Paris are further indications of the interest that this motif, the vast sky punctuated by heavenly bodies, held for artists of the first decade of the twentieth century. These pictures, however, no longer suggest the mystery and cosmic scope of Amiet's *Moonlit Landscape,* qualities which still attach it to the Symbolist movement and the Jugendstil.

The painting was shown in May, 1905, at the Galerie Richter in Dresden, in an exhibition of Amiet's work, where it was seen by the future members of the "Brücke". The exhibition served as a catalyst for the formal organization of the group, which occurred a few weeks later. Amiet himself was invited to join it the following year.[3]

GM

56a Cuno Amiet
The Great Winter, 1904
Oil on canvas, 70 × 92½ inches (178 × 235 cm)
Private collection (on extended loan in the Kunstmuseum Bern)

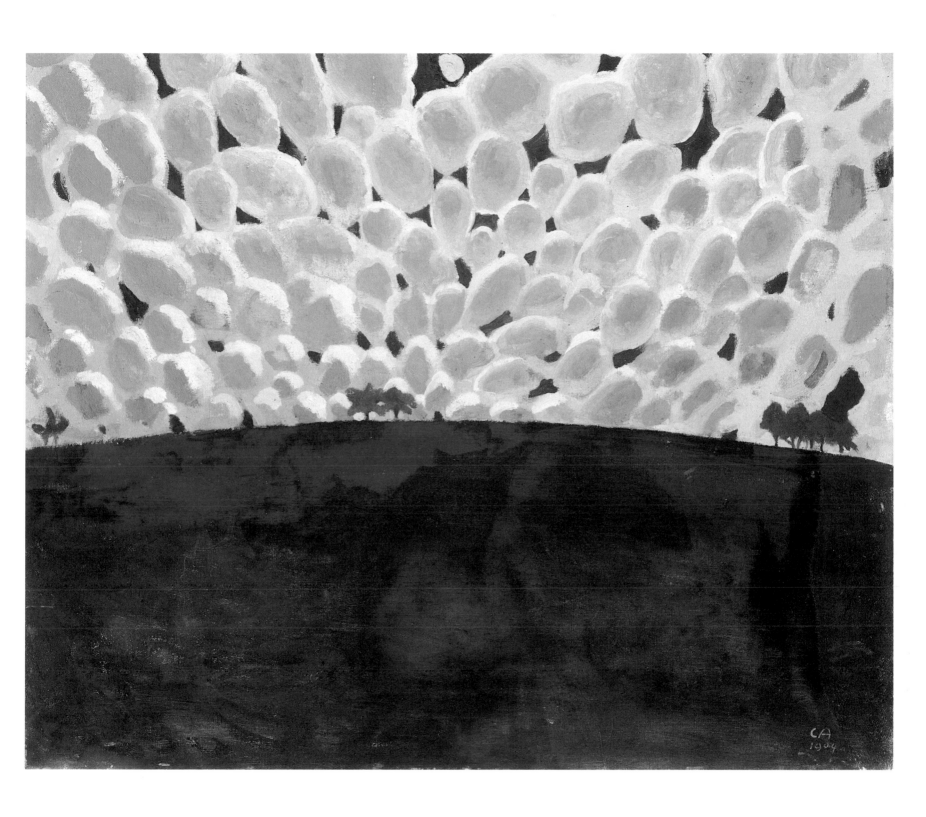

Cuno Amiet

Autumn Landscape, 1905

cat. no. 57
Oil on canvas
21 ¼ × 25 ³/₁₆ inches
(54 × 64 cm)
Signed lower left: "C. Amiet 1905"
Private collection

Bibliography:
Cuno Amiet und die Maler der Brücke, exh. cat. (Zürich/Berlin, 1979), no. 29.

[1] Amiet's original letter is lost, but Heckel's reply makes its content clear. Heckel writes that he and Kirchner were delighted with Amiet's honest criticism, and goes on to remark that the few works he had seen by Seurat had struck him as being "too academically calm" ("zu akademisch ruhig"). Erich Heckel to Cuno Amiet, 30 January 1908, Amiet Archives, Oschwand (Bern).

Soon after his arrival in Pont-Aven in June of 1892, Amiet began to experiment with the application of pure color as he learned it from the painters of the Gauguin circle. (Gauguin himself had left for Tahiti in 1891). Amiet, however, did not begin to apply color in flat planes, in the manner of Paul Gauguin and Emile Bernard, until the following year. Initially, he was attracted to the more activated surfaces of Van Gogh, whose paintings he saw for the first time at Pont-Aven. And, under the guidance of Roderic O'Conor, he began to lay colors down in brilliant adjacent stripes. The shortening of the brushstroke, in a way that approached the spots of Seurat and the Pointillists, made its first appearance in 1894, the year after Amiet's return to Switzerland. The use of spots of color recurs intermittently during the years of his dependence on Ferdinand Hodler, and emerges in a consummate and personal manner in 1905. Two years later, in a letter to Erich Heckel criticizing the work of his fellow Brücke artists, Amiet recommended that they study Seurat, a piece of advice not readily taken by Heckel.[1]

The *Autumn Landscape* of 1905 is a fine example of Amiet's artistic rebirth during this period. Independently of the Fauves, he followed a path which paralleled theirs in developing and attenuating certain aspects of Post-Impressionism. Like Matisse and his comrades in 1904/05, Amiet revived Pointillism, but in a manner quite different from Seurat's original intention of twenty years earlier. Amiet employs the dots not for a more accurate transcription of natural luminosity, but to achieve a heightened aesthetic effect. The depth of feeling already observed in *Moonlit Landscape* of 1904 (cat. no. 56) here no longer depends upon references to great cosmic mysteries, as had been typical of the Symbolist movement, but rather upon the selective abstraction of seasonal peculiarities. The artist is at pains to reveal his extraordinary response to the ordinary, familiar aspects of nature. It is a more exclusively artistic procedure, by means of which content is carried entirely by the multitude of purely painterly choices which constitute the picture.

In this landscape, Amiet has reduced the overlapping spatial zones of his distant view to a series of relatively flat planes which are treated as independent horizontal elements, both in color and texture. These are ultimately united in both a satisfactory spatial representation and a harmonious surface structure. The four major zones of sky, mountains in the distance, wooded hills in the middle ground, and sloping meadow in the foreground are each textured in a particular way. The color spots in the sky are dense and complex in their relationships; those of the distant mountains are looser and more widely spaced; the principal zone of red and orange hills is composed of still more loosely applied spots, but also contains vertical rose-colored strokes near the bottom, announcing the broadly painted foreground area, which in texture and color echoes the island of trees on the red hillside.

Amiet's use of color, notably his combining spots of differing hue but similar value, seen here in the handling of the sky, and his integration of areas of different character, reveal a strong artistic personality whose works are entirely characteristic of the *avant-garde* of their time (one is reminded most of Henri-Edmond Cross), but which are also the products of an individual sensibility. That he could achieve this in an isolation (for he made no trips to France between 1893 and 1907) is all the more remarkable. It is at this time that Amiet emerges as a painter of international stature. *GM*

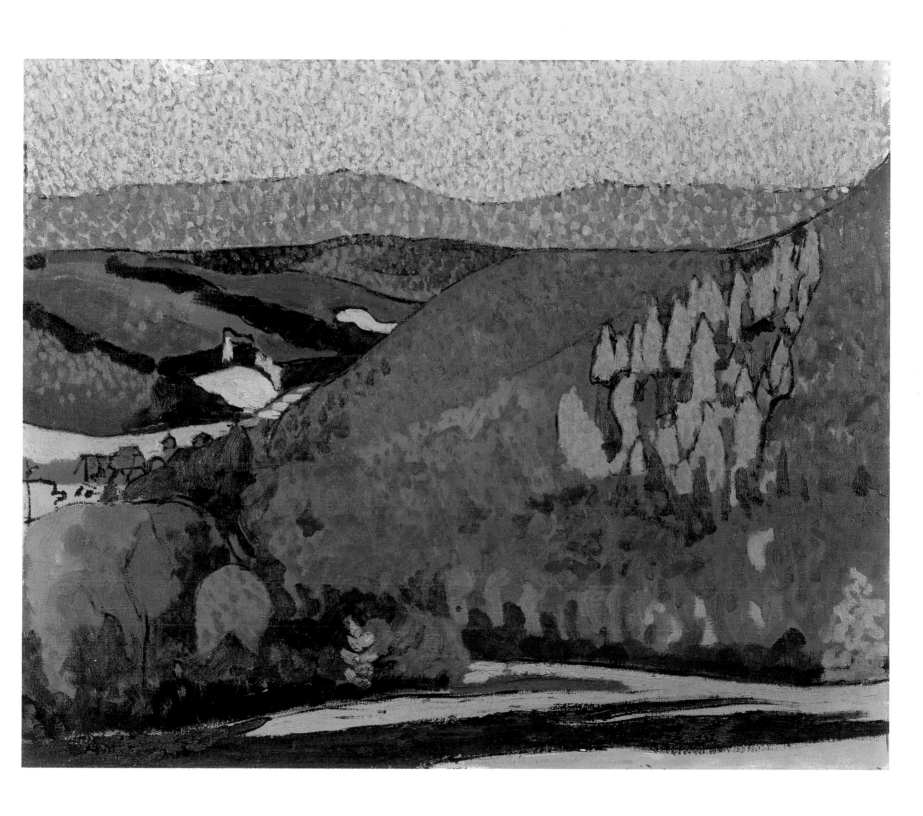

Augusto Giacometti

Rainbow, 1916

cat. no. 58
Oil on canvas
52 × 59 inches (132 × 150 cm)
Signed lower left: "AUGUSTO
GIACOMETTI"; on reverse:
"Augusto Giacometti Zürich Rämi-
strasse 5 (Suisse) Arc en Ciel"
Kunstmuseum Bern, inv. no. 1656

Bibliography:
*Augusto Giacometti: Ein Leben für die Farbe,
Pionier der abstrakten Malerei,* exh. cat.
(Bündner Kunstmuseum, Chur) (Chur, 1981),
134–135 (color ill.), 221 no. 875; *Augusto
Giacometti 1877–1947: Gemälde, Aquarelle,
Pastelle, Entwürfe,* exh. cat. (Kunstmuseum,
Lucerne) (Lucerne, 1987), 51 (color ill.), 94 no.
109.

[1] See Beat Stutzer, "Anmerkungen zu Augusto
Giacomettis abstrakter Malerei," in *Augusto
Giacometti 1877–1947: Gemälde, Aquarelle,
Pastelle, Entwürfe,* exh. cat. (Kunstmuseum
Lucerne) (Lucerne, 1987), 4–15.
[2] A first attempt has been made. See Beat
Stutzer, "Anmerkungen zu Augusto Gia-
comettis abstrakter Malerei" (see n. 1), 4–5.
[3] See Beat Stutzer, "Anmerkungen zu Augusto
Giacomettis abstrakter Malerei" (see n. 1),
10–12.
[4] *Augusto Giacometti: Ein Leben für die Farbe,
Pionier der abstrakten Malerei,* exh. cat.
(Bündner Kunstmuseum, Chur) (Chur,
1981), 221, nos. 889 and 890.
[5] Tilman Osterwold, "Regenbögen für eine
bessere Welt" and "Materialien zur Kultur-
geschichte des Regenbogens," in *Regen-
bögen für eine bessere Welt,* exh. cat.
(Württembergischer Kunstverein, Stuttgart)
(Stuttgart, 1977), 14 and 176.

Augusto Giacometti crossed the threshold of pure ab-
straction shortly before the turn of the century in a se-
ries of small, intimate pastels which were not destined
for a broad public.[1] Only with his large, symbolist com-
positions of the first decade of the 20th century did he
gain *public* recognition. More important in the art histor-
ical context is a series of large oil paintings which Gia-
cometti produced between 1910–12 and 1917: abstrac-
tions based on emotional reactions to nature, pure, au-
tonomous painting which is above all concerned with
the unrestrained release of clear, undiluted color. The
paint is applied with a spatula in a manner not unlike
the application of mosaic tiles. The rather large color
stains fill the picture plane to the edges, sometimes
densely clustered together and other times loosely
strewn revealing expanses of the pale underlying
primed canvas. The "all-over-patterning" based on the
achievements of Neo-Impressionism allows for a lumi-
nous, free fluctuation of the thickly painted, dispersed
color values.

Always interspersed with figurative compositions, it
was Giacometti's second non-representational period
which caused him to be posthumously labeled a pioneer
of abstract painting, or even, as a precursor of *Tachism,*
or action painting — an historically illogical argument
which must be questioned.[2] Nevertheless, Giacometti, a
progressive Swiss artist, maintained continuous ex-
change with Dadaists in Zürich after an initial contact
in February 1916.[3] Though not atypical of the artist's
work of this period, *Rainbow* occupies a special posi-
tion. The distinctive feature which sets it apart from
other figurative pictures, including close-up landscape
views, summer gardens, and portraits, is a return to sym-
bolist motives. Near the lower edge of the picture, Gia-

cometti indicates a grey zone which develops at the
right into a mound of rock, a cliff with sparse olive-col-
ored shrubs. The vegetation frames two seated figures
seen from the back. Their posture allows the viewer to
be included as a spectator looking at the same arresting
natural event. The object of their contemplation is an
enormous, almost completely circular rainbow. Span-
ning the entire canvas, it rises at the lower left corner,
spreads across the upper edge, and continues to the
right edge out of view. The distance between the awed
couple and the diaphanous vision bestows a cosmic di-
mension on the entire space. The color, handled with
great restraint in the representation of shrubs and
figures, is almost exclusively concentrated on the yel-
low, green, blue, and purple bands of the rainbow. The
figurative elements which are pushed to the edges of the
picture frame the wide open space like a tondo. The
empty space is filled with alternating grey and white
zones which evoke associations with misty veils of fog
and haze. Two small, figurative pastel studies are asso-
ciated with the painting.[4]

The motif of the rainbow is connected with antique
mythology, Christian iconography, and romanticism,
each of them embodying different ideas about the tran-
sitory quality of beauty. Giacometti expresses the yearn-
ing for a union with God and the cosmos. In his paint-
ing, the rainbow is a symbol of peace, "a bridge be-
tween man and God, between temporal and eternal;" it
"signifies a harmonious world, a pantheistic belief in
nature."[5]

BS

Augusto Giacometti (Stampa 1877 – 1947 Zürich)
Biography, see p. 182

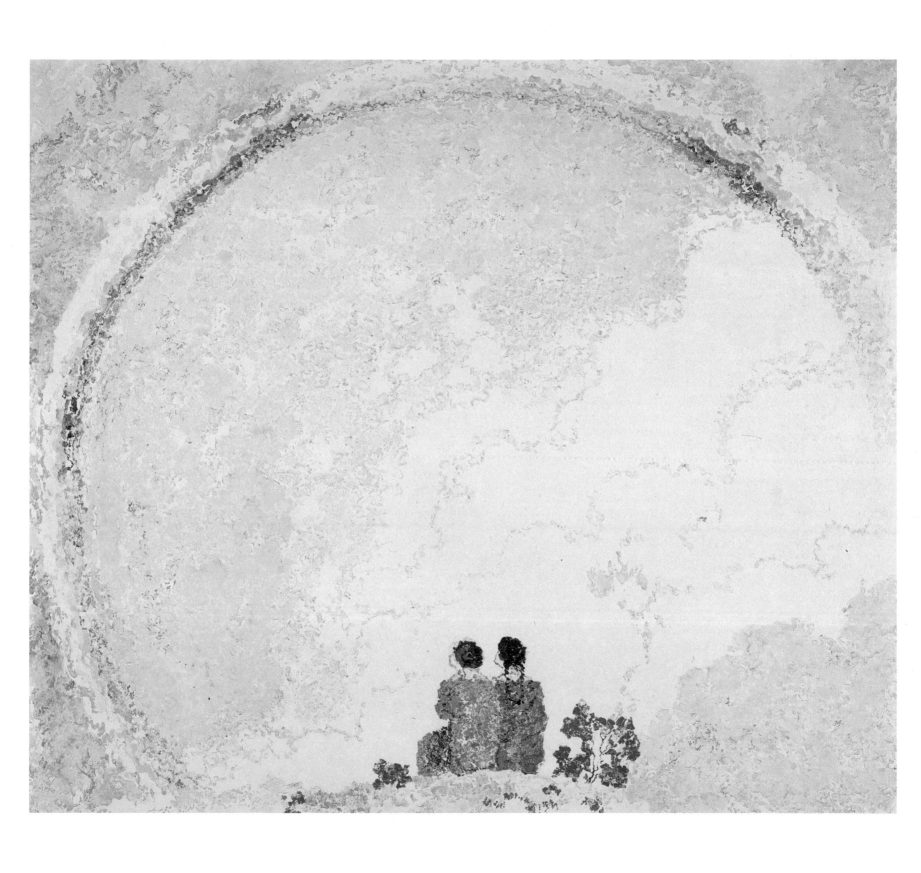

Paul Klee

Architecture with the Red Flag, 1915

cat. no. 59
Oil and watercolor on cardboard
primed with chalk
12 × 10¼ inches (30.5 × 26 cm)
Signed and dated upper left:
"Klee" and "1915/248"
Private collection, Bern

[1] In 1914, Klee executed a small oval oil painting which he titled *Hommage à Picasso* (no. 192 in his catalogue of his own work).
[2] See Marianne L. Teuber, "Zwei frühe Quellen zu Paul Klees Theorie der Form. Eine Dokumentation," in *Paul Klee, Das Frühwerk 1883–1922*, exh.cat. (Städtische Galerie im Lenbachhaus, München, 1979/80) (München, 1979), 272–273.
[3] Ibid., 269 and 273.
[4] *Paul Klee, Tagebücher 1898–1918*, critical edition, published by the Paul Klee Foundation, Wolfgang Kersten ed. (Stuttgart, 1988), 341 (nos. 926–927).
[5] Christian Geelhaar ed., *Paul Klee — Schriften, Rezensionen und Aufsätze* (Cologne, 1976), 100, 105–111.
[6] See Karl Otto Werckmeister, *Versuche über Paul Klee* (Frankfurt, 1981), 10–23.
[7] *Paul Klee, Tagebücher 1898–1918* (see n. 4), 366 (no. 951).
[8] Ibid.

For this irregular octagonal oil painting, Klee had used originally an oval frame, which has not survived, but whose traces are still recognizable on the painted surface. The oval format may be understood as a reference to Cubism, in particular to the oval-shaped paintings by Picasso.[1] In 1912, Klee stayed in Paris to become better acquainted with contemporary art, since in 1905, during his first stay in Paris, he was little concerned with it. He first saw works by Picasso in the galleries of Daniel-Henry Kahnweiler and Wilhelm Uhde, but since 1913 he had access to the private collection of Hermann Rupf in Bern, who had bought cubist works from his friend Kahnweiler.[2]

The motif of the red flag which flies from a black and white ringed flagpole is a dominating element of the picture and juts out of the architecture rendered in geometric shapes of the cubist language. Marianne L. Teuber tried to prove that the motif is based on the psychology of structural recognition, and that it dates back to Klee's involvement with Ernst Mach's *Analyse der Empfindungen,* reflecting in particular an illustration, *Fahne und Buch* (Flag and Book).[3] In any case, this kind of literary reference to Klee's theory of form is only marginally relevant to deciphering the meaning of an image.

Architecture with the Red Flag is closely related to the watercolor *Landscape with Flags* (Fig. 59a). Both "flag paintings" are structured according to the same formal pattern. Read together, they visualize Klee's attempt to approximate the "synthesis art/nature/ego,"[4] following his preoccupation with the cubist principles of form and his journey to Tunisia in April, 1914. This integrative perspective includes nature (landscape) as well as culture (architecture). In both pictures, however, the flag points beyond nature and culture respectively, towards a celestial realm.

In 1912, Klee dealt theoretically with the dialectic of destruction and construction in Cubism, publishing critical essays in the Swiss monthly *Die Alpen*[5] and focusing primarily on aesthetic problems. In the beginning of 1915, he recognized the cubist dialectic as an issue reaching beyond pictorial concerns, subsequent to the outbreak of World War I, when he attempted unsuccessfully to formulate his outlook on contemporary developments.[6] He then defined it anew as an ideological program of art. In his diary entries dated to the beginning of 1915, he distinguished the crypto-cubist formulation "Can I, a crystal, ever die?"[7]. The "transition from this world to the beyond"[8] postulated in the same context, is expressed by the flag in our painting, which symbolizes an equivalent to the transcendental claim of sacred architecture. *WK*

Paul Klee
(Münchenbuchsee/Bern 1879 – 1940 Muralto-Locarno)
Biography, see p. 184

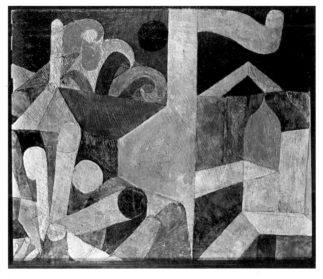

59a Paul Klee
Landscape with Flags, 1915
Watercolor, oil and pencil on cardboard,
9¼ × 11⅛ inches
(23.3 × 28.3 cm)
Kunstmuseum Hannover, Sprengel Collection

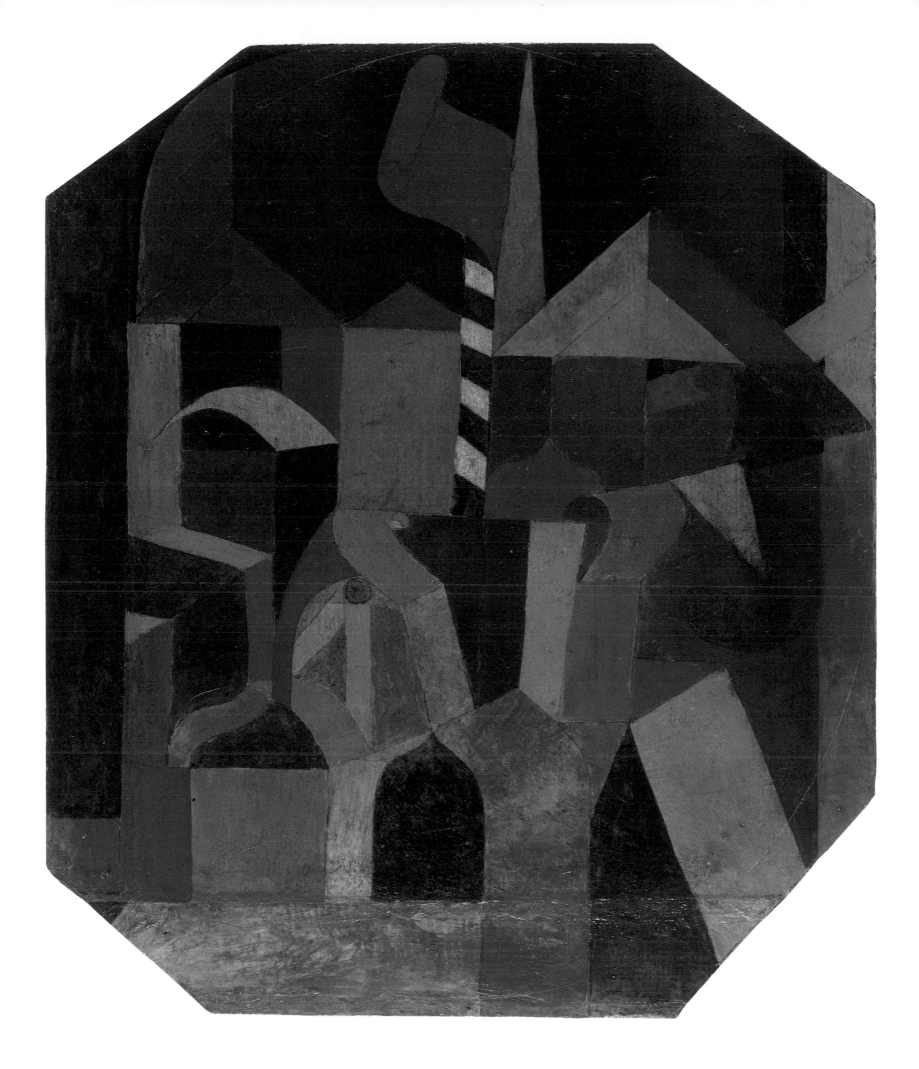

Paul Klee

With the Marionette, 1919

cat. no. 60
Oil on canvas, mounted on
cardboard primed with plaster
14 ¾ × 12 ¾ inches
(37.5 × 32.5 cm)
Signed and dated lower left:
"Klee/1919.159"
Private collection, Bern

[1] Otto Karl Werckmeister, "From Revolution to Exile," in *Paul Klee,* exh. cat. (The Museum of Modern Art, New York, 1987), 44.
[2] *Paul Klee, Tagebücher 1898–1918,* critical edition, published by the Paul Klee Foundation, Wolfgang Kersten ed. (Stuttgart, 1988), 519.
[3] See *Paul Klee, Puppen Plastiken Reliefs Masken Theater,* Galerie suisse de Paris ed. (Neuchâtel, 1979).
[4] Margaret Plant, *Paul Klee, Figures and Faces* (London, 1978), 56.
[5] Felix Klee kindly confirmed this interpretation in an oral conversation.
[6] Otto Flake, "Das Reich," in *Das Tribunal, Hessische radikale Blätter* (Darmstadt), vol. 1, no. 3 (1919), 40. Klee was to reproduce his painting *Barbarian King* of 1917 in the September issue of the same year.

The years 1919–20 mark a culmination in Klee's artistic career. The monographs by Leopold Zahn, Hermann von Wedderkop, and Wilhelm Hausenstein (1921) were published, and a contract for the exclusive representation with Hans Goltz, owner of a gallery in Munich, was signed in October 1919, which helped to organize his sales and exhibitions. Klee's income had reached a comfortable level which allowed him to approach the relatively high expense of oil painting. Werckmeister writes that "within the span of seven months, from early November 1918 to June 1919, Klee experienced in rapid succession fear, hesitation, enthusiastic acceptance, disillusion, recoil, and resignation, acting out the ambivalence of the modern artist torn between the ideology of progressive culture and the revolutionary politics of mass movements."[1] His attempt to get engaged in the politically charged cultural life in Munich in 1918–19 ended unsuccessfully, the Bavarian Räterepublik being defeated by the Freikorps troops in May 1919. Klee was satisfied with a brief conclusive statement on the short-lived events of 1919 in an autobiographical note which he sent off to Hausenstein at the end of the year: "In February 1919 definitive leave from the military. Continued to work on a broad scale. Developed the small oil painting. Correspondence and visits to my studio are steadily increasing, signed a contract with Goltz in self-defence."[2]

One of the small oil paintings Klee was working on in 1919 was *With the Marionette.* It was exhibited twice in 1920, first at Fritz Gurlitt's gallery in Berlin, and a little later with Goltz in Munich. However, it was not sold. The composition shows an abstract landscape, built up by simple drawn and colored elements. On the right side of the painting stands a figure looking at the landscape. In the title Klee signified it as a *Marionette.* The puppets he was about to make for the puppet theater of his son Felix probably served as a source.[3] The impulse itself stemmed from the connection with the Dada circles in Zürich around Tristan Tzara, Hans Arp, and Hugo Ball, and the puppets of Sophie Taeuber-Arp, Carl Fischer, and Otto Morach.[4]

One of the first puppets Klee produced in 1919 represented a bearded Frenchman donning the hat of a Jacobin (Fig. 60a). This image played a very topical political role in the private representations of Felix and Paul Klee's puppet theater in view of the French victory over the German empire in November, 1918.[5] The "puppet" in the painting resembles the hand-puppet in its physiognomy. His helmet, with a disproportionate tuft of feathers reminds us of a French, or even German soldier of the eighteenth and nineteenth centuries. Thus, the two figures can be understood as complementary opposites, in the context of Klee's genuinely dialectic way of thinking: the hand-puppet as a radical democrat and follower of the French Revolution, the puppet in the painting as a military figure with imperial claim to sovereign authority.

Such a recourse to examples from the history of French and German Revolutions was generally adopted in the debates of the critical intellectuals in the period following World War I. In the issue of March, 1919 of the magazine *Das Tribunal,* Otto Flake wrote: "Weimar seemed to me like a ghost from 1848; so to say, as if one would be astonished to have, finally, reached 1848."[6] Although it is difficult to establish the precise meaning of Klee's painting in the contemporary context, it nevertheless seems certain that Klee developed the subjective composition in a conscious reference to the general post-war condition, in accord with his ideological notion of art as "abstraction with memories." *WK*

60a Paul Klee *Bearded Frenchman,* 1919
Plaster and cloth, 3⅛ × 1¾ × 2 inches (8 × 4.5 × 5 cm) Private collection

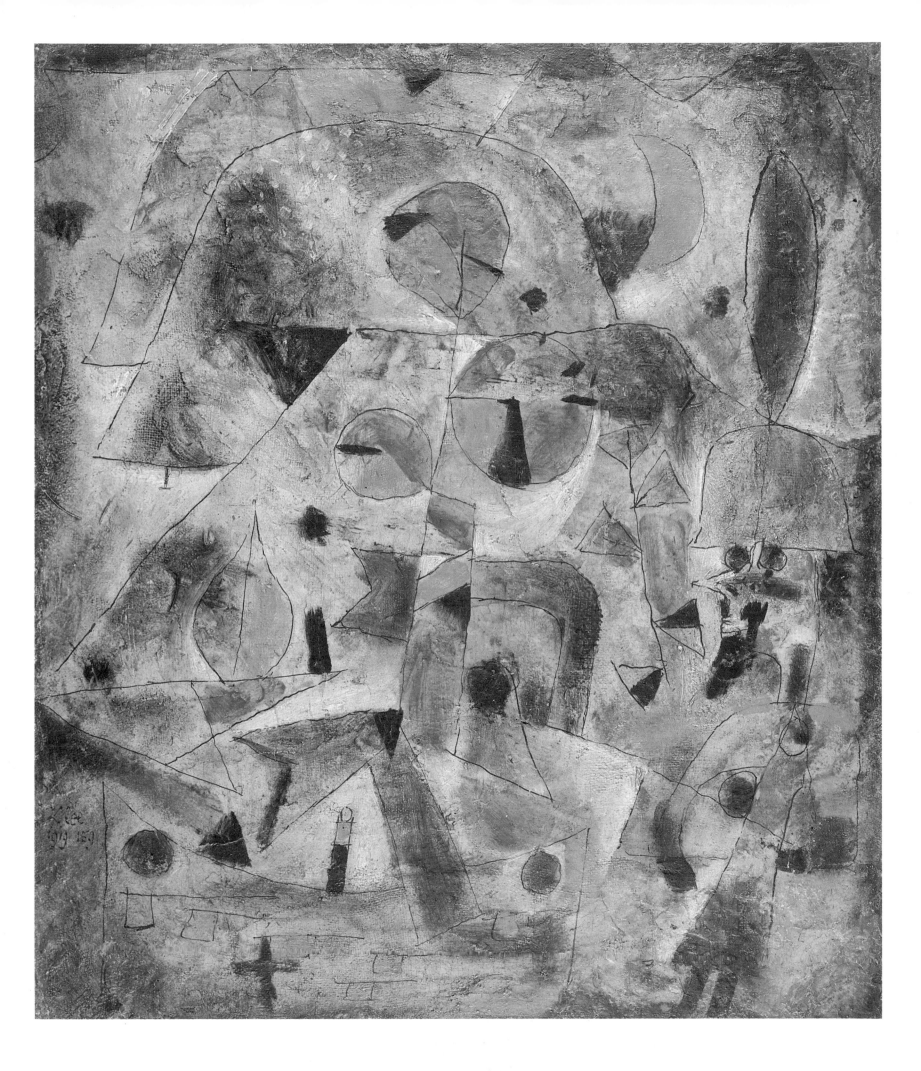

Paul Klee

Image of a City (Graded Red/Green) with the Red Dome, 1923

cat. no. 61
Oil on cardboard
18 ½ × 13 ¾ inches (46 × 35 cm)
no. 1929/90 in Klee's catalogue of
his own work, with the remark:
"later 1927 reworked"
Private collection, Bern

[1] Christian Geelhaar, *Paul Klee und das Bauhaus* (Cologne, 1972), 44.
[2] The most recent study is Eva Maria Triska, *Die Quadratbilder Paul Klees — ein Beitrag zur Analyse formaler Ausdrucksmittel in seinem Werk und in seiner Theorie* (Vienna, 1980).
[3] *Paul Klee, Tagebücher 1898 – 1918,* critical edition published by the Paul Klee Foundation, Wolfgang Kersten ed. (Stuttgart, 1988), 341 (nos. 926 – 927).
[4] In the Wastelands and Red and White Domes (both of 1914) were originally the right and left part of a watercolour that Klee cut in two; *Kairouan, before of the Gate* and *View of Kairouan* (both of 1914) were the upper and lower part of another painting; this is also true of *Kairouan with Camels and a Donkey (after a sketch of that time)* (1919), *With two Camels and the Donkey (after a sketch of 1914 from Kairouan)* (1919) and *Kairouan (after no. 1914/216)* (1921); in reference to this technique see Wolfgang Kersten, *Paul Klee, "Zerstörung, der Konstruktion zuliebe?"* (Marburg, 1987).
[5] Quotation from Hans M. Wingler, *Das Bauhaus, 1919 – 1933 Weimar Dessau Berlin* (Bramsche, 1962), 39.
[6] On this subject, see Marcel Franciscono, *Walter Gropius and the Creation of the Bauhaus in Weimar: The Ideals and Artistic Theories of its Founding Years* (Urbana, 1971), and Ian Boyde Whyte, *Bruno Taut, Baumeister einer neuen Welt, Architektur und Aktivismus 1914 – 1920* (Stuttgart, 1981).
[7] See, for example, Wingler, 1962 (see n. 5), 82.

Klee provides the image of a city, built up in colored rectangles and squares, with two arches integrated into the color fields to animate the architectural scenery. This structural reduction of architecture to the primary shapes of geometry is the basis of a universal system of composition, which Klee (since 1923) helped to theorize when he was a member of the faculty at the Bauhaus between 1921 and 1930. His theoretical reflections constituted the frame of his teaching and of the concepts he carried out in his own work, as for example in the compositions with squares.

Christian Geelhaar indicated correctly that the compositions with squares are of particular interest in the context of Klee's oeuvre, pointing out that they permeate his work from 1921 on until the last period.[1] Numerous studies confirm this observation, while acknowledging Klee's singular and autonomous development of this part of his artistic production.[2] However, the shift in the art historical significance of the compositions with squares still remains largely unexplored.

The title *Image of a City* is a particular key in Klee's reflexions on the theory of art. As a term it becomes the equivalent of the aesthetic program which he expressed in his famous formula that pictorial architecture and urban architecture must be synthesized. He copied the essence of this theory into his diary in 1914, where it is related to his journey to Tunisia.[3]

Image of a City is actually based on the watercolor

Before the Gates of Kairouan, 1914 (Fig. 61a), executed during his stay in that Tunisian town. Klee painted subsequently no less than five variations of the composition between 1914 and 1923, adopting the cubist principle of "destruction for the sake of construction"[4]. But *Image of a City* is essentially different from the previous variations in two respects. For the first time, Klee abandons the primary concern of representing the duality of nature and civilization in a pictoral synthesis, deciding instead in favor of a purely architectural representation. And the rising element of sacred architecture, prevailing in earlier paintings, is entirely subordinated to the two-dimensional expanse of this composition. In this respect he abandons as well a symbol of the utopian vision of a better society, which was closely related to the contemporary expressionistic culture.

This shift in implication occurs simultaneously to a renewal in the direction of the Bauhaus program. The famous text of the flyer of 1919 stated: "Let us together aspire, perceive, and create the new building of the future, which will [. . .] rise to the sky as a crystal symbol of a new faith."[5] Since 1922 there were violent discussions on a modern reform of the Bauhaus[6], which found a preliminary conclusion in the well known constructivist motto of "art and technology — a new entity". The symbol of this new ideology was no longer the uprising cathedral of Lyonel Feininger, but the universal, if not unchallenged[7], square. *WK*

61a Paul Klee
Before the Gates of Kairouan, 1914
Watercolor, 8⅛ × 12⅜ inches (20.7 × 31.5 cm)
Kunstmuseum Bern, Paul Klee Foundation

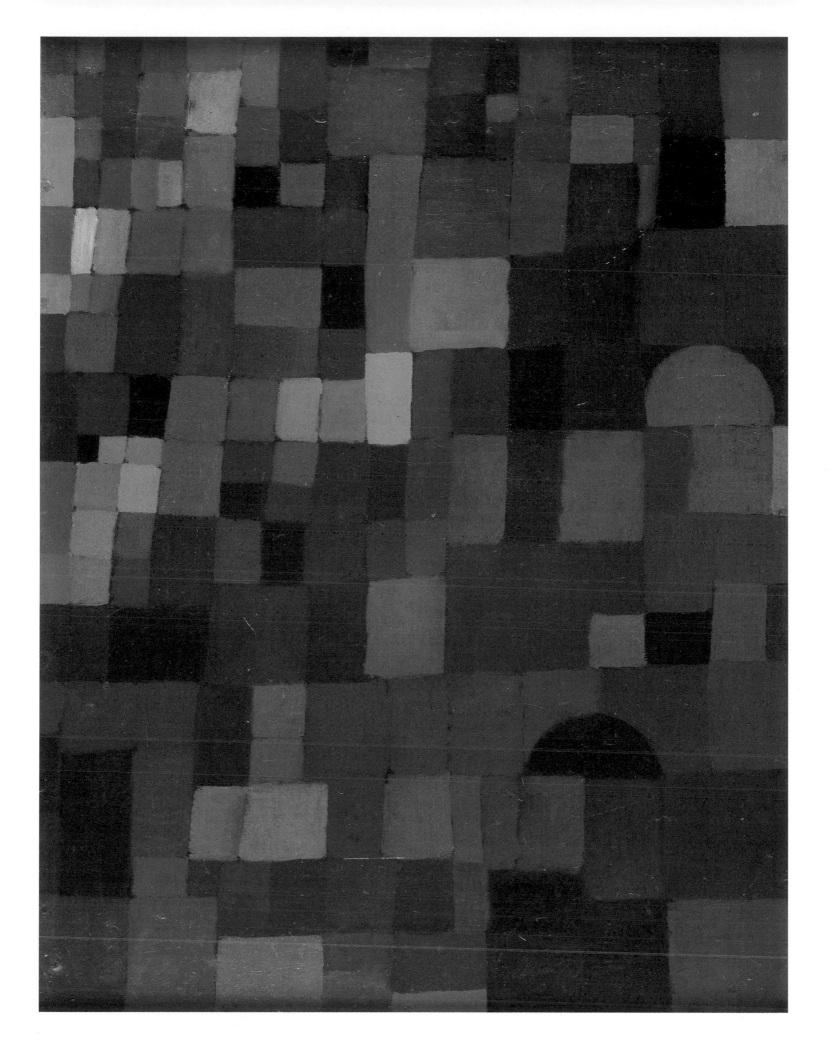

Paul Klee

Mixed Weather, 1929

cat. no. 62
Oil and watercolour on
cheese-cloth
19 ¼ × 16 ⅛ inches (49 × 41 cm)
Signed lower left: "Klee"
no. 1929/343 (3H43) in Klee's cata-
logue of his own work
Private collection, Bern

[1] Georg Graf von Matuschka, *Annäherungen an Paul Klee, Zwanzig Bildinterpretationen,* Schriften des Kunstpädagogischen Zentrums im Germanischen Nationalmuseum Nürnberg, Horst Henschel ed. (Nürnberg, 1987), 56.

[2] Jürg Spiller ed., *Paul Klee, Das bildnerische Denken* (2nd ed. Basel, 1964), 402.

[3] Paul Klee, "exakte versuche im bereich der kunst," in *bauhaus, zeitschrift für gestaltung,* Hannes Meyer ed. (Dessau) vol. 2, no. 2–3 (1928), 17.

[4] See Magdalena Droste, "Wechselwirkungen — Paul Klee und das Bauhaus", in *Paul Klee als Zeichner 1921–1933,* exh. cat. (Bauhaus Archiv Berlin) (Berlin, 1985), 37.

[5] Paul Klee, price-list for six paintings for the Alfred Flechtheim gallery, January, 1930 (Bequest of Paul Klee's autographs, Bern); in reference to the sale of paintings in 1930 see Stefan Frey and Wolfgang Kersten, "Paul Klees geschäftliche Verbindung zur Galerie Alfred Flechtheim," in *Alfred Flechtheim, Sammler, Kunsthändler, Verleger,* exh. cat. (Kunstmuseum Düsseldorf) (Düsseldorf, 1987), 81.

[6] Further illustrations published in Carl Einstein, *Die Kunst des 20. Jahrhunderts,* Propyläen-Kunstgeschichte, vol. 16 (2nd ed. Berlin, 1931), 547; and in *Omnibus, Eine Zeitschrift,* no. 2 (Berlin/Düsseldorf, 1932), 17.

[7] Alfred H. Barr Jr., in his introductory essay, reduces the history of the Bauhaus to the period of Walter Gropius' directorship; see *Paul Klee,* exh. cat. (The Museum of Modern Art, New York) (New York, 1930), 8.

[8] Ibid., 8–9.

[9] Ibid., 10.

[10] See Otto Karl Werckmeister, *Versuche über Paul Klee* (Frankfurt, 1981), 185.

The image seen here represents a vaguely defined space, integrating a schematic illustration of a meteorological process which has been interpreted repeatedly at various times. The most recent text dealing with it reads as follows: "The title misleads the viewer to an easy understanding of the content as a depiction of the natural cycles, exemplified by the circuit of water: sea — sunshine — evaporation — condensation — cloud formation — discharge — downpour — rainshower — rising sea-level — low tide — high tide — cold and warm sea-currents."[1] Not all of these observations are equally evident in the painting: the rising sea-level, high and low tide, cold and warm sea-currents are not recognizable in the picture. However, the evocative power of the image produces this kind of association, which leads continuously to new interpretations, based on the subjective experience and the individual knowledge of different viewers, and hence influences the art historical significance of the painting. And in fact, Klee's own reflections on the theory of art may support this kind of interpretation.

Klee repeatedly referred to water circuits and to the meteorological processes during his lectures at the Bauhaus. This fact is documented by a note published in the edition of Klee's teachings, edited by Jürg Spiller: "Water comes from the sky and rises again to the sky as vapor, hence I continue the line upwards and close the circle."[2] Nevertheless, it seems obvious that in 1929, when Klee painted *Mixed Weather,* the meteorological event was not the only meaning of the work. Rather, the composition is based upon a contradiction, which was discussed in the context of the Bauhaus in Dessau under the directorship of Hannes Meyer. The sensual treatment of space and the didactic meteorological representation evoke the dialectic between intuition and reason, a topic which Klee discussed in 1928 as follows: "We construct and construct, but still intuition is a good thing."[3]

Hannes Meyer[4] advocated the same dialectical relation between "free art" and exact (scientific) research. Official exhibitions, however, seemingly did not reflect this discussion and this new, differentiating assessment of modern art. Klee sold *Mixed Weather* as early as January, 1930 for 2800 Marks to Carry Ross in New York through the Gallery of Alfred Flechtheim.[5] The painting was exhibited in the first important Klee exhibition at the Museum of Modern Art, and it was reproduced in the catalogue.[6] The design of the catalogue evoked the expressionistic period of the Bauhaus (1919–1923), rather than the functionalist tendencies of 1928.[7] Similarly, Alfred H. Barr's essay introduced Klee's work also from the standpoint of expressionistic value, while denying the scientific: "His pictures cannot be judged as representations of the ordinary visual world. Often they defy the laws of design and cannot be judged as formal compositions, though some of them are remarkably interesting to the aesthetic purist. Their appeal is primarily to the sentiment, to the subjective imagination."[8] In regard to *Mixed Weather,* Barr wrote the following: "The arrow is a motive which frequently occurs in Klee's compositions. [...] In 'Mixed Weather' it sweeps along the earth like a tempest beneath the dripping moon."[9]

The rift between such an interpretation of the picture and the topical discussions which took place at the Bauhaus in 1929 may be explained by Klee's ambiguous reception by the society of the Weimar Republic: on the one hand, he was considered by bourgeois circles as a modern master, while on the other hand, he represented a critical stand on culture, which was aimed at integrating modern art into life and society.[10] *Mixed Weather* is an expression of Klee's attempt to combine the contradicting directions in a visual synthesis. *WK*

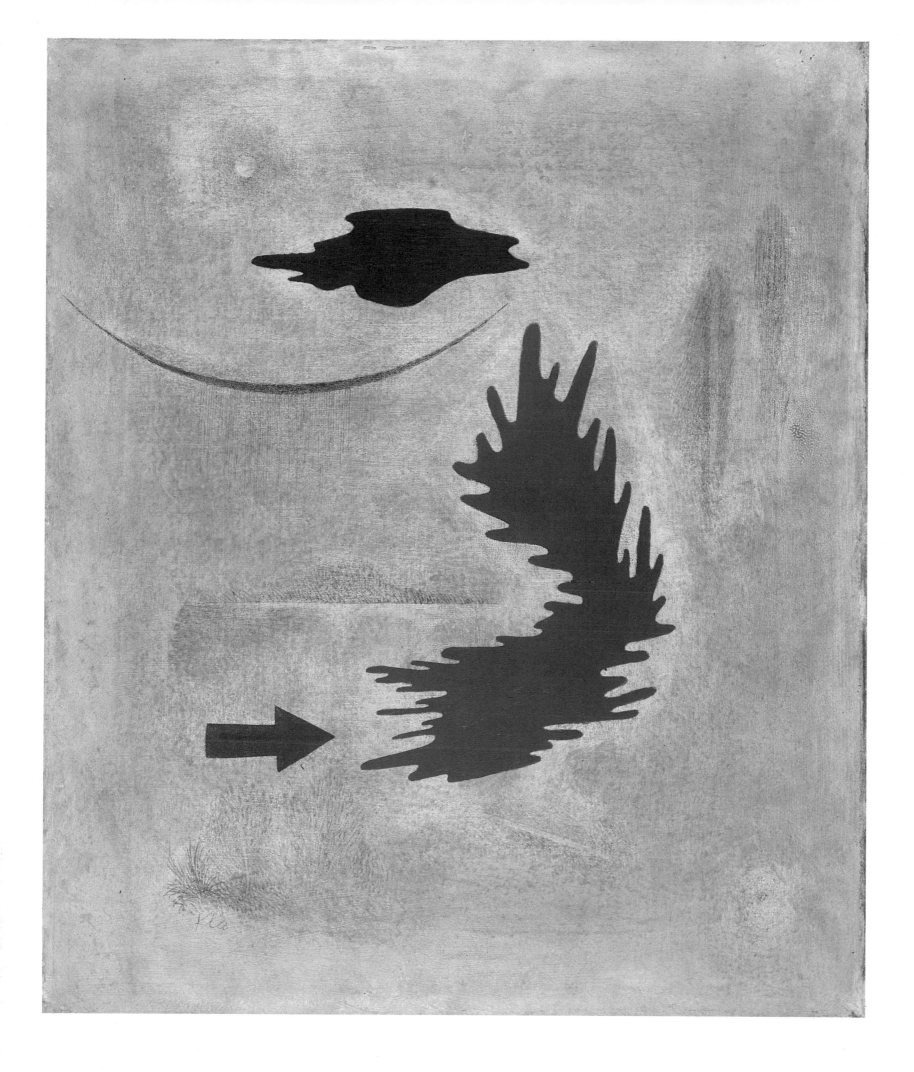

Paul Klee

Through a Window, 1932

cat. no. 63
Oil on cheese-cloth on cardboard
12 × 20 ¼ inches (30.5 × 51.5 cm)
Signed lower right: "Klee"
no. 1932/184 (T 4) in Klee's cata-
logue of his own work
Private collection, Bern

[1] Otto Karl Werckmeister, *Versuche über Paul Klee* (Frankfurt, 1981), 189.
[2] Ibid.
[3] Jürgen Glaesemer, *Paul Klee, Die farbigen Werke im Kunstmuseum Bern*, catalogue of collection, vol. 1 (Berne, 1976), 187.
[4] Werckmeister, 1981 (see n. 1), 189.
[5] See Glaesemer, 1976 (see n. 3), 187.
[6] Ibid., 185.

Since March 1930, Klee negotiated an opportunity of employment with Walter Kaesbach, the director of the Academy in Düsseldorf, who was known for his liberal democratic inclinations. Klee terminated his position at the Bauhaus on April 1, 1931 and started his new activity within the framework of the traditional academy. As Werckmeister noted[1], this move can be seen as the logical consequence of the fundamental crisis the Bauhaus had undergone during Hannes Meyer's directorship in the years of the worldwide financial break-down and of the political uncertainty of the Weimar Republic between 1928 and 1930: "His encyclopedic-pedagogical concept of painting had failed historically, without Klee as an artist having any responsibility for it".[2]

Glaesemer wrote that, soon after moving to Düsseldorf, Klee started developing an expansive, color intense, and increasingly hermetic language of signs and symbols, which he was to elaborate during the years of his Swiss exile.[3] Simultaneously, he reflected on an articulation of forms which can be controlled "scientifically,"[4] and created again a series of paintings in a perfected version of "pointillism," which referred to the encyclopedic goal of the program for the visual arts at the Bauhaus: that is, to create paintings which are readily accessible to a general public.[5] The two pictures *Through a Window* and *Tendril* (see cat. no. 64) belong to this series.

In the first painting, Klee combines his way of color field composition, which he had developed under the influence of his journey to Tunisia and French Cubism in 1914, and which he developed further with regard to contemporary artistic currents, with the "pointillistic" treatment of the painted surface. The "superimposed layers of colored squares with the dissemination of *pointillist* dots" result in a symphony of colors, equalled only by the analogy to musical polyphony.[6] Only the brown window bars and the suggested curtain in the upper left of the picture tie the otherwise entirely abstract composition to an actual view out of the window, a motif seen in Klee's oeuvre since 1908, and which he painted in over forty different versions. *Through a Window* is the end point of the series of window-pictures; the ambiguous play of nearness and distance is articulated here for the last time in an accomplished way by the well-balanced relationship between abstraction and memory. This remains finally the contrasting difference to the last, already over-shadowed version done in exile, *Black Cross-Bars*, 1939 (Fig. 63a). WK

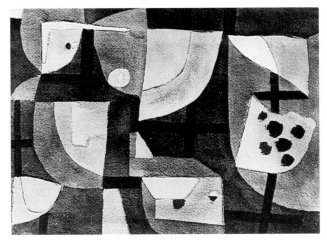

63a Paul Klee
Black Cross-Bars, 1938
Watercolor, 11 ¼ × 15 ⅜ inches (28.5 × 39 cm)
Whereabouts unknown

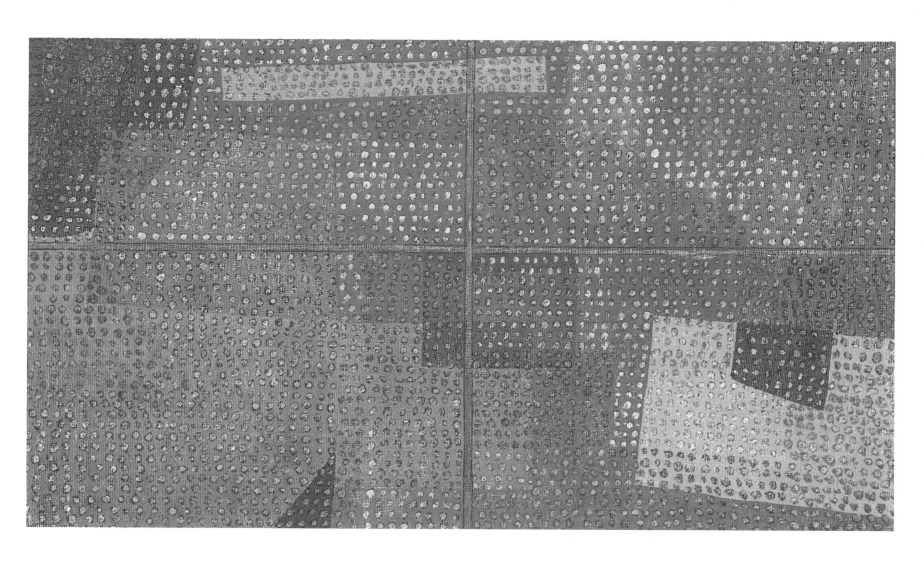

Paul Klee

Tendril, 1932

cat. no. 64
Oil on sprucewood,
oval brass frame
15⁹/₁₆ × 13⁹/₁₆ inches
(39.5 × 34.5 cm)
no. 1932/29 (K 9) in Klee's
catalogue of his own work
Private collection, Bern

[1] See Jürgen Glaesemer, *Paul Klee, Die farbigen Werke im Kunstmuseum Bern,* catalogue of collection, vol. 1 (Berne, 1976), 185.
[2] Andrew Kagan, "Paul Klee's *Ad Parnassum:* The Theory and Practice of Eighteen-Century Polyphony as Models for Klee's Art," in *Arts magazine,* vol. 52, no. 1, (September 1977), 90 – 104.
[3] *Paul Klee, Tagebücher 1898 – 1918,* critical edition, published by the Paul Klee Foundation, Wolfgang Kersten ed. (Stuttgart, 1988), 366 – 368.
[4] Glaesemer, 1976 (see note 1), ill. 68.
[5] Otto Karl Werckmeister, *Versuche über Paul Klee* (Frankfurt, 1981), 62 – 63.
[6] Quotation from Christian Geelhaar, ed., *Paul Klee — Schriften, Rezensionen und Aufsätze* (Cologne, 1976), 118.
[7] Quotation from Jürgen Glaesemer, ed., *Paul Klee, Beiträge zur bildnerischen Formenlehre,* facsimile edition of the original manuscripts of Paul Klee's first series of lectures given at the Staatliches Bauhaus Weimar 1921/22 (Basel/Stuttgart 1979), 9.

Polyphony and *Ad Parnassum,* both of 1932, are two paintings which Klee developed as an analogy to primary musical patterns. Both compositions are accepted among his key works.[1] *Ad Parnassum* is a direct reference to a text by Johann Joseph Fux *Gradus ad Parnassum,* a system of musical composition published in 1725.[2]

The title of the present painting, *Tendril,* painted in the same style, seems to focus on the formal, ornamental elements of the composition. The colored dots are painted on a monochrome priming, not on a field of colored squares as in *Through a Window* (see cat. no. 63) or in the two other pictures mentioned above. The dots are clearly arranged around the linear forms, in particular in regard to the sun and the tendril, which moves above and below the horizon in a serpentine flow. Without belaboring the point, the language of colors and forms appears to suggest a southern landscape. In this sense, the painting is reminiscent of the watercolors executed in Tunisia in 1914. In addition, the composition depicts a strong verticality. The linear forms are aligned almost symmetrically around the middle axis. In form and content, the vertical order culminates in the eye hovering above the sun; this motif reminds one of Klee's equally introverted attitude at the beginning of 1915[3], and of compositions executed during World War I, such as *With the Eagle* of 1918[4], which includes a similar motif, visualizing the transcendence from the material to the cosmic realm[5].

The tendril and the horizon are the horizontal elements which balance the vertical direction of the composition. The tendril as a motif dates back to the beginnings of Klee's *Bildnerische Formenlehre* which he developed for his first series of lectures at the Bauhaus. On November 14, 1921, Klee discussed the "freedom of lineation," based on a strict reduction of the pictorial means in using the example of lines curved in the manner of tendrils (Fig. 64a). In a contribution to Kasimir Edschmid's anthology *Schöpferische Konfession* of 1920, Klee suggests that the reader develops his own phantasy looking at lines: "Let us develop, and undertake a short journey into the land of better understanding, by establishing a topographical map."[6] But in a lecture in November, 1921, he maintained: "It is actually like a walk for its own sake."[7]

There are no documents relating to the significance Klee attributed to abstract linear forms in 1932. This leaves the question unanswered, whether the tendril in the present picture has a purely ornamental function or whether it has associative meaning as well. Nevertheless, it remains obvious that *Tendril* links up with very early problems of Klee's artistic production on several levels; namely, the journey to Tunisia in 1914, his introverted attitude, the idea of spiritual ascent developed during the period of World War I, and the *Bildnerische Formenlehre* from late 1921. It seems that at the Düsseldorf Academy, he tried to re-establish the expressive means he had previously acquired, and to use them in a synthesis with the newly developed pictorial techniques, without the obligation of referring to them rationally.

WK

64a Paul Klee
Beiträge zur bildnerischen Formlehre
Manuscript for a lecture, delivered on 14 November 1921, at the Bauhaus in Weimar, p. 8

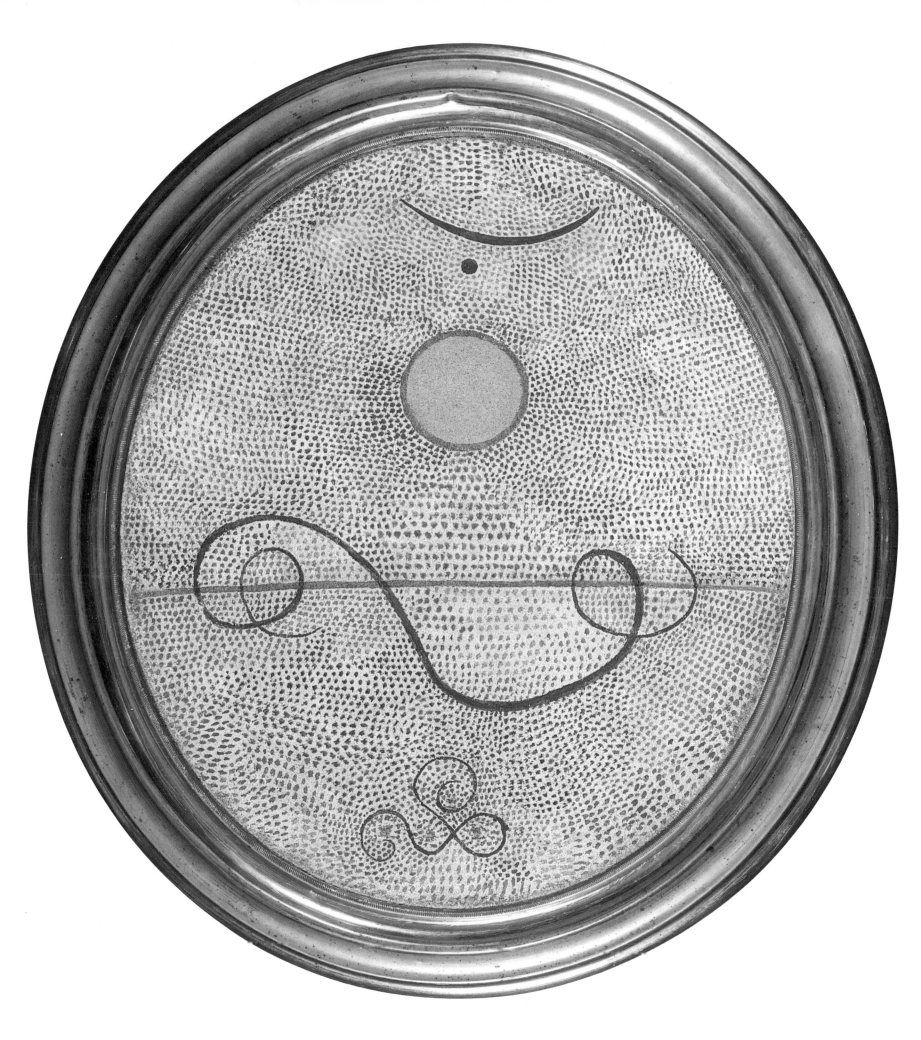

Le Corbusier

Composition: Violin, Bone, and Saint-Sulpice, 1930

cat. no. 65
Oil on canvas
51 3/16 × 35 1/16 inches
(130 × 89 cm)
Signed and dated lower right:
"Le Corbusier./ 30"
Kunstmuseum Winterthur,
inv. no. 1391

Bibliography:
Le Corbusier: Peintures, exh. cat. (Centre Le
Corbusier Heidi Weber, Zürich) (Zürich,
1986); Jean Petit, *Le Corbusier lui-même*
(Geneva, 1970), 220; *Kunstverein Winterthur,*
64. Jahresbericht, 1984, 6.

1 Stanislaus von Moos, *Le Corbusier, l'archi-
tecte et son mythe* (Paris, 1971), 288.
2 Siegfried Giedion, in *Le Corbusier,* exh. cat.
(Kunsthaus Zürich) (Zürich, 1938), 11. See
also Arthur Rüegg, "Der Pavillon de l'Esprit
Nouveau als Musée imaginaire," in *L'Esprit
Nouveau, Le Corbusier und die Industrie
1920–1925,* exh. cat. (Zürich/Berlin/Stras-
bourg, 1987), 134–151.
3 See *Léger et l'Esprit Moderne. Une alterna-
tive d'avant-garde à l'art non-objectif
(1918–1931),* exh. cat. (Paris/Houston/Ge-
neva, 1982–83).

Following the purist period still marked by the pictorial traditions of French painting, after 1927 Le Corbusier began to dedicate five hours a day to painting and adopted a highly personalized style. He made a definite break with the prevailing contemporary stylistic currents in *Violin, Bone, and Saint-Sulpice.* The painting is closely related to two of his other works of the same period: *Léa,* of 1931, which takes up the motif of the violin borrowed from the purist vocabulary, and *Saint-Sulpice,* of 1929–30, composed of architectural elements related to those of the present painting.

The most obvious feature of the picture is the expression of a dialectical tension: the formal language is consistent with the aesthetic conventions of cubism, while the plasticity of organic shapes is an anticipation of the sculptures which Le Corbusier would produce in the 1940s and 1950s. The carefully constructed space, built up according to the laws of traditional perspective or by superimposing planes according to cubist techniques, contradicts the sensual perception of space evoked by the modeled forms. The resulting ambiguity precludes a clear definition of the pictorial space.

The manifesto *Après le cubisme,* which Le Corbusier wrote together with Amédée Ozenfant in 1918, clearly states his intention to abandon any anecdotal reference, and to subordinate the "descriptif" to the "plastique". *Violin, Bone, and Saint Sulpice* fulfills these demands to a far greater extent than the paintings of the purist period. The objects, or parts of objects, have imparted a compelling power to the picture through their isolation from all literal connotations. This evocative power comes neither from the fact that the objects carry symbolic meaning, nor from poetic resonances derived from new and unexpected associations in the manner of the Surrealists, though Le Corbusier may in fact have maintained some sort of "underground contacts"[1] with them. The architect-painter forcefully depicts the image of an everyday universe, at once interior and exterior, which he utterly transfigures, rendering it devoid of all descriptive resolution.

The color is still tied to the objects, which would no longer be the case in later paintings; the interaction of the various warm and cool tones supports the subliminal dynamics of the composition and its expressive consistency. The natural elements which Le Corbusier calls "objects of poetic reactions," such as pebbles, bark, roots, or bones, and which would be seen in the *Pavillion de l'Esprit Nouveau* in 1925,[2] reappear in the paintings after 1928. The presence of organic elements bears witness to the significance nature always held for Le Corbusier.

Le Corbusier's paintings of the late 1920s have much in common with those of his friend Fernand Léger: for example, the confrontation on the picture plane of objects belonging to different domains, with a disparity of scale which provokes unreleased tensions. The particular interpretation or treatment of the shapes and materials invests them with a certain monumentality, be it through the outline of a volume or through use of a certain color. Like Léger, Le Corbusier emphasizes the plasticity of these objects, and reveals their weight. However, his paintings display a structural coherence lacking in the paintings of Léger.[3]

The "haute généralité" of painted forms — a notion postulated in the 1918 manifesto —, the originality of composition, the prescient artistic talent Le Corbusier-Jeanneret had demonstrated even before moving to Paris and before the development of his purist style: all these qualities produce an emotional presence in *Composition: Violin, Bone, and Saint-Sulpice* which is at once subtle and profound. *DP*

Le Corbusier (Charles-Edouard Jeanneret)
(La Chaux-de-Fonds 1887 – 1965 Roquebrune-Cap Martin)
Biography, see p. 185

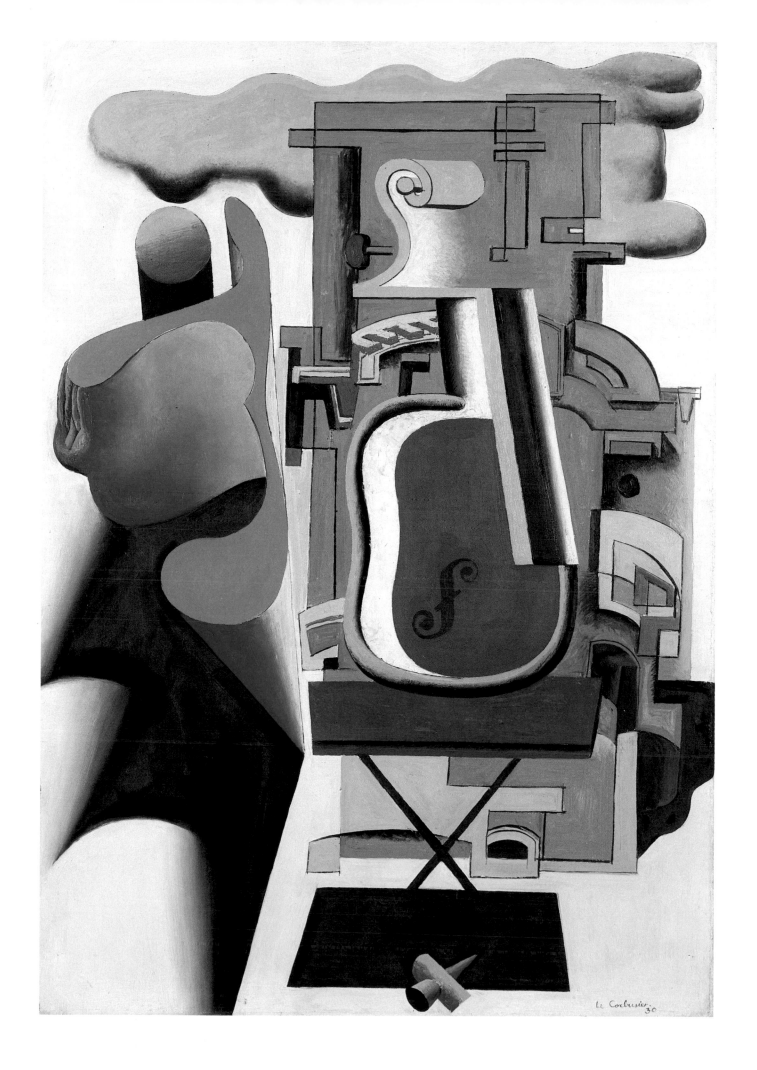

Biographies

Jacques-Laurent Agasse
(Geneva 1767 – 1849 London)

see cat. nos. 21, 22

Son of wealthy Geneva citizens of Scottish origin. Grew up spending much time in the countryside, in close contact with animals. First drawing education with Jacques Cassin (1739 – 1800) and Georges Vanière (1740 – 1834). Friendship with Wolfgang-Adam Töpffer and Firmin Massot (1766 – 1849). 1786 – 1789 in Paris studying with Jacques Louis David (1748 – 1825), from whom he learned the careful drawing of French neoclassicism and the importance of close observation of nature. Moreover, he attended veterinary lectures and even dissected animals to expand his knowledge. 1790 journeyed to England with Lord Rivers, his future patron. After returning to Switzerland he relied on painting for income because of the collapse of his father's fortune during the Revolution. At the insistence of Lord Rivers, he moved permanently to London in 1800. However, he maintained his old connections to Geneva. Participated regularly from 1801 in the exhibitions of the Royal Academy. Influenced by the paintings of George Stubbs (1724 – 1806). Agasse was one of the most outstanding animal painters of his time. He painted for the European haute bourgeoisie, the aristocracy, and for the royal Court of Britain. He worked in stables, parks, menageries, and zoological gardens, frequently portraying animals in connection with portraits or genre scenes.

Arnold Neuweiler, *La peinture à Genève de 1700 à 1900* (Geneva, 1945).

Cuno Amiet
(Solothurn 1868 – 1961 Oschwand)

see cat. nos. 55 – 57

First drawing education around 1844 with the history painter Heinrich Jenny (1824 – 1891) and, irregularly with Frank Buchser. 1886 began his studies at the Academy of Arts in Munich. Friendship with Giovanni Giacometti. 1888 moved to Paris to study at the Académie Julian. Spent the summer months with Giacometti, either in Stampa or in Solothurn. 1892 – 93 in Pont-Aven (Brittany), where he came into contact with the group of painters living there. Back in Switzerland he met Ferdinand Hodler. 1893 – 1898 studio in Solothurn, 1895 second studio at Hellsau. The paper industrialist Oscar Miller at Biberist became his first patron and collector. Met Giovanni Segantini. 1898 moved to the Oschwand. 1907 acquaintance with the Solothurn collector Josef Müller. 1901 participated in the twelfth exhibition of the Viennese *Sezession*. Became a member of the Dresden artists' group *Die Brücke* in 1906. 1932 – 1939 spent some months each year in Paris. In the 1931 fire of the Munich Glass Palace, fifty of his paintings were lost.

Cuno Amiet und die Maler der Brücke, exh. cat. (Kunsthaus Zürich/Brückemuseum, Berlin) (Zürich, 1979); George Mauner, *Cuno Amiet* (Zürich, 1984).

Albert Anker
(Ins 1831 – 1910 Ins)

see cat. nos. 40, 41

After moving to Neuchâtel, first drawing education with Friedrich Wilhelm Moritz (1783 – 1855). 1851 – 1854 studied theology at Bern and Halle (Germany). 1854 gained permission from his father to become a painter. 1854 – 1856 in Paris, studied with Charles Gleyre, and at the Ecole des Beaux-Arts. 1861 – 62 first journey to Italy, where he copied paintings by the old masters. Forced to return to Switzerland when he contracted typhoid. 1862 – 1890 Anker spent most summer months at Ins, and winters in Paris. 1870 – 1874 member of the Bernese *Grosser Rat*. Engaged himself in the erection of the art museum in Bern. 1882 journey to Belgium and France, 1887 and 1889 second and third journeys to Italy. 1889 – 1893 and 1895 – 1898 member of the Federal Art Commission. 1898 presided over the organizing committee of the fifth National Art Exhibition in Basel. Suffered from a stroke in 1901 which largely paralyzed his right hand. In the last decade of his life, Anker painted few canvases, but produced hundreds of watercolors.

Albert Anker: Katalog der Gemälde und Ölstudien (Kunstmuseum Bern, 1962); Sandor Kuthy and Hans A. Lüthy, *Albert Anker* (Zürich, 1980).

François Bocion
(Lausanne 1828 – 1890 Lausanne)

see cat. no. 34

Arnold Böcklin
(Basel 1827 – 1901 San Domenico di Fiesole)

see cat. nos. 38, 39

Frank Buchser
(Feldbrunnen 1828 – 1890 Feldbrunnen)

see cat. nos. 35 – 37

Spent his youth in Montreux, Vevey, and Lausanne. Drawing education with the French landscape painter François Bonnet (1811 – 1894) in Lausanne. 1845 moved to Paris. Painted first in the studio of Louis-Aimé Grosclaude (1784 – 1869), later in the atelier of Charles Gleyre. Returned to Switzerland in 1848. Became a teacher of drawing in 1849 at the Ecole industrielle in Lausanne. Was elected district councilor in 1851. Several journeys to Italy: Rome, Naples, Venice, and San Remo. Member of the Federal Art Commission.

Béatrice Aubert-Lecoultre, *François Bocion* (Lutry, n.d. [1977]).

1845 – 1847 studied at the Academy of Arts in Düsseldorf under Wilhelm Schirmer. 1847 – 48 traveled with Rudolf Koller (1828 – 1905) to Aachen, Brussels, Antwerp, and Paris. 1850 first journey to Rome where he painted idealized landscapes. 1857 returned to Basel, shortly afterwards moved to Munich. For the rest of his life he would divide his time between Italy and his native Switzerland, with intermittent stays in Germany. In 1859, his painting entitled *Pan in the Reeds* was purchased by King Ludwig I of Bavaria for the Neue Pinakothek collection. Made the acquaintance of the art collector Count Adolf Friedrich Schack, who would become his most important patron. 1860 professorship at the Academy of Arts at Weimar. Returned to Rome two years later. 1866 – 1871 in Basel. Was commissioned to paint a fresco for the garden room of the house of Carl Sarasin. Moved to Florence in 1874, where he became acquainted with the art dealer Fritz Gurlitt from Berlin. Gurlitt regularly exhibited Böcklin's work in Berlin, and later in Dresden. 1885 – 1893 in Zürich. Friendship with the writer Gottfried Keller (1819 – 1890). 1893 moved to Florence, 1895 to San Domenico di Fiesole. His 70th birthday was commemorated with a series of retrospective exhibitions in Berlin, Hamburg, and Basel.

Rolf Andree, *Arnold Böcklin: Die Gemälde* (Basel/Munich, 1977); *Arnold Böcklin,* exh. cat. (Ausstellungshallen Mathildenhöhe, Darmstadt, 1977).

Apprenticeship as organ builder at Solothurn. First drawing education with Heinrich von Arx (1802 – 1858), successor of the caricaturist Martin Disteli (1802 – 1844). 1847 journey to Paris, subsequently to Florence and Rome. In Italy, he decided to become a painter. 1848 joined the Swiss Guard in Rome. During the Revolution, he fought on the side of the liberator Giuseppe Garibaldi. While living in Rome he acquired great skill in copying paintings of the old masters. 1849 – 50 in Paris. Journeyed to Belgium and Holland. Copied canvases by Peter Paul Rubens and Anthonis van Dyck. 1852 – 53 sojourn in Spain. 1853 – 54 first trip to England. Painted several portraits. Returned to Switzerland. In the years to follow, Buchser lived for a time in England as well as in Spain and Morocco. Depicted scenes from daily life. 1859 accompanied the Spanish army as draughtsman during the Moroccan war. Buchser was one of the founders of the Vereinigung schweizerischer Künstler, from which emerges the Society of Swiss Painters, Sculptors, and Architects. 1866 – 1871 sojourn in North America. Painted portraits, landscapes, and scenes from everyday life of the Blacks and native American Indians. Returned to Switzerland in 1871. In the following years visited Italy, England, and Morocco. 1883 – 1885 journey to Greece and the Balkans. Settled in his native country in 1885. Engaged himself with the promotion of Swiss art (National Art Exhibition, Federal Art Commission).

Gottfried Wälchli, *Frank Buchser 1828 – 1890. Leben und Werk* (Zürich/Leipzig, 1941); Peter Vignau-Wilberg, *Museum der Stadt Solothurn: Gemälde und Skulpturen* (Solothurn/Zürich, 1973).

Max Buri
(Burgdorf 1868 – 1915 Interlaken)

see cat. no. 46

Alexandre Calame
(Vevey 1810 – 1864 Menton/France)

see cat. no. 29

François Diday
(Geneva 1802 – 1877 Geneva)

see cat. no. 28

First education with Fritz Schider (1846 – 1907) at the drawing school and vocational schools in Basel. 1886 student at the Academy of Arts in Munich. 1887 studied in the atelier of Simon Hollosy (1875 – 1918). Became acquainted with the work of Wilhelm Leibl (1844 – 1900) and Fritz Uhde (1848 – 1911). Traveled to Austria and the Scandinavian countries. 1889 studied at the Académie Julian in Paris. At the Paris World Fair of the same year, he was impressed by the work of Pierre Puvis de Chavannes (1824 – 1898). Traveled from Paris to Spain, North Africa, Holland, and Belgium. In 1893, again in Munich, in the studio of Albert von Keller (1844 – 1920). 1898 returned to Switzerland. Lived in Lucerne until 1903, and then moved to Brienz. In 1915, Buri died of a heart attack. Only during his years in Lucerne did he definitively turn away from the tradition of the Munich school of painting. Influenced by the work of Ferdinand Hodler, he discovered his own style with a clear, linear structure of composition, and flat application of color.

Hans Graber, *Max Buri: Sein Leben und Werk* (Basel, 1916).

Son of a stone cutter and father of the painter Arthur Calame (1843 – 1919). Grew up in great poverty. Lost his right eye as a child. After his father's death in 1826, apprenticeship as a bank clerk in Geneva. The director of the bank recognized Calame's artistic talent and sent him to the studio of the landscape painter François Diday. Diday roused in his student a love for the mountains. After three years of studying, Calame left the studio of Diday. 1835 first journey to the Bernese Oberland. In the same year sojourn in Italy, especially Paestum. 1837 journey to Paris; 1838 to Germany and the Netherlands. In subsequent years he frequently painted in the Bernese Oberland. A respiratory disease caused him to leave the mountains and find new subjects in the environs of Lake Lucerne. After 1853 made several trips to the Riviera. Celebrated triumphant successes in the 1840s and 1850s like François Diday. In Geneva, Calame directed a studio with students from all of Europe. The painting of Alexandre Calame came to terms with a romantic affection for nature and with a passion for the high mountain region. It also supported the patriotism which flourished in the nineteenth century. His large studio paintings often have an academic look. The smaller canvases and studies, with their sense of immediacy, however, radiate liveliness and spontaneity. Moreover, Calame left a rich opus of lithographs and etchings which for the most part adopt the motifs of the paintings.

Valentina Anker, *Alexandre Calame: Vie et œuvre, Catalogue raisonné de l'œuvre peint* (Fribourg, 1987).

Grandson of the engraver Jean Louis Diday (1727 – 1790). Student at the Ecole de dessin in Geneva. Directed his own studio in Geneva from 1824. On the recommendation of the French portrait, genre, and history painter Auguste Robineau, Diday obtained a scholarship from the Geneva Société des Arts for an educational journey to Italy. 1825 – 1828 with Wolfgang-Adam Töpffer painting in the environs of Geneva, in the canton of Vaud, and in the Savoy region. After 1827, Diday painted regularly in the Bernese Oberland. 1830 journey to Paris. Studied in the Louvre and with Antoine Jean Gros (1771 – 1835). Students joined Diday in his studio as he became more well-known, among them Alexandre Calame. Successful at foreign exhibitions after the late 1830s. Numerous commissions from an international clientele. Bequeathed part of his fortune to the city of Geneva (the Diday Foundation), and another part to the Société des Arts for the organization of competitions called the *Concours Diday*.

A. Schreiber-Favre, *François Diday. Fondateur de l'école suisse du paysage* (Geneva, 1942).

Abraham-Louis-Rodolphe Ducros
(Moudon 1748 – 1810 Lausanne)

see cat. nos. 13 – 15

Originally urged by his family to become a businessman, Louis Ducros finally had his own way and became a painter. Moved to Geneva for initial studies with Jean-Pierre Saint-Ours and Pierre-Louis de la Rive (1753 – 1817). Journey to Flanders. About 1772 moved to Italy. Remained in Rome for more than thirty years. Intermittent sojourns in Naples, Sicily, and Malta. Specialized in landscape painting. Depicted the most famous views of ancient Rome. Published a series of views with the engraver Giovanni Volpato. Directed a well-organized atelier, where many Swiss artists worked on a temporary basis. Accessory figures and architectural elements in his paintings were sometimes finished by assistants. Returned to Switzerland in 1805 – 06. Settled first at Nyon, later in Lausanne, where he founded an art school.

Images of the Grand Tour, Louis Ducros 1748 – 1810, exh. cat. (The Iveagh Bequest, Kenwood House, London/The Whitworth Art Gallery, University of Manchester) (Geneva, 1985); *A.L.R. Ducros (1748 – 1810), Paysages d'Italie à l'époque de Goethe,* exh. cat. (Musée cantonal des beaux-arts, Lausanne) (Lausanne, 1986).

Johann Heinrich Füssli
(Zürich 1741 – 1825 Putney Hill/London)

see cat. nos. 10 – 12

Descendant of a family of artists, and son of the portraitist, art critic, and town clerk Johann Caspar Füssli. Grew up in the intellectual circles of Zürich. His family pressured him to study theology, and as a result, Füssli acquired a many-faceted literary and historical foundation, primarily through his contact with Johann Jacob Bodmer. 1761 ordination as clergyman. For supporting Lavater in his charge against the provincial governor Grebel, he had difficulties with the authorities in Zürich. Left Switzerland in 1763. After staying in Berlin for a period, traveled to England in 1764. First translation of Winckelmann's *Reflections on the Painting and Sculpture of the Greeks.* Produced illustrations to the works of Shakespeare. 1766 journey to France and meeting with Rousseau. In 1768 Sir Joshua Reynolds (1723 – 1792) motivated Füssli to devote himself entirely to painting. Eight years' sojourn in Rome. During this time he visited Florence, Venice, and Naples. Sketched from antique sculpture as well as works from the Renaissance, Mannerist, and early Baroque periods. Especially admired Michelangelo. After a short stay in Zürich, returned to England in 1779. Received encouragement from Reynolds. Painted a series of pictures illustrating the works of Shakespeare and Milton, and scenes from the works of Homer, Dante, and Wieland. In 1787 friendship with William Blake (1757 – 1827). Active as writer, poet, art and literary critic. After 1799, taught at the Royal Academy.

Gert Schiff, *Johann Heinrich Füssli, 1741 – 1825,* 2 vols. (Zürich, 1973); *Henry Fuseli: 1741 – 1825,* exh. cat. (Tate Gallery, London) (London, 1975).

Augusto Giacometti
(Stampa 1877 – 1947 Zürich)

see cat. no. 58

Cousin of Giovanni Giacometti. Attended classes for drawing teachers at the Kunstgewerbeschule in Zürich. Inspired by Eugène Grasset's book *La Plante et ses applications ornamentales,* he traveled to Paris in 1897. Studied with Grasset at the Ecole Normale d'Enseignement de Dessin until 1901. From 1902 to 1915 taught figure drawing at a private academy in Florence, spending summers in Stampa. Settled in Zürich in 1915. 1918 joined *Neues Leben,* a group of artists including a number of Dadaists. Numerous travels in Europe. In 1931 traveled to Tunisia, and in 1932 to Algeria. In 1939 elected president of the Federal Art Commission.

Augusto Giacometti: Ein Leben für die Farbe, Pionier der abstrakten Malerei, exh. cat. (Bündner Kunstmuseum, Chur, 1981); *Augusto Giacometti 1877 – 1947: Gemälde, Aquarelle, Pastelle, Entwürfe,* exh. cat. (Kunstmuseum Luzern) (Lucerne, 1987).

Giovanni Giacometti
(Stampa 1868 – 1933 Glion)

see cat. nos. 52 – 54

Karl Girardet
(Le Locle 1813 – 1871 Versailles)

see cat. no. 30

Charles Gleyre
(Chevilly 1806 – 1874 Paris)

see cat. nos. 25 – 27

Cousin of Augusto and father of Alberto, Diego, and Bruno Giacometti. Childhood in Stampa. In 1886 private art school in Munich. In 1887 met Cuno Amiet, and they became life-long friends. Deeply impressed by French *plein-air* painting at the International Art Exhibition of Munich 1888. Moved to Paris. Studied at the Académie Julian until 1891. Returned to Stampa. Journey to Italy in 1893. In 1894 decisive encounter with Giovanni Segantini, who had settled in neighboring Maloja. Giacometti temporarily took up Segantini's divisonistic method of painting. In the same year Giacometti extensively studied the work of Cézanne, Van Gogh, Gauguin, the school of Pont-Aven, Amiet, and Hodler. 1908 participated in the exhibition of *Die Brücke* in Dresden. 1920 met Ernst Ludwig Kirchner in Davos. Like Cuno Amiet and Hans Berger (1882 – 1977), Giovanni Giacometti represented a generation of Swiss artists who overcame Hodler's strong influence, particularly through the intensive study of French prototypes. Light and color were central to his artistic intentions.

Elisabeth Esther Köhler, *Giovanni Giacometti 1868 – 1933: Leben und Werk,* Ph.D. diss., University of Zürich (Zürich, n.d. [1968]); *Giovanni Giacometti im BündnerKunstmuseum Chur. Katalog zur Ausstellung Giovanni Giacometti zum 50. Todestag: Werke im Bündner Kunstmuseum,* exh. cat. (Bündner Kunstmuseum, Chur, 1983).

Born into the artist family Girardet from Le Locle. In 1822 his father emigrated to Paris with the family. Training with Léon Cogniet (1794 – 1880). 1839 was commissioned to produce a history painting by the city of Neuchâtel. 1839 sojourn in Venice, 1840 in Rome, and 1842 in Naples. Exhibited and won prizes repeatedly at the Salon. Received numerous commissions from Louis-Philippe; among them were history paintings for the *Galerie historique de Versailles* and depictions of court life. In 1842 traveled with his brother Edouard to Egypt to make sketches for images of the crusades. In 1846 the French government requested him to accompany the Duke of Montpensier to Spain to portray the ceremonies of the princely wedding. 1848, after the fall of the monarchy, sojourn in Brienz at the home of his brother Edouard. Traveled throughout Switzerland and dedicated himself to landscape painting. Later returned to France. Girardet illustrated numerous literary works, among them Rousseau's *Nouvelle Héloïse,* and many of his paintings were reproduced as prints.

Maximilien de Meuron et les peintres de la Suisse romantique, exh. cat. (Musée d'art et d'histoire, Neuchâtel, 1984).

Gleyre was orphaned and grew up in Lyon with his uncle, a textile merchant. After beginning his drawing education there, he moved to Paris in 1825. Studied with the history and portrait painter Louis Hersent (1777 – 1860), at the Ecole des Beaux-Arts, and at the studio of Richard Parkes Bonington (1802 – 1828). 1828 journey to Milan, Parma, Bologna, Florence. Arrived 1829 in Rome, where he remained four years. Acquaintance with Léopold Robert. 1834 – 1837 accompanied a rich American on an extended journey to Naples, Sicily, Malta, Greece, Turkey, and Egypt. Painted landscapes and costumes of the native population. In 1835 Gleyre separated from his companion to remain in Sudan. He returned to Lyon in 1837, seriously ill. 1838 again in Paris. In the same year, he took over the studio of Paul Delaroche (1797 – 1856) where he taught for 21 years. 1845 traveled to Padua and Venice. After 1848, numerous commissions for history and other paintings.

Charles Clément, *Gleyre: Etude biographique et critique* (Paris, 1878); *Charles Gleyre ou les illusions perdues,* exh. cat. (Kunstmuseum Winterthur, et al., 1974/75) (Zürich, 1974); *Charles Gleyre: 1806 – 1874,* exh. cat. (Grey Art Gallery, New York University/The University of Maryland Art Gallery, Maryland) (New York, 1980).

Ferdinand Hodler
(Bern 1853 – 1918 Geneva)

see cat. nos. 42 – 45

Angelika Kauffmann
(Chur 1741 – 1807 Rome)

see cat. nos. 5, 6

Paul Klee
(Münchenbuchsee/Bern 1879 – 1940 Muralto/ Locarno)

see cat. nos. 59 – 64

Eldest among five children of a carpenter. 1867 – 1870 first training in art with Ferdinand Sommer, a painter of views for tourists. Traveled on foot to Geneva to copy works by Calame and Diday. 1872 – 1877 studied with Barthélemy Menn in Geneva. 1877 first visit to Paris. 1878 – 79 sojourn in Spain where he visited the Prado. 1883 traveled to Munich and visited the Alte Pinakothek. Lived in extreme poverty. 1884 liaison with Augustine Dupin, and acquaintance with the poet Louis Duchosal and his Symbolist circle. 1887 birth of son, Hector. 1889 married Bertha Stucki. With the *Night* at the Salon du Champ-de-Mars, first public success and appreciation, from Puvis de Chavannes and Gustave Moreau among others. Contact with Cuno Amiet and Giovanni Giacometti. Member of the *Sezession* in Berlin, Vienna, and Munich. 1904 triumphant success in Vienna as guest of honor at the nineteenth exhibition of the *Sezession*. Friendship with Gustav Klimt (1862 – 1918). Wealth and social reputation. 1905 first trip to Italy. From 1908 association with Valentine Godé-Darel. 1913 birth of daughter, Paulette. 1910 awarded honorary doctorate by the University of Basel. 1918 named honorary citizen of Geneva. Hodler proved his importance as a European artist through his early *plein-air* paintings, his symbolistic figure compositions, the landscapes of his mature and later periods, his self-portraits, and also through the portraits of the sick and dying Valentine Godé-Darel.

Hans Mühlestein and Georg Schmidt, *Ferdinand Hodler, sein Leben und Werk* (Zürich, 1942: Reprint Zürich, 1983); Peter Selz, ed., *Ferdinand Hodler,* exh. cat. (University Art Museum, Berkeley) (Berkeley, 1972); Sharon L. Hirsh, *Ferdinand Hodler* (New York/London, 1982); *Ferdinand Hodler,* exh. cat. (Nationalgalerie Staatliche Museen Preussischer Kulturbesitz, Berlin/Musée du Petit Palais, Paris/Kunsthaus Zürich) (Zürich, 1983); Oskar Bätschmann, Stephen F. Eisenman and Lukas Gloor, *Ferdinand Hodler. Landscapes,* exh. cat. (Wight Art Gallery, University of California, Los Angeles/The Art Institute of Chicago/National Academy of Design, New York) (Zürich, 1987).

Angelika Kauffmann was first educated by her father, a portrait and religious painter from Vorarlberg in Austria. As a ten year-old-girl, she painted portraits, including one of the bishop of Como, for which she gained the reputation of being a child prodigy. Copied old master paintings in Milan, and collaborated on her father's commissions. 1762 painted a self-portrait for the Uffizi and became a member of the Academy in Florence. In Rome, acquaintance with Johann Joachim Winckelmann (1717 – 1768). 1766 – 1781 sojourn in London. Became the artistic attraction of the refined British society. Friendship with artists such as Sir Joshua Reynolds (1723 – 1792), who influenced her painting. 1768 became a member of the Royal Academy, and was commissioned to decorate the reading room. 1781 married the Italian painter Antonio Zucchi (1726 – 1795). Returned to Rome by way of Venice. Angelika Kauffmann was a highly esteemed portraitist, obtaining commissions from numerous European principalities. Her studio was a social and intellectual centre of the town, frequented by Goethe, Herder, and Tischbein. Her success was established on the popularity of a superficial classicism still rooted in the Rococo.

Victoria Manners and George C. Williamson, *Angelica Kauffman. R.A. Her Life and her Works,* (New York, 1924: Reprint New York, 1976).

Son of a German father and a Swiss mother. 1889 – 1901 studied in Munich in the studio of Heinrich Knirr (1862 – 1944), and at the Academy of Arts with Franz von Stuck (1863 – 1928). 1901 – 02 traveled to Italy with the Bernese sculptor Hermann Haller (1880 – 1950). 1902 – 1906 living in Bern, then moved to Munich. 1910 – 11 first exhibitions in Bern, Zürich, Winterthur, and Basel. 1911 met Wassilij Kandinsky (1866 – 1944) and Franz Marc (1880 – 1916). In 1912, participated in the second exhibition of *Der Blaue Reiter,* and in 1913 at the First German Autumn Salon. 1912 in Paris where he became acquainted with Robert Delaunay (1885 – 1941). 1914 traveled to Tunisia with August Macke (1887 – 1914) and Louis Moilliet (1880 – 1962). Discovered the intrinsic value of color. Taught at the Bauhaus in Weimar (1921 – 1926) and Dessau (1926 – 1931). 1928 – 29 journey to Egypt. 1931 professor at the Academy of Düsseldorf. Emigrated to Bern in 1933, where he fell seriously ill in 1935.

Will Grohmann, *Paul Klee* (New York, 1967); Christian Geelhaar, *Paul Klee: Life and Work* (New York, 1982); *Paul Klee,* exh. cat. (The Museum of Modern Art, New York) (New York, 1987).

Le Corbusier (Charles-Edouard Jeanneret)
(La Chaux-de-Fonds 1887 – 1965 Roquebrune-
Cap Martin/France)

see cat. no. 65

Jean-Etienne Liotard
(Geneva 1702 – 1789 Geneva)

see cat. no. 4

Barthélemy Menn
(Geneva 1815 – 1893 Geneva)

see cat. no. 33

First education with Charles L'Eplattenier (1874–1946) at the art school of La Chaux-de-Fonds. At the age of eighteen, he constructed his first one-family house. Subsequent journeys to Italy, Budapest, and Vienna. Established contact with Josef Hoffmann (1870–1956), head of the *Wiener Werkstätten*. 1908 first visit to Paris. Worked in the studio of the architect Auguste Perret (1874–1955), a pioneer in reinforced concrete construction. 1910 with the industrial architect Peter Behrens (1886–1940) in Berlin. After a trip to the Balkans, Athens, and Rome, he returned to teach at the art school in La Chaux-de-Fonds. 1917 moved to Paris. Friendship with the Cubist painter Amédée Ozenfant (1886–1966). In 1920 he founded the periodical *L'Esprit Nouveau*. 1923 first important publication on architecture *Vers une Architecture,* which was followed by numerous other publications. Intensive activity as architect and town planner with many pupils and followers. 1928 joint founder of the *CIAM* (International Congress of Modern Architecture). Became a French citizen in 1930. After the war, he obtained many important commissions in the United States, India, and Japan. As a painter, Le Corbusier founded the purist movement, a special form of synthetic Cubism, with his friend Ozenfant.

Stanislaus von Moos, *Le Corbusier, l'architecte et son mythe* (Paris, 1971); "Le Corbusier 1905–1933," in Kenneth Frampton, ed., *Oppositions,* vol. 15/16 (Cambridge, Mass.: MIT Press, 1979); *L'Esprit Nouveau, Le Corbusier und die Industrie 1920–1925,* exh. cat. (Museum für Gestaltung, Zürich/Bauhaus-Archiv, Museum für Gestaltung, Berlin / Ancienne Douane, Strasbourg) (Zürich/Berlin, 1987).

Son of a Geneva jeweler of French descent. First artistic education with the miniaturists Daniel Gardelle (1679–1753) in Geneva, and, after 1723, Jean-Baptiste Massé (1687–1767) in Paris. Frequent contact with the writer and philosopher Voltaire (1694–1778). 1736 traveled to Italy with the entourage of the French ambassador, 1738 to Constantinople at the invitation of the chevalier William Ponsonby. Portrayed Turkish dignitaries and foreign ambassadors. Remained for some years in Constantinople producing culturally and historically important genre paintings. 1743–1745 sojourn in Vienna. Portrayed the Empress Maria Theresia and the nobility of the imperial court. Several journeys and extended stays in England (1754–55) and Holland (1755–56). Obtained portrait commissions from aristocrats and wealthy citizens everywhere. 1757 returned to Geneva. 1762 and 1767 again in Vienna, 1771 in Paris, 1773–74 in London. 1781 published his *Traité des principes et des règles de la peinture*. Liotard, above all a portraitist, but also a painter of still lifes in his later years, favored pastels, a medium in which he excelled among his contemporaries.

François Fosca, *La vie, les voyages et les œuvres de Jean-Etienne Liotard* (Lausanne, 1956); Renée Loche, *Jean-Etienne Liotard* (Musée d'art et d'histoire, Geneva, 1976); Renée Loche and Marcel Roethlisberger, *L'opera completa di Liotard* (Milan, 1978).

1813–1833 first training with the history painter Jean-Léonard Lugardon (1801–1884) in Geneva. 1833 in Paris, studying with Jean-Auguste Dominique Ingres (1780–1867). 1835 sojourn in Italy, following his teacher to Rome. In Venice, acquaintance with Léopold Robert. In Rome studied the *Stanzas* of Raphael, of which he made copies. 1837 traveled to Naples, Capri, and Salerno. 1838 again in Paris. Friendship with the painters of the Barbizon school. After 1840 friendship with Camille Corot (1796–1875). In 1842, Delacroix invited Menn to collaborate on the decoration of the cupola of the library in the Palais du Luxembourg, but Menn declined. 1843 returned to Geneva. Menn's new conception of landscape painting contradicts the prevailing "heroic" vision of the Alps characteristic of the Geneva school led by François Diday and Alexandre Calame. 1845 sojourn in the Bernese Oberland. 1846–1849 private studio with students. In 1850, became director of the Ecole de figure where he taught successfully for forty-two years. Among his students were Ferdinand Hodler and Edouard Vallet (1876–1929). 1851–1857, along with Corot and others, produced paintings for the great Salon of the castle of Gruyère. 1865–1870 traveled to Germany (Dresden, Munich). 1865 moved to a new atelier on the estate of his wife Louise Gauthier in Coinsins, near Nyon.

Jura Brüschweiler, *Barthélemy Menn 1815–1893. Etude critique et biographique* (Zürich, 1960).

Giuseppe Antonio Petrini
(Carona 1677 — c. 1759 Carona)

see cat. nos. 1 — 3

Léopold Robert
(Les Eplatures 1794 — 1835 Venice)

see cat. nos. 23, 24

Jacques Sablet
(Morges 1749 — 1803 Paris)

see cat. nos. 7, 8

Training in the Turin studio of the Genovese artist Bartolomeo Guidobono around 1700 — 1708(?); however, his painting suggests that other impressions and influences affected him during the years of his apprenticeship. Visited Milan, Genoa, Como, and Bergamo, though he was principally active in the Swiss Ticino. 1753 knighted *Il cavaliere* Petrini. Documents mention him as *fabbriciere* of the pilgrimage church of Madonna d'Ongera (near Carona) in 1711/ 12, from 1727 to 1729, and again from 1753 to 1755. Two of the large frescoes in this church are recognized as Petrini's. In his oil paintings and frescoes, Petrini is related to the late Baroque decorative tradition of Genoa. He moves from strikingly dramatic range of colors to a harmony of subtle nuances of restrained colors. A remarkable feature is Petrini's untiring representation of human figures, frequently half-figures of aged saints and philosophers.

Edoardo Arslan, *Giuseppe Antonio Petrini* (Lugano, 1960); Marco Bona Castellotti, *La pittura lombarda del '700* (Milan, 1986).

1810 first artistic training with the engraver Charles Samuel Girardet (1780 — 1863) in Paris. 1811 admission to the Academy. 1812 began studying with Jacques-Louis David (1748 — 1825) who appreciated his work a great deal. 1817 — 1818 sojourns in Geneva, Neuchâtel, and La Chaux-de-Fonds. Received numerous portrait commissions. From 1818 to 1831 living in Rome. There he came to know Jean-Auguste Dominique Ingres (1780 — 1867). 1821 and 1825 traveled to Naples. 1822 his brother Aurèle (1805 — 1871) moved to Rome to become Léopold Robert's assistant. After 1822, participated regularly in the Paris Salon. 1829 became acquainted with Napoléon-Louis and Charlotte Bonaparte. Leaving Rome in 1831, traveled via Florence to Paris. Knighted in the *Légion d'Honneur*. Moved in 1832 from Florence to Venice, where he lived until his suicide.

Georges B. Ségal, *Der Maler Léopold Robert 1794 — 1835. Ein Beitrag zur Geschichte der romantischen Malerei in der Schweiz* (Basel, 1973); Pierre Gassier, *Léopold Robert* (Neuchâtel, 1983).

First lessons in painting from his father, a house painter and gilder. 1772 student of Joseph-Marie Vien (1716 — 1809) at the Academy in Paris, whom he followed to Rome in 1775 on a government scholarship. Continued training as a history painter at the French Academy in Rome. Sketched after the antique and after masters of the Renaissance. 1777 received the second prize at the Academy of San Luca in Rome, 1779 the first prize at the Academy in Parma. As a result of revolutionary incidents, French painters were expelled from Rome. 1793 hasty departure from Rome to Florence. Return to Paris via Switzerland in the same year. 1794 member of the Société populaire et républicaine des Arts. Among eminent contemporary collectors, François Cacault, Cardinal Fesch, and Lucien Bonaparte all showed great interest in Sablet's painting. 1800 — 01 traveled to Madrid in the entourage of Bonaparte. Returned to Paris where he remained until his death.

Anne van de Sandt, *Les frères Sablet (1775 — 1815),* exh. cat. (Musées départementaux de Loire-Atlantique, Nantes/Musée cantonal des beaux-arts, Lausanne/Palazzo Braschi, Rome) (Rome, 1985).

Jean-Pierre Saint-Ours
(Geneva 1752 — 1809 Geneva)

see cat. no. 9

Giovanni Segantini
(Arco/Italy 1858 — 1899 Schafberg/Pontresina)

see cat. no. 52

Wolfgang-Adam Töpffer
(Geneva 1766 — 1847 Geneva)

see cat. nos. 19, 20

First artistic training in the atelier of his father, an enamel painter, engraver, and chaser. After 1769, training at the Academy in Paris with Joseph-Marie Vien (1716 — 1809). Through Vien, Saint-Ours met Jacques-Louis David (1748 — 1825), who gradually introduced him to the ideas and works of the classical periods. During his first years in Paris, achieved minor academic successes. 1780 won the important Prix de Rome with his *Rape of the Sabine Women*. Along the way to Rome, he studied the Italian masters of the Renaissance and Baroque periods. Lived in Rome until 1792, then in his native city of Geneva. 1803 corresponding member of the Institut de France. For Saint-Ours, the most creative years were those spent in Rome. They brought him social acknowledgement, commissions, and possibilities for exhibitions. Contemporary art critics considered him a first-rate history painter, but he himself attached much importance to landscape painting as well. Towards the end of his life he withdrew from public life. In the changing intellectual atmosphere of Geneva society, he abandoned the field of history painting and dedicated himself exclusively to portrait painting.

Daniel Baud-Bovy, *Peintres genevois 1702 — 1817,* première série (Geneva, 1903); Hugh Honour, *Neo-Classicism* (Harmondsworth, 1986).

After his mother's death, Segantini lived from 1863 to 1881 in poverty-stricken conditions with relatives in Milan. Apprenticed to a house painter, then attended the Brera Academy. Friendship and contractual commitment to the painter, critic, and art dealer Vittore Grubicy. In 1881 moved to the Brianza area, north of Milan. Achieved his international reputation with a series of exhibitions: Amsterdam 1883, Munich 1892, and Turin 1893. In 1886, the family of six moved to the Grisons, first to Savognin, and in 1894 to Maloja. Friendship with Giovanni Giacometti. The themes of Segantini's mature period focus on man's existential being. They are intense, symbolic compositions drawn from nature, which Segantini saw as the "stage" for cosmic events. He is considered to be the most important representative of Italian Divisionism, which influenced to some extent the early works of the futurists.

Hans A. Lüthy and Corrado Maltese, *Giovanni Segantini* (Zürich, 1981); Annie-Paule Quinsac, *Segantini, Catalogo generale,* 2 vols. (Milan, 1982).

Son of an immigrant tailor from Schweinfurt (Franken, Germany) and a woman from Geneva. Apprenticeship in etching. First employment as illustrator with a publishing house in Lausanne. Friendship with Firmin Massot (1766 — 1849) and Jacques-Laurent Agasse. In 1789 traveled to Paris. Surprised by the outbreak of the Revolution, Töpffer fled back to Geneva. 1791 second sojourn in Paris. For a short time, student of Joseph-Benoît Suvée (1743 — 1807). Friendship with the Flemish painter Jean Louis de Marne (1754 — 1829). After his return to Geneva, he joined Pierre-Louis de la Rive (1753 — 1817) whom he accompanied on his "campagnes de peinture" through the region of Savoy and the canton of Vaud. 1804 again in Paris. Contact to art dealers and artists such as de Marne, Carle Vernet (1758 — 1836), and Louis-Léopold Boilly (1761 — 1845). In 1807, in Paris teaching drawing to the Empress Joséphine. 1816 traveled to England. Studied English landscape painting and the work of William Hogarth (1697 — 1764). 1817 publication of an *Album de caricatures.* 1824 traveled to Italy. After returning to Geneva, Töpffer was active as a teacher of drawing, miniaturist, draughtsman, and painter. He contributed substantially to the development of genre painting in Switzerland: Turning away from the refined genre modes of the eighteenth century, he was instead influenced by those of the Netherlands, and thus depicted daily life in the streets, markets, and in nature.

Daniel Baud-Bovy, *Peintres genevois 1766 — 1849,* deuxième série (Geneva, 1904); *Des Monts et des Eaux: Paysages de 1715 à 1850,* exh. cat. (Galerie Cailleux, Paris/Galerie Cailleux, Geneva, 1980/81).

Johann Jakob Ulrich
(Andelfingen 1798 – 1877 Zürich)

see cat. no. 32

Childhood in Weisslingen and Zürich. At his father's wish, commercial apprenticeship in a Paris banking house. 1822 joined the atelier of Jean Victor Bertin (1775 – 1842), where he met Corot who was working there at the same time. 1828 – 1830 sojourn in the environs of Naples. Discovered Mediterranean light and a bright palette. Made *plein-air* studies of the landscape. Traveled through France, England, and Switzerland. Shared an atelier with the Parisian animal painter Raymond Brascassat (1804 – 1867) until 1838. 1835 was awarded the gold medal at the Paris Salon. Directed an atelier in Zürich after 1837. Continuing to practice *plein-air* painting, he traveled on foot through Switzerland, depicting Swiss landscapes in the *Mittelland* and Lower Alps. 1855 received professorship in landscape drawing at the newly-founded Federal Institute of Technology in Zürich. Ulrich is considered a mediator between landscape painting of the French- and that of the German-speaking regions of Switzerland. He contributed to the overcoming of miniature landscape and view painting which was common in Switzerland during the eighteenth and first half of the nineteenth century, and he is the most gifted forerunner of later landscape painters such as Rudolf Koller (1828 – 1905), Robert Zünd, and Frank Buchser.

Hans Armin Lüthy, *Der Zürcher Maler Johann Jakob Ulrich II. 1798 – 1877. Ein Beitrag zur Geschichte der schweizerischen Landschaftsmalerei in der ersten Hälfte des 19. Jahrhunderts* (Zürich, 1965).

Félix Vallotton
(Lausanne 1865 – 1925 Paris)

see cat. nos. 47 – 51

Attended the gymnasium in Lausanne. At the age of seventeen, traveled to Paris and pursued artistic training at the Académie Julian. 1885 first participation at the Salon des Artistes Français. Worked as portrait painter, etcher, and restorer. Acquaintance with Charles Cottet (1863 – 1925), Henri de Toulouse-Lautrec (1864 – 1901), and Edouard Vuillard (1868 – 1940). 1889 traveled to Italy. 1890 – 1897 wrote art criticism for the *Gazette de Lausanne*. 1891 produced first woodcuts, which immediately caused a sensation. Produced illustrations for magazines like *La Revue Blanche, Pan, Jugend, Studio, Chap Book* and *Scribner*. 1892 joined the artists' group of the *Nabis*. In 1899, Vallotton married Gabrielle Rodrigues-Henriques who was related to the art dealers Bernheim-Jeune. Became a French citizen in 1900. Around 1903 expanded to larger-scale nudes, genre pictures, landscapes, and still lifes. In 1913 traveled to Russia. Sojourn in Rome and Perugia. As he aged, Vallotton alienated himself from the bourgeois milieu of his wife's family and became an eccentric outsider. Vallotton's œuvre is marked by a stylized realism. Classical forms, combined with minute, often ironic details, result in a vision of reality sometimes overshadowed by misanthropy.

Günter Busch, Bernard Dorival and Doris Jakubec, *Félix Vallotton: Documents pour une biographie et pour l'histoire d'une œuvre*, 3 vols. (Lausanne/Paris, 1973 – 1975); Anton Friedrich and Rudolf Koella, *Félix Vallotton* (Zürich, 1979); Günter Busch, Bernard Dorival, Patrick Grainville and Doris Jakubec, *Félix Vallotton* (Lausanne, 1985).

Caspar Wolf
(Muri 1735 – 1783 Heidelberg)

see cat. nos. 16, 17

Apprenticed as painter to Johann Jakob von Lenz (1701 – 1764), artist at the Episcopalian court of Constance. Worked in Augsburg as journeyman for the view painter Jacob Christoph Weyermann (1698 – 1757). Excursions to Munich and Passau. 1760 – 1768 lived in Muri. Worked as painter of altars, wall-covering designs, and tile stoves. He also produced landscape paintings. 1768 traveled to Paris, where he was extremely impressed by contemporary French landscape painting. After 1771, again living in Muri, and occupied thereafter exclusively as a landscape painter. From 1774 to 1779 worked at Bern and Solothurn. 1780 – 1783 in the Rhineland (Germany). In the years 1774 – 1778 he painted over 140 mountainscapes for the Bernese publisher and alpine enthusiast Abraham Wagner. These found wide circulation as colored etchings and aquatints. The artist himself published landscapes and a series on Swiss national costumes. Wolf was a pioneer in the depiction of the Alps, and holds a significant place among Swiss landscape painters. His studies of nature have importance not only for art historians, but also for alpine researchers, geologists, and glaciologists. In his Romantic view of nature he was far ahead of his time.

Willi Raeber, *Caspar Wolf 1735 – 1783. Sein Leben und sein Werk* (Aarau, 1979); Yvonne Boerlin-Brodbeck, *Caspar Wolf (1735 – 1783). Landschaft im Vorfeld der Romantik,* exh. cat. (Kunstmuseum Basel) (Basel, 1980).

Johann Heinrich Wüest
(Zürich 1741 – 1821 Zürich)

see cat. no. 18

1750 – 1760 apprenticed to a house painter, besides being self-trained as a draughtsman. First introduction to fine arts through the painter Johann Balthasar Bullinger (1713 – 1793). Sojourn in Amsterdam, where he studied between 1760 – 1766. Via Brussels and Antwerp, traveled to Paris in 1766. Returned to Zürich in 1769. Friendship with the poet and landscape painter Salomon Gessner (1730 – 1788). Founding member of the Künstlergesellschaft in Zürich. One of his most important students was Ludwig Hess (1760 – 1800), who translated Wüest's style, which was characterized by harmony and serenity, into a more Romantic mode. Wüest was successful as painter of both easel pictures and wall coverings depicting decorative landscapes.

Liselotte Fromer-Im Obersteg, *Die Entwicklung der schweizerischen Landschaftsmalerei im 18. und frühen 19. Jahrhundert* (Basel, 1945); Yvonne Boerlin-Brodbeck, *Caspar Wolf (1735 – 1783). Landschaft im Vorfeld der Romantik.* exh. cat. (Kunstmuseum Basel) (Basel, 1980).

Robert Zünd
(Lucerne 1827 – 1909 Lucerne)

see cat. no. 31

Began studying painting in Lucerne, Stans, and Geneva (1848 – 1850), where he was a pupil of François Diday and Alexandre Calame. 1851 sojourn in Munich. Disappointed not to be more inspired by the art movements prevailing in Munich. Beginning of a lifelong friendship with the painter Rudolf Koller (1828 – 1905). Traveled to Dresden (1860) and Paris (1859, 1861, 1867, 1878). Copied old master paintings in the Louvre and studied works of Claude Lorrain and Nicolas Poussin. 1860 painted his first major work, *The Harvest*. 1882 completed the important painting entitled *Eichwald*. Friendship with the business magnate Theodor Reinhart, who would later be his patron. 1902 honorary member of the Kunstgesellschaft of Lucerne. 1906 honorary doctorate from the University of Zürich.

Robert Zünd in seiner Zeit, exh. cat. (Kunstmuseum Luzern) (Lucerne, 1978).

Selected Bibliography

Swiss Painting 1730 – 1930

Carl Brun, ed., *Schweizerisches Künstler-Lexikon*, 3 vols. and supplement (Frauenfeld, 1905 – 1917); Kraus Reprint (Nendeln, 1982).

Eduard Plüss and Hans Christoph von Tavel, eds., *Künstler Lexikon der Schweiz, XX. Jahrhundert*, 2 vols. (Frauenfeld, 1958 – 1967).

Joseph Gantner and Adolf Reinle, *Kunstgeschichte der Schweiz. Von den Anfängen bis zum Beginn des 20. Jahrhunderts*, 4 vols. (Frauenfeld, 1947 – 1968); vol. 3: Adolf Reinle, *Die Kunst der Renaissance, des Barock und des Klassizismus* (1956), vol. 4: Adolf Reinle, *Die Kunst des 19. Jahrhunderts, Architektur/Malerei/Plastik* (1962).

Hans Christoph von Tavel, *Ein Jahrhundert Schweizer Kunst, Malerei und Plastik. Von Böcklin bis Alberto Giacometti* (Geneva, 1969).

Florens Deuchler, Marcel Roethlisberger, and Hans Lüthy, *Swiss Painting from the Middle Ages to the Dawn of the Twentieth Century* (New York, 1976).

Hans A. Lüthy and Hans-Jörg Heusser, *Kunst in der Schweiz, 1890 – 1980* (Zürich and Schwäbisch Hall, 1983).

Unsere Kunstdenkmäler, vol. 38, no. 3 (Bern, 1987). General theme: "Von Füssli bis ARS HELVETICA — Kunstgeschichte in der Schweiz."

Florens Deuchler, ed., *ARS HELVETICA, Die visuelle Kultur der Schweiz*, 12 vols. and index (Disentis, 1987 ff.); especially vol. 1: Dario Gamboni, *Kunstgeographie* (1987); vol. 2: Florens Deuchler, *Kunstbetrieb* (1987); vol. 6: Oskar Bätschmann, *Malerei der Neuzeit* (forthcoming); vol. 10: Hans Christoph von Tavel, *Nationale Bildthemen* (forthcoming).

Photographic Credits

C: Figures in the catalogue entries
F: Brandon Brame Fortune, *Painting in America and Switzerland 1770 – 1870*
H: William Hauptman, *The Swiss Artist and the European Context*
J: Hans Ulrich Jost, *Nation, Politics, and Art*

Emanuel Ammon, Lucerne
Fig. J 11b

Amt für Bundesbauten, Bern
Fig. J 15

Bildarchiv Felix Klee, Bern
Figs. C 60a, C 63a – cat. nos. 59, 60, 61, 62, 63, 64

The Brooklyn Museum, New York
cat. no. 38

Bündner Kunstmuseum, Chur
cat. nos. 6, 52

The City of Zürich
cat. no. 11

The Crysler Museum, Norfolk, Virginia
Fig. C 27a

The Corcoran Gallery of Art, Washington, D. C.
Fig. F 16

Documentation photographique de la Réunion des musées nationaux, Paris
Fig. C 5a

The Fine Arts Museum of San Francisco
Fig. F 21

Hamburger Kunsthalle
Fig. C 39a

Kunsthaus Zürich
cat. nos. 10, 18, 48, 51

Kunstmuseum Bern
cat. no. 58

Kunstmuseum Bern, Paul Klee Foundation
Fig. C 61a

Kunstmuseum Hannover
Fig. C 59a

Kunstmuseum, Lucerne
Fig. C 31a – cat. no. 21

Kunstmuseum St. Gallen
cat. no. 44

Kunstmuseum Solothurn
cat. no. 55

The Metropolitan Museum of Art, New York
Figs. F 20, F 23

Musée d'art et d'histoire, Geneva
Fig. C 19a – cat. nos. 4, 22, 29, 53

Musée des beaux-arts, Lille
Fig. C 41a

Musée cantonal des beaux-arts, Lausanne
Fig. C 15a – cat. nos 7, 8, 9, 13, 14, 15, 23, 25, 26, 27, 34

Museum für Gestaltung, Zürich
Figs. J 10, J 14

The Museums at Stony Brook
Fig. F 22

Photocolor Hinz, Allschwil
cat. nos. 31, 36, 37, 41

Princeton University Art Museum
cat. no. 5

Reproductions
Figs. C 11a, C 31b, C 38a, C 38b, C 38c, C 47a, C 64a, F 2, F 3, F 6, F 9, F 10, F 12, F 13, F 14, F 17, F 18, F 19, J 1, J 2a, J 2b, J 6, J 8a, J 8b, J 8c, J 11a, J 12, J 13

Rijksmuseum-Stichting, Amsterdam
Fig. C 14a

Swiss Institute for Art Research (Jean-Pierre Kuhn)
Figs. C 10a, C 30a, C 31c, C 43a, C 43b, C 43c, C 53a, C 55a, C 56a, F 1, F 7, F 8, F 11, F 24, H 1, H 2, H 3, H 4, H 5, H 6, H 7, H 8, H 9, H 10, H 11, H 12, H 13, H 14, H 15, H 16, H 17, H 18, J 5, J 7, J 9, J 16, J 17 – cat. nos. 1, 12, 16, 17, 19, 20, 24, 28, 30, 32, 33, 35, 39, 40, 42, 43, 45, 46, 47, 49, 50, 54, 56, 57, 65

Swiss National Museum, Zürich
Fig. J 3

University Art Gallery, New Haven (Joseph Szaszfai, Branford)
Fig. F 4

Vincenzo Vicari, Lugano
cat. nos. 2, 3

Wadsworth Atheneum, Hartford, Conn. (Joseph Szaszfai, Branford)
Fig F 15

Zentralbibliothek, Zürich
Fig. J 4